THE DICTIONARY
OF SCOTTISH PAINTERS
1600–1960

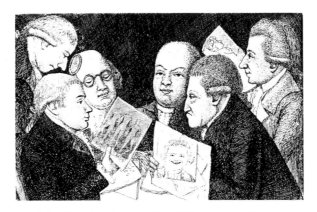

John Kay *Connoisseurs* etching 1785, private collection

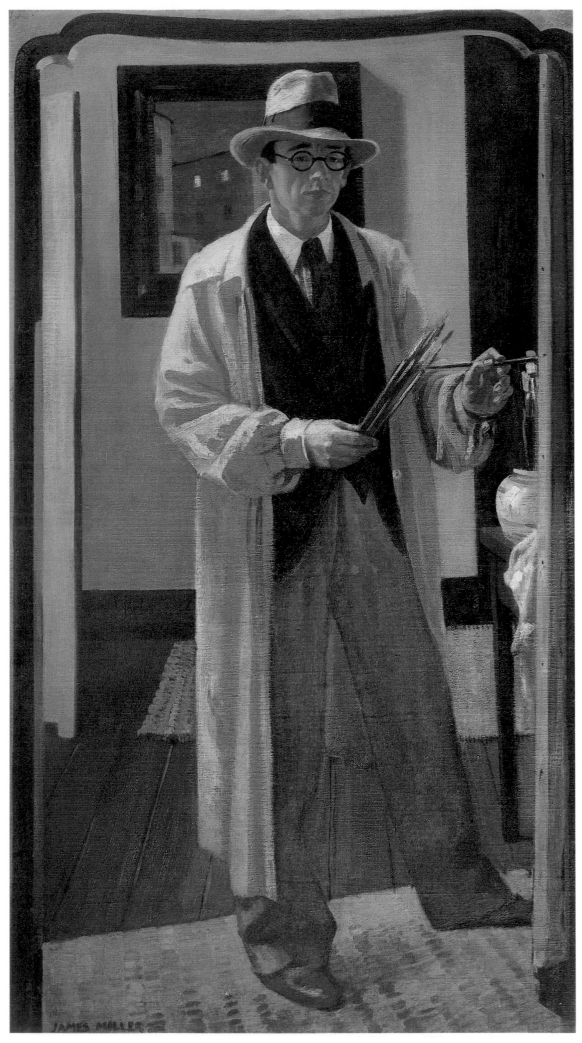

James Miller *The Artist in his Studio* oil, private collection

THE DICTIONARY
OF SCOTTISH PAINTERS
1600–1960

Julian Halsby and Paul Harris

CANONGATE / PHAIDON PRESS
in association with
BOURNE FINE ART

First published 1990 by
Canongate Publishing
16 Frederick Street, Edinburgh

and Phaidon Press,
Jordan Hill Road, Oxford;

in association with
Bourne Fine Art
3 Dundas Street, Edinburgh
and Mason's Yard,
St.James's, London

British Library Cataloguing in Publication Data
Halsby, Julian
A dictionary of Scottish painters 1600–1960
1. Scottish paintings, history
I. Title II. Harris, Paul
759.2911

ISBN 0–86241–328–1

Typeset by Falcon Typographic Art, Edinburgh & London
Printed and bound by Gorenjski Tisk, Kranj, Yugoslavia

Acknowledgements

In compiling a work of this type one inevitably draws upon many and varied sources both public and private, published and unpublished. It would be impossible to chronicle all the assistance we have received but we should like to take this opportunity to thank anybody who has shared even the smallest morsel of information with us.

We should particularly like to thank those who have been closely involved with the project and, in particular, Patrick Bourne of Bourne Fine Art who put us together and encouraged us to proceed with the book. Others have been particularly generous with their time and advice: James Holloway of the National Gallery of Scotland who has been as helpful privately as he has been in his professional capacity; Bill Smith of Robert Fleming Holdings who has not only given of his own time and advice but who made available to us the wonderful collection which Flemings have built up over the years; and Jack Firth who has freely shared with us his own deep knowledge and understanding of Scottish art and made available his own personal research materials.

Many individuals and organisations have helped with our research including Joanna Soden and the Royal Scottish Academy; the Fine Art Department, Edinburgh Central Library; the Mitchell Library, Glasgow; the Publications Department, National Galleries of Scotland; staff at the Scottish National Portrait Gallery; Tom Hewlett; Niall Duncan and Guy Peploe.

We are especially grateful to all the public and private galleries and to the owners who have allowed us to reproduce their paintings or shared their knowledge on particular painters: J D M Robertson Esq; the Ellis Campbell Collection; Peter Grosch Esq; Alan W Cope Esq; Lynn McGilvray Douglas; Lyn Newton; Brian Neill Esq; Angus Grossart Esq; Charles G Spence Esq ; Lady Evelyn Brander; Paul Roberts and Stephanie Donaldson; The Royal Bank of Scotland plc; The EFT Group; Michael Hardie of the George Street Gallery, Perth; Barclay Lennie, Barclay Lennie Fine Art, Glasgow; Ewan Mundy, Glasgow; The Scottish Gallery, Edinburgh and London; Malcolm Innes and Anthony Woodd of The Malcolm Innes Gallery, Edinburgh and London; Mr & Mrs John Kemplay, Edinburgh; Mr & Mrs A Stewart; Ailsa Tanner for her memories of Eleanor Moore Robertson; Miss Mary Herdman for information on the Herdmans; The Moss Galleries, London; The Portland Gallery, London; Forrest McKay Gallery, Edinburgh; Nick Curnow at Phillips Scotland; Alexander Meddowes at Christie's Scotland and Sotheby's in London. Other images have been drawn from Perth Museum & Art Gallery; Kirkcaldy Art Gallery; Dundee Art Gallery; Aberdeen Art Gallery and the collection of The Scottish Arts Club, Edinburgh. We should like to record our thanks to all those who looked out pictures for us and, in many cases, arranged special photography. Our thanks also to artists who have supplied transparencies of their work and given permission for it to

be reproduced: Barbara Balmer, Willhelmina Barns-Graham, Jack Firth, William Gear, James McIntosh Patrick and Sir Robin Philipson.

We have tried to contact surviving relatives and estates of artists deceased within the last 50 years but in a few instances this has proved quite impossible. In the interests of as complete an entry as possible, we trust it will be understood that reproductions of monograms, signatures and work examples have been necessary in the context of review and criticism of artists' work.

In a reference book like this containing some 2,000 entries we reckon there are probably something of the order of a quarter of a million items of factual information. Inevitably, there will be mistakes although we have, of course, endeavoured to check as much of our information as is humanly possible; and there will be omissions even within our own parameters (see Introduction). We shall be very glad to be corrected on these matters and can be contacted through our ever willing publishers Canongate in Edinburgh.

Julian Halsby & Paul Harris

July 1990

Introduction

Never before has there been such widespread general interest in Scottish painting. Indeed, in commercial terms, the market can never have been so active since the turn of the century when the art dealer Duveen was able to secure upwards of $100,000 for a Raeburn portrait. It is not just that some spectacular prices have been achieved in the auction rooms, like the price of £506,000 for S J Peploe's *Woman in White* at Christie's in Glasgow (1988). Awareness has become widespread well beyond the area of mega-prices. In recent years, the development of a Scottish school of painting as such has become widely recognised and research over the last ten or fifteen years has clearly established links and interconnections between artists working in both 19th and 20th centuries which reinforce the concept of the development of a distinctly Scottish school.

The need for a reference work outlining the careers of Scottish painters seems clear: apart from the biographical section in *Scottish Watercolours 1740–1940* (Julian Halsby, London 1986) and *The Concise Dictionary of Scottish Artists* (Paul Harris, Edinburgh 1976), there are no alphabetically arranged general reference works on Scottish art available.

In attempting to remedy this situation, the authors have necessarily had to establish some firm parameters in compiling such a large amount of information and early decisions had to be made on precisely what this book was seeking to achieve. Our objectives are broadly as follows: to provide basic biographical information on all easel/studio painters working in oil, watercolour, pastel, pencil, pen and ink, etc. within Scotland during the period 1600 to 1960. By 'working', we mean producing a body of work for sale or exhibition: exhibiting for a year at the RSA or SSA or, say, visiting Scotland for a holiday and painting a number of pictures does not qualify an artist for inclusion. Consequently, we have purposely omitted very minor figures or artists whom we know to be purely amateur. On the other hand, we have included a number of essentially English painters who lived in Scotland for just a few years but who made major contributions to artistic life in the country through, principally, teaching, usually at Glasgow or Edinburgh Colleges of Art.

We have regarded 1600 as a logical starting date as the beginning of the 17th century marks the start of easel painting within Scotland, as opposed to ceiling, mural, heraldic and other essentially decorative forms of painting. Earlier painters are most unlikely to be encountered by those using this book and, indeed, if details are required on such figures then the reader is referred to the standard work *Painters in Scotland 1301–1700* (M R Apted and S Hannabus, Edinburgh 1978). Establishing a cut-off date was certainly somewhat more difficult but 1960 seems logical to us. Information on the younger artists working today in Scotland is widely available in the form of public and private gallery catalogues and from current newspaper and magazine sources. We feel that most people using this book will require it essentially as a reference source to earlier generations of artists, information about which is far more difficult to ascertain.

Certain categories of artist are specifically excluded: architects, graphic designers, muralists, heraldic and decorative painters, workers in textile and embroidery, and sculptors. Such artists are, however, included where they have produced a body of work in pen, pencil, watercolour or similar medium.

We have endeavoured to follow a standard format in the entries giving birth and death dates, memberships and decorations, places of birth and work, artistic education and type of work produced. Wherever possible we have tried to place entries – especially the more important ones – in an art historical context rather than simply presenting them as bald and telegrammatic biographical information, and we have sought to cross reference them to other, associated entries (using small capital letters). Abbreviations and contractions are separately listed. In many cases exact dates are not known and we have indicated the dates artists were working (fl.) by reference to exhibition catalogues and dated works in public and private collections.

The work of more than 300 painters is illustrated. These works have been chosen on the grounds of typicality rather than as being the most outstanding or visually dramatic output of the artist concerned. We felt that typicality would represent a more useful and truthful guide for the reader consulting this book. We have consciously sought not to illustrate the best known work of well known artists held in public collections: such works tend to be widely illustrated and we very strongly felt that fresher examples should be identified and used. Thus, a very substantial proportion of the illustrations have never been seen in print before. Indeed, many of the artists have never been illustrated in any art book before: the compilation of a Dictionary such as this has given us a unique opportunity to illustrate many comparatively minor and relatively unknown figures.

The illustrations accompany the entries for the artists concerned. The entry itself is headed by the artist's name in full, insofar as we know it, and the illustration bears the style of name by which the artist is normally known. Captions also indicate the title of the picture, medium and ownership. Wherever possible, any original title for a picture, i.e. the title given by the artist at the time of painting, is used. Over the years, however, many original titles have ceased to be used or have been forgotten or lost. Subsequent owners or picture dealers then tend to ascribe their own titles to paintings, ranging from the prosaic to the positively lyrical, which is, of course, a perfectly legitimate exercise so long as they do not mislead or obliterate original designations. Insofar as is possible, we have sought to check that this is not the case.

So far as possible, monograms and signatures are given where difficulties might be encountered, either through indistinct rendering, contractions, existence of several artists with similar names (whether Scottish or not), forgery (happily rare), generally idiosyncratic practice, or on the grounds of general importance. In many cases, artists using contractions or, particularly, initials also tended at times to sign with their full name. Therefore, the inclusion of a monogram or initialled style of signature should not be regarded as necessarily excluding the common usage of a full signature.

This is necessarily an incomplete work. It is patently impossible to hope to list every artist working in Scotland over a period of three and a half centuries. This is, however, the most complete work to date and, as such, it fills a rather obvious gap in information generally available to all those interested in Scottish art. Mistakes and omissions will be rectified in later editions.

A Guide to Sources

Biographical information in this book is drawn from a wide range of sources both published and unpublished (see Acknowledgements). A booklist of the published sources which might form a basic library in the area of Scottish art is given below.

For more specific information on individual artists we would refer the reader to the detailed Bibliography in *Scottish Watercolours 1740–1940* by Julian Halsby (London 1986, reprinted 1990); and to the excellent critical overview of writing on Scottish painting, *The Literature of Scottish Painting*, by Jack Firth in *Books in Scotland* numbers 31 & 32 (Summer & Autumn 1989) published by the Ramsay Head Press, Edinburgh.

Aberdeen Art Gallery, Permanent Collection Catalogue, compiled by Charles Carter. Aberdeen 1968

Armstrong, Sir Walter, Scottish Painters. A Critical Study, Seeley and Co., London, 1888

Bate, Percy, Art at the Glasgow Exhibition 1901, Virtue, London, 1901

Bate, Percy, The English Pre-Raphaelite Painters. Their Associates and Successors, G. Bell and Sons, London 1899

Billcliffe, Roger, The Glasgow Boys, John Murray, 1985

Brown, Gerard Baldwin, The Glasgow School of Painters, J. Maclehose, Glasgow, 1908

Brydall, Robert, Art in Scotland. Its Origins and Progress, Blackwood, Edinburgh, 1889

Caw, Sir James, Scottish Painting Past and Present 1620-1908, J.C. and E.C. Jack, Edinburgh, 1908 (reprinted 1975)

Caw, Sir James, Scottish Portraits, 2 vols, J.C. and E.C.Jack, Edinburgh 1902-3

Croal, T.A., 'The Edinburgh Pen-and-Pencil Club' Art Journal, 1899 pp. 232-4

Cursiter, Stanley, Scottish Art to the Close of the Nineteenth Century, George Harrap and Co., London, 1949

Cursiter, Stanley, Looking Back: A Book of Reminiscences, Edinburgh, 1974

Dewar, Decourcy Lewthwaite, History of the Glasgow Society of Lady Artists' Club, Maclehose, Glasgow, 1950

Dundee City Art Gallery, Catalogue of the Permanent Collection, compiled by W.R. Hardie, 1973

Eyre-Todd, G., Who's Who in Glasgow in 1909, Gowans and Gray, Glasgow, 1909

Finlay, Ian, Art in Scotland, Longmans, 1945

Finlay, Ian, Art in Scotland, O.U.P., 1948

Geddes, Patrick (ed.), Evergreen. A Northern Seasonal, 4 issues, Edinburgh 1895-6

Glasgow, The Glasgow Society of Lady Artists in 1882, Centenary Exhibition Catlogue, 1982

Fergusson, J.d., Modern Scottish Painting, William Maclennan, Glasgow 1943

Halsby, Julian, Scottish Watercolours 1740-1940, Batsford 1986, 1990

Hardie, Martin, Watercolour Painting in Britain, 3 vols, Batsford, 1966-8

Hardie, William R., Scottish Painting 1837-1939, Studio Vista, 1976

Hartrick A.S., A Painter's Pilgrimage through Fifty Years, C.U.P., 1939

Hay, George, The Book of Hospitalfield, A Memorial of Patrick Allan Fraser HRSA of Hospitalfield, Arbroath,1894 (privately printed)

Helensburgh and District Art Club, West of Scotland Women Artists, 25th Anniversary Loan Exhibition, Introduction by Ailsa Tanner.

Honeyman, T.J., Three Scottish Colourists, Thomas Nelson and Sons, 1950

Irwin, David and Francina, Scottish Painters at Home and Abroad 1700-1900, Faber and Faber, 1975

Irwin, Francina, 'Lady Amateurs and their Masters in Soctt's Edinburgh', Connoisseur CLXXXV, 1974, pp.230-237

Larner, Gerald and Celia, The Glasgow Style, Paul Harris, 1979

Mcconkey, Kenneth, 'From Grez to Glasgow: French Naturalist Influence in Scottish Painting', Scottish Art Review vol.XV, November 1982, pp.16-34

Mackay and Rinder, The Royal Scottish Academy 1826-1916, Glasgow, 1917

Mackay, William Darling, The Scottish School of Painting, Duckworth and Co., London, 1906

Macmillan, Duncan, Painting in Scotland: The Golden Age, Phaidon, 1986

Martin, David, The Glasgow School of Painting (with an introduction by Francis H.Newbery), George Bell and Sons, 1897

Miles, Hamish, Early Exhibitions in Glasgow I (1761-1838) Scottish Art Review, new series, VIII, 3, 1962, pp.26-30 II (1841-1855) ibid., 4 pp.26-9

Millar, A.H., 'Hospitalfields: A proposed College for Artists', Art Journal, 1896, pp.246-8

National Gallery of Scotland, Catalogue of Scottish Drawings, Keith Andrews and J.R. Brotchie

Selected Scottish Drawings, Keith Andrews, 1960

The Discovery of Scotland, exhibition catalogue by Lindsay Errington and James Holloway, 1978 Master Class: Robert Scott Lauder and his Pupils, exhibition catalogue by Lindsay Errington, 1983

Pinnington, Edward, 'Robert Scott Lauder RSA and his Pupils', Art Journal, 1898, pp.339-43; 367-71

Pinnington, Edward, The Art Collection of the Corporation of Glasgow, Glasgow, 1898

Power, William, 'Glasgow and the Glasgow School', Scottish Art Review, 1946

Reid, J.M. and Honeyman, T.J., Glasgow Art Club 1867-1967, Glasgow, 1967

Scottish Arts Council Exhibition catalogues The Artist and the River Clyde, 1958-9 The Glasgow Boys, catalogue by W. Buchanan and others, 1968 and 1971 A Man of Influence; Alex Reid, catalogue by Ronald Pickvance, 1967 Mr Henry and Mr Hornel visit Japan, catalogue by W. Buchanan, A. Tanner and L.L. Ardern, 1978

Three Scottish Colourists, catalogue by W.R. Hardie, 1970

Skinner, Basil, Scots in Italy in the Eighteenth Century, Edinburgh, 1966

Spencer, Isobel, 'Francis Newbery and the Glasgow Style', Apollo XCVIII, 1973, pp.286-93

Staley, Allen, Pre-Raphaelite Landscape, O.U.P., 1973

Stirling smith Art Gallery and Museums, The Artists of Craigmill and Cambuskenneth, Catalogue by Fiona Wilson, 1978

Tonge, John, The Arts of Scotland, Kegan Paul, Trench and Trubner, 1938

Williams, Iolo, Early English Watercolours, London, 1952

ABBREVIATIONS

ARSA	Associate of the Royal Scottish Academy
b.	born
c.	century
c./ca.	circa
d.	died
GI	Glasgow Institute
GSA	Glasgow School of Art
GSWA	Glasgow Society of Women Artists
ECA	Edinburgh College of Art
n.d.	no dates (available)
NEAC	New English Art Club
NGS	National Galleries of Scotland
RA	Royal Academy
RBA	Royal Society of British Artists
RCA	Royal College of Art
RI	Royal Institute of Painters in Watercolour
RE	Royal Society of Etchers and Engravers
RGI	Royal Glasgow Institute
RMS	Royal Society of Miniaturists
ROI	Royal Institute of Oil Painters
RP	Royal Society of Portrait Painters
RSA	Royal Scottish Academy (full Member of)
RSW	Royal Scottish Society of Painters in Watercolour
RWA	Royal West of England Academy
SNPG	Scottish National Portrait Gallery
SSA	Society of Scottish Artists
SSWA	Society of Scottish Women Artists
VAM	Victoria and Albert Museum
WSA	West of Scotland Academy

A

Abercrombie, Douglas b.1934
Born Glasgow and studied at GSA 1952–56. Won Carnegie Travelling Scholarship and travelled with Bertram Mills Circus before post as painter-designer at Glasgow Citizens Theatre. Moved to London 1964. Paints abstracts in watercolour and in acrylic.

Abercromby, James fl.1720s
Second holder of the office of H M Painter and Limner for Scotland. Spent most of his time as a soldier in the American colonies and took little interest in either his office or painting.

Abercromby, John Brown 1843–1929
Edinburgh painter mostly known for his figure and domestic genre work; also landscapes and seascapes. He often painted on small panels.

Abercromby, J. R. fl. late 19c
Portrait painter in oil. Portrait of WILLIAM BEATTIE BROWN in RSA Collection.

Aberdeen Artists' Society
Formed in January 1885 by a group of local artists, prominent in which was JAMES CADENHEAD. The Society has organised regular exhibitions over the years but went into abeyance after the beginning of the Second World War. It was revived around 1954 by the artist IAN FLEMING after he went to Gray's School of Art in Aberdeen.

The Academy of St Luke 1729–1731
The Academy of St. Luke was named after the successful academy in Rome where several of the pupils were to study. These included the older and younger ALLAN RAMSAY, WILLIAM ADAM, the architect, the portrait painter JOHN ALEXANDER, the engraver RICHARD COOPER and two of the NORIE family – James Norie Senior (1684–1757) and his elder son James (1711–36).
The Academy met from November to February and in June and July and a 'small sum' was charged; however it appears that the room it occupied in Edinburgh University was only open for 8 hours a week. There were 18 artist members who drew from casts of classical sculpture and copied Old Master drawings and engravings. As in the FOULIS ACADEMY there was life drawing, but never from nude models. The Academy was thus for the benefit of working artists and was not intended to train students.

Adam, James 1730–94
Younger brother of ROBERT ADAM and his architectural partner. Was in Rome 1760–63. His watercolours usually include architectural subjects, in pen with lighter coloured washes.

Adam, Joseph fl. 1858–80
Father of J.D. ADAM. Painted oils of landscapes in Scotland and the north of England.

Adam, Joseph Denovan 1842–96
RSW 1883, ARSA 1884, RSA 1892
A prolific painter of animals, Highland landscapes and still-life. Son of JOSEPH ADAM Established in 1887 a school of animal painting at Craigmill, near Stirling which became the centre for a group of Stirling and Glasgow artists. It was based on Adam's small farm, and students were encouraged to paint his herd of Highland cattle from life. Died Glasgow.

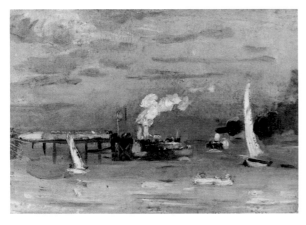

John Brown Abercromby *On the Clyde* oil, private collection

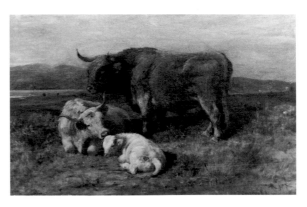

Joseph Denovan Adam *Highland Cattle* oil, private collection

1

Adam, Joseph Denovan junior d. ca.1935
Worked with his father, J.D. ADAM on Craigmill Farm, becoming an animal painter in his own right with a looser watercolour style than that of his father. Sometimes collaborated with him on large oil paintings.

Adam, Margaret d. 1820
Unmarried sister of ROBERT ADAM and an amateur draughtsman. Represented in the Blair Adam Collection by *Rocky Landscape with Trees* and a *Classical Building in the Distance* signed M.A.

Adam, Patrick William, 1854–1929
ARSA 1883, RSA 1897, Society of Eight 1912
Born Edinburgh. Studied at RSA Schools. First successes were in portraiture, but widened his scope to include interiors for which he is best known. In 1889 made his first trip to Venice and between then and 1894 painted a notable series of Venetian views. In 1896–7 painted a series of winter landscapes.
In 1908 settled in North Berwick where most of his well-known interiors were painted. Worked mainly in oil and pastel, but some of his earlier landscapes were in watercolour. Caw praised 'the daintiness and charm of ladies and children and their surroundings' but noted that 'he is apt to be a trifle sentimental'. Died North Berwick.

Adam, Robert 1728–92
Son of William Adam. Possibly best known as

Robert Adam *Roman Ruins* pen & ink,
Sir John Soane's Museum

an architect, also interior designer and property developer. In 1747 met Paul Sandby, then working in Scotland, and was influenced by his watercolour style.
In 1754 left for extended trip in Italy. In Rome he worked with ALLAN RAMSAY, the French artist Jacques-Louis Clérisseau and Antonio Zucchi. In 1758 returned to London and, despite his busy life as architect, found time to draw fantasy landscapes in pen with washes in restrained tones of green, blue and brown. Interested in the role of light and shade in landscape as well as in Picturesque theories. Although never a professional painter, left on his death some 200 drawings in his London home.

Adam, William b.1846
Born Tweedmouth and lived in Glasgow and in Holland. Painted coastal scenes.

Adamson, David Comba 1859–1926
Born Ayrshire, studied in Paris under Constant and Carolus-Duran. Returned to Paris to live and work in the 1890s. Painter in oil of interiors, figures, portraits and historical genre. Also worked as a sculptor. Later lived in Cambuslang.

Adamson, Miss Sarah Goffe 1888–1963
Born Manchester and studied ECA. Painted landscapes in Scotland, England and abroad in oil, pastel and watercolour. Exhibited RA, RSA and Paris Salon.

Affleck, Andrew 1869–?
Painter and etcher, best known for large and richly-contrasted etchings of Venice. Worked extensively in France, Belgium, Spain and Italy.

Agnew, Eric Munro 1887–1951
Born Kirkcaldy, studied GSA and the Slade. Portrait and landscape painter. Frequent exhibitor at the RA 1924–39. Served in both World Wars reaching rank of Major.

Aiken, John Macdonald 1880–1961
ARSA 1923, ARE 1924, RSA 1935, RI 1944

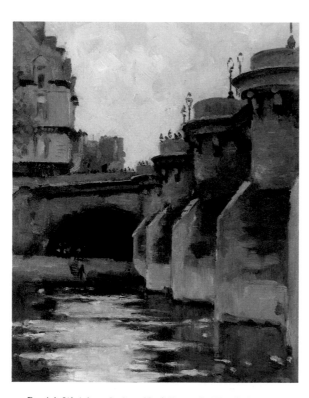

Patrick W Adam *Le Pont Neuf, Paris* oil, The Robertson Collection, Orkney

Born Aberdeen, he studied at Gray's School of Art under GERALD MOIRA and in Florence. Influenced by Moira's decorative style. Painted mostly portraits in oil and watercolour, but also worked in stained glass. Later Head of Gray's 1911–14 before serving in the First World War.

Aikman, George W, 1831–1905
RSW 1878, ARSA 1880
Landscape painter in oil and watercolour. Also engraver. His oils are often sombre in colour. Caw describes them as 'sombre and over-brown moorland and fir-wood scenes'. His watercolours are lighter, and reflect the influence of the Dutch School. Often painted harbour and coastal scenes.

Aikman, William 1682–1731
Graduated from the University of Edinburgh and took up painting with the support of his uncle, SIR JOHN CLERK of Penicuik. Trained under MEDINA in Edinburgh and then continued his studies in London and Italy. Returned to Scotland in 1711 and established himself as a portrait painter. Moved to London in 1723 and painted many of the leading political and literary figures of the day, many sitters being Scots. Died London.

Ainslie, John fl.1816–35
Lived in Edinburgh and Dalkeith. Portrait painter in oil who was patronised by the Duke of Buccleuch. Painted a remarkable series of highly effective portraits of the family and servants at Dalkeith Palace.

Aitchison, Craigie b.1926
ARA 1978

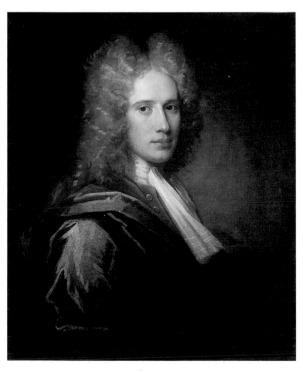

William Aikman *Self portrait* oil, Scottish National Portrait Gallery

Born in Scotland and lived for many years at Tulliallan. Trained at the Slade 1952–4. Has worked and travelled for the main part outside Scotland in London and Italy. Paints still-life, religious composition, landscapes and portraits, many of the last based on his former home in Scotland. 'Of all the artists now living and working in Britain, there is none with such a naturally Mediterranean soul.' (Helen Lessore, Scottish Arts Council Exhibition Catalogue, 1975).

Aitken, James Alfred 1846–97
ARSA 1871 (resigned 1890), RSW 1878
Born Edinburgh, lived for a period in Dublin before returning to Edinburgh to study art, being influenced by HORATIO MCCULLOCH. Later settled in Glasgow. Prolific watercolourist, he painted views of the Highlands and coastal scenes in a vigorous style. Also worked in America and Europe. His Venetian scenes are particularly effective.

Aitken, Janet Macdonald 1873–1941
Born Glasgow, studied at GSA and Colarossi, Paris. Member of C.R. MACKINTOSH's circle and a leading member of the GLASGOW SOCIETY OF LADY ARTISTS. Painted portraits, landscapes and views of old buildings in oil and watercolour. A memorial Exhibition of Janet Aitken, KATE WYLIE and ELMA STORY was held at the Glasgow Society of Lady Artists in 1942.

Alexander, Annie Dunlop fl.1917–40
Trained at GSA where she was influenced by the illustrative work of JESSIE KING and ANN MACBETH. Painted in watercolour, illustrated books, and decorated ceramics.

Alexander, Cosmo 1724–72
Son of the painter JOHN ALEXANDER. Worked in Scotland 1742–45 painting portraits but fled to Rome after the '45. Arrived back in London in 1754 and was engaged by the Town Council of Aberdeen to paint portraits of the Earl and Countess of Findlater. Painted in London and Scotland before travelling to America 1765–71. Died in Scotland.

Alexander, Daniel c.1800–64
Born in or near Glasgow where he worked for most of his life. Glasgow Art Gallery has a series of pencil and wash drawings of views around Glasgow dating from 1818 onwards. In the 1820s made pen and wash drawings in Italy and Switzerland which are initialled D.A.

Alexander, Donald fl.1825–50
Edinburgh based portrait painter. Many private commissions recorded for domestic scenes and portraits.

Alexander, Edwin John, 1870–1926
Born Edinburgh, son of ROBERT ALEXANDER. Learnt much from his father and in 1887–8 visited Tangiers with his father, POLLOCK NISBET and JOSEPH CRAWHALL who had already, by age

Edwin Alexander *The Rooster* watercolour, Robert Fleming Holdings Ltd

26, developed a distinctive style. Took a liking to the desert and painted many watercolours of Arab tents and donkeys. Also made studies of desert flowers and grasses which he called his 'weeds'.

In 1891, after intermittent attendance at the RSA schools, spent a short period in Paris with ROBERT BURNS studying art, before returning to the Arab World which he had come to love. Between 1892 and 1896 based in Egypt sharing a houseboat on the Nile with ERSKINE NICOL JUNIOR. He lived simply among the Arabs and learnt to speak fluent Arabic. Avoided famous views of Egypt, painting instead the desert stretching into the distance, or grasses along the Nile.

In 1904 married and settled in Edinburgh, continuing to paint birds, animals, flowers and some landscapes in Kirkcudbright and the Western Isles. Kept owls and peacocks in his garden. Some of his best watercolours are of birds, their plumage depicted freely yet in great detail. His technique was unusual, often working on sugar paper, linen or rough cardboard. Painted little after the outbreak of war in 1914 and suffered a stroke in 1917. He had been close to Crawhall and other members of the GLASGOW SCHOOL. Was related by marriage to ALEXANDER ROCHE and WILLIAM WALLS. Alexander and Crawhall are amongst the finest animal and bird painters of their period and well represent the superb draughtmanship of the Glasgow School. Died Musselburgh.

Alexander, James Stuart Carnegie 1900–52
Etcher and landscape painter in oil and watercolour. Lived in Selkirk and exhibited at Aitken Dott RSW, RSA, RGI and SSA.
Friend of EDWIN ALEXANDER, ROBERT ALEXANDER and TOM SCOTT.

Alexander, John 1686–c.1766
Recorded as working in London in 1710. Travelled to Rome and studied under Chiari. Returned to Scotland 1720 and began the staircase ceiling at Gordon Castle, for the Duke of Gordon. Engraved GEORGE JAMESONE's self portrait with his wife and child (1728) and signed the Charter of the ACADEMY OF ST LUKE (1729). Just before his death was painting the *Escape of Mary Queen of Scots from Loch Leven Castle*, the landscape painted from nature representing an unusual innovation at this time.

Alexander, John fl.1870s–92
Glasgow landscape painter.

Alexander, Lena (Mrs Lees Duncan) fl.1940s
Studied at GSA. Painted flowers, portraits and views of Paris and Venice in pastel and sometimes in watercolour. Last member of the KIRKCUD-BRIGHT SCHOOL.

Alexander, Patrick fl.1666–70
Portrait and heraldic painter working in Aberdeen.

Alexander, Robert 1840–1923
ARSA 1878, RSA 1888, RSW 1889 (resigned 1901)
Born Ayrshire. Established a reputation in Edinburgh as painter of rather sentimental oils of domestic and farm animals. Was in demand for portraits of horses and dogs. In 1887 visited Tangiers with his son EDWIN ALEXANDER and JOSEPH CRAWHALL. During the course of this visit painted a number of fluent watercolours influenced by Crawhall which reveal his ability as a draughtsman. Died Edinburgh.

Algie Jessie, 1859–1927
Studied at GSA. Painter of flowers in oil and watercolour. Associated with the CRAIGMILL group of artists near Stirling, where she lived for a period. In 1908 held an exhibition of flower paintings at the Baillie Gallery, London, with ANNIE MUIR, JESSIE KING and LOUISE PERMAN.

Alison, David 1882–1955
ARSA 1916, RSA 1922, Society of Eight, RP
Born Dysart, studied GSA and in Paris, Italy and Spain. Taught at ECA where he became Head of Drawing and Painting. Was a noted portrait painter. 'Reached his fullest height as an artist in painting his family and his intimate friends'. (RSA Report, 1955).

Alison, Henry Young 1889–1972
Figure and portrait painter; brother of DAVID ALISON. Exhibited RSA 1916–21. Joined staff at GSA 1928, becoming Registrar 1930, Interim Director 1945–6.

Alison, Thomas fl.1880–1914
Lived in Dalkeith and also worked in Spain. Exhibited SSA. Painted landscapes.

Allan, Alexander 1914–72
Studied at Dundee College of Art 1932–38 and

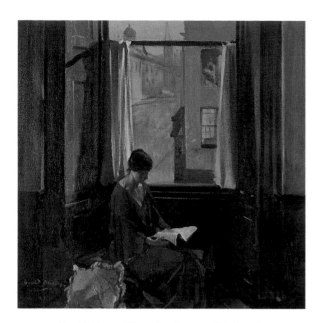

David Alison *Woman Reading by a Window* oil,
Robert Fleming Holdings Ltd

then at Westminster and Hospitalfield. Taught in various art schools and travelled extensively in Europe. Painted landscapes in Scotland and exhibited widely.

Allan, Alexander S. 1830–?
Edinburgh based landscape painter. Studied at Trustees' Academy 1848–9. Exhibited RSA 1847–9.

Allan, Andrew 1863–?
Glasgow flower painter and illustrator; was strongly influenced by French *fin de siècle* style.

Allan, Archibald Russell Watson 1878–1959
ARSA 1931. RSA 1932
Born Glasgow. Studied GSA and in Paris at Julian's and Colarossi's. Worked in oil and pastel, often painting domestic interiors, garden scenes and animals.

Allan, David 1744–96
Born Alloa. Spent nine years at the newly established FOULIS ACADEMY in Glasgow. With the help of Lord Cathcart was sent to Rome where he stayed from c.1768 to 77. In Rome made his mark with witty caricatures and sketches, as well as with sparkling conversation.
Although winning the Concorso Balestra and a gold medal at the Academy of St Luke for his history painting. He particularly enjoyed sketching local characters, costumes and festivities. His pictures in Naples and Rome 'reveal a considerable interest in life and character, as it is and for its own sake.' (Caw).
In 1777 returned to London, but failed to gain suceess, so in 1779 he settled in Edinburgh, succeeding ALEXANDER RUNCIMAN as Master of the Trustees' Academy in 1785. Also ran a school from his studio in Dickson's Close, where

he had many pupils including HUGH 'GRECIAN' WILLIAMS.
Paul Sandby made a series of prints from Allan's *Sketches of the Roman Carnival*, the success of which led to Allan being dubbed 'the Scottish Hogarth' although his work lacks Hogarth's biting moral comments. In 1788 Foulis published Allan's illustrated edition of *The Gentle Shepherd* which became an instant success.
At the time of his death, Allan was working on illustrations for Robert Burns' *Scottish Songs* and although these were never finished his watercolours of subjects such as *The Penny Wedding, The Cottar's Saturday Night* and *Madge and Bauldy* had a great influence on CARSE, GEIKIE and WILKIE and can be considered the foundation of Scottish genre. Died Edinburgh.

Allan, Hugh fl.1880–1898
Glasgow painter of rural scenes, cottages and landscapes, he exhibited at the GI and RSA.

Allan, Richard 1817 – ?
Born Falkirk and studied at Trustees Academy 1848-9. Portrait painter in oil.

Allan, Robert Weir 1851-1942
RSW 1880, NEAC 1886, ARWS 1887, RWS 1896, VPRWS 1908-10
Born Glasgow, the son of an amateur painter, and moved to Paris in 1875 to study at the Ecole des Beaux Arts and the Atelier Julian, remaining there until 1880. In Paris his watercolour style was influenced by the Impressionists. Developed a blottesque technique using broken brushstrokes and wet watercolour. His market scenes and views of the Seine and harbours in Northern France were also influenced by Impressionism. Settled in London in the 1880s and produced a large number of watercolours and some oils. A great traveller, he painted in India in 1891–2, Japan in 1907 and North Africa in 1911–12. Also painted in Italy, France, Spain and Holland. In Scotland he painted the fishing villages of the east coast.

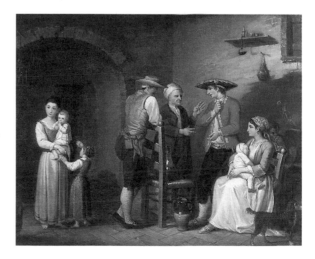

David Allan *A Neapolitan Tavern* oil, James Holloway Esq

Robert Weir Allan *An Egyptian Market* watercolour,
Julian Halsby Esq

Allan was a friend of ARTHUR MELVILLE, who visited
him in Paris in 1878, and it seems likely that Allan
influenced Melville's watercolour technique.

Allan, Sir William 1782–1850
RSA 1830, PRSA 1837–50
Trained at the Trustees' Academy before spend-
ing ten years in Russia (1805–14) painting Tartar
horsemen, Turkish warriors, fair Circassian girls
and other exotic subjects.
After his return began to modify his style and
change his subject matter. Stylistically was influ-
enced by DAVID WILKIE, who had been a fellow
student at the Trustees. For subject matter Sir
Walter Scott encouraged him to turn towards
Scottish history. *The Murder of Rizzio* and *The
Murder of Archbishop Sharpe*, both painted in the
1820s, represent Allan's Scottish historical paint-
ings and are amongst the first ever painted. In
1826 appointed Master of the Trustees' Academy,
but had an eyesight problem, and was forced to
make a recuperative trip to Italy, Greece and

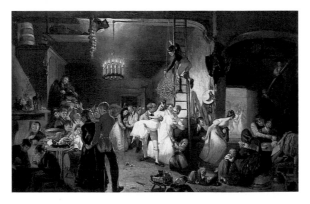

Sir William Allan *The Penny Wedding* oil, Aberdeen Art
Gallery, Aberdeen City Arts Department

Constantinople returning in 1830. Deeply influ-
enced by the Waverley novels and produced
illustrations for the Cadell edition. Also painted
the interior of Abbotsford in watercolour. Died
Edinburgh.
In 1834 worked in Spain and Morocco making
many fresh and sparkling watercolours. During the
1830s continued to paint large historical canvases
and in 1840s painted several battle scenes.

W. Allan
Pinxt 1841

Allan-Fraser, Patrick 1813–90
HRSA 1871
Born Arbroath, studied at the Trustees' Academy
with ROBERT SCOTT LAUDER and in London, Paris,
Florence and Venice. Was also a frequent visitor
to Rome. Known for his portraits, as a collector
and for his contribution to the teaching of art.
His home, HOSPITALFIELD HOUSE, later became a
summer school for artists.

Allison, Robert fl.1926–40
Glasgow painter of harbour scenes and landscapes.
Exhibited RSA.

Allsop, Fred 1830–?
Born Edinburgh and attended Trustees' Academy
1845–5. Exhibited RSA. Landscape and animal
paintings.

Alston, I. W. fl. late 18c.
Contemporary of DAVID ALLAN; painted genre
watercolours of figures in rustic settings.

Alston, Thomas fl. late 18c. / early 19c.
Landscape painter; worked in neat topographical
style.

Amour, Elizabeth Isobel 1885–?
Painter and potter, she founded the 'Bough Pottery' in
Edinburgh and signed her work E.A. Bough. She was
married to the architect and painter GPH WATSON.

Ancrum, Marion (Mrs G Turnbull) fl. 1887–1919
Edinburgh based landscape and interior painter;
also watercolours of old Edinburgh. Exhibited
RSA.

Anderson, David R. 1883–1976
Born Glasgow. Studied at GSA and Ecole des
Beaux Arts, Paris as well as Glasgow University.
By profession journalist and editor, he was a keen
amateur artist. Had a studio at Gairloch, but on
retirement moved to Ilkley, Yorkshire, to paint. Pro-
duced powerful watercolours and chalk drawings of
the dramatic landscapes around Gairloch.

Anderson, James Bell 1886–1938
ARSA 1932, RSA 1938
Studied at Hospitalfield, Arbroath, and ECA, fol-
lowed by Julian's, Paris. Made his reputation as a
portrait painter, although also painted landscapes
and still life. Based in Glasgow.

Anderson, John fl. 1600–49
A decorative court painter who is known to have worked at Edinburgh Castle; he is sometimes credited with the emblematic ceiling at Rossend Castle, Burntisland. GEORGE JAMESONE was apprenticed to him in Edinburgh in 1612.

Anderson, John Farquharson fl. 1879–82
Watercolour painter of landscapes in Perthshire and the Highlands.

Anderson, Martin ('Cynicus') 1854–1932
Born Leuchars, Fife. Landscape painter in oil and watercolour. Also a cartoonist under name of 'Cynicus'.

Anderson, Robert 1842–85
RSW 1878, ARSA 1879
Line engraver who turned to watercolour. Produced large and powerful watercolours of fishing boats and fishermen, as well as scenes of rural life in Brittany and Holland.

Anderson, William 1757–1837
Born Scotland. Moved to London where his reputation was made as a painter of well-executed shipping and coastal views. Influenced the Hull School.

Andrews, D.A. fl. early 19c.
He was the first drawing master in the Dundee Seminaries (later Dundee High School). Portrait painter in oil.

Annand, Louise Richard b.1915
Educated at Hamilton Academy and Glasgow University she was encouraged to paint by J W Ferguson. Joined New Art Club at its inception in 1941 and exhibited with New Scottish Group 1943–5. Influenced by Adler, Herman and J. D. FERGUSSON. Also produced book illustrations and murals. President Society of Scottish Women Artists 1963–65. President Glasgow Society of Women Artists 1977–79. Chairman J D Fergusson Foundation.

Anson, Peter Frederick 1889–?
Born Portsmouth and studied at the Architectural Association School. Lived at Macduff and later at Montrose and painted landscapes, seascapes, marine and architectural subjects. Particularly interested in fishing boats and ports and produced *Fishing Boats and Fisherfolk* (1930).

Archer, James 1823–1904
ARSA 1850, RSA 1858
Studied at the Trustees' Academy under SIR WILLIAM ALLAN and THOMAS DUNCAN. Early work was portraiture in chalk, but in the late 1850s embarked upon a series of canvases based on the Arthurian legends reflecting the influence

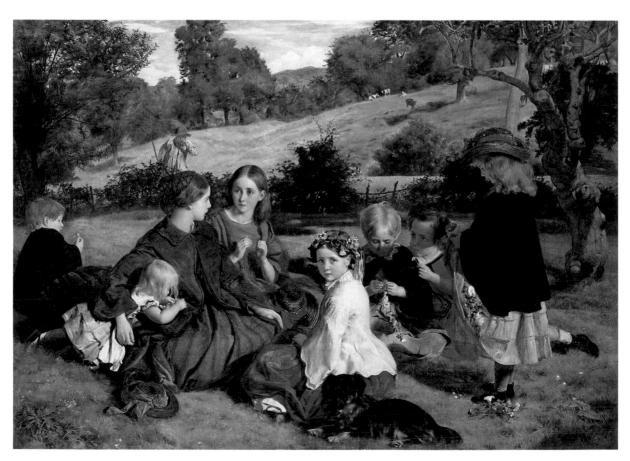

James Archer *Summertime in Gloucestershire* oil, Scottish National Portrait Gallery

G D Armour *A Confrontation* oil, The Ellis Campbell Collection

of the Pre-Raphaelites. In 1864 settled in London painting portraits and historical subjects. Reputedly the first Victorian to paint children's portraits in period costume.

While intellectually less interesting than SIR NOEL PATON, had fine technique in oil. As a colourist he attained silvery opalescence and rich glowing tones. Died Haslemere.

Archibald, Gordon R. b.1905
RSW
Born Falkirk. Painted landscapes in watercolour.

Archibald, James fl.1840s–70s
Lived in Edinburgh and often painted in Perthshire. Landscapes and views.

Armour, George Denholm 1864-1949
Born Lanarkshire. Trained at ECA and RSA, having first attended St Andrews University. Was close friend of JOSEPH CRAWHALL. During the 1880s visited Tangiers with Crawhall, who also shared his house in the New Forest – later at Wheathamstead. Settled in London in the 1890s and produced illustrations for *Punch*, *The Tatler*, and *The Graphic*. Also illustrated books including *With Rod and Gun* (Hodder and Stoughton 1912). His hunting and shooting watercolours were popular. His work at its best has the dash and brio of Crawhall. Served as Lieutenant-Colonel in the Dardanelles and Salonika. Awarded OBE in 1919.

Armour, Hazel (Mrs John Kennedy) fl.1914–40
Studied at ECA and in Paris. Principally a sculptress but also painted flower pieces.

Armour, Mary Nicol Neill (née Steel) b. 1902
ARSA 1941, RSW 1956, RSA 1958
Born Blantyre. Attended Hamilton Academy where her art teacher was PENELOPE BEATON. Studied at GSA from 1920 under FORRESTER WILSON and MAURICE GREIFFENHAGEN. She married WILLIAM ARMOUR in 1927. Lecturer in still life at GSA 1951–62. Paints landscapes, flowers and still-life in oil, pastel and watercolour. She is generally regarded as the most senior living Scottish woman artist. Failing eyesight precluded her from further painting, 1988.

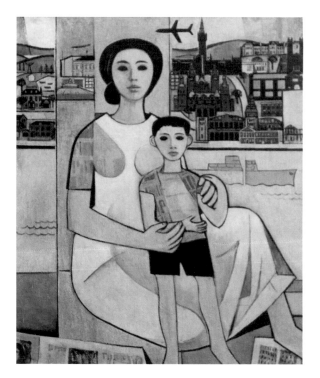

Anthony Armstrong *Mother and Child* oil 1962, portion of tryptich *Let Glasgow Flourish* for Glasgow Press Club

Armour, William 1903–79
RSW 1941, ARSA 1958, RSA 1966
Born Paisley. Married MARY ARMOUR (née Steel) in 1927. Painted landscapes and still-lifes in oil, pastel and watercolour.

Armstrong, Anthony b.1935
Born Dundalk, Ireland, and trained at GSA. Has exhibited RGI, NEAC and in North America. Works in pastel, watercolour and oil. Landscapes, cityscapes and figure subjects. Series of prints published under the title *The Glasgow Collection*. Major commission by RAC for Museum of Transport, Glasgow (1990). Lives in Glasgow and Blairgowrie.

Arroll, James fl. 1883–1909
Helensburgh painter of landscapes and West Coast scenes, he exhibited at the GI and RSA.

Ashworth, Miss Susan fl. 1860s–1880s
Flower painter who took over the Trustees' Academy on the retirement of ROBERT SCOTT LAUDER. Described by Lindsay Errington as 'conscientious nonentities', she and a Mr Hodder ran a low-level Government Design School. Ashworth was probably an English artist and retired to London in the mid-1870s.

Auld, Peter fl. 1835–65
Landscape painter who began to exhibit watercolours at the RSA in 1825. Moved from Ayr to Aberdeen c.1844, painting views around Balmoral, Deeside and the Highlands, mostly in watercolour.

Mary Armour *Still Life* oil, Royal Scottish Academy (Diploma Collection)

Babianska, Isabel Brodie b.1920
Studied GSA 1936–1940 and at HOSPITALFIELD 1941. Founder member of the NEW ART CLUB and NEW SCOTTISH GROUP. Married in 1943, she adopted her husband's name Babianska. She painted figures influenced like other painters in her circle by Herman and Adler. She also painted murals for Glasgow Corporation.

Baillie, William James Laidlaw b.1923
ARSA 1968 RSA 1979 RSW 1963 PRSW 1974–79
Born Edinburgh and studied at ECA, later joining the staff in 1960 and becoming Depute Head of School of Drawing and Painting. His large watercolours and thinly painted oils have a strong sense of pattern based on natural or abstract forms. Treasurer RSA 1980.

Bain, Donald 1904–79
Born Kilmacolm, Renfrewshire, the son of a textile designer, his family moved to Harrogate and Liverpool before settling in Derbyshire. In 1920 he met W.Y. MACGREGOR, who introduced him to the work of PEPLOE and FERGUSSON, and in 1928 he saw the work of Matisse in Paris. It was only in 1940 that he returned to live in Glasgow, exhibited with the New Art Club and became involved in the formation of the New Scottish Group (1942) which included Fergusson and the Polish artists Jankel Adler and Josef Herman. In 1946 he returned to France until 1948, painting highly coloured landscapes with rich paint textures. In 1948 MARGARET

Donald Bain *An Old Street in the South of France* oil, private collection

MORRIS commissioned him to design scenery for the ballet *A Midsummer Night's Dream*, but despite an exhibition in Glasgow in 1952 his work remained largely ignored. His best work was in the 1940s when he achieved a power and depth of expression likened by William Hardie to the work of the COBRA group (Alechinsky, Asger Jorn and Appel) who were working in Paris at the same time.

Baird, Edward McEwan 1904–1949
Born Montrose and studied at GSA 1923–27, winning a travelling scholarship which took him to Italy. Returned to live in Montrose, working hard in his studio and rarely venturing far except for a period teaching at Dundee College of Art 1938–40. Ill-health confined him to Montrose and kept him out of the public eye, and his work was virtually unknown until an exhibition organized by the Scottish Arts Council in 1968. Baird's work of the 1930s is closely related to the Surrealist movement. Was evidently influenced by Magritte as can be seen in his best known work *Birth of Venus*, but other paintings are closer to Nash and Wadsworth. He also painted detailed portraits in his later years.

Bain, George 1881–1968
Born in Caithness, he studied at ECA and the RCA. After the First World War, during which he recorded incidents of the 26th Division in Salonika, became Principal Teacher of Art at Kirkcaldy High School until his retirement in 1946. He was an expert on Celtic art, publishing an important book on the subject in 1951. He painted Scottish landscapes in watercolour and often worked abroad, particularly in the Balkans and Greece. A retrospective exhibition of his work was held in Kirkcaldy in 1978.

Baird, George 1876–?
Portrait painter recorded working in Perthshire and on Tayside.

Baird, Henry 1831–?
Born Edinburgh and trained at Trustees' Academy 1846-50. Exhibited RSA. Landscape painter.

Baird, Johnstone fl.1910–1930
Painter and etcher, studied at GSA before working as a naval architect with the Admiralty 1917–19. After the War painted on the Continent.

Baird, Nathaniel Hughes John 1865–?
ROI 1897
Born Yetholm and studied in Edinburgh, London and Paris. Exhibited RSA, RA 1882–7. Landscapes,

Edward Baird *Yellow Tulips in a Glasgow Jug with Pears and Apples* oil 1940, Christie's Scotland (Scottish National Gallery of Modern Art).

pastoral subjects and portraits in oil and watercolour.

Baird, Robert fl. 1872–81
Edinburgh based painter of landscape and pastoral subjects. Exhibited RSA.

Baker, Edmund fl.1880–1910
Stirling based artist in oil and watercolour. His

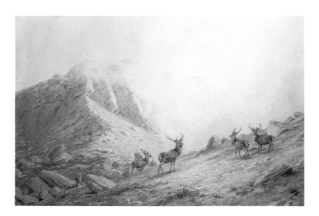

Vincent Balfour-Brown *Children of the Mist* watercolour, Malcolm Innes Gallery

watercolours of the Fife coast are painted in a broad 'wet' style influenced by the Dutch School.

Baker, Eve fl. 1890–1915
Studied in London and Paris, and opened an *atelier* in Albany Chambers, Glasgow in 1898. A painter of seascapes and harbour scenes in oil and watercolour, she was also a militant suffragist.

Baker, Leonard fl. 1865–1910
Drawing Master at Stirling High School, he painted local views in Stirling and Fife and landscapes, mostly in watercolour.

Balfour-Brown, Vincent 1880–?
Painter of sporting scenes in watercolour whose popularity has never waned. His hunting, shooting and golfing scenes are still much in demand and during his lifetime he held successful exhibitions at the Fine Art Society.

Ballantyne, John R 1815–1897
ARSA 1841, RSA 1860
Studied in Edinburgh, moving to London for a period in the 1830s. He specialised in portraits and historical genre, and is best known for a series of portraits of artists in their studios. The whole series was exhibited at H. Graves and Co., Pall Mall in November 1866.

Ballantyne was also noted as a teacher, working under ROBERT SCOTT LAUDER at the Trustees' Academy, where he ran the antique and life classes. Ballantyne had a reputation as an academic draughtsman.

Ballantyne, R.M. fl. 1865–87
Lived in London, Edinburgh and Harrow-on-the-Hill. Exhibited RSA landscapes, marine and sporting pictures.

Ballingall, Alexander fl. 1880–1910
Watercolourist who specialised in views of east coast harbours, taking care over details of shipping. He also worked in Venice, often on a large scale. His style is sometimes tight but often fresh and rugged like BOUGH.

Balmain, Kenneth Field 1890–?
Studied ECA and RSA Life School, he served in the RFC during the First World War. He painted landscapes, harbours and coastal scenes in oil and was also a noted photographer.

Balmer, Barbara b.1929
RSW 1966, ARSA 1973.
Born Birmingham and studied at Coventry and Edinburgh Colleges of Art. First exhibited 1953 with many works in public and private collections. Landscapes, still life, and portraiture in oil, watercolour and lithography. Married to the artist GEORGE MACKIE. Large mural painting in Cumbernauld Town Hall. Now lives and works in

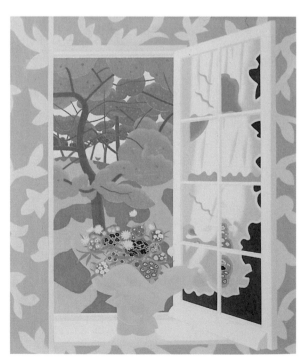

Barbara Balmer *Normandy Window* oil, private collection

John Rankine Barclay *Paris 1910* oil, Bourne Fine Art

Stamford, Lincolnshire with annual working visits to Tuscany.

Banks, Violet 1896–?
Born Kinghorn, Fife, she studied at ECA, later becoming art mistress at St Ornan's School, Edinburgh. She exhibited watercolours at the RSW.

Bannatyne, John James 1836–1911
RSW 1878
Watercolourist influenced by the pre-Raphaelite movement, he painted detailed yet delicate views of the Highlands and Iona, with good effects of sunset and moonlight.

Banner, Alexander fl.1860s–'90s
Art teacher and landscape painter who worked in Glasgow.

de Banzie, Marie b.1918
Studied at GSA 1937–41 and at HOSPITALFIELD. She was a founder member of the NEW ART CLUB and Secretary to the NEW SCOTTISH GROUP 1943–5. Trained as a dancer with Celtic Ballet Company. Executed murals in association with ISABEL BABIANSKA.

Barclay, A. Patterson fl.1930s
Edinburgh painter of landscapes and figures.

Barclay, John Maclaren 1811–86
ARSA 1863, RSA 1871 Treasurer of RSA 1884–6
Born Perth, he painted portraits, genre and figure subjects. According to Caw he 'displayed considerable accomplishment, if no distinction'.

Barclay, John Rankine 1884–1962
Born Edinburgh, he studied at ECA where he met A.R. STURROCK. He was a member of the EDINBURGH GROUP, a group of progressive painters which included SPENCE SMITH, D.M. SUTHERLAND DOROTHY JOHNSTONE and A.R. STURROCK and which was established in 1912. He painted in both oil and watercolour, frequently depicting figures in a landscape or a town setting in an individual and often experimental style. Moved to St Ives in the late 1920s where he died after several years of mental illness.

Wilhelmina Barns-Graham *Summer Painting no. 2* oil 1985, artist's collection

Barclay, William fl.1850–1906
Dundee landscape painter in oil and watercolour, he painted the landscape and coast around Dundee.

Barnard, Mary B. (Mrs MacGregor Whyte) 1870–1946
Born Wiltshire, studied art in Paris where she came to admire the pastels of Mary Cassatt. In 1901 married DUNCAN MACGREGOR WHYTE whom she had met in Paris, and after a period in Glasgow they moved to Oban in 1910. Summers were spent on the Isle of Tiree where they had a studio. Produced pastels of interiors, children and landscapes.

Barnes, Sir Harry Jefferson d.1982
Lived in Glasgow. Painted landscapes and townscapes of the city. Principal of GSA and a founder of the Charles Rennie Mackintosh Society.

Barns-Graham, Wilhelmina b.1912
Born St Andrews, she studied at ECA 1932–7 and rented a studio in Edinburgh between 1936 and 1940. In 1940 she went to St Ives on the suggestion of HUBERT WELLINGTON, Principal of ECA, who thought that her abstract work would benefit from the influence of artists working in St Ives. This proved an important move and she became friendly with Nicholson, Hepworth and Gabo joining the Newlyn Society of Artists and the St Ives Society of Artists in 1942. In 1949 she became a founder member of the Penwith Society. In 1948 she visited Switzerland and glaciers became the subject of many of her paintings; at this time she started working on painted abstract reliefs. Other inspirations included the movement of waves and, more recently, Orkney.
Barns-Graham taught at Leeds School of Art 1956–7 and had a studio in London 1961–3. Now divides her time between St Andrews and Cornwall.

Barr, James fl.1860s–92
Glasgow based landscape painter who often worked on Arran and the west coast.

Barrie, Mardi b.1931
RSW 1968
Born Kirkcaldy and educated at Edinburgh University and ECA 1948–53. Teacher at Broughton High School, Edinburgh. Early work in oil and watercolour; latterly in oil and acrylic. Has exhibited extensively with work in many public collections.

Barry, William fl.1880s
Edinburgh based painter of coastal and harbour scenes.

Bartlett, Josephine Hoxie fl.1880s–90s
Lived in Edinburgh and exhibited SSA. Painted landscapes.

Douglas, Gordon Baxter b.1920
RSW (resigned) SSA 1961
Born Kirkcaldy and studied at ECA where he later taught in evening classes, and received travelling scholarships to France, Scandinavia and Spain. He was art master at Loretto College, and painted landscapes and equestrian portraits.

Bayne, James fl.1880–1910
Watercolourist who painted highly composed Scottish landscapes.

Bear, George Telfer 1874–?
Born Greenock and studied at GSA. He exhibited with PEPLOE, HUNTER, CADELL, FERGUSSON and R.O. DUNLOP at the Galeries Georges Petit in 1931 under the name 'Les Peintres Écossais' and his work showed the influence of Cadell. In addition to working in oil he also produced powerful charcoal and wash drawings.

Beaton, Penelope 1886–1963
RSW 1952, ARSA 1957
Studied at ECA graduating in 1917 and, after teaching at Hamilton Academy, joined the staff of ECA in 1919, later becoming Head of the Junior Department (equivalent to the modern Foundation course). Her colleagues on the staff included A.B. THOMSON and DONALD MOODIE whose adventurous use of colour made a great impression. During the 1930s her watercolour style was influenced by GILLIES' Expressionist approach, but during the 1940s she moved towards a more constructed manner. Her later watercolours make use of a pen-and-ink framework coloured with rich and sonorous tones. Her subjects include landscapes, harbour scenes and flowers. Died Edinburgh.

George Telfer Bear *The Village Pond* oil, private collection

Penelope Beaton *Tarbert* watercolour, Jack Firth Esq

Beattie-Scott, J. fl.1880–1905
Aberdeen based watercolourist who painted local views and coastal scenes in a tight, richly coloured style.

Bell, Alexander Carlyle fl.1847–91
Born Edinburgh and lived in Wales for a period during the 1850s. Later moved to London before returning to Scotland where he painted landscapes.

Bell, Harold Fraser fl.1880s–90s
Lived in Edinburgh and painted landscapes and river scenes.

Bell, Henry Jobson 1863–1925
Dundee based artist who painted interiors and landscapes in oil.

Bell, James Torrington 1898–1970
Born Leven, he painted landscapes in tempera and oil.

Bell, John D. fl.1878–1910
RSW 1878, resigned 1902
Marine and coastal painter who worked mostly in watercolour. He specialised in breezy views of Scottish fishing villages and boats under sail. He also painted on the Isle of Man.

Bell, John M. fl.1894–1940s
Lived in Glasgow and painted figure compositions, portraits and still-life. Exhibited widely.

Bell, John Zephaniah 1794–1885
Born Dundee, he studied at the RA Schools in London and then under Martin Archer Shee whom he accompanied to the Continent. He also studied in Paris in Baron Gros' studio and in Rome 1825–6.
In Rome he saw the work of the Nazarenes and his interest in Italian fresco painting developed. On his return to Edinburgh he painted two ceilings of Muirhouse Mansion in fresco, and WILKIE, who visited Muirhouse in 1834, described Bell as the "reviver of fresco painting" in Scotland. In 1837 Bell took up the post of head of the Government School of Design in Manchester, but resigned in 1843 after a disagreement with DYCE on how the courses should be run. In 1843 he won a prize of £200 with his cartoon in the Westminster Hall competition. The fresco was never executed but an oil version is in the Tate. William Etty considered Bell's cartoon *Cardinal Bourchier urging the widow of Edward IV to let her son out of sanctuary* to be amongst the best in the competition.
Bell returned to London in 1843, setting up his own art Academy and painting many portraits. He continued to travel, visiting Portugal to paint Queen Maria II for the town hall at Oporto.

Bell, Jonathan Anderson 1809–65
Born Glasgow an architect who trained at Edinburgh University and Rome. He painted highly-coloured watercolours of Italian scenes and buildings, and architectural engravings of Scottish buildings and of Cambridge colleges, where he lived for a period.

Bell, Joseph J. fl.1883–1908
Lived in Lasswade, Midlothian, and exhibited SSA. Painted landscapes on the west coast.

Bell, Robert Charles 1806–1872
Born Edinburgh, he studied under the housepainter Gavin Beugo and at the Trustees' Academy. Painted some genre watercolours but was better known as a steel-engraver.

Bell, Robert Purves 1841–1931
ARSA 1880
Born Edinburgh, the son of R.C. BELL, he studied at the RSA Schools. He painted landscapes, genre, portraits and flowers in both oil and watercolour, but was best known for his Moorish subjects.

Bell, Stuart Henry fl.1880s
Painter of harbour and coastal scenes.

Bell, Thomas Currie fl.1890s
Edinburgh painter of domestic genre and portraits.

Bennett, John fl.1820s–30s
Edinburgh landscape painter.

Berry, Mary Elizabeth fl.1885–1933
Lived in Edinburgh and painted domestic genre, interiors, portraits and landscapes. Exhibited SSA.

Berstecher, Harry 1893–?
RSW 1926
Born Glasgow, he painted fishing villages of the east coast, living for a period in Pittenweem. His fresh and energetic watercolour style is combined with a charcoal structure and is not unlike the contemporary work of WILLIAM HANNA CLARKE and WILLIAM CROZIER.

Beugo, John 1759–1841
Worked in Edinburgh as an engraver. Painted by SIR GEORGE CHALMERS.

Beveridge, Erskine d. 1972
Seascape and coastal painter who lived in Glasgow. His watercolours are colourful and are sometimes similar to the work of ROBERT CLOUSTON YOUNG.

Billings, Robert William 1813–1874
London architect who illustrated *The Baronial and Ecclesiastical Antiquities of Scotland* (1852) and other architectural books. His crisp watercolours of Scottish buildings can be found in several Scottish museums.

Binning, Walter fl. 1540–1600
A decorative painter working at the Scottish court, he specialised in armorial painting.

Binny, Graham d. 1929
RSW 1909
Edinburgh watercolourist who painted portraits and figure subjects. His output was relatively small.

Bird, Mary Holden ('Molly') d. 1978
An English artist who worked on the west coast of Scotland. She was married to the cartoonist, Kenneth Bird, known as *Fougasse*, but had a house at Morar where she painted the sands of Arisaig and other coastal views. Her style is accomplished, having an almost Chinese emphasis upon well-placed brushstrokes, leaving white paper to shine through. At times her style can become slick and insubstantial, but, at her best, she produced sparkling watercolours which capture the colours and drama of the west coast. She signs with a monogram. Many photographic prints of her watercolours were made, and must be distinguished from the originals.

Birnie, William b. 1929
RSW 1964
Lives in Kilbarchan and paints still life and landscapes, particularly of France. Married to the artist CYNTHIA WALL. Formerly an art teacher and Chief Examiner for SCE Art to the Examinations Board.

Bissett, Peter T. d. 1962
Perth based landscape artist who painted watercolours in Perthshire, the north east of Scotland and on the continent.

Black, Andrew 1850–1916
RSW 1885
Trained at GSA and in Paris; worked as a designer before turning to art full-time in 1877. He specialized in marine pictures, usually watercolours, and mostly of Scottish subjects. He was a keen yachtsman and had an intimate knowledge of the waters around Scotland.

Black, Ann Spence 1861–1947
RSW 1917
Born Dysart, Fife, and worked in Edinburgh. A prolific watercolourist, she produced many landscapes, but possibly the best works are her richly coloured flower pieces.

Black, E. Rose fl. 1920–39
Watercolourist who produced freely painted landscapes.

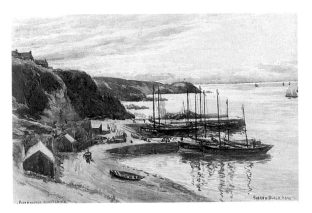

Andrew Black *Portknockie* watercolour, Julian Halsby Esq

Black, Thomas fl. 1830s–40s
Painted animals, rural scenes and cottage interiors. Exhibited RSA.

Black, Tom fl. 1880–1907
Lived in Glasgow and painted coastal scenes, harbours and shipping.

Blackadder, Elizabeth b. 1931
ARSA 1963, ARA 1971, ARSA 1972, RA 1976
Born Falkirk, she studied at Edinburgh University and ECA where her teachers included BEATON, HENDERSON BLYTH, PHILIPSON, MACTAGGART and GILLIES, who was to have the greatest influence on her work.
A Carnegie Travelling Scholarship took her to Yugoslavia, Greece and Italy where she returned 1954–5 studying the work of the Quattrocento as well as contemporaries like Morandi. In 1956 she married fellow-student JOHN HOUSTON and began to teach part-time at ECA
Blackadder works primarily in watercolour, painting landscapes, cats, flowers, still lifes and portraits. Her flowers and still-lifes have broken from the traditional organization of space to create a carefully composed arrangement of the objects against a flattened background, which is brought parallel to the picture plane. In this way the eye is allowed to concentrate upon the quality of the painting and the details without distraction from three-dimensional backgrounds. The arrangement of the flowers or objects plays a major part in the compositions, and there is always a visual excitement when her three-dimensional objects meet her two-dimensional space.

Blackburn, Jemima (née Wedderburn) 1823–1909
Born Edinburgh, the youngest daughter of the Solicitor-General for Scotland who died six months before her birth, her childhood was overshadowed by her father's death and her own delicate health. Drawing was prescribed as a therapy, arousing a talent that she was to use throughout her life, and her art was based upon a visual record of her experiences. While largely self-taught, Jemima Blackburn cannot be considered an amateur, and her work was admired by Landseer, Ruskin and Millais. Although she visited London, Northern

Europe, Switzerland, Italy, Greece, North Africa and Iceland, much of her inspiration came from the west coast of Inverness-shire where she and her husband, Hugh Blackburn, Professor of Mathematics at Glasgow University, had bought a house called Roshven in 1855. Here she recorded the wild-life, landscape, effects of weather and her family life in a series of well-observed drawings and watercolours. She also illustrated books, painted in oil, and worked as an etcher and lithographer. The Blackburns had a wide circle of friends amongst artists, including MACNEE, MACWHIRTER and Millais, and amongst politicians, writers and academics. Her memoirs and sketchbooks, published in 1988 (*Jemima: The Paintings and Drawings of a Victorian Lady*, ed. R. Fairley, Edinburgh), provide a fascinating insight into Victorian life and art in Scotland.

Blacklock, Thomas Bromley 1863–1903
Kirkcudbright artist, trained in Edinburgh. Worked mostly in oil, but also did pen-and-ink illustrations. He originally painted landscapes, but began to introduce children and fairies in the 1890s. Mentally affected by a spinal condition and committed suicide in the Clyde near Greenock. His closest

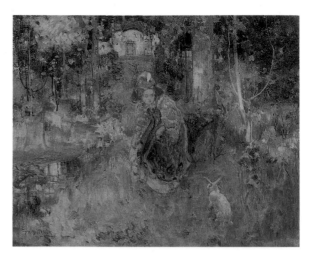

T B Blacklock *Fairy Tale* oil, The Scottish Arts Club

friend and helper in his later years was EWAN GEDDES.

Blackwell, Mrs fl.1730s
Drew and engraved flowers for a herbal publisher 1737–9.

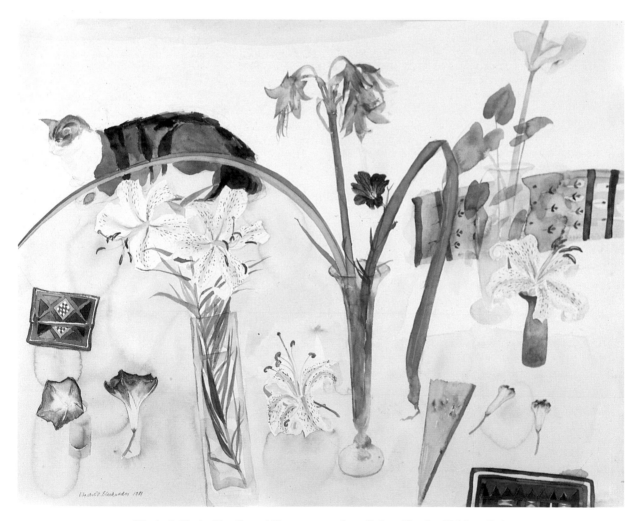

Elizabeth Blackadder *Cat and Flowers* watercolour, Robert Fleming Holdings Ltd

Blaikley, Alexander 1816–1903
Born Glasgow and lived in Edinburgh before moving to London in the 1840s. Painted literary and historical themes, portraits and landscapes on the west coast.

Blair, Andrew fl.1880s
Lived in Dunfermline and painted landscapes, town scenes and cattle in a detailed style in watercolour.

Blair, John fl. 1880–1920
Edinburgh artist who worked largely in watercolour, producing views of towns and villages on the east coast, including topographical views of Edinburgh.

Blair, William Charles d.ca.1887
Lived in Kincardine-on-Forth and later moved to Paris and Madeira. Painted children and worked for a while in Holland.

Blatherwick, Dr Charles d. 1895
RSW 1878
Amateur artist, closely connected with the founding of the RSW in 1878. He was, a doctor and practised in Highgate, London, before moving to Rhu as Chief Inspector of Alkali and Chemical Works for Scotland and Northern Ireland in 1865. A novelist and watercolourist, he painted Scottish landscapes in a tight style. Twice married; his daughter from his first marriage – LILY BLATHERWICK – married his stepson, A.S. HARTRICK. President, Glasgow Art Club 1891-93.

Blatherwick, Lily (Mrs A.S. Hartrick) 1854–1934
RSW 1878, ASWA 1886, SWA 1898
Born Richmond, daughter of DR CHARLES BLATHERWICK. Moved to Scotland with her father in 1865. A founder member of the RSW in 1878, and a distinguished painter of flowers. Married A.S. HARTRICK in 1896, moved to Gloucestershire where she painted many successful landscapes and flower pieces. Died Fulham.

R Henderson Blyth *The Copse in Winter* pen, wash & chalk, Jack Firth Esq

Blake, Frederick Donald b.1908
Born Greenock and painted coastal scenes and landscapes in watercolour and acrylic.

Bliss, Douglas Percy 1900–1984
Born Karachi, he was educated in Edinburgh graduating from Edinburgh University in 1922. Studied painting at the RCA 1922–4, sharing lodgings with Edward Bawden and Eric Ravilious, with whom he became close friends and, as a post graduate in 1925, he studied wood-engraving under Sir Frank Short. He illustrated 12 books and wrote criticism, essays and *A History of Wood Engraving* (1928). He served in the RAF during the war, meeting IAIN MACNAB. He was Director of GSA 1946–64 and in 1979 published a book on Edward Bawden.

Blyth, Robert Henderson 1919–1970
RSW 1949, ARSA 1949, RSA 1957
Born Glasgow and studied at GSA. Later taught at ECA from 1946, moving to Aberdeen in 1954. He was Head of Drawing and Painting, Gray's School of Art, Aberdeen 1960-70. He had also been involved in HOSPITALFIELD with JAMES COWIE.

Douglas Percy Bliss *Nesting Time* wood engraving, Perth Museum & Art Gallery

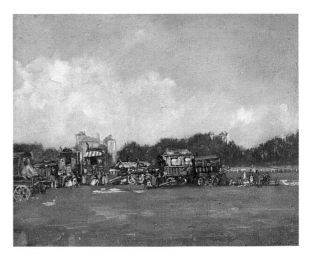

Sir David Muirhead Bone *The Fair, Ayr Racecourse* oil, Robert Fleming Holdings Ltd

Henderson Blyth painted powerful landscapes in oil and pen-and-wash, often emphasizing the abstract patterns of nature.

Bogle, John ca. 1746–1803
Studied FOULIS ACADEMY, Glasgow and moved to London 1770, returning to Edinburgh in 1800. Was known for his portraits, often in watercolour, and miniatures.

Bogle, William Lockhart fl. 1881–1900
Painter of Scottish history, especially Gaelic subjects, military scenes and portraits. His portrait of W.M. Thackeray (1900) is at Trinity College, Cambridge. Probably trained in Dusseldorf: moved from Glasgow to London c. 1886.

Bone, Sir Muirhead 1876–1953
NEAC 1902, Knighted 1937, HRSA 1951, (HRIBA 1937) RE, HRWS
Born Glasgow he studied at GSA and with ARCHIBALD KAY, moving to London in 1901, having also trained as an architect. This interest in architecture was soon revealed in his powerful drawings in charcoal with wash depicting Gothic cathedrals or Norman doorways, executed before 1910. During the First World War, Bone acted as an official war artist, and his drawings and watercolours of the Somme Battlefield executed in 1916 are amongst the most moving images of the war. In 1917 he worked with the Grand Fleet, and a selection of both series were subsequently published as *The Western Front* and *With the Grand Fleet*. Between the wars Bone worked extensively in Europe, visiting Spain, France, Holland and Italy and producing not only drawings but also etchings. During the 1939–45 war he acted as an official War Artist. Muirhead Bone and JAMES MCBEY are amongst the finest Scottish draughtsmen of their period.

Bone, William Drummond 1907–79
RSW 1950, ARSA 1969
Born Ayr, the nephew of SIR MUIRHEAD BONE.

William Drummond Bone *A Seaside Frolic* watercolour, private collection

Studied GSA and won a travelling scholarship to Italy. Later visited Germany and Holland and returned to join staff of GSA in 1934. After war service became a senior lecturer. Painted landscapes, seascapes and figures in oil and watercolour, his best work being in pencil or watercolour, often of wartime subjects. Died Ayr.

Bonnar, John fl. 1760s–70s
Pupil of ROBERT NORIE recorded working in Rome.

Bonnar, William 1800–1855
Edinburgh painter of historical and genre scenes. His best oils are his small portraits and studies of children, rather than his more ambitious historical canvases. He also worked in watercolour, painting portraits, genre and views of Edinburgh. His genre watercolours show the influence of DAVID ALLAN and, to a lesser extent, DAVID WILKIE.

Borrowman, Lt Colonel Charles Gordon 1892–1956
RSW 1945
Born Edinburgh, commissioned Indian Army 1912, studied ECA part-time. For much of his life Borrowman was in India where he painted landscapes in watercolour. On his retirement he settled in Dunkeld, where he continued to paint.

Borthwick, Alfred Edward 1871–1955
ARE 1909, RSW 1911, ARBA 1927, ARSA 1928, RBA 1930, RSA 1939, PRSW 1932–1951
Born Scarborough, he trained at ECA and in Julian's in Paris. He served in the Boer War and First World War, settling in Edinburgh where he painted landscapes and large religious works. His landscapes were often executed in a 'wet' watercolour style and he was President of the RSW for many years.

Borthwick, Majorie fl. 1933–40
The daughter of A.E. BORTHWICK, she worked in watercolour.

Boswell, Elizabeth fl. 1820–30
Elizabeth Boswell of Balmuto attended PATRICK SYME's drawing classes in Edinburgh in the early 19th Century. To the horror of her aristocratic family, she eloped and secretly married her teacher. Despite the scandal, and the fact that her parents never forgave them, the marriage was successful and Elizabeth Boswell developed into a skilful flower painter.

Bough, Sam 1822–78
ARSA 1856, RSA 1875, RSW 1878
Born Carlisle, he was apprenticed to Thomas Allom the London engraver, but rebelled against the discipline and returned to Carlisle on foot. He walked through the Lake District, and later the Borders, seeking out interesting views to sketch and enjoying the Bohemian life.
In 1845 he left Carlisle because of difficulties selling his watercolours and settled in Manchester working in the Theatre Royal as a scene painter. He continued to paint, mostly in watercolour, and in 1847 won the Heywood Silver medal for the best watercolour in the Manchester Exhibition. In 1848

Sam Bough *Edinburgh from Bonnington* oil, private collection

he settled in Glasgow and married the opera singer Isabella Taylor. While in Glasgow he worked at the New Princes Theatre, but also continued to paint. He met a number of artists in Glasgow including JOHN MILNE DONALD, ALEXANDER FRASER and THOMAS FAIRBAIRN and his reputation as a topographical and landscape painter grew in the 1850s. His topographical works included views of Glasgow and Edinburgh, where he settled in 1855. During the late 1850s, Bough developed an interest in marine painting and after his move to Edinburgh spent time in the fishing villages of the Fife coast. He was at home with the fishing folk who came to recognise this extraordinary figure, often armed with a multi-coloured umbrella, painting in the open air. At times he painted breezy harbours with boats rocking in the swell, at other times he chose tranquil sunsets or moonlit scenes, or figures on a beach gathering seaweed. His skies are particularly effective. He also worked both in oil and watercolour in the Lake District, Holland and Germany, but was most at home in Scotland. Bough was the most important watercolourist of his period and influenced the development of Scottish watercolour painting towards a freer, *plein-air* style. He was active in the establishment of the RSW and was the original Vice-President. Died Edinburgh.

Bourne, Peter b. 1931
Born Madras and studied at GSA. Lives and works in Perthshire.

Bowie, John Dick 1864–1941
ARSA 1903
Born Edinburgh and studied at ECA, the RSA Life Schools and in Paris at Julian's. During the 1880s he painted genre and costume pieces in the Orchardson-Pettie manner, but a visit to Haarlem and Madrid intoduced him to the bravura of Hals and Velasquez which became evident in later portraits. These are painted broadly, 'powerfully and slickly handled with big brushes in paint of good quality, the forms are indicated with breadth' (Caw).

Bowie, W. fl. 1920s
Amateur Aberdeen artist who painted somewhat naive views of Aberdeen. A number are held at Aberdeen Art Gallery.

Bowman, Margaret H c.1860–1931
Trained at RA Schools, Paris and GSA (1894). Portraits and woodcuts.

Boyd, Agnes S. fl.1860s–90s
Lived in Edinburgh and painted landscape, flowers and still life. Lived in Chelsea in the early 1870s.

Boyd, Alexander Stuart 1854–1930
RSW 1885
Born Glasgow, studied GSA. Journalist and magazine illustrator. He illustrated CHARLES BLATHERWICK's novel *Peter Stonnor* with GUTHRIE in 1884 and worked for *Punch*. In 1905 a series of his sketches were published as *Glasgow Men and Women*.

He was also an accomplished flower painter, and a group of flower paintings dated 1905 are in Glasgow Art Gallery. He lived for many years at St John's Wood before emigrating to New Zealand, where he died.

Boyle, James 1872–1935
Perth artist, manager of Pullars of Perth. Painted landscapes in watercolour.

Brackett, Nancy b. 1907
Studied at ECA under WILLIAM WALLS. Edinburgh animal painter.

Briggs, Ernest Edward 1866–1913
RI 1906, RSW 1913
Born Broughty Ferry. Trained at the Slade under Legros. A keen fisherman, many of his watercolours are concerned with angling in rivers or views of fishing villages. He wrote and illustrated *Angling and Art in Scotland* (1908) and contributed illustrations to other books on fishing. Watercolours are often on a large scale, the paint being well-worked and used almost as oil. The effects are usually impressive. Shared a studio with J.SYDNEY STEEL who observed of his friend's work: 'You know, I think you've put in too many little 'scriggles' in the water'. Briggs viewed his sketch with a critical eye. 'I suppose I have', said he wistfully, 'but they are such fun to do'. Died Dunkeld.

Brichta, Frank F. fl.1880s–90s
Lived in Edinburgh and painted landscapes. Exhibited SSA.

Brig O'Turk
The GLASGOW BOYS gathered in this beauty spot in the Trossachs during the summer of 1881 developing their *plein air* techniques together. SIR JAMES GUTHRIE derived the inspiration for his painting *A Highland Funeral* on this stay. This picture was subsequently sold to the Aberdeen collector, John Forbes White. Also at Brig O'Turk that summer was the slightly older ROBERT MCGREGOR and it is often supposed that Guthrie and WALTON came into contact with the other painters who had already grappled with trends towards realism.

Brodie, A. Kenneth fl.1890s
Lived in Edinburgh and painted portraits, figures and interiors.

Brodie, James fl.1736–8
Talented early painter who recorded the members of the Brodie family. Thought to have been the son of Ludovick Brodie of Whytfield, Writer to the Signet.

Bronckhurst, Arnold fl.1565–84
Netherlandish portrait painter who travelled to Scotland around 1570 and found favour with the Scottish court. He was succeeded by ADRIAN VANSON at court in 1584.

Brown, Davina F. fl.1904–38
Glasgow painter of flowers.

Brotchie, Theodore Charles Ferdinand 1868–1937
Born Ceylon, studied ECA. Director of Glasgow

Art Galleries and a writer on art. Also painted watercolours of the Scottish landscape.

Brough, Robert 1872–1905
ARSA 1904
Born Invergordon, Ross-shire and brought up in Aberdeen. Student at the RSA Life School 1891. Then spent some months in Paris with close friend J.D. PEPLOE before returning to Aberdeen where he worked for three years as a portrait painter. During this period also contributed some interesting drawings for *The Evergreen*. In 1897 moved to London, becoming a friend and neighbour of J. S. Sargent who influenced his technique towards a more bravura approach. Brough was more than a portrait painter and the influence of Symbolism can be seen in his non-commissioned and decorative work. Died in a railway accident near Sheffield.

Brown, Alexander Kellock 1849–1922
RSW 1878, RI 1878, ARSA 1892, RSA 1908
Born Edinburgh and brought up in Glasgow. Associated with that city throughout his life, becoming President of the GLASGOW ART CLUB. Had no formal training; worked as textile designer before turning to painting, coming under the influence of JAMES DOCHARTY. Worked in both oils and watercolours, painting dramatic views of Highland moors and

Robert Brough *Outside the Paris Opera* oil 1894, private collection

mountains in 'wet' washes and rich colours. Edward Pennington wrote of his work 'A leaning towards low tones is accompanied by a frequent choice of evening, moonlight and winter effects. He loves to look dreamily across moorland when the sun is low, when the clouds absorb the dying light and the world reposes in shadow.' Died Lamlash, Arran.

AKB

Brown, H.W. Jennings d.c.1887
Lived in Edinburgh and painted landscapes. Also painted scenes in Brittany.

Brown, Henry James Stuart 1871–1941
Landscape etcher who also worked in watercolours. He enjoyed flat landscapes with wide skies, working in East Anglia and Holland. Lived in Linlithgow.

Brown, Helen Paxton 1876–1956
Lauder Award 1923R
Born Glasgow, studied GSA. A close friend of JESSIE KING and other members of her circle, she produced embroidery designs which, like those of ANNIE FRENCH, were illustrated in *The Studio*. A successful portrait painter and developed a proficient, elegant style both in oil and watercolour. Also painted groups of figures in cafés with great skill, revealing her witty personality and personal style. Taught GSA 1911–17. Retired from Glasgow to live in Kirkcudbright.

Brown, J. Osborne fl.1860s–70s
Edinburgh painter of Inverness and the Scottish Highlands.

Brown, J. Taylor fl.1893–1940
Lived in Ayrshire and painted landscapes.

Brown, James Michael 1854–1957
Born Edinburgh, studied ECA and Dundee. Won a travelling scholarship to the Continent. Exhibited RSA and RA 1879–87. Painted landscapes – usually in watercolour – and is renowned for those of golf courses and golfing scenes, especially Edinburgh and East Lothian. Member of the Pen and Pencil Club and SCOTTISH ARTS CLUB.

Brown, John Crawford 1805–67
ARSA 1843
Born Glasgow and painted rural scenes and incidents, particularly harvesting. Worked abroad in Holland and Flanders and in Spain in the late 1830s.

Brown, John of Rome 1752–87
Born Edinburgh and studied under WILLIAM DELACOUR at the Trustees' Academy. In 1771 visited Italy with the diplomat David Erskine and was introduced to Roman society by Erskine's cousin who held a post at the Vatican (later to become Cardinal). Met ALEXANDER RUNCIMAN, JACOB MORE and many British collectors and travellers. Brown drew landscapes around Rome influenced by Claude Lorrain and Poussin, but more interesting are his superb studies of Roman street characters and women, executed in pen-and-wash with rich contrast. The influence of Fuseli is evident but they are, nevertheless, highly individual. Brown also drew from classical sculpture. On return to Edinburgh he produced many pencil

J Michael Brown *The First Green, North Berwick* watercolour, private collection

portraits which, while being extremely competent, lack the pure genius of his Roman sketches.

Brown, Joseph d.1923
Lived in Edinburgh and painted landscapes. Also worked abroad, including Egypt.

Brown, Margaret Oliver b.1912
Born Glasgow. Worked as a commercial artist before studying at GSA 1937–41. Painted portraits and was a founder member of the NEW SCOTTISH GROUP.

Brown, May Marshall 1887–1968
RSW 1936
Born May Mary Robertson, studied ECA before marrying WILLIAM MARSHALL BROWN, whose style of painting greatly influenced her. Painted water-colours of fishing villages and boats, also working in France and Holland. Style is fresh with a lively, wet handling of the washes.

Brown, Neil Dallas b.1938
ARSA 1975
Born Elgin and studied at Dundee College of Art, Hospitalfield, British School at Rome and the RA Schools. Has exhibited widely since 1959, utilising a number of recurring themes: images of menacing dogs as well as cats, the attack by a sniper and lovers found together on a marshy landscape. Often on a large scale, there are many disturbing elements in his works. Works in many public collections. Lectures at GSA.

Brown, Thomas fl.1840s–60s
Lived in Edinburgh and painted rural genre, land-scape and coastal scenes. Exhibited RSA.

Brown, Thomas Austen 1857–1924
RI 1888, RSW 1889, ARSA 1889
Born Edinburgh, studied RSA Schools. Moved to London c. 1890. Caw traces his development from the early 'daintily clad rustic girls' to a rustic realism closer to Clausen and La Thangue. He worked at CAMBUSKENNETH and was associated with the GLASGOW BOYS, working both in oil and watercolour.
Later lived in Northern France where he painted watercolours in a bold if somewhat clumsy style, possibly in an attempt to keep up with post-war developments. Was influenced by book illustration and produced views of Etaples for publication. Died Boulogne.

Brown, Thomas Wyman 1868–1930
Painted landscapes and flowers in oil and watercolour, but particularly noted for his paintings of fish. Lived in Perth.

Brown, William 1801–74
Art Master at Perth Academy. Painted local scenes in a simplified 18th century classical style.

Brown, William fl.1830s–40s
Lived in Glasgow and, later, Perth, where he taught at Perth Academy. Painted landscapes.

Brown, William Beattie 1831–1909
ARSA 1871, RSA 1884
Born Haddington, studied Trustees' Academy. A popular painter of the Scottish Highlands in oil

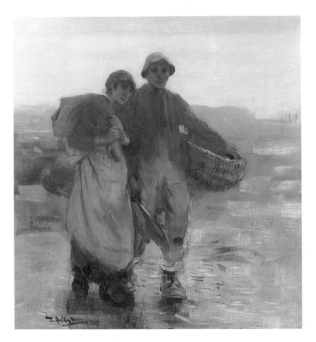

Thomas Austen Brown *Homeward* oil, private collection

and watercolour. Colours tend to be dull. Died Edinburgh.

Brown, William Beattie Junior fl. 1895–1915
Painted in a similar style to his father, but achieved less success. Also painted some watercolours.

Brown, William fl.1830–73
Perth artist who painted local views.

Brown, William Fulton 1873–1905
RSW 1894
Born Glasgow, the nephew of DAVID FULTON, he studied at GSA and under his uncle. Specialized in costume and character pieces, also painting some highly competent 'swish' portraits in watercolour, probably influenced by Sargent. Also painted some fine landscapes in watercolour showing a mastery of the 'wet' technique favoured by the GLASGOW BOYS. Died young at 32 and, like ROBERT BROUGH, it can only be speculated upon as to what he might have achieved with maturity.

W Beattie Brown *Glenspean* oil, private collection

W F Brown *David Fulton* lithograph for *Quiz*, 1893

Brown, William Marshall 1863–1936
ARSA 1909, RSA 1928, RSW 1929
Born Edinburgh, he studied at the RSA Schools and South Kensington. Painted in Scotland, France and Holland, often choosing windswept beaches with children playing or breezy fishing villages. His technique in both oil and watercolour was broad and lively. Lived and worked in Edinburgh and Cockburnspath.

Brownlie, James Miller fl.1895–1921
Lived at Strathbungo and in Glasgow and exhibited RSA, RSW and GI. Good draughtsman with some strong pencil work.

Brownlie, Robert Alexander d.1897
RSW 1890

William Marshall Brown *Boys Sailing Boats* oil, Bourne Fine Art

Painter of coastal views and fishing villages. His output was small.

Bruce, Harriet fl.1822–99
Lived in Edinburgh and Argyllshire. She painted detailed watercolours showing the influence of Pre-Raphaelitism. Signs with a monogram.

Brunton, Elizabeth York 1880–?
Member, Colour Woodcut Society
Born Musselburgh, studied ECA. Painted views of Continental markets in both oil and water-colour, sometimes using linen as a ground. Spent much time in Paris, and exhibited only rarely in Scotland.

Brunton, Mary Campbell fl.1885–1933
Lived in Glasgow and painted flower pieces. Exhibited SSA.

Bryce, David 1803–76
ARSA 1851, RSA 1856, FRIBA
Edinburgh architect who painted watercolours of architectural subjects.

Brydall, Robert 1839–1907
Born Glasgow and studied at GSA under CHARLES HEATH WILSON, later becoming Second Master. He is better known today as the author of *Art in Scotland, Its Origins and Progress* (1889) rather than as a painter, but he also produced landscapes in oil and watercolour based on trips to Italy and Switzerland. Also some genre.

Bryden, Robert 1865–1939
ARE 1891, RE 1899
After working initially in an architect's office, Bryden moved to London where he attended the RCA and the RA Schools. Then travelled abroad to Italy and Spain producing a series of etchings based on his travels. Returning home to Ayrshire, he embarked upon a series of etchings illustrating the poems of Burns. Was also interested in religious and character studies using not only etchings but mezzotint, dry point and woodcut.

Brydon, Charles fl.1880–1901
Lived in Edinburgh and painted landscapes, views on the west coast and marine and coastal scenes.

Buchan, Denis b.1937
Born Arbroath. Studied at Duncan of Jordanstone School of Art and Hospitalfield. Joined staff at Duncan of Jordanstone, 1962. Exhibited from 1959.

Buchanan, Allan fl.1880–1900
Glasgow watercolourist and oil painter whose land-scapes were exhibited at the Glasgow Institute.

Buchanan, Mrs E. Oughtred fl.1930–40
Edinburgh painter working in the style of GILLIES.

Buchanan, George F. fl.1840s–50s
Lived in Edinburgh and painted scenes in the Highlands, Ayrshire and Argyllshire.

Buchanan, George F. fl.1840s
Glasgow painter of landscapes and coastal scenes.

Buchanan, James 1889–?
Born Largs, studied GSA. Painted landscapes and figures of North Africa in watercolour.

Buchanan, Peter S. fl.1860–1910
Glasgow painter of landscape in oil and water-colour, who began exhibiting at the RSA in the 1860s. Painted coastal and harbour scenes. Settled in England c. 1885, later moving to Wales.

Bunting, Thomas 1851–1928
Born Aberdeen. Painted landscapes in Aberdeen-shire and Perthshire. Often chose views with rivers or the sea, using muted silvery tones. Painted in both oil and watercolour.

Burgess, James G. 1865–1950
Amateur artist, studied Dumbarton Art School. Established a firm of interior decorators and became a friend of the GLASGOW BOYS. Lived in Helensburgh and painted local scenes.

Burnet, James M. 1788–1816
Younger brother of JOHN BURNET. Born Mussel-burgh, studied under DAVID SCOTT at the Trustees' Academy. Painted Scottish landscape scenes.

Burnet, John 1784–1868
Fellow student of DAVID WILKIE at the Trustees' Academy, and inspired by Wilkie's success moved to London in 1806. Had trained in Edinburgh as an engraver under ROBERT SCOTT, and in London he engraved many of Wilkie's earlier works as well as painting his own genre and historical canvases. Was also a good draughtsman and produced a number of illustrations for Cadell's edition of Scott's *Waverley Novels* (1830-4) along with WILKIE, ALEXANDER FRASER, WILLIAM ALLAN and others. He also painted some landscapes and seascapes in watercolour. Died London.

John Burnet *The Scissor Grinder* watercolour,
Aberdeen Art Gallery, Aberdeen City Arts Department

Burnett, Miss J.S. died c. 1960
Painter of flowers and landscapes in watercolour. Probably from Dundee, she lived and worked for a period in the 1890s in London.

Burnett, David Duguid fl.1920–40
Edinburgh landscape watercolourist who exhibited at the RSW.

Burn-Murdoch, Sarah Jessie Cecilia ('Morag') 1858–1933
Lived in Edinburgh and exhibited SSA. Worked in Paris c. 1901. Painted landscapes. Sister of W. G. BURN-MURDOCH.

Burn-Murdoch, William Gordon 1862–1939
Lithographer and etcher who also worked in oil and watercolour. Studied in Antwerp and Paris, acquiring a knowledge of European developments in art. Contributed to *The Evergreen – The Book of Spring* and *The Book of Summer* (1895 and 1896) published by Patrick Geddes. Later settled in Edinburgh painting figure subjects, interiors, portraits and landscapes relating to his trips abroad. In 1892 he accompanied an expedition to Antarctica as official artist. Later painted in India and China.

Burns, Alexander S. 1911–87
RSW 1957
Lived in Aberdeen. Trained at Grays School of Art, Aberdeen, and worked principally in watercolour. Painted landscapes, architectural subjects, wood-land scenes and flowers.

Burns, Robert 1869–1941
ARSA 1902, resigned 1920
Born Edinburgh and studied in Paris between 1890 and 1892. He made his mark with a notable draw-ing *Natura, Naturans* executed in 1891 for Patrick Geddes' magazine *The Evergreen*. It is one of the ear-liest examples of art nouveau in Scotland, although not published until 1895. Also contributed to the German art nouveau review *Ver Sacrum*. Burns worked in Edinburgh as a graphic designer, on stained glass windows, interiors and even for the early motor car. As a result, his output of easel paintings was restricted. During the 1890s Burns

Robert Burns *Peacocks of Desire* watercolour, private collection

collated and studied various versions of Scottish ballads, which his father had taught him to love, and intended to produce a hand-written and illustrated book. Lack of money and time delayed the project, but in 1929 after a severe illness he returned to the project, illustrating the ballads in his style of the 1890s. These illustrations painted on vellum in watercolour, gouache, ink and gold leaf are amongst the finest modern Scottish book illustrations.

Burns' relationship with the RSA was not happy; elected ARSA in 1902 he resigned in 1920. Likewise his position as Head of Drawing and Painting at ECA was terminated due to his unorthodox teaching methods. Burns was also a fine landscape painter in oil and watercolour. In 1920 he visited Morocco and his sparkling North African views with their strong sense of pattern and colour are notable.

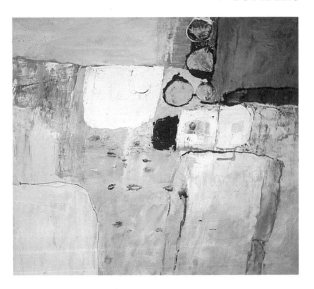

William Burns *Floats* gouache, Lothian Region Education Department

Burns, William Alexander 1921–72
ARSA 1955, RSW 1957, RSA 1970
Born at Newton Mearns, studied at GSA 1944–8 and at HOSPITALFIELD. Principal lecturer Aberdeen College of Education 1967–70. He painted landscapes and marine subjects in oil and watercolour. Art Critic T. G. Rosenthal commented: 'Burns put on great vivid blobs of rusty red matching the colour of the keels of beached trawlers; he composes abstract patterns out of harbour breakwaters with carefully placed propeller shapes, so that you can see in these paintings, which at first glance have no significant shape but appear to be subdued symphonies of lustrous colour, an unmistakable reality of both image and feeling.' Died flying his own aircraft solo in north-east Scotland.

Burr, Alexander Hohenlohe 1835–99
ROI 1883
His career is very similar to that of his older brother JOHN BURR. Also trained at the Trustees' Academy under SCOTT LAUDER, and settled in London in 1861 painting genre scenes and children. Colours are somewhat brighter and gayer than those of his brother, but his technique is less assured. Unlike his brother, he rarely worked in watercolour.

Burr, Gordon G. fl.1890s
Aberdeen artist who painted landscape watercolours.

Burr, John 1831–93
RBA 1875, ROI 1883, ARWS 1883
Studied at the Trustees' Academy under SCOTT LAUDER before moving to London in 1861 where he achieved considerable success. Elected Associate of the Old Watercolour Society and President of the RBA. Genre paintings are similar to those of THOMAS FAED, although they possibly lack his tenderness and sadness. His technical handling of both oil and watercolour is notable, achieving

unlaboured detail and a rich patchwork of colour. His later works are slightly freer in handling and introduce a humorous note in the subjects. Lived and worked in London where he died.

Burton, Miss M.R. Hill fl.1880s–1900
Painter of flowers and figures in landscape. Exhibited SSA.

Burton, Mungo 1799–1882
ARSA 1845
Edinburgh based portrait painter in oil.

Burton, Nancy 1891–1972
RSW 1932. Lauder Award 1924
Born Insh, Inverness-shire, studied GSA, Paris and Italy. Specialized in painting animals, and lived on a farm in Tyndrum, Perthshire for many years. During the early 1930s visited India, Kashmir and Afghanistan where she painted many watercolours.

Burton, William Paton 1828–83
RSW 1882
Born in Madras, the son of an officer in the Indian Army, he was educated in Edinburgh, before joining the office of the architect DAVID BRYCE. He devoted much time to watercolour painting and travelled widely, including India and Egypt. Moved from Edinburgh to Surrey in the 1860s, and painted landscapes of Surrey and Sussex. Returned to Scotland and died at Cults, Aberdeen. His watercolours are competent, if a little dull.

Busby, John P. b.1928
RSW 1982, ARSA 1986
Born Bradford and studied at Leeds Art College 1948–52, ECA 1952–54. Joined staff at ECA 1956. Exhibited from 1955. President SSA 1973–76. Founder member of the Society of Wildlife Artists.

Buttberg, Victorine fl.1930s–'40s
Lived in Edinburgh and painted flower pieces. Exhibited SSA.

Cadell, Agnes Morrison d.1958
Sister of FLORENCE CADELL, she lived and worked in Edinburgh. Often painted abroad in Africa, Malta, France, Italy and Spain, usually working in oil.

Cadell, Florence St John 1877–1966
Born Cheltenham, moved to Edinburgh. Painted landscapes in oil and watercolour; her best works are her colourful paintings of Continental market places and of Paris, where she studied around the turn of the century. She travelled abroad regularly to paint. Her still-life is less effective.

Cadell, Francis Campbell Boileau 1883–1937
Born Edinburgh and educated at the Edinburgh Academy; at 16 Cadell went to Paris to study painting at the Academie Julian. His exposure to the powerful forces that were emerging in France at the time – mature Impressionism and the early Fauve works of Matisse and Derain – had a more profound effect on the artist than the prosaic training he received at the Academie. Pre-1914, Cadell remained in Edinburgh apart from a brief period in Munich and a short stay in Venice at the end of the decade. In Scotland he had little direct contact with the progressive ideas that were emanating from abroad. As a result he chose as his subject matter articles and environments that were close at hand: bottles, fans, fashionable New Town interiors and glamorous women painted in a loose, impressionistic manner, the colours strong and fresh.
His trip to Venice not only provided the ideal setting for his naturalist colourist talent, but by 1911 enthused him enough to make arrangements

for an annual exhibition of like-minded artists of a standard higher than those at the established venues. THE SOCIETY OF EIGHT, although it exhibited in the Scottish capital, transcended the traditional Glasgow/Edinburgh divide, as it comprised artists from both cities, among them PATRICK ADAM, DAVID ALISON and JOHN LAVERY. Later PEPLOE was elected a member. The annual exhibitions were a success and established the COLOURISTS' credentials.
A dramatic change can be discerned in Cadell's work after the First World War, in which he served in the 9th Argyll, 9th Royal Scots and the Sutherland Highlanders. His style became much tighter and his work up until his death in 1937 showed a tendency towards stark, clearcut still lifes and interior scenes, with an emphasis on the creation of precise, almost geometric patterns. His palette, although still light in tone, tended towards primary colours, and his brushwork lost its pre-war vigour. Cadell's canvases began to show a greater debt to the tenets of still-life painting laid down by Cezanne in his structured approach in the application of colour. Like Cezanne, Cadell spent much time experimenting with still-life arrangements as they allowed him to mobilise form, line and colour in their purity, without the intrusion of narrative content. At his first London exhibition in 1923, which he shared with Peploe and HUNTER, the critics commented on this 'new solidity' of his painting.
In the summer months Cadell would stay on the island of Iona in the Western Isles. The stark white sands and the impressive views, together with the dramatically changeable weather conditions, were ideal subjects for Cadell's style, and these landscapes tend to be more relaxed and painterly compared with his formal studio work. He found his paintings increasingly difficult to sell towards the end of his life, perhaps due to the general economic conditions of the 1930s. Died Edinburgh. (*Tom Hewlett*)

Florence St John Cadell *In a Paris Market* oil, private collection.

Cadenhead, James 1858–1927
NEAC 1886, RSW 1893, ARSA 1902, RSA 1921
Born Aberdeen and studied at the RSA schools and in Paris under Carolus Duran. Returned to Aberdeen in 1884 after two years in Paris; moved to Edinburgh in 1891. He was greatly influenced by Whistler and the Aesthetic Movement and in 1886 became a founder member of the New English Art Club.

F C B Cadell *Lady in Black and Gold* oil, private collection

His landscapes were decorative in effect and reveal the influence of Japanese prints. He enjoyed the effects of twilight and a romantic and mystic feeling emerges from his carefully arranged landscapes, which are often in watercolour and occasionally on a huge scale. In later years he worked more in oil using a bold technique but restrained colours.

 JC

Cadzow, James 1881–1941
Born Carluke, moved to Broughty Ferry as a child. Studied ECA. Art Master, Dundee High School and

27

James Cadenhead *Robert Brough ARSA* etching, private
collection

President of Dundee Arts Society. Painted land-
scapes of Scotland in a powerful style, using strong
charcoal outlines and rich washes. Also produced
pencil drawings and etchings.

Cairns, John fl.1845–70
Probably born Paisley, he painted Scottish and
northern French landscapes in both oil and water-
colour in great detail, possibly influenced by the
Pre-Raphaelite movement.

Cakly, H. fl.1840s
Perthshire artist who painted local views.

Calderwood, William Leadbetter 1865–1950
Born Glasgow and educated at Edinburgh Univer-
sity. By profession a naturalist and marine biologist,
but also a competent portrait painter.

Caldwall, John d.1819
Practised in Scotland as a miniature painter and
enjoyed a considerable reputation. Brother of
the English engraver James Caldwall. Died in
Scotland.

Caldwell, William Taylor fl.1858–1900
Lived in Edinburgh and painted landscapes on the
West coast.

Callender, Robert b.1932
ARSA 1966 (resigned 1969)
Born Mottingham, Kent, and studied at South
Shields Art School. Attended Edinburgh Univer-
sity 1950–54 and ECA 1954–58. Awarded Travelling

Scholarship and has lived in France, Italy and Spain.
Exhibits widely with work in many private and public
collections. Works in oil, acrylic and gouache but it
is his pencil drawings of coastal and marine subjects
which have aroused widespread interest. President
SSA 1970–73 and lecturer at ECA.

Calvert, Edwin Sherwood 1844–98
RSW 1878
Born England, lived in Glasgow painting quiet
but effective landscapes in watercolour. His
earlier works depict coastal scenes and fishing
villages, but his later work is more distinctive.
He paints pastorals in subdued tones, sometimes
introducing figures of shepherds. His water-
colours are usually entitled *Reverie* or *Pastoral*
rather than names of specific locations. Caw
likens his style to that of Corot.

Cambuskenneth
The GLASGOW BOYS worked together here in the
summer of 1888. ARTHUR MELVILLE and E.A.
WALTON rented studios and CRAWHALL, GUTHRIE
and HENRY all became regular visitors. There is
some evidence that WILLIAM KENNEDY may have
introduced the others to the area, and some of his
best work was painted there.

Cameron, Sir David Young 1865–1945
ARE 1889, RE 1895, ROI 1902, ARSA 1904, ARWS
1904, RSW 1906, RWS 1915, ARA 1916, RA 1920,
HRSW 1934, Knighted 1924
Born Glasgow and studied at GSA and the RSA
Schools. First successes came with his etchings in
the 1890s, including the 'North Italian' set (1895–6)
'London' set (1899) and the 'Paris' set (1904). Like
SIR MUIRHEAD BONE, Cameron was fascinated by
architecture and his etchings of French Gothic
portals reveal a grasp of the complex design.
His etchings are generally richer and heavier
than those of Whistler, possibly being influenced
more by Rembrandt and Meryon. Cameron also
worked in oil and watercolour, often painting the
hills and mountains of Scotland in an economical
and uncluttered manner. These works have an
undeniable grandeur, which Caw saw as a lack of
passion and spontaneity. This reflects Cameron's
personality - a quiet retiring man, the son of a
clergyman and himself a keen churchman with an
interest in church music and ceremony. He was not
interested in the decorative possibilities of painting
and thus, although he knew the GLASGOW BOYS, his
work stands outside the mainstream of the Glasgow
School. He was the King's Painter and Limner in
Scotland and lived for many years at Kippen in
Stirlingshire 1933–45. Died Perth.

D.Y. Cameron

Cameron, Duncan 1837–1916
Born Perthshire and educated at Dundee and South
Kensington. Exhibited regularly at RSA and RA and

D Y Cameron *Old Paris* oil, Robert Fleming Holdings Ltd

a softer, more relaxed technique for both his oils and watercolours.

He lived in London for twelve years after 1876, but returned to live in Edinburgh during the winters and Largo in the summers. He made a visit to the French Riviera around 1880 and also to Italy, and this lightened his colours. Died Edinburgh.

HC

Cameron, Katharine (Mrs Arthur Kay) 1874–1965

RSW 1897, ARE 1920, RE 1964

Born Hillhead, Glasgow, the sister of D.Y. CAMERON, she studied at GSA 1890–93 and later in Paris with Colarossi. Her early interiors were influenced by the Glasgow Four although her technique is wetter and her drawing less stylized. Her series of illustrations for *There Were Two Sisters Sat in a Bower, Binnorie-O-Binnorie* were discussed in an article in *The Art Journal* in 1900. Between 1904 and 1910 she illustrated a number of children's fairy tales and legends, but her real love was flower painting. Her earlier flower pieces from the 1890s and early 1900s tend to be rich in colour and wet in technique; this gave way to a more delicate style with careful drawing and restrained colour, influenced by painters like CRAWHALL and EDWIN ALEXANDER. The earlier flower pieces depict large bouquets of flowers in bowls, while the later examples are usually single stems set in the open often with bees or butterflies. She also experimented with thin oils on silk. During the 1920s and 30s, she painted landscapes in a linear style, but these later became richer and more expressive. After 1940, she returned to her earlier style of fully-blown compositions. Was also an etcher.

Katharine Cameron *Bees and Tropaeolum Speciosum* watercolour, private collection

in 1876 gained the Gold Medal at Crystal Palace for the best landscape. His landscapes in oil are often painted on a grand scale and his obituary in *The Scotsman* noted 'his distinctive note ... best expressed in his treatment of cornfields'. Died Edinburgh.

Cameron, Gordon Stewart b.1916

ARSA 1958, RSA 1971

Born Aberdeen, he studied under R. SIVELL. Taught at Dundee College of Art until retirement in 1981. Painter of interiors, garden areas, landscapes and still-life. Married to the artist ELLEN MALCOLM.

Cameron, Hugh 1835–1918

ARSA 1859, RSA 1869, RSW 1878, ROI 1883, HRSW 1916

Born Edinburgh. Painter of genre, he studied under LAUDER at the Trustees' Academy where MCTAGGART was a fellow student. He shared CHALMERS' and McTaggart's love of colour and interest in freer brushwork, but his subject matter is more tender and intimate - children inside or in fields, cottage interiors, studies of old people. His earlier work, like that of McTaggart, reveals a Pre-Raphaelite finish, but he developed

In 1928 she married Arthur Kay, the art collector and connoisseur.

Cameron, Mary (Mrs Alexis Miller) c.1865–1921
Born Edinburgh, studied Edinburgh and Paris. Painted large oils of Spanish and rural scenes, but also did watercolours based on her trips abroad. She specialized in bull fighting scenes, and lived for a period in Madrid and Seville. She later worked in the South of France.

Campbell, Alexander 1764–1824
Topographical artist who worked in pen and sepia washes. Author of *Journey from Edinburgh through Parts of North Britain* 1802.

Campbell, Alexander b.1932
ARSA, RSW
Born Edinburgh, he studied at ECA and Edinburgh University.

Campbell, Archibald b.1914
Perth artist recorded as painting local views and characters.

Campbell, Ian 1902–?
Born Oban and trained at GSA 1921–6. Won the Guthrie Award at the RSA 1931. A noted portrait painter his paintings were exhibited at the RA 1932 and '37. Head of Dundee Academy Art Department 1937–68.

Campbell, James fl.1860s–80s
Glasgow landscape painter, he worked in Cadzow Forest and also made pen and sepia drawings of Glasgow.

Campbell, John Hodgson fl.1880s–1906
Lived in Edinburgh and moved to Newcastle in the mid-1880s. Painted genre, rural scenes and landscapes.

Campbell, Reginald Henry b.1877
Born Edinburgh and studied at the RSA Schools. Portrait and historical genre painter who later moved to London.

Campbell, Tom fl.1880–1900
Glasgow topographical artist.

Tom Campbell *'The Nahlin' at Rhu* watercolour, Barclay Lennie

Campbell, Tom 1865–1943
Landscape watercolourist and exponent of gouache who painted views of the west coast and islands, using a sharp, highly coloured style. He often painted sheep, children on beaches, and his views of sands with sea-birds can be effective. A most prolific painter, he sold many of his works through the Glasgow department store, Daly's.

Carlaw, John 1850–1934
RSW 1885
Born Glasgow, lived Helensburgh. An animal painter and friend of the GLASGOW BOYS, he worked mostly in watercolour using a wet technique typical of the Glasgow School. His best works are effective with a well-controlled, fluent handling of washes, but less good examples can be poorly drawn and weak in technique.

Carlaw, William 1847–89
RSW 1878
The brother of JOHN CARLAW, died young aged 42. Like his brother, he was connected with the Glasgow School, but he concentrated on watercolours of marine subjects, working in Scotland and in the west of England.

Carlyle, Thomas c.1775–1837
Lived Dumfries, Carlisle and Liverpool where he was active and exhibited his work as a miniaturist and portrait painter.

Carmichael, James F. fl.1833–46
Teacher of drawing in Edinburgh. Painter of landscapes and seascapes. Also painted mystic genre.

Carmichael, Stewart 1867–1950
Educated at Dundee High School and studied art in France and Belgium. His reputation was first established with his decorative murals for public buildings in Dundee including the *Leaders of Scottish Liberties* for the Liberal Club. As a young man he was inspired by the work of fellow Dundonians, especially JOHN DUNCAN and GEORGE DUTCH DAVIDSON, but in later years he reverted to a more conservative style of painting, often depicting architectural subjects. A popular figure in Dundee, he once described art as 'like little green leaves that grow between the stones of the city.'

Carrick, Robert 1829–1904
ARI 1848, RI 1850, ROI 1883
Genre painter, born in the west of Scotland, moved to London in the 1840s.

Carrick, Robert fl.1845–85
Glasgow artist who worked in the same lithographic studio as WILLIAM 'CRIMEAN' SIMPSON and painted in a similar style. Painted oils and watercolours of Glasgow and its surrounding countryside.

Carrick, William Arthur Laurie 1879–?
Trained as an architect, but turned to painting for health reasons. Painted watercolours of landscapes, coastal and beach scenes.

Stewart Carmichael *The Countess of Buchan 1306 AD*
watercolour 1908, Dundee Art Galleries & Museums

Carse, Alexander d.1843
Pupil of DAVID ALLAN before joining the Trustees'
Academy in 1806. He worked in both oil and
watercolour in a genre style initially influenced by
Allan, but later by the successful formula of DAVID
WILKIE, whom he followed to London in search of a
public. It has been suggested that his Scottish genre
scenes painted from the 1790s influenced the young
WILKIE. His drawing lacks the finesse and liveliness
of Allan, and his watercolours are restrained in
colour. His oils with their attention to detail,
composition and the effects of light are possibly
more successful than his watercolour work. Carse

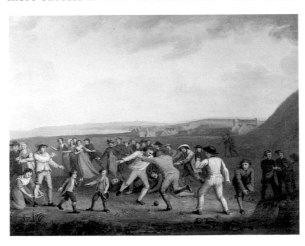

Alexander Carse *The Doonies v. the Croonies on New Year's Day*
oil, The Robertson Collection, Orkney

settled in London in 1812, returning to Edinburgh
in 1820.

Carse, James Howe c.1819–1900
Believed to be the son of WILLIAM CARSE, he
worked in Scotland before 1860. Exhibited in
London 1860–62. Emigrated to Australia c.1865.
Painted industrial scenes in Lancashire.

Carse, William n.d.
The son of ALEXANDER CARSE, painted similar sub-
jects to his father but in a cruder style.

Carslaw, Evelyn 1881–1968
Born Glasgow, studied GSA and Paris. The wife
of a Glasgow surgeon, born Evelyn Workman.
She painted views of Holland, Spain, Italy and
Scotland in oil and watercolour, and produced
illustrations for *Leaves from Rowan's Logs* (1944),
a book written by her husband, a keen yachts-
man, about a cruise around the west coast. A
close friend of NORAH NEILSON GRAY, she lived in
Helensburgh.

Cassie, James 1819–79
ARSA 1869, RSW 1878, RSA 1879
Born Inverurie, Aberdeenshire, he moved as a child
to Aberdeen, but was seriously injured in a street
accident and suffered physical disabilities for the
rest of his life. Trained under JAMES GILES and
worked initially as a portrait and animal painter.
During the 1860s he turned more towards land-
scapes and seascapes and his work became known
in Edinburgh and London where he exhibited at the
Royal Academy. In 1869 he moved to Edinburgh
and was elected ARSA, but he returned to the
north-east coast to paint. He often signs with a
monogram. Died Edinburgh.

Catchpole, Neil M. b.1904
Born Glasgow, he lived in Greenock painting topo-
graphical views of Glasgow in oil and watercolour.

Caunter, Robert fl.1840s–50s
Painted literary themes, genre, still-life and rural
subjects. Visited Italy in the mid-1840s and painted
in Naples and Amalfi.

James Cassie *At Cove* oil, Aberdeen Art Gallery, Aberdeen
City Arts Department

Caw, James fl.1840s
Glasgow portrait painter.

Caw, Sir James 1864–1950
Born Ayr, studied GSA. Author of *Scottish Painting Past and Present* (1908), the first and most comprehensive work on Scottish art, and of several other studies of Scottish artists. Curator of the National Galleries of Scotland (1907) and the Scottish National Portrait Gallery (1895). He also painted landscapes in pastels and watercolour, often choosing coastal scenes. Died Lasswade.

Chalmers, Sir George d.1791
A descendant of GEORGE JAMESONE, he lived at Cults, near Aberdeen. Studied with ALLAN RAMSAY in Italy and painted portraits, including William St Clair of Roslin as Captain of the Honourable Company of Golfers.

Chalmers, George Paul 1833–78
ARSA 1867, RSA 1871, RSW 1878
Born Montrose, he studied at the Trustees' Academy under LAUDER, where he was a fellow student of MCTAGGART. He painted genre, portrait and landscapes, his best known work being of single figures set in dimly lit interiors. In these paintings, his excellent sense of chiaroscuro and his subtle, yet bold, colour are seen to their best advantage. He was also an extremely sensitive painter of children and old people, sometimes put together. He was by nature erratic, often rising late and his output was not large, cut short by his brutal murder in Charlotte Square, Edinburgh. He was, nevertheless, an important artist whose free use of colour and loose

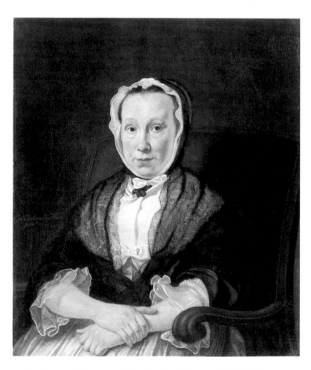

Sir George Chalmers *Portrait of a Woman* oil 1765, James Holloway Esq

brushwork, seen especially in his landscapes, look towards the 1880s and 90s.

Chalmers, Hector 1848–1943
Studied Edinburgh with MCTAGGART and GEORGE PAUL CHALMERS at the Trustees' Academy, RSA Schools and Art School at the Mound. His early work consists predominantly of figure subjects in oil before moving on to landscapes and portraits. Member of the SCOTTISH ARTS CLUB and Pen and Pencil Club.

Chanler, Albert 1880–?
Studied at GSA and at the Royal Institute, Edinburgh. Painted and etched architectural subjects.

Cheyne, Ian 1895–1955
Born Broughty Ferry and studied at GSA under GREIFFENHAGEN. He worked originally as a painter, but his interest in colour woodcuts eventually dominated his work. His woodcuts were influenced by Japanese design using flat-planes of colour and oriental perspective.

Chisholm, Alexander 1792–1847
Born Elgin and apprenticed to a weaver in Peterhead before moving to Edinburgh c. 1809 to study under the patronage of the Earl of Buchan. In 1818 he moved to London and exhibited his genre watercolours with some success at the RA and OWS. In addition to genre he painted portraits and historical subjects in oil and watercolour. Died Rothesay.

Christie, Adam 1869–1950
Born Cunningsburgh, Shetland, the son of a crofter, he showed artistic talent at an early age. Admitted to Sunnyside Asylum, Montrose, in 1876 where he spent the rest of his life working on drawings and paintings, usually portraits of inmates or staff or religious subjects, and sculptures in stone. Examples of his work are still held at Sunnyside. Signed '. . . by Adam Christie, late of Aith, Cunningsburgh, Shetland, N.B. . . . A.C.'. 'He did not use conventional paint brushes, but made his own by splaying out the ends of discarded match sticks . . . he never purchased special paints . . . he used tins of paint left outside the painter's shop. Sacking from empty flour bags was the only source of canvas that he had.' (Kenneth Keddie, *The Gentle Shetlander*, Edinburgh 1984). Died Sunnyside.

Christie, Alexander 1807–60
ARSA 1848
Edinburgh painter of portrait and some historical subjects, he trained at the Trustees' Academy and for a short period in London. He was director of the Ornamental Department at the Trustees' Academy, 1845.

Christie, Alexander 1901–?
Born Aberdeen and studied at Gray's School of Art and the RA Schools. Painted portraits, interiors and landscapes. He lived in Aberdeen and later at Rothesay.

Christie, Arthur S. 1841–1931
Lived Rothesay. Trained as an architect but developed as a competent watercolourist. Exhibited RSW and RGI; also in Paisley and Gourock. Topographical subjects. Died Lasswade.

Christie, James Elder 1847–1914
NEAC 1887
Born in Fife, he trained at the Art School in Paisley and in South Kensington, winning Gold Medals at the RA in 1876 and 1877. He then moved to Paris 1882–5 and on his return became a founding member of the New English Art Club. In 1893 he returned to Glasgow. Christie was known for his genre and allegorical paintings executed in a broad style and for his pictures of children and scenes from Burns. Returned to London 1906 and was associated with THE GLASGOW BOYS. Died London.

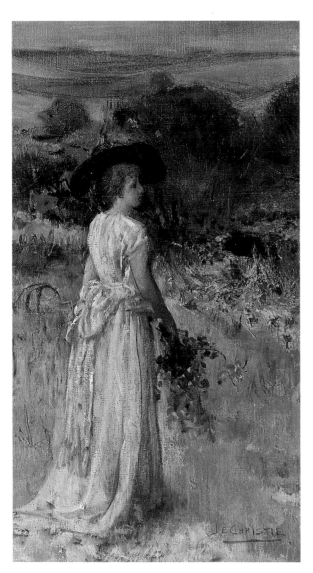

James Elder Christie *Fairest Maid by Devon Banks* oil, private collection

Christie, Jean Lyal (Mrs James Gray) fl.1920s-30s
Watercolourist who married JAMES GRAY and herself painted and exhibited watercolours at the RSA and RSW.

Christie, Robert J. fl.1860s–70s
Lived in Edinburgh and painted landscapes, fishing scenes, birds and interiors.

Chrystal, Arthur fl.1926–41
Perth artist who painted topographical views, architecture and figure studies in watercolour. Worked in Perthshire and in London.

Clark, James fl.1770s
Artist from Inverness recorded as working in Rome and Naples.

Clark, John Heaviside 1771–1863
A topographical artist known as 'Waterloo' Clark from his sketches made of the battlefield in 1815. He painted a number of views of Glasgow before moving to London in 1802 where he produced aquatints, illustrated books and wrote a treatise *Practical Essay on the Art of Colouring and Painting Landscapes* (1807). He returned to Edinburgh where he died.

Clark, Thomas 1820–76
ARSA 1865
Edinburgh landscape artist, he painted mostly Scottish scenes, but as his health failed he spent winters in the south painting English landscapes.

Clark, William 1804–83
Born Greenock, where he lived and worked. Marine subjects. His output of both oils and watercolours

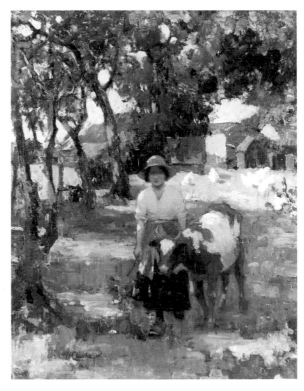

William Hanna Clarke *The Young Cowherd* oil, private collection

John Clerk of Eldin *Haddington* etching, private collection

was large and of a consistently high quality revealing a great knowledge of boats and rigging. Many of his ship pictures were lithographed.

Clarke, Derek b.1912
RP 1950, ARSA 1989
Born in England and studied at the Slade. Worked in the west of Ireland and painted portraits in the 1930s. Joined staff of ECA in 1947. 'Derek Clarke is stimulated by the immediate physical problems of painting watercolours on a large scale and out of doors' (*Scottish Gallery biography*, 1976).

Clarke, William Hanna 1882–1924
Born Glasgow, he settled in Kirkcudbright and became a leading member of the KIRKCUDBRIGHT SCHOOL. His subject matter was mostly landscape and figures painted in a bold manner, yet always showing impeccable draughtmanship. He worked in oil and watercolour, the latter often having a strong charcoal framework. He died young after a stack of doors fell and crushed him at a builder's merchant in Kirkcudbright.

Cleland, Peter fl.1830s–80s
Lived in Edinburgh and, later, Aberdeen where he taught at the School of Art. Painted still-life and dead game.

Clelland, David fl.1930s
Born Larkhall and trained at GSA. Painted landscapes and portraits in rich, glowing colours.

Clennell, Luke 1781–1840
Born near Morpeth, he painted border scenes in watercolour.

Clerk, Alexander fl.1720s–30s
Brother of Sir John Clerk of Penicuik and one of the founders of the ACADEMY OF ST LUKE. Minor portrait painter.

Clerk, Sir George fl. late 18c.
A relation of JOHN CLERK OF ELDIN, he worked as an amateur watercolourist in the late eighteenth century, painting darkly toned wash drawings with dramatic chiaroscuro.

Clerk, John of Eldin 1728–1812
The son of Sir John Clerk of Penicuik, he married Susannah, ROBERT ADAM's younger sister. Between 1747 and 1754 he took part in sketching expeditions with Paul Sandby and ROBERT ADAM, and during the 1760s he sketched the landscape around Edinburgh with ALEXANDER RUNCIMAN and JACOB MORE. He developed from a purely topographical artist towards a painter interested in the changing light effects of the Scottish landscape. He was deeply interested in Scottish architecture and travelled the country drawing castles and abbeys. He also produced geological drawings for his friend Dr James Hutton's *Theory of the Earth*. Also produced a very considerable number of etchings, for which he is best known today. Although an amateur, John Clerk is interesting both as a draughtsman and as an early enthusiast of the Scottish landscape and its architecture.

Clouston, Robert Stewart 1857–1911
Born Orkney, and entered RSA School in 1876. Also studied under Herkomer at Bushey. Genre and portraits as well as highly accomplished mezzotints. *The Daily Graphic* described him as 'one of the finest exponents of the medium'. Exhibited RA and RSA. Died Sydney, Australia.

Clyne, Thora b.1937
Born Caithness and studied ECA. Principal Assistant at Aberdeen Art Gallery, then moved to University of Colorado. Joined staff of ECA 1963.

Cochran, Robert d. 1914
RSW 1910
Amateur artist who was Provost of Paisley. Travelled in Egypt and painted watercolours of that country. Also worked in Holland and Western Isles.

Cochran, William 1711–58
Entered the FOULIS ACADEMY in 1754 and continued his training in the studio of GAVIN HAMILTON in Rome and in Naples in 1763. Painted portraits and history scenes.

Cockburn, Laelia Armine fl.1910–40
RSW 1924

Studied at the Lucy Kemp-Welsh School at Bushey. Painted somewhat sweet oils, watercolours and pastels of animals, particularly foals and ponies, but she also painted some landscapes. Her colours and technique are light and often effective.

Cockburnspath
This small village in Berwickshire was visited by JAMES A. AITKEN in 1882 but it was in the following year that a group of THE GLASGOW BOYS first came upon it. GUTHRIE and E.A. WALTON arrived in May 1883 and were later joined by JOSEPH CRAWHALL. The following year saw ARTHUR MELVILLE GEORGE HENRY, J WHITELAW HAMILTON and T CORSAN MORTON painting there. According to Caw, 'for a few summers in the early eighties nearly every cottage had an artist lodger and easels were to be seen pitched in the gardens or the square, in the fields close by, or near the little harbour in the rocks . . .'.

Guthrie and his mother abandoned their home in Helensburgh to live at Cockburnspath and he produced many of his most important paintings there. The influence of Cockburnspath on all the Boys was significant as they developed their *plein-air* painting techniques. Village workers and children provided subject matter for certain key works like Guthrie's *A Hind's Daughter* and *Field Work in the Lothians*. When Guthrie returned to the west of Scotland in 1886, to take up a career as a Society portrait painter, Cockburnspath's importance declined.

Coia, Emilio b. around 1910
Born Glasgow and trained at GSA to which he was admitted at the age of 15. Well known for his authentic and telling likenesses of notable personalities. Works in pastel, oil and black & white. He has exhibited widely both in London and in Scotland. Also works as an art critic. LLD from Strathclyde University, Fellow of the Royal Society of Edinburgh.

Collins, Hugh d.1896
Dundee portrait painter who painted many Dundee notables. He exhibited at the RSA, often showing scenes from military history.

Collins, Peter G. b.1935
ARSA 1965, RSA 1974

Born Inverness and studied at ECA 1952–6. Awarded travelling scholarship and was in Italy 1957–8. Joined staff at Duncan of Jordanstone College of Art. Influenced by JOHN MAXWELL, some of his themes have been 'abstruse and audacious' (Edward Gage, *The Eye in the Wind*, 1977).

Colone, Adam de fl.1620–28
The son of ADRIAN VANSON, he was born in Scotland where he painted portraits in the early 17th century. His patrons included Lord Winton who admired his continental style. He greatly influenced GEORGE JAMESONE.

The Colourists
Although the generic term 'The Colourists' is so often applied to the work of S J PEPLOE, LESLIE HUNTER and F C B CADELL, with J D FERGUSSON usually also included, these artists did not all work in the same place and at the same time together and as such only comprise a group in terms of certain distinctive stylistic similarities. The term came into general usage following the publication of T J Honeyman's book *Three Scottish Colourists* in 1950 and, then, Honeyman did not include the work of Fergusson: 'Unlike the others, he made his home more or less permanently in Paris returning home in 1939'.

The common factors which have led to art history grouping these artists together might be summarised as a common predilection for bright and vibrant colours derived from their exposure to the brilliant light of the south of France, the practical influence of French painting generally just after the turn of the century and the more ethereal and spiritually exciting exposure to the life of Paris before and after the First War. The work of the four should be considered against the background of the Bohemian cafe life of the Montparnasse, the van Gogh and Cezanne retrospectives of 1901 and 1907, the Whistler memorial exhibition of 1905 and the potent influence (on Peploe and Fergusson at least) of the performances of Diaghilev and the Ballets Russes in 1909.

Whilst they worked as individuals (Peploe and Fergusson did work together at Cassis, Paris Plage and at Royan in 1910; also on Iona), their careers were all encouraged by the Scottish dealers Aitken Dott and Alexander Reid and in 1923 a joint exhibition was held at The Leicester Galleries in London. In 1924 there was a Paris exhibition at the Galerie Barbazanges and another in 1931 at the Galeries Georges Petit; on this last occasion the group was supplemented by R O DUNLOP and GEORGE TELFER BEAR. Their work featured in the Exhibition of Scottish Art at Burlington House in 1934: there were 21 Peploes, eight Cadells and five Hunters. Critical comment at that time was not encouraging and their work was not particularly popular: 'Peploe in particular was an excellent painter, but there is a feeling that these recent Scottish artists did not know quite what to do about colour as between its constructive and its decorative function'.

During the 1980s the work of the Colourists has undergone a quite extraordinary re-evaluation. Their *oeuvre* is now firmly located on the international map and represents a body of work increasingly attractive to collectors at home and abroad. They must be considered as having had a seminal influence on the development of Scottish art in the twentieth century.

Colquhoun, Robert 1914–62
Born Kilmarnock, he studied at GSA where he met ROBERT MACBRYDE who became his lifelong friend. HUGH ADAM CRAWFORD and IAN FLEMING were his principal tutors, but he also came into contact with

Robert Colquhoun *Self-portrait* oil, Scottish National
Portrait Gallery

JAMES COWIE at HOSPITALFIELD where HENDERSON
BLYTH and JOHN LAURIE were fellow students. In
1937–9 Colquhoun and MacBryde visited France
and Italy and in 1940–1 he served as an ambulance
driver before being invalided out of the Army.

In 1941 Colquhoun and MacBryde moved to
London where they shared a studio in Bedford
Gardens with John Minton and Jankel Adler, who
moved in in 1943. Adler encouraged Colquhoun to
forget landscape and concentrate on figures which
he treated in an angular manner. His first one-man
show was held at the Lefevre Gallery in 1943
and during the later 1940s Colquhoun painted
many of his most moving works. Keith Vaughan
and Michael Ayrton also had an influence upon
Colquhoun's work in London.

In 1947 Colquhoun and MacBryde were evicted
from their studio for their rowdy behaviour and
moved to Lewes, Sussex, where they made litho-
graphs and drawings for Miller's Press. A visit to
Italy in 1949 resulted in a further show in London,
but the paintings were badly received. Between
1949 and 1954 MacBryde and Colquhoun lived
in Dunmow, Essex, and Colquhoun concentrated
on animal painting; he sold little and money was
short. Together they designed costumes and sets for
the ballet *Donald of the Burthens*, choreographed by
Léonide Massine at Covent Garden in 1951 and
Colquhoun also designed for the 1953 *King Lear*
at Stratford. He also produced a large canvas for
the Arts Council Festival of Britain exhibition *Sixty
Paintings for '51*.

In 1958 a major retrospective exhibition of Colqu-
houn's work was staged at the Whitechapel but he
died of heart disease in London four years later.
Colquhoun's best work is powerful and tragic
implying loneliness and desolation.

Condie, R. Hardie 1898–1981
Born Kirkcaldy, he studied at ECA where he
was a contemporary of GILLIES, MOODIE and
SUTHERLAND, and later taught at Brechin High
School from 1928 until his retirement in 1963. He
painted landscapes in oil and watercolour.

Congreve, Frances Dora 1869–?
SSA 1909
Lived at Nairn, a painter of landscapes and marine
scenes, often with sailing yachts. She studied art in
Rome, Naples and Edinburgh. She worked both in
oil and watercolour.

Connon, William John b.1929
Born Turriff, he studied at Gray's School of Art,
Aberdeen, under HENDERSON BLYTH and IAN
FLEMING.

Constable, James Lawson 1890–?
Born Hamilton, he studied at GSA. He painted
portraits and landscapes in oil.

Constable, Jane Bennett b. 1865
Born Perthshire, she studied art in London under
Frank Calderon, and Walter Donne. She painted
scenes of rural genre with figures working the land.
Lived in Blairgowrie, Perthshire.

Cook, James B. fl.1917–40
Glasgow landscape and coastal artist who worked
in watercolours. His *Cullen Harbour* was admired by
The Studio at the RSA in 1921.

Cooke, Thomas Etherington fl.1860s–90s
Edinburgh painter of Scottish buildings and land-
scape, mostly coastal and river scenes, in oil and
watercolour.

Cooper, Richard, Senior d.1764
Born in England and moved to Edinburgh. Worked
as an engraver and joined the ACADEMY OF ST
LUKE in 1729, acting as Treasurer. Established the
Winter Academy in 1735. Students worked from
his engravings of Old Masters.

Cooper, Richard, Junior ca. 1740–1814
Son of RICHARD COOPER, SENIOR, he worked as an
engraver, interior designer and decorative painter.

Copland, John 1854–1929
Lived in Dundrennan, Kirkcudbrightshire, where
he worked as a photographer and painter. Painted in
a naive but attractive style. Was a friend of WILLIAM
MOUNCEY.

Cordiner, Charles 1746–94
Studied at the Foulis Academy in Glasgow 1763–6
before becoming Episcopal minister in Banff. While
in Glasgow he made drawings of local views includ-
ing Bothwell and Crookston Castles, which were
engraved by ROBERT PAUL, a fellow student at the
FOULIS ACADEMY. Together they went on sketching
expeditions to the Glasgow countryside.

Charles Cordiner *The Bridge of Alvah, Banffshire, 1774* gouache, Paul Harris Esq

In Banff, Cordiner established a considerable reputation as an artist and received commissions to paint local views in oil and watercolour.

His painting of *Bridge of Alvah* shows the grounds of Duff House and was commissioned by the Earl of Fife. 'Cordiner's pretty gouache admirably catches its contrived naturalism in a scene where Lord Fife's coach and six crosses the Alvah bridge with on one side a Gothic tower and on the other a small grotto and garden. Lord Fife hung this picture above the library fireplace at Rothiemay, another of his houses.' (A. A. Tait *The Landscape Garden in Scotland*, 1980).

In 1769 he made a sketching tour of Northern Scotland which resulted in his *Antiquities and Scenery of the North of Scotland* (1780) His interest in Celtic remains is revealed in his book *Remarkable Ruins and Romantic Prospects of North Britain* published after his death in 1795

Cornock-Taylor, Anne b.1916
Studied at the Margaret Morris School in London in 1933, moving to Glasgow in 1936. Around 1950 she helped establish the Margaret Morris Movement School in London. During the 1940s her painting style involved thick impasto, strong colours and dynamic forms.

Corrudes, James fl.1671–3
Portrait painter recorded as living in the Canongate, Edinburgh. Painted the Duchess of Lauderdale and Sir William Bruce.

Couling, Arthur Vivian 1890–?
Born Shantung, China, he studied at ECA. Lived in Edinburgh and produced landscapes and marines in oil as well as etchings. Often worked in France. Taught art at the Royal High School, Edinburgh.

Coventry, Gertrude Mary (Mrs Edward Robertson) 1885–1964
The daughter of R M COVENTRY, she was born Glasgow and studied at GSA 1902–1911. Often painted with her father in Holland, Belgium and at Pittenweem where she met her husband; married in 1915. From 1921–34 her husband was Professor of Semitic Languages at Bangor, North Wales. In 1934 they moved to Didsbury near Manchester and Coventry painted a number of portraits including

Robert McGown Coventry *Kirkcaldy* watercolour, Julian Halsby Esq

the Chief Rabbi of Manchester. In 1962 they went to Canada where she died.

Coventry, Robert McGown 1855–1942
RSW 1889, ARSA 1906
Attended evening classes at GSA under ROBERT GREENLEES before studying in Paris. He was closely associated with artistic life in Glasgow. He painted Scottish fishing villages, both east and west coasts, in oil and watercolour, his watercolours being influenced by the 'blottesque' technique of the Glasgow School. He also painted in Belgium and Holland where his oils were influenced by the work of Mesdag and Maris. During the 1890s he visited the Middle East. Died Glasgow.

R. M. G. Coventry.

Cowan, Mrs Jean Mildred Hunter 1882–1967
SSA 1945, PSSWA 1951–8
Painter in oil and watercolour and portrait sculptures. She was a many-sided talent: amateur violinist, first woman to fly (in 1911), winner of the golf championships of India 1924 and double tennis champion of Malaya 1924.

Cowan-Douglas, Lilian Horsburgh 1894–?
Born on Mull, trained ECA. Painted flower pieces in watercolour.

Cowan, William fl.1830s
Landscape painter in watercolour.

Cowie, James 1886–1956
ARSA 1936, RSA 1943

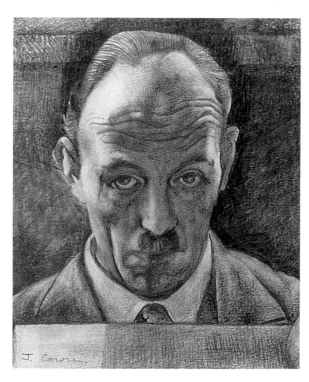

James Cowie *Self-portrait* pencil, The Scottish Arts Club

Born on a farm in Aberdeenshire, Cowie progressed from local school to become art master at Fraserburgh Academy in 1909 before enrolling at GSA in 1912. After graduating, taught for 20 years at Bellshill Academy near Glasgow and it was here that during the 1930s he painted haunting portraits of his pupils such as *Two Girls*. He made careful preparatory sketches in pencil or watercolour for these oil portraits.

Cowie was interested in the technique of painting, studying the methods of the Quattrocento artists as well as later innovators like Degas. He experimented with many media – oil, watercolour, pastel and gouache – sometimes combining all in one work. He had an extraordinary ability to draw, grasping the essentials of a portrait or a landscape, and some of his portraits represent an aspect of British art rarely found in Scotland – a kind of *Neue Sachlichkeit* imbued with visionary qualities. At other times he moves towards a Surrealist approach, especially in his still-lives which combine objects with art historical references. He has favourite objects – Tangara figurines, windows within windows, reflections. The visionary quality of his landscapes reflects his interest in the work of Paul Nash. He disliked the free Expressionism of GILLIES and his followers, preferring a constructive, literary approach.

After a short period as Head of Painting at Gray's School of Art, Aberdeen, he moved to HOSPITALFIELD at Arbroath where he painted and taught in the summer months. As a teacher he influenced a whole generation including HENDERSON BLYTH, COLQUHOUN, MACBRYDE and EARDLEY.

Cowieson, Agnes M. fl.1880–1940
Painted attractive oils and watercolours of figures on beaches and in interiors. In the 1890s she travelled to South Africa, Malaya and Java. She often painted Portobello Sands, near Edinburgh.

Cowper, Max 1860–1911
Born Dundee, worked as an illustrator for the *Dundee Courier*. He later moved to London to join the staff of the *Illustrated London News*. He painted market scenes and figures in oil and watercolour.

Crabbe, William 1811–76
Lived in Montrose. Portrait painter said by Robert Brydall to have painted numerous portraits very similar in style and sometimes almost equal in quality, to those of RAEBURN. He also painted religious subjects, and appears to have settled in London c.1857. Member of WSA.

Craig, Ailsa 1895–1967
Born Dumfries she studied at GSA 1912–18. Specialized in lettering and illumination, joining the GSA staff 1931–4. She published *Design and Spacing of Lettering* (1948).

Craig, John fl. early 19c
Early nineteenth-century Edinburgh artist who painted landscapes in oil and watercolour. Painted many views of east coast fishing villages and marine subjects, mostly in watercolour.

The Craigmill School

JOSEPH DENOVAN ADAM (1842–1896) lived in Craigmill House near Stirling from 1887 until his death. He ran an art school in his studio which was situated in a park across the road from the house. Adam was an important animal painter and this was the main subject taught at the school. He kept a small herd of Highland cattle which provided models, and he also had sheep, poultry and dogs, all of which were used in the teaching. The studio itself had a 60 by 30 foot glass side which enabled classes to continue in bad weather.

During the summer months as many as 25 students could be found at work in Craigmill, and in addition Adam welcomed established artists, notably WILLIAM KENNEDY whose love of horse painting developed here. It is possible that Kennedy brought JOSEPH CRAWHALL to Craigmill. Other artists stayed as tutors, including JOHN LOCHHEAD and JOHN ROBERTS, while T A BROWN painted *A Gipsy Encampment* while staying at Craigmill. Other artists who were regular visitors include JOHN MACWHIRTER, JOHN SMART and Adam's son JOSEPH DENOVAN ADAM JUNIOR who often helped his father on the farm and in the studio.

Craig-Wallace, Robert 1886–1969

Born Glasgow. His views of shipping and yachting on the Clyde have sparkle and capture the flavour of the inter-war years. He was a keen yachtsman, often painting on the family yacht the *Calmara*, and demonstrated a remarkable facility with the subject matter which was his own hobby. Painted in oil and watercolour and etched. Although he produced only some 34 etchings, during the late 1920s and early '30s, these show him to have been in close touch with developments in British art: in some we see the influence of Briscoe whilst others, like *Bathing Belles*, are reminiscent of the Newlyn School. Died Glasgow.

Cranstoun, James Hall 1821–1907

Born Perth, studied at the Slade before returning to Perth. Painted Perthshire landscapes in both oil and watercolour in a careful, yet not over-worked style. His work is similar to that of THOMAS FAIRBAIRN.

Crawford, Edmund Thornton 1806-85

ARSA 1839, RSA 1848
Born Cowden near Dalkeith, he trained at the Trustees' Academy, becoming a close friend of WILLIAM SIMSON. He visited Holland in 1831, the first of several visits, and his style was influenced by the Van de Veldes and Hobbema. He painted Scottish fishing villages, rivers and landscapes in both oil and watercolour and his restrained colours and northern skies have a close affinity to the Dutch School. Died Lasswade.

ЄΤL Є.Ж

Crawford, Hugh Adam 1898–1982

ARSA 1938, RSA 1958
Born Busby, Lanarkshire, and studied at GSA 1919–23

under GREIFFENHAGEN and DAVID FORRESTER WILSON. He then moved to London, studying part-time at St Martin's and the Central School. He returned to Glasgow in 1925, joining the staff of GSA, where his pupils included COLQUHOUN and MACBRYDE. In 1934 he married the artist KATHLEEN MANN, Head of Embroidery at GSA. During the 1930s he painted strong portraits of his wife and friends and executed murals for the Roman Catholic chapel at Bellahouston. He was Head of Painting at Glasgow until 1948 when he moved to Gray's School of Art as Head (1948–54) and was Principal of Duncan of Jordanstone College of Art, Dundee 1954–64. Crawford's work had a strong sense of social realism combined with an interest in the fresco painters of the 15th century.

Crawford, Robert Cree 1842–1924

RSW 1878
Born Govanbank, studied at Glasgow University before moving to Canada. He later returned to Scotland and made a local reputation for his portraits in oil. Also painted watercolours of landscapes and marine scenes. Signs with initials.

Crawford, Susan Fletcher d.1919

ARE 1893
Glasgow etcher mostly of topographical subjects and landscapes. She studied at GSA 1881–1888, joining the staff 1894–1914. Exhibited RA, RSA.

Crawford, Thomas Hamilton fl.1880–1933

RSW 1887

Robert Craig-Wallace *Bathing Belles* etching 1926, private collection

Hugh Adam Crawford *Homage to Clydeside* oil, The Royal College of Physicians and Surgeons, Glasgow

Architectural painter in watercolour and draughtsman. Painted church interiors and façades in Britain and France and did illustrations of Edinburgh for R.L. Stevenson's *Picturesque Notes*. Moved to London in 1893, and later lived in Hertfordshire.

Crawford, William 1811–69
ARSA 1860
Born Ayr, he specialized in drawings in crayon. Member of *The Smashers* he produced wash drawings for the club, along with the Faeds.

Crawford, William Caldwell 1879–1960
Born Dalkeith and attended RSA Schools, where he came under the influence of ROBERT BURNS, who taught the life class, EDWIN ALEXANDER and FCB CADELL. All became life-long friends. After further training in Paris he returned to Scotland and painted on the west coast where he was particularly fond of Mull and Iona: it is said he introduced PEPLOE and CADELL to Iona. Settled in East Linton after the war, for a while shared a studio in Ainslie Place with Cadell and became a regular exhibitor at the RSA and SSA (President 1928). Seascapes and landscapes. Prominent member of the SCOTTISH ARTS CLUB. President of the SSA 1928; declined an associateship of the RSA.

Crawhall, Joseph 1861–1913
RSW 1887, resigned 1893
Born to a wealthy family in Morpeth, Crawhall was able to devote his life to his two passions: hunting on horseback and painting. His father was a cultivated man and an amateur artist, and he encouraged his son to draw. His father's friend, the cartoonist Charles Keene, gave Crawhall some lessons, and following the marriage of his sister to the architect brother of E.A. WALTON, Crawhall moved to Glasgow to continue his studies.
In 1879 GUTHRIE, Walton and Crawhall worked together at Rosneath and Brig O'Turk, repeating

the exercise in 1881 joined by SAM FULTON and HARRY SPENCE, and in 1882 Crawhall, Guthrie and Walton visited Crowland in Lincolnshire. Up to this point, Crawhall had been working in oil, but after a period in Paris in 1882, he returned to work in watercolour. In 1882 and 1823 Crawhall worked with the GLASGOW BOYS at Cockburnspath and in 1884 he visited Morocco for the first time to stay with LAVERY. Crawhall was thus closely involved in the early years of the Glasgow School.
Crawhall was an unorthodox artist: he would work in short bursts following long periods of inactivity and he rarely worked from nature, relying upon his extraordinary visual memory. He avoided the 'art world' and had neither need nor desire to sell his work.

William Crawford *A Family Group* oil, private collection

Joseph Crawhall *The White Drake* gouache, private collection

Crawhall's watercolours fall into several different 'types'. There is a group of 'wet' watercolours painted on paper dating from the mid-1880s. During the 1890s he looked toward the Aesthetic Movement and the Japanese influence, producing dashing studies of birds and animals often painted on holland, a thin linen. His sister, who watched him at work, recalled that he experimented with materials and washes to create the exact effects he desired. Thus his apparently effortless watercolours were the result of great experience.

Crawhall's subject matter is wider than that of his friend and contemporary EDWIN ALEXANDER. Not only did he paint birds, but all sorts of animals in natural and man-made surroundings. He also recorded everyday life, balancing observation with carefully planned composition. He was in addition a witty and dashing cartoonist and his pen-and-ink sketches are amongst the most fluent, economical and effective in British art of the period. He also worked well in pastels.

Crawhall was most at home in the country and although he was greatly admired by Whistler and his circle, he was rarely to be seen in the Chelsea studios. Whistler described him as 'going about with a straw in his teeth'. Thus a real feeling for nature and a deep understanding of animals, combined with an extraordinary talent, turned Crawhall into one of the greatest draughtsmen of his generation.

Crawshaw, Lionel Townshend 1864–1949
RSW 1923
Born Doncaster, he studied law before taking up painting. Studied in Germany and Paris, settled in Edinburgh. Painted a wide variety of subjects, including views of towns with figures, and flowers. His second wife, Frances Crawshaw, also painted flowers.

Cribbes, George Oswald 1903–1967
Studied at ECA under ADAM BRUCE THOMSON and lived and worked in Edinburgh. Also painted in Belgium, Holland and France. Painted interiors, townscapes and river scenes and executed a stylish series of etchings during the 1920s and 30s; turned to abstract work later in life. Founded the Albyn Press in Edinburgh.

Crombie, Benjamin W. 1803–47
Born Edinburgh and best known for his published collection of portraits *Modern Athenians*. His drawings and engravings were popular; his first print was published in 1825. Also a miniaturist. Exhibited RSA.

Crombie, William fl.1860s
Lived in Dalkeith and painted Scottish landscape.

Crosbie, William b.1915
Born Hankow, China, of Scottish parents, his family returned to Glasgow in 1926 and in 1932 he entered GSA. In 1935 he was awarded a travelling scholarship and spent a year in Paris studying with Fernard Léger and Aristide Maillol. After Paris he travelled in Greece, Turkey and Egypt returning to Scotland on the outbreak of war. His work during the 1930s was strongly influenced by Léger and the French Surrealists, but during the 1940s and 50s he made a reputation as a mural painter on a large scale. He divides his time between Hampshire and Glasgow.

Crozier, William 1893–1930
ARSA 1930
An important figure in the development of the Edinburgh School despite his early death. He studied at

George O Cribbes *Stonehaven* etching 1932, Alan W Cope Esq

William Crosbie *Odalisk* watercolour, private collection

William Crozier *At the Crooked Bridge* oil 1988, The Scottish Gallery

Cruickshank, Francis 1825–?
Portrait painter who attended the Trustees' Academy 1845–52. Portrait of Lord Palmerston in NPG, London.

Cumming, Miss C.F. Gordon fl.1860s–'80s
Painter of landscapes, seascapes and riverscapes.

Cumming, James b.1922
ARSA 1962, RSW 1962, RSA 1970, Treasurer RSA 1973–8, Secretary from 1978
Born Dunfermline and studied at ECA before and after the War. Awarded a travelling scholarship and spent just over a year at Callanish on the Isle of Lewis. Joined the staff at ECA in 1950 and became a senior lecturer. He is noted for his still-life compositions, which are freely balanced between abstraction and figuration and which frequently seem to hark back to the figurative and Celtic influences of Callanish and its standing stones.

Cumming, William Skeoch 1864–1929
Born Edinburgh, studied ECA and RSA Schools. A painter of military subjects, mostly in watercolour.

ECA and his knowledge of Italy and France, and of their language, was important for many of his contemporaries. In 1923 he visited Paris to study with André Lhote along with GILLIES and GEISSLER, but, unlike Gillies, he admired Lhote's work, and the influence of decorative Cubism can be seen in Crozier's watercolours of the later 1920s. Crozier's watercolours have a stylish sense of construction, suggesting that he was seeking abstract pictorial qualities within a figurative framework. During the late 1920s he shared a studio with WILLIAM MACTAGGART and together they visited France, where they stayed at St. Raphael, Italy and the Netherlands. Crozier, who was a haemophiliac, fell in his studio and died of internal bleeding aged 37.

Crozier, William b.1930
Born Yoker on the Clyde he studied at GSA 1949–53 before working for two years as a theatre designer. He has taught at Bath Academy of Art and the Central School of Art, London, and was Head of Fine Art at Winchester until 1987. From the 1950s to around 1980 he worked within an abstract idiom loosely based on landscape motifs, but during the 1980s he has moved towards more easily recognisable depictions of landscape. Between 1955 and 1965, he spent prolonged periods in Dublin, Paris and Malaga. Now divides his time between studios in Winchester and Ireland.

William Crozier *Vineyards, South of France* oil ca. 1928, Lyn Newton

42

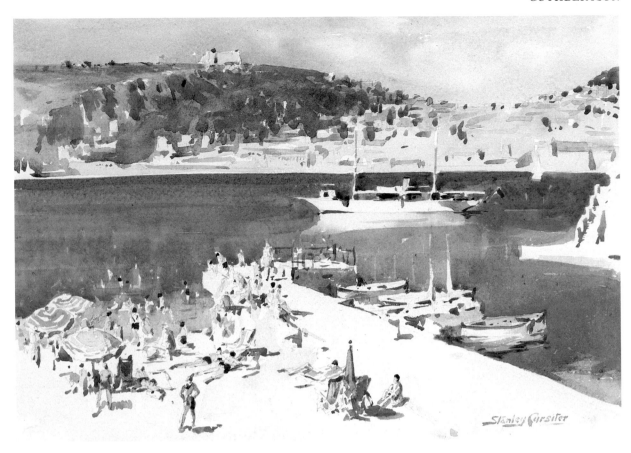

Stanley Cursiter *Villefranche* watercolour c. 1920, The Robertson Collection, Orkney

He served in the Boer War, and made watercolours of incidents during the campaign. He also painted portraits in watercolour. His wife, Belle Skeoch Cumming, born 1888, also worked in watercolour.

Cunningham, John b.1926
Born in Lanarkshire and studied at GSA, later becoming a lecturer there. Has exhibited widely including RSA and RGI. Works in many public and private collections. Particularly effective still-life.

Curdie, John fl.1850s–60s
Lived in Kilmarnock and painted landscapes, particularly of Ayrshire. Exhibited RSA.

Cursiter, Stanley 1887–1976
RSW 1914, ARSA 1927, RSA 1937, Director NGS 1930–48, King's Painter and Limner in Scotland 1948, Secretary RSA 1953–5, PRSW 1951–2
Born Kirkwall, Orkney, he studied at ECA. He was inspired by the 1912 Futurist Exhibition in London and proceeded to paint a series of oils and watercolours based on Futurist conceptions, the most famous being *The Sensation of Crossing the Street - the West End, Edinburgh* (1913).
Cursiter served during the First World War. In 1920 he spent six months at Cassis and Avignon and painted the landscape and architecture of southern France, mostly in an elegant and fluent watercolour technique with vibrant colours that have a marked affinity with the Colourists. He was also noted for his elegant oil portraits and studies of girls in interiors. Wrote *Peploe* (1947) and *Scottish Art* (1949). He also painted lively watercolours of East Lothian, Shetland and Orkney where he lived for many years.

Cuthbertson, Kenneth J. fl.1920–40
Edinburgh artist who painted landscapes in watercolour between the wars. he often painted abroad, especially in Italy.

43

D

Dakers, Robert Alexander fl.1913–24
Often worked in Galloway painting local scenes and landscapes.

Dalglish, William 1857–1909
Born Glasgow, studied under A.D. ROBERTSON, a local art teacher with a studio in Dundas Street, and at GSA. He painted marine subjects, often in watercolour, in a style similiar to that of J.D. TAYLOR, his contemporary in Glasgow.

Dalkeith, Thomas Alison fl.1880s
Painted west coast landscapes and coastal scenes. Exhibited RSA.

Dallas, Alastair fl.1920–40
Watercolourist who painted landscapes of Galloway. Lived for many years in Kirkcudbright.

Dallas, E.W. fl.1840s–50s
Painted church interiors, often in Italy. Exhibited RSA.

Dalyell, Amy (Mrs J Birrell) d.1962
RSW 1883
Edinburgh artist who exhibited at the RSA and RSW, painting landscapes, often with figures.

Dalziel, Robert 1810–42
Son of Alexander Dalziel, he studied in Edinburgh under JOHN THOMSON OF DUDDINGSTON and later settled in London.

Daniel, Henry Wilkinson fl.1909–36
Studied Slade School and taught art at Trinity College, Glenalmond. Was a governor of HOSPITAL-FIELD. Painted Scottish landscape, particularly on Arran, and also worked in Cornwall and the Lake District. Used watercolours and etched.

Davidson, Alexander 1838–87
RSW 1883
Painter of historical subjects and genre, similar in style to his friend DUNCAN MACKELLAR. Often depicted scenes from the life of Prince Charles Stuart, but also painted old buildings. His watercolours are often large, and somewhat over-worked.

Davidson, Bessie 1880–1965
Born Adelaide, Australia, a descendant of DAVID SCOTT. Educated Munich and then Paris where she settled with a studio in the Rue Boissonade, Montparnasse. A frequent visitor to Scotland where she painted regularly in the Edinburgh and Perth areas (where her cousins lived). Interiors, landscapes and flower studies.

Davidson, Charles Lamb 1897–1948
Born Brechin, Forfarshire, he studied at GSA. He was a cartoonist working for the *Evening Times*, interior decorator and stained glass designer. He worked with his wife J. NINA MILLER on stained glass designs for Loretto Church, Musselburgh.

Davidson, David Pender 1885–1933
Born Camelon near Falkirk, he studied at GSA, also in Brussels and Munich. Painted portraits, landscapes and still life in oil.

Davidson, George Dutch 1879–1901
Born Yorkshire, the son of a marine engineer from Dundee, he was educated in Dundee and intended to follow his father's profession. A bad attack of influenza forced him to abandon engineering and he turned towards art, enrolling at art classes in Dundee High School in 1897. JOHN DUNCAN was an important influence on his career at this stage. Between 1898 and 1899 Davidson shared a studio with Duncan and came to appreciate the growing interest in Celtic decoration as reflected in the illustrations for *The Evergreen*. Duncan admired Davidson's ability to learn, especially his interest in all periods of decoration.
In 1898–9 Davidson produced a series of decorative watercolours based on Celtic patterns, their strong colours and abstract shapes looking forward to art deco.
In September 1899 Davidson left Dundee with his mother to visit London, Holland, France and Italy. *The Hills of Dream* dates from this period, illustrating a Celtic Revival poem and showing Davidson's sensitive draughtsmanship, as well as his ability to organize a complex pattern. It also shows his interest in the Italian Quattrocento which was reinforced by his visit to Florence and Venice. Davidson returned to Scotland in August 1900 but his early death in the following year removed one of the most fascinating of the Scottish Symbolists. Died Dundee.

Davidson, Jessie fl.1890s
Lived and worked in Edinburgh and Holland. Painted landscapes and exhibited SSA.

George 'Dutch' Davidson *The Tavern Door* pen & ink, Dundee Art Galleries & Museums

Davidson, John fl.1860s–70s
Painted landscapes and some portraits. Exhibited RSA.

Davidson, Mary C. d.1950
RSW 1936
Edinburgh artist who worked mostly in watercolour, painting landscapes in Scotland and France, and many flower pieces. Her work is competent with light colours but occasionally weak in drawing. Painted some Indian landscapes.

Davidson, Majel (née Margaret Elizabeth Davidson) 1885–1969
Born Aberdeen and studied at Gray's School of Art, graduating 1907. Studied under Guerin in Paris 1908–9 and came under the same sort of influences as were being experienced by THE COLOURISTS around that time. Settled for a time in Toronto in the 1920s, meeting members of The Group of Seven. Before and after the Second War, she became interested in pottery and a kiln was built for her at the family home at Cults, near Aberdeen. In the 1950s she settled with other women friends at Powis House near Stirling – they became known as 'the Powis Family' – and she returned to painting.

Davie, Alan b.1920
Born Grangemouth, Stirlingshire, into an artistic family. Entered ECA in 1937 studying under JOHN MAXWELL, working in textile design, pottery and jewellery as well as painting. He served in the Royal Artillery 1940–6 and during this time painted, wrote poetry and played jazz.
In 1947 he was awarded an ECA Travelling Scholarship and made an extensive trip through Europe. While in Venice, Peggy Guggenheim introduced him to the work of the American abstract expressionists, and this influence can be seen in his paintings of the 1950s. He settled in London in 1948 and held the first of many one-man shows at Gimpel Fils Gallery in 1950.
During the 1950s he became interested in Zen Buddhism and oriental mysticism, and he uses an elaborate system of symbols in his painting, more recently looking towards Indian mythology.
He divides his time between Hertfordshire, Cornwall and St Lucia in the Caribbean.

Davies, William fl.1890–1910
Painter of landscape with sheep and cattle, often in Argyllshire. He worked in oil, creating interesting atmospheric effects.

Davison, Jeremiah c.1695–1745
Born London of Scottish parents. Moved to Scotland in 1736 with the encouragement of the Duke of Atholl, whose family became longstanding patrons. Painted many portraits of the Murrays, their kinsmen and other landed families, particularly in Perthshire. The outstanding large group portrait of the Earl of Morton and his family was painted in 1740. Died London.

Dawson, Mabel 1887–1965
RSW 1917
Born Edinburgh, studied ECA under ROBERT MCGREGOR and WILLIAM WALLS, who taught her to paint animals and birds, for which she became known. She also painted historical scenes, east coast fishing villages, interiors and flowers. Her style is fluent and wet, not unlike that of EMILY PATERSON. She was also noted for embroidery.

Dean, Stansmore (Mrs R Macaulay Stevenson) 1886–1944
Born Castle Douglas, the daughter of Alexander Davidson Dean, artist engraver of the Glasgow firm Gilmour and Dean, she studied at GSA and in Paris. In 1902 she became the second wife of R MACAULAY STEVENSON and had a studio in their house at Bardowie. They lived in France 1910–26 at Montreuil-sur-Mer and from 1932 in Kirkcudbright. Primarily a portrait painter.

Deas, William 1876–?
A pupil of William Proudfoot in Perth, he was an amateur artist until 1923 when he devoted his career to art. Lived in Forgandenny, Perthshire and painted the Perthshire landscape in fresh water-colour style.

Dekkert, Eugene fl.1900–40
Probably from a Dutch family, he worked in Glasgow and later in St Monance, painting coastal views in a wet watercolour style, influenced by the Dutch School.

Delacour, William d.1767
Born outwith Scotland and recorded working as a portrait painter and theatre designer in London during the 1740s. Moved to Edinburgh around 1757. Painted portraits, worked in theatres in Glasgow and Edinburgh and also painted land-scapes in watercolour and oil. Became the first Master of THE TRUSTEES' ACADEMY in 1760. Died Edinburgh.

Demarco, Richard b.1930
RSW 1969, OBE 1985

Jeremiah Davison *James Douglas, 13th Earl of Morton and his family* oil, Scottish National Portrait Gallery

46

Born Edinburgh and studied at ECA 1949–53. Primarily known as an Edinburgh based international art entrepreneur who has been responsible for the presentation of much that is radical and innovative, he also works himself as a painter in a more traditional vein. Most of his output is topographical in nature, executed in watercolour or pen and ink. Local views in the collection of the City of Edinburgh Art Centre.

Dennistoun, William 1838–84
Trained as an architect, painted architecture in watercolour. First President and founder of the Glasgow Art Club 1867–68, he later moved to Italy and died in Venice. His earlier works are views of Glasgow, while his later watercolours depict Italian buildings and landscapes. His style is somewhat staid.

Denune, William c.1712–50
Signed the charter of the ACADEMY OF ST LUKE in 1729. First recorded portrait, of the Rev. Archibald Gibson, painted in 1735. Painted in Edinburgh and Dumfries with flourishing practices in both places. Patronised by the Duke of Hamilton. Died Dumfries.

Des Granges, David 1611–72
Born in the Channel Islands and painted in oil as well as working as an engraver and miniaturist. Came to Scotland with Charles II in 1650 and in 1651, and was appointed His Majesty's Limner.

Devlin, May (Mrs Alex Dale) fl.1922–36
Born Dumbarton and studied at GSA. She painted landscapes and coastal scenes mostly in watercolour. Exhibited RGI.

Dewar, De Courcy Lewthwaite 1878–1959
Born Kandy, studied GSA and Central School, London. On staff of GSA 1898–1928. Enameller, metal-worker and black and white artist. Author of *The History of the Glasgow Society of Lady Artists' Club* (1950).

Dewar, John Stewart fl.1940s
Glasgow painter of genre, domestic scenes and portraits.

Dick, Jessie Alexander 1896–1976
ARSA 1960
Born Largs and studied at GSA 1915–19. Later joined the staff 1921–59. An active member of the Ladies' Art Club and painted in Glasgow and Arran. Signed her work J. Alix Dick.

Dickson, Thomas Elder b.1899
Studied GSA under GREIFFENHAGEN, later lectured on History of Art at ECA. Painted Scottish landscapes in oil and watercolour.

Dinkel, Ernest Michael b.1894
RWS, ARCA
Born Huddersfield. Formerly Head of Design at ECA and an acknowledged expert on the wall paintings of Canterbury Cathedral. Landscape and biblical subjects in oil, watercolour and tempera.

Dixon, Anna d.1959
RSW 1917
Edinburgh artist, trained RSA Schools under WALTON and WALLS. Painted effective watercolours in a fluent style, depicting the landscape and crofts of Western Scotland and the isles. Also painted domestic animals, donkeys and horses, sometimes with children.

Dixon, Arthur Percy fl.1884–1917
Lived in Edinburgh and exhibited SSA. Painted figures and landscapes with figures.

Dobson, Cowan 1894–1980
RBA 1922
Born Bradford, studied ECA. Lived in Glasgow and London painting portraits in oil; also watercolour studies of heads.

Dobson, Henry John 1858–1929
RSW 1890
Born Innerleithen, studied ECA. Apart from a visit to America in 1911, he lived and worked in Edinburgh and Kirkcudbright, painting and illustrating genre and Scottish interiors. His energetically worked watercolours are luminous and successful. Exhibited with A K BROWN at the Scottish Gallery, 1900. His two sons, COWAN DOBSON and H R DOBSON, both painted.

Dobson, Henry Raeburn b.1901
Studied ECA and turned, like his brother, to portraiture. Some of his watercolours of old Scottish characters are not unlike those of HENRY WRIGHT KERR.

Docharty, Alexander Brownlie 1862–1940
Nephew of JAMES DOCHARTY, a landscape painter who worked in oil, he studied part-time at GSA under ROBERT GREENLEES, and after a period designing calico, he took up painting as a profession in 1882. Studied in Paris in 1894. Lived and worked in Kilkerran, Ayrshire, but also painted the Highlands and European countries, visiting Venice on several occasions. Worked mostly in oil, but his watercolours can be fine with good composition and sensitive colour. Died Glasgow.

Docharty, James 1829–78
ARSA 1878
Born in the Vale of Leven near Glasgow he worked for many years as a calico designer before turning to painting c.1862. He was influenced by the Glasgow landscape painter MILNE DONALD, who himself was influenced by the Dutch School. He painted mostly Highland scenes, moorlands, rivers and lochs, but in 1876 he set off to Egypt via Italy and France,

James Docharty *The Mill Dam, Ardnaham* oil, Robert Fleming Holdings Ltd

ordered by his doctor to benefit from warmer weather. The sketches he executed on this trip are interesting and would have added variety to his work had he been able to work them up. He died, however, shortly after his return in 1878.

Docharty, James L.C. d.1915
Glasgow landscape watercolourist who painted west coast views.

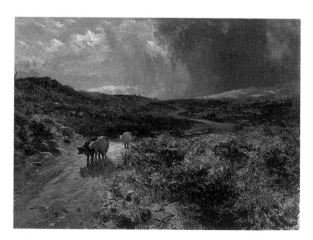

John Milne Donald *The Drove Road* oil 1857, Dundee Art Galleries & Museums

Dodds, Albert Charles 1888–1964
RSW 1937
Born Edinburgh, trained ECA and RSA Schools. Dodds was one-armed and was Drawing Master at Edinburgh Academy for many years. He was the model for the Art Master in Muriel Spark's novel *The Prime of Miss Jean Brodie*. Painted landscapes in Italy, France and southern England, as well as in Scotland, and he exhibited with the EDINBURGH GROUP.

Donald, John Milne 1819–66
Born Nairn, he spent his youth in Glasgow apprenticed to a horse painter who also dealt in pictures. In 1840 he visited Paris and copied pictures in the Louvre; he returned to London where he spent some years working as a picture restorer. Around 1844 returned to Glasgow to paint landscapes basing his style on the Dutch School, but also coming under the influence of MCCULLOCH. His earlier work tended to be brown, but his colour became freer and more luminous. He was a careful observer of nature, and while lacking BOUGH's imagination, he painted many direct landscapes.
He was not appreciated in his lifetime except by fellow artists, and lack of money forced him to paint decorative panels for Clyde boat-building yards. He was never recognized by the RSA in Edinburgh. He

was, nevertheless, important in the development of painting in Glasgow and had considerable influence upon younger west coast artists. Had he lived longer he might have achieved recognition.

Donald, Tom 1853–83
RSW 1878
Glasgow landscape painter in watercolour who worked in the West Highlands and on the coast. A Founder Member of the RSW in 1878, he died five years later aged only 30.

Donaldson, Andrew 1790–1846
Born Comber near Belfast he came to Glasgow and joined his father's trade as a spinner. A serious injury damaged his health and he turned to art as a career, beginning to sketch at the age of 20. His early works are views of Glasgow but in the late 1820s and early 1830s he travelled extensively in the Highlands, North Wales and Norther Ireland. He worked entirely in watercolour and was known as a good pencil sketcher. His early work is tightly topographical but later his landscape style became freer with fresh washes. Lived in Glasgow where he taught drawing.

Donaldson, David Abercrombie b.1916
ARSA 1951, RSA 1962, RP 1964
Born Chryston, Lanarkshire, and studied at GSA 1932–37. Won the Directors' Prize and the Haldane Travelling Scholarship. Travelled to Florence and Paris and returned to GSA. Joined staff part time 1938–44, become a full time lecturer 1944 and Head of the Department of Drawing and Painting, 1967.
Has exhibited in Glasgow, Edinburgh, New York, Canada and France. Appointed Her Majesty's Painter and Limner in Scotland in 1977 and generally regarded as the leading portrait painter working in Scotland. Also paints still-lifes, allegorical and biblical subjects.

Donaldson, John 1737–1801
Born Edinburgh. One of the earliest Scottish artists to paint portraits in watercolour. Self-taught, he moved to London in 1762 where he painted miniatures on ivory, decorated porcelain, and produced pencil and watercolour portraits and caricatures. Also painted china at Worcester.

Donnan, Robert fl.1888–1937
Studied South Kensington and Paris and became art master at Allan Glen's School, Glasgow. Painted landscapes, often on Iona, and also worked as etcher, potter and designer.

Donnelly, William A. fl.1860s – 70s
Lived at Bowling and painted landscapes, seascapes and birds in watercolour.

Dott, Jessie W. fl.1882–1918
Lived in Edinburgh and exhibited SSA. Painted landscapes.

Douglas, Andrew (André) 1870–1935
ARSA 1920, RSA 1933
Born Midlothian, he studied and lived in Edinburgh before spending several years in France. He painted in oil and watercolour, his favourite subject being cattle in fields, strongly painted, and boldly executed market scenes. Died Edinburgh.

Douglas, Edwin 1848–1914
Born Edinburgh, he trained at the RSA Schools, moving to England in 1872 and settling in Sussex. Made a name as a animal and sporting painter, and Caw described him as 'an understudy of Sir Edwin Landseer in sentiment and technique'. Was noted for his paintings of horses, foals, and cattle, often seen with milkmaids in lush pastures.

Douglas, James 1858–1911
RSW 1900, resigned 1907
Dundee artist who worked extensively in watercolour. His style is fresh and loose, and its wetness reflects the influence of the Glasgow School. He painted views around the Scottish coast, achieving particularly luminous blues, as well as rural scenes with figures in sun-dappled landscapes. He painted some sparkling Italian landscapes earlier in his career. During the mid-1890s he lived and worked in Rothenburg, Germany befor settling in Surrey. He later returned to Tayport and became a member of the Tayport Artists Circle. He was committed to a mental hospital in Perthshire in 1907 where he died. His wife Anna was also a talented watercolourist.

Douglas, John 1867–?
Born Kilmarnock, he studied at GSA. Lived in Ayr for many years painting landscapes and figures in oil and watercolour.

Douglas, Sholto Johnstone 1871–1958
The son of the Laird of Lockerbie, he studied at

James Douglas *The Peaks of Arran from Ardrossan* watercolour, Julian Halsby Esq

the Académie Julian, in Antwerp and at the Slade under Tonks and Steer. During the 1890s he built up a successful portrait practice in Scotland, especially in Dumfriesshire, and his 1901 exhibit at the RA was compared to Sargent. By now Douglas was established in London.

During the war Douglas worked as a war artist resuming his career as a portrait painter in 1918. In 1926 he went to live in the South of France near St. Raphael with his young family and abandoned portraiture. His later landscapes with figures are free and spontaneous: they are executed in oil, watercolour, pastel and charcoal. He returned to Scotland in 1939, painting until his death.

Douglas, William 1780–1832

Born Fife, a portrait painter usually on a small or miniature scale. Miniature painter for Scotland to Princess Charlotte and Prince Leopold. His work has considerable charm and often includes animals. Died Edinburgh.

Douglas, William fl.1840s–50s

Lived in Edinburgh and painted portraits, figures and historical subjects.

Douglas, Sir William Fettes 1822–91

ARSA 1851, RSA 1854, PRSA 1882–91

After ten years as a bank clerk, he took up painting in 1847 and was mainly self-taught. His pictures were soon noted and in 1851 he was elected ARSA. Douglas' subjects included portraits, figures usually within a historical context and often set in elaborate interiors, and still-life. His interest in detail has led his work to be compared to the Pre-Raphaelites, but his figures are sometimes rather wooden. He was probably at his best as a still-life painter and antiquities, coins, medals, ivories and enamels, of which he was a keen collector, are often included in his compositions.

In later years he turned more towards landscape, often working in watercolour, especially when ill-health prevented him working on large canvases.

These watercolours are quiet and controlled but they contain a quality of concentration and precision which make them unforgettable.

Douglas was a very learned man: he first visited Italy in 1857, returning subsequently and becoming an authority on many aspects of Italian art. Curator of the National Gallery of Scotland 1877–1882 and President of the RSA 1882–91. Died Newburgh, Fife.

Douglas-Irvine, Lucy Christina 1874–?

Born Virginia Water, Surrey and studied at Clifton, GSA and Kemp-Welch School of Painting. Exhibited RSW and lived at Pittenweem.

Douthwaite, Pat b.1939

Born Glasgow. Studied mime, movement and dance with MARGARET MORRIS, whose husband J.D. FERGUSSON encouraged her to paint. Largely self-taught, she went to live in Suffolk in 1958 and came into contact with COLQUHON, MACBRYDE and WILLIAM CROZIER. First solo exhibition in 1958. Has travelled extensively and lived for some of the time in Majorca. Her imagery is often disturbing: 'I deal in anger, joy, rage and happiness.' Women from history such as Amy Johnson and Mary Stuart often provide her subject matter.

Dow, Thomas Millie 1848–1919

RSW 1885, NEAC 1887, ROI 1903

Born Dysart, Fife and studied in Paris under Gerome and Carolus Duran. In Paris met William Stott of Oldham whose style, itself based upon that of Bastien-Lepage, greatly influenced Dow. Before returning to settle in Scotland, Dow visited America having first painted at Grez-sur-Loing, the French village where many artists worked, including LAVERY, ROCHE, KENNEDY, Stott and the Irish artist Frank O'Meara.

Sir William Fettes Douglas *Among Books* oil 1872, James Holloway Esq

T M Dow *Spring* oil 1886, Christie's Scotland

In Scotland Dow was associated with the Glasgow School, although his work is more dreamy and subjective than that of the Boys, and lacks their interest in social realism. His work shared with Whistler an interest in the decorative possibilities of nature, and he often looked toward allegorical subjects. In the winter of 1889 Dow worked in Morocco and during the 1890s he visited Italy. In 1895 he settled in St Ives and his connections with the Glasgow School became less strong. Dow was versatile in many media – his main output was in oil, but both his watercolours and pastels are effective. His watercolours are close in style to his oils, with carefully planned designs and flat-areas of wash, unlike the 'blottesque' style of MELVILLE. His pastels reveal the influence of both William Stott and Whistler. In addition to painting landscapes and figures in landscapes, Dow was also a notable flower painter. Died St. Ives.

Dowell, Charles R. d.1935
RSW 1933
Born Glasgow, he studied at GSA, winning a travelling scholarship to Rome. He was a watercolour painter and illustrator, and his watercolours are decorative and stylized.

Downie, John Patrick 1871–1945
RSW 1903
Born Glasgow, studied at the Slade under Alphonse Legros, and in Paris at the Académie Julian under Bouguereau and Ferrier. Was influenced by Hague School watercolours, developing a wet and fluid style. He painted interiors and genre, as well as fishermen in Scotland, in both oil and watercolour.

Downie, Patrick 1854–1945
RSW 1902
Born Greenock, he was mainly self-taught although spent some time studying in the Paris *atelier*. Downie was essentially a marine painter, working in both oil and watercolour, depicting the Clyde with its great variety of shipping from the smallest fishing boat to the great squarc-riggers. Married the daughter of the Provest of Paisley but died in poverty living the life of a down and out.

Doyle, Charles Altamont 1832–93
Born London of an Irish Catholic family and taught by his father, John Doyle (1797–1868). Sent to Edinburgh in 1849, aged 17, to work in the Scottish Office of Works, where he remained for 30 years. He turned to alcohol and was eventually committed to Montrose Royal Lunatic Asylum. Illustrated a number of books between 1859 and 1877 and produced humorous watercolours such as *Curling Match on Duddingston Loch* (Edinburgh City Art Collection) and *Bank Holiday* (National Gallery of Ireland, Dublin). His later work, painted in the Asylum, is introspective and brooding. His brother, Richard Doyle (1824–83) pursued a successful career in London as an illustrator and artist. C.A. Doyle's son was Sir Arthur Conan Doyle.

Drummond, James 1816–77
ARSA, 1845 RSA 1852
Born in the House of John Knox in the Canongate, Edinburgh, he studied at the Trustees' Academy

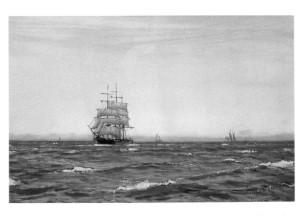

Patrick Downie *The Morning Breeze* gouache, Barclay Lennie

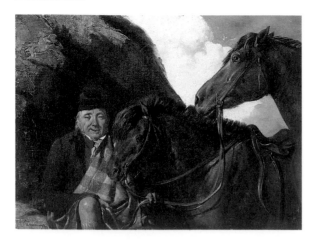

James Drummond *Tonald and Ta Peasties* oil ca. 1848, James Holloway Esq

under SIR WILLIAM ALLAN. He turned to historical painting and his great knowledge of arms and costume enabled him to paint accurately but, as Caw pointed out 'he failed to appreciate, or at least express, the dramatic and emotional elements in the stirring scenes of Scottish history he chose to illustrate'. He made his name with the large historical canvas *The Porteous Mob*. He was also a good topographical watercolourist and recorded many of the old streets and buildings of Edinburgh prior to their demolition. He was the author of a book on the sculptural stones of the West Highlands and was appointed Keeper of the National Gallery of Scotland in 1868. Died Edinburgh.

Drummond, John Murray 1802–89
A soldier by profession he had studied under ALEXANDER NASMYTH in Edinburgh and continued to paint during his military career. Produced some paintings for Queen Victoria.

Dudgeon, T. fl.1850s
Mid-nineteenth-century topographical artist. Represented in Glasgow Art Gallery by *The Clyde from Denottar Hill*.

Duffy, Daniel 1878–?
A landscape, portrait and still-life painter, he studied at GSA and worked in Glasgow, moving to Coatbridge in the 1920s.

Duguid, Henry fl.1830–60
Edinburgh teacher of drawing and music who painted many topographical views of Edinburgh in a style similar to that of JAMES DRUMMOND. He also painted views of the Highlands in watercolour which were exhibited at the RSA.

Dun, John fl.1875–1908
Lived in Edinburgh and painted rural scenes, genre and coastal views.

Dunbar, Peter fl.1840s–60s
Lived in Glasgow and painted landscape in England and Scotland.

Dunbar, R. Brassey fl.1886–1912
Lived in Glasgow and painted landscapes. Exhibited SSA.

Dunbar, Lady Sophia fl.1860s–1904
Painted flowers and landscapes. Travelled and painted in Spain, Corsica and northern Africa.

Dunbar, W. Nugent fl.1820s–30s
Scottish artist living in Rome during the 1820s. Painted watercolours of Italy which were exhibited at the RSA.

Duncan, Alexander C.W. fl.1884–1932
Glasgow landscape and figure painter. Exhibited regularly at the Glasgow Institute.

Duncan, David 1869–1943
Studied art in Dunfermline and Edinburgh. Watercolour painter and etcher of landscapes and seascapes. Was chief damask designer for the Victoria Linen Works, Dunfermline. Died Dunfermline.

Duncan, John fl.1917–38
Watercolour painter of birds, he often composed in circles or ovals, and his drawings, although not outstanding, can be attractive.

Duncan, John McKirdy 1866–1945
ARSA 1910, RSA 1923, RSW 1930
Born Dundee, he worked as an illustrator before studying art in Antwerp and Dusseldorf. He returned to Dundee where he remained until 1901, belonging to the circle of artists in Dundee working in a Symbolist style, as well as to the Celtic Revivalists in Edinburgh. He was closely involved with Patrick Geddes, and painted a frieze in the hall of Geddes' Edinburgh apartment representing *The Evolution of Pipe Music*. Duncan was also interested in the Italian Quattrocento and in addition the work of Puvis de Chavannes influenced his decorative panels.

Duncan continued to produce illustrations, most notably those for *The Evergreen*. From 1901 to 1904 he was Associate Professor of Art in Chicago and on his return settled in Edinburgh, where he painted his most famous work *Riders of the Sidhe* in 1912. This painting is one of the greatest Scottish Symbolist works and its many sources reveal Duncan's deep art historical knowledge. After the war, Duncan continued to work in a Symbolist manner, although his forms became more angular, possibly as a result of his knowledge of Vorticism. He also tended to work more in watercolour, choosing religious and allegorical subjects.

Duncan was an unconventional character and between the wars the young Edinburgh artists looked to him as a spiritual leader. His studio was the meeting point for members of the EDINBURGH GROUP and despite his age he was considered a leader of the *avant-garde*.

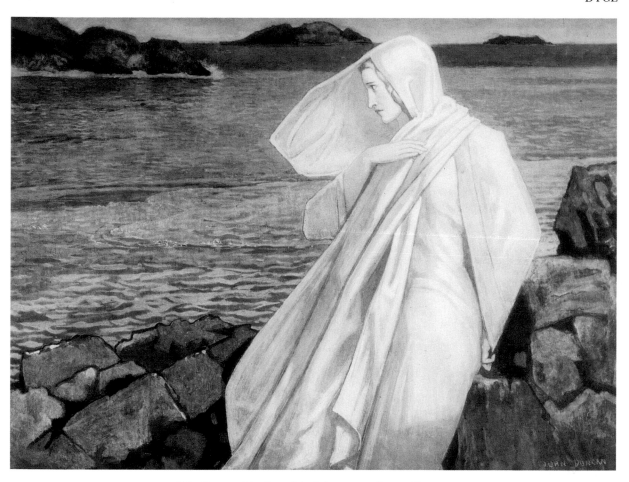

John Duncan *The Turn of the Tide* tempera, Bourne Fine Art

Duncan, Thomas 1807–45
RSA 1830, ARA 1843
Born Perth. After a short period in a solicitor's office, Duncan trained at the Trustees' Academy where his talents were quickly recognized. Painted scenes from Scottish history, especially the '45 Rebellion, and from Scottish literature. He was noted as a gifted colourist as well as having a remarkable technique in handling oils. Duncan was also a portrait painter both in oil and watercolour, executing many commissions in the Perth area.

Duncan's ability to draw led to a teaching post at the Trustees' Academy and in 1844 he was appointed Head-master in succession to SIR WILLIAM ALLAN. He died the following year aged 38. His last picture, *George Wishart Administering the Sacrament*, is at Perth Art Gallery. Died Edinburgh.

Thomas Duncan Pinx

Dundee Art Club
Founded in 1880 and ran regular exhibitions of work by local painters and others from further afield. Local patron of the arts, James Guthrie Orchar, was associated with the Club.

Dundee Graphic Arts Association
Established in 1890. An artists' group, self-run and self-financing with annual exhibitions until 1895.

Dunlop, Jessie I. (Mrs. Wilson) fl.1920s–30s
Studied GSA. Painted figure compositions, sometimes on Biblical themes.

Dunn, William fl.1896–1927
Lived in Helensburgh and painted landscapes and harbour scenes.

Durnford, F. Andrew fl.1840s–50s
Painted Scottish landscapes, Dutch coastal views and scenes on the Thames. Exhibited RSA.

Duthie, William fl.1889–1905
Lived and painted landscapes in East Lothian.

Dyce, J. Stirling d.ca.1900
Son of WILLIAM DYCE. Painted landscapes in France, England and Scotland in oil and watercolour, and some portraits. Lived in England, but retained links with Aberdeen, where he sometimes exhibited. His style shows a continuing influence of detailed Pre-Raphaelite landscape.

Dyce, William 1806–64
ARSA 1835, ARA 1844, RSA 1848
Born Aberdeen, he originally intended to study

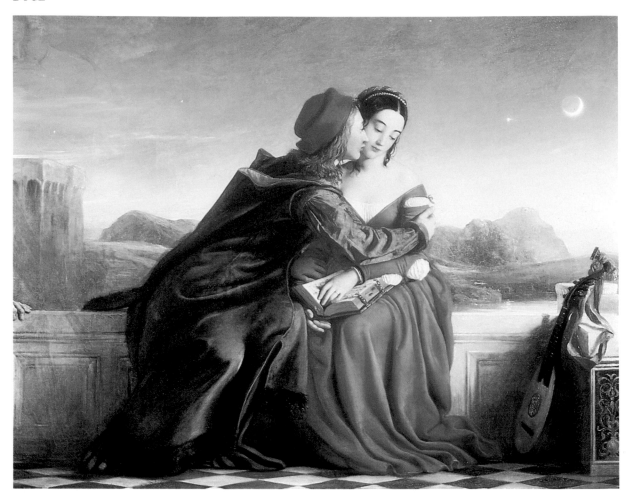

William Dyce *Francesca da Rimini* oil, National Gallery of Scotland

theology at Oxford, but turned towards art and in 1825 entered the RA Schools in London. The teaching disappointed him and in the same year he went to Rome to study the 17th century painters. Returned to Aberdeen briefly in 1827, but was soon back in Italy, this time meeting the Nazarenes, a group of mainly German painters, who aroused his interest in the Italian Quattrocento. Between 1829 and 1832 Dyce worked as a portrait painter in Edinburgh, but returned to the Continent, staying in Venice for a while with DAVID SCOTT, having visited Paris, the Rhone Valley and Northern Italy. In 1837 he was appointed Master of the Trustees' Academy (jointly with CHARLES HEATH WILSON), was also Superintendent of the Government Schools of Design and was involved in the Ecclesiological Movement - taking an interest in the revival of stained glass window design and in early church music, being a founder member of the Motet Society. Also became an expert on fresco painting, writing a government report on the subject and painting a fresco for Prince Albert at Osborne House. Dyce's most important works were painted during the last seven years of his life, when he was influenced by the Pre-Raphaelite movement. In 1859 he spent a holiday on Arran painting the landscape in a detailed style which he

used as backgrounds to *Man of Sorrows* and *David in the Wilderness*. In 1858 he had stayed on the Kent coast and the resulting picture *Pegwell Bay, Kent – A Recollection of October 5, 1858* completed in 1860, is one of the most successful Pre-Raphaelite landscapes. Died Streatham, Surrey.

Eadie, Ian Gilbert Marr b.1913
Born Dundee and was taught at Dundee College of
Art 1931–5. Travelling scholarship in France and
Italy and studied Ecole des Beaux Arts (1937),
Westminster School of Art (1939) and returned to
Dundee as an instructor 1939–40. Frequent exhibi-
tor RSA, RSW, RA. War service with the Gordon
Highlanders resulted in a series of war drawings
and paintings, a number of which were acquired by
the Imperial War Museum. Returned to teaching
at Dundee College of Art, 1946. Painted portraits
and landscapes, also murals in public buildings
throughout Britain.

Eadie, Robert 1877–1954
RSW 1917, VPRSW
Born Glasgow and studied in Paris and Munich,
and later lived in Glasgow and Cambuslang. He
painted elegant and stylish portraits which well
capture their period, as well as street scenes,
landscapes and beach scenes. He had a feel for
costume, hairstyles and period details. He worked
both in oil and watercolour. Also worked as a book
illustrator.

Eardley, Joan Kathleen Harding 1921–1963
ARSA 1955, RSA 1963
Born Warnham, Sussex, of Anglo-Scottish parents,
and studied at Goldsmith's and GSA (1940–3) under
HUGH ADAM CRAWFORD. In 1947 spent some
months at HOSPITALFIELD under JAMES COWIE,
returning to GSA in 1943 to take up post-Diploma
scholarship. In 1948–9 she travelled in Italy and
France and the resulting sketches and paintings

were exhibited at her first one-man show at GSA in
1949. During the early 1950s Eardley devoted much
time to the depressed areas of Glasgow, making
sketches and photographs which were worked up
into larger oils. Some of her most haunting and
perceptive portraits of Glasgow's poor children date
to this period.
In 1950 she began to paint at Catterline, taking
up semi-residence there in 1956. Painted powerful
seascapes and landscapes around Catterline, with
expressive brushwork and thick paint conveying the
force of the sea and wind. Also produced powerful
studies of the sea and sky executed in charcoal.
Died Killearn.

East Linton
The picturesque rural charm of this village in East
Lothian, just 20 miles from Edinburgh, which
attracted so many artists, led to it being called
'the Scotland Barbizon' just after the turn of the
century.
Its first artistic associations had been with JOHN

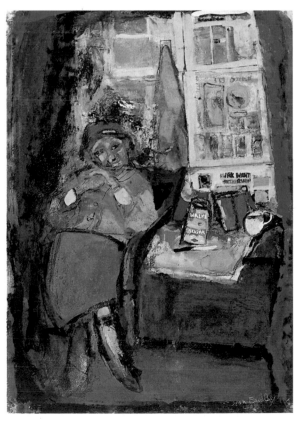

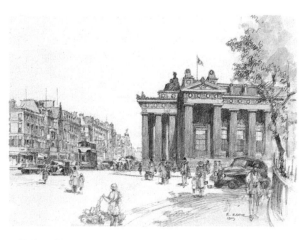

Robert Eadie *The Royal Scottish Academy and Princes Street,
Edinburgh, 1949* pencil & watercolour, private collection

Joan Eardley *Jeannie* gouache, pen and chalk, Bourne
Fine Art

PETTIE, the son of a local grocer, and he was followed by C M HARDIE and ARTHUR MELVILLE, both local boys who made good in the art world. By the end of the century, the village had become a mecca for artists: ROBERT MCGREGOR, JAMES CAMPBELL NOBLE, W.D. MCKAY (born nearby in Gifford) and ROBERT NOBLE all became active in painting local scenes. Noble, particularly, was responsible for promoting the attractions of East Linton among fellow artists and his influence led to further connections with JOSEPH FARQUHARSON, ROBERT HOPE and WILLIAM MILLER FRAZER, all of whom gained inspiration from the picturesque mills, the willow-fringed meadows, the red pantiled roofs, the rocky linn and the easygoing local rustics.

Although the East Linton painters never formed themselves into any organised grouping, the village's influence is only rivalled in Scotland by that of COCKBURNSPATH or KIRKCUDBRIGHT.

Easton, Meg (Mrs Viols) fl.1920–39
Edinburgh artist who painted landscape watercolours in a free, wet style.

Ebsworth, Joseph Woodfall 1824–1908
Studied at the Trustees' Academy under SIR WILLIAM ALLAN and DAVID SCOTT and became known as a lithographer and typographical draughtsman. Produced interesting views of Edinburgh from the newly erected Scott Monument in the late 1840s. Also painted landscapes in Italy and England. Became Artistic Director of the Manchester Institute of Lithography and later Professor at GSA.

Edgar, James 1819–76
Edinburgh genre, portrait and landscape painter. Also views of Edinburgh. Exhibited RSA 1846–75.

Edgar J. B. fl. 1860s
Glasgow painter of landscapes in watercolour, he exhibited at the Glasgow Institute.

Edinburgh College of Art, School of Drawing and Painting 1909–1960
When the College opened in 1909 it inherited from the TRUSTEES ACADEMY a tradition of teaching by distinguished artists, a system which had produced most of Scotland's finest painters, PEPLOE and CADELL recently among them. An Art Inspector from South Kensington, Frank Morley Fletcher, was the first Principal of the College; the first Head of Drawing and Painting was the versatile painter/designer ROBERT BURNS; and on the staff were the etcher and painter ERNEST LUMSDEN and two teachers of immense influence over the next 40 years – HENRY LINTOTT and ADAM BRUCE THOMSON.

After the Great War the noted portrait painter DAVID ALISON succeeded Burns and began to build one of the most effective teaching teams in Britain. It had the inspirational PENELOPE BEATON, mentor of countless First Year students; the brilliant draughtsman DONALD MOODIE and DAVID FOGGIE, DAVID M SUTHERLAND, WALTER GRIEVE and, from the talented 'Twenty Two Group' of post-war students, WILLIAM GILLIES and WILLIAM JOHNSTONE, an artist of vision and later the Principal of the Camberwell and Central art schools; the short-lived WILLIAM CROZIER, WILLIAM GEISSLER, a dashing watercolourist, and ANNE REDPATH. The mural artist GERALD MOIRA was Principal from 1924 until 1932, in which year S.J. PEPLOE took up teaching duties only to have ill-health overtake him. Moira's successor was HUBERT L. WELLINGTON, an art historian and an associate of some of the Camden Town Group, and additions to staff in the Thirties brought in ROBERT HERIOT WESTWATER and the uniquely gifted JOHN MAXWELL. Among outstanding students of the decade were such as WILHELMINA BARNS-GRAHAM, WILLIAM GEAR, MARGARET MELLIS, CHARLES MCCALL, Norman Reis (later Sir Norman, Director of the Tate Gallery), ROBIN PHILIPSON (later Sir Robin, Head of School and President of the RSA) and ALAN DAVIE.

After 1946 and under Gillies's leadership, the Painting School underwent huge changes of approach and of staff. From Glasgow came ROBERT HENDERSON BLYTH, an influential painter-teacher, Leonard Rosoman the former War Artist, DEREK CLARKE and Alan Carr – three artists from London – while from Edinburgh itself were Philipson, DAVID MCCLURE and JAMES CUMMING. They taught alongside such established 'veterans' as A. Bruce Thomson, Moodie, Maxwell, Gillies – the father-figure of the College after his Principalship and Knighthood – and the next President of the Royal Scottish Academy WILLIAM MACTAGGART (also to become a Knight). When, by the mid 1950s, ELIZABETH BLACKADDER and JOHN HOUSTON arrived, the mixture of experience and youth had already given the Edinburgh School its distinctive character. (*Jack Firth*)

The Edinburgh Group
This group of painters exhibited together for the first time in 1913 at Doig, Wilson and Wheatley's Gallery and consisted of: DAVID ALISON, J.R. BARCLAY, HA CAMERON, WILLIAM MERVYN GLASS, W.O. HUTCHISON, ERIC ROBERTSON, J.G. SPENCE SMITH, J.W. SOMERVILLE, A.R. STURROCK and D.M. SUTHERLAND. The following year they exhibited together at the New Gallery in Shandwick Place. After Alison left, his place was taken by CECILE WALTON.

The War interrupted activities and the Group did not exhibit again until 1919. Cameron and Glass did not re-join and Somerville was killed in action. DOROTHY JOHNSTONE and MARY NEWBERY joined the Group, which exhibited until 1921. They were a bohemian crew and their outlandish behaviour and art tended to affront polite Edinburgh society. A critic wrote: 'Half Edinburgh goes to Shandwick Place secretly desiring to be righteously shocked and the other half goes feeling deliciously uncertain it may be disappointed by not finding anything sufficiently shocking.'

John Wilson Ewbank *Rotterdam* oil, Dundee Art Galleries & Museums

Edmonstone, Robert 1794–1834
ARSA
Portrait painter in oil. Self-portrait in RSA collection. Also painted figures, mural subjects and genre.

Edmonston, Samuel 1825–?
Studied at the Trustees' Academy 1844–55 under SIR WILLIAM ALLAN and THOMAS DUNCAN. He painted landscapes, portraits and Scottish genre often with a humorous element. His wife Anne Edmonston also painted.

S. Edmonston.

Edmunston, Samuel fl.1870–1887
Lived in Edinburgh and painted fishermen and coastal scenes.

Ednie, John fl.1900–08
Trained at School of Art in Edinburgh and went to work for Wylie & Lochhead in Glasgow as an interior designer. His work was first shown at the Glasgow Exhibition of 1901 where he designed a tea-room interior and the dining room in the Wylie & Lochhead Pavilion. Watercolour designs for these rooms exhibited at Turin in 1902, although subsequently wrongly attributed to 'Jane Fonie'. His main influence was C.R. MACKINTOSH, although Baillie Scott also important. Nothing more is known of him with the decline of the Glasgow style after 1908.

Edward, Alfred S. 1852–1915
Born Dundee, the son of an architect, W.M. Grubb, he was art master at Dundee High School. Moved to Edinburgh and later settled in Cambridgeshire, painting in oil landscapes and coastal views in Scotland and Holland.

Elder, Andrew Taylor 1908–1966
Studied at ECA 1927–31 and won a Travelling Scholarship spent in André Lhote's studio in Paris. During the later 1930s he worked in France and Spain, settling in Glasgow in 1940. Painted landscapes and figures.

Evans, Marjorie (Mrs A. Scott Elliot) d.1907
RSW 1891, resigned 1902
Flower and landscape painter in watercolour.

Ewart, David Shanks 1901–65
ARSA 1934
Born Glasgow and studied at GSA from 1919, winning a travelling scholarship in 1924. Also studied in France and Italy. Was primarily a portrait painter, and from 1946 onwards visited the USA each year to paint American industrialists and their wives.

Ewbank, John Wilson 1799–1847
RSA 1826
Born Gateshead, Durham and was brought up in Yorkshire before studying under ALEXANDER NASMYTH in Edinburgh, which became his adoptive home. Was primarily a marine painter, his oils being strongly influenced by the Dutch Schools, in particular the younger Van de Velde whose calm seascapes appealed to Ewbank. Also produced fresh pencil and wash seascapes as well as some pencil landscape drawings. He executed a series of pencil and wash vignettes depicting Abbotsford and its neighbourhood and his views of Edinburgh were engraved by W.D. Lizars for Dr James Browne's *Picturesque Views of Edinburgh* (1825). He also drew in the Trossachs and around Loch Lomond. He became addicted to drink, and his career, which had shown much promise, suffered. His work, after about 1835, declined markedly. Died Edinburgh.

F

Faed, James Junior 1856–1920
Born Kirknewton. Son of JAMES FAED SEN-
IOR. Landscape painter and illustrator of Sloan's
Galloway. His oil paintings of the Galloway hills
and the Trossachs are distinctive and he developed
his own highly effective way of painting heather.

Faed, James Senior 1821–1911
Painted fresh watercolours of the Scottish coast and
landscape, although his main work was the engrav-
ing of paintings by his brothers and other artists,
including SIR NOEL PATON and DANIEL MACNEE.

Faed, John 1818–1902
ARSA 1847, RSA 1851, HRSA 1896
Born Gatehouse-of-Fleet, Kirkcudbrightshire.
Began to paint miniatures and soon made
a name for himself in Galloway. Moved to

Edinburgh around 1841, and attended some
classes at the Trustees' Academy. Faed disliked
the limitations of miniature painting and was able
to broaden his horizons in Edinburgh, painting
historical and literary subjects and illustrating
some of Burns' characteristic stories. A visit to
the Middle East in 1857 resulted in Biblical and
Eastern subjects, painted on a large scale. In 1864
he moved to London, following the success of his
brother THOMAS FAED. Settling in St Johns Wood,
he spent half of each year in Gatehouse where he
built a house in 1869.
In London, Faed painted large historical canvases,
sometimes borrowing costumes from Tussaud's
waxworks. As an artist, however, he was more
successful in his smaller genre compositions and
his illustrations. His more ambitious historical
canvases reveal a weakness in composition and

James Faed, Sr. *Harvest on the Solway Coast* oil, Mrs Jean Bourne

James Faed, Jr. *The Water of Leith, Coltbridge* oil 1893,
private collection

drawing. In 1880 Faed returned to Gatehouse to
live and one of his best works was a large-scale
landscape of the local countryside seen through a
trompe-l'oeil stone archway flanked by two spear-
bearing warriors, painted for the Town Hall of
Gatehouse in 1885. Died Gatehouse-of-Fleet.

Faed, Thomas 1826–1900
ARSA 1849, ARA 1861, RA 1864

Born Gatehouse-of-Fleet, the younger brother of
JOHN FAED, he joined his brother in Edinburgh
aged 17 and enrolled at the Trustees' Academy,
where he won the prize in the life class in 1847.
In 1849 he exhibited six paintings at the RSA, all
selling on the first day and in 1851 he had three
paintings hung at the RA.

John Faed *The Parting of Evangeline and Gabriel* oil, The
Robertson Collection, Orkney

Tom Faed *Sophia and Olivia* oil, private collection

In 1852 Faed settled in London, his first great suc-
cess being *The Mitherless Bairn*, which was shown
at the RSA in 1855. Faed's carefully composed and
finely painted scenes from Scottish life appealed
to the Victorian public, and while he played upon
their emotions, he never degenerated into pure
sentimentalism. Another successful work was *The
Last of the Clan*, which highlighted the decline of
the Highland society. He also painted a number
of canvases depicting single figures, usually pretty
girls in landscapes. These had a great influence on
artists like ROBERT HERDMAN. Technically, Tom
Faed was expert; his handling of oil in interiors,
figures, still-life details and landscape and his sense
of colour and composition rarely failed him. He
managed to relate his subjects to his public, telling
students at London Art School to 'paint the gutter
children of London rather than Helen of Troy,
Agamemnon or Achilles.' Died London.

Fairbairn, Thomas 1820–84
RSW 1882

Fairbairn studied with ANDREW DONALDSON in
Glasgow before becoming friendly with ALEXANDER
FRASER and SAM BOUGH with whom he painted in
the wooded landscape of Ayrshire. Like Fraser, he
was interested in detail and his landscapes often
have an almost Pre-Raphaelite exactitude. He also
painted on the east and west coasts and on Arran,
as well as in Cadzow Forest. Among his best work is
a series of watercolours of Glasgow painted between
1844 and 1849 which were published in 1849 and
reprinted in 1884. These topographical views, many
of which are in The People's Palace, reveal his abil-
ity as a draughtsman and watercolourist.

Falconer, Agnes Trotter b. 1883
Born Edinburgh and studied at ECA; later lectured at the National Gallery of Scotland to schoolchildren. Painted landscapes, flowers and seascapes, and also produced lithographs.

Farquharson, David 1840–1907
ARSA 1882, RSW 1885, ROI 1904, ARA 1905
Born Blairgowrie, Perthshire, he was largely self-taught. Moved to Edinburgh in 1872. Lived in London from 1886 to 1894, after which he moved to Sennen Cove, Cornwall, returning to Scotland regularly.
Farquharson painted the Scottish Highlands, moors and rivers, the lush pastures and river valleys of the Lowlands and the estuaries of Holland. In later life he also painted the English landscape. His work, which is mostly in oil, is well executed with good tonal balance, atmospheric effects and never overworked or fussy. Died Birnam, Perthshire.

Farquharson, John fl. 1880–1905
Lived in Edinburgh and London. Watercolour painter of some talent, who specialized in coastal views of Scotland and the West Country.

David Farquharson *Dundee* Robert Fleming Holdings Ltd

Farquharson, Joseph 1846–1935
ARA 1900, RA 1915
Born Edinburgh of an Aberdeenshire family he studied at the RSA Schools and with PETER GRAHAM, followed by a period in Paris in 1880 under Carolus Duran. In 1885 he visited Egypt and mosques and market places feature in some of his canvases. He is known, however, for his many snow scenes in which shepherds and sheep are often seen against an evening sky. The observation and composition in these works is always good, although his reputation has suffered from repetition. Lived at Aboyne in Aberdeenshire, where he was the Laird of Finzean.

Farrell, Frederick Arthur 1882–1935
Self-taught etcher and draughtsman influenced by MUIRHEAD BONE, he produced powerful watercolours of the Battle of Ypres in 1917. Also did illustrations for *The 51st Highland Division War Sketches* (1920). Later painted and etched views of London, Glasgow, Paris and other cities. His work as an etcher is comparable to that of many of his contemporaries and deserves more attention. Lived mostly in Glasgow.

Faulds, James G. fl. 1896–1938
Glasgow painter of coastal landscapes.

Thomas Fairbairn *In Cadzow Forest* watercolour heightened with white, Moss Galleries

Joseph Farquharson *When Snow the Pasture Sheets* oil, Robert Fleming Holdings Ltd

Fenwick, Thomas fl. 1835–50
Newcastle artist, he moved to Edinburgh with his apprentice-master Coulson and fellow apprentice JOHN EWBANK. Later lived in northern England, often painting landscapes in Scotland, but never achieved Ewbank's success. Exhibited at RSA. Died 1850.

Ferguson, Dan b.1910
ROI 1958
Born Motherwell, he studied at GSA under HUGH ADAM CRAWFORD. Paints still-lifes and birds in oil and watercolour.

Ferguson, James 1710–76
Portrait painter most probably working under the patronage of the 5TH Duke of Perth.

Ferguson, James W. fl.1915–40
Lived in Glasgow and painted views of the city as well as figures and portraits in a detailed style.

Ferguson, John Gow fl.1880s and 1890s.
Edinburgh painter of figures and historical scenes.

Ferguson, Roy Young b. 1907
Born Motherwell, the brother of DAN FERGUSON, he studied at GSA and paints landscapes in oil and watercolour.

Ferguson, Walter fl. 1840s
Edinburgh painter of fishing scenes and people. He also painted fruit.

Ferguson, William Gouw 1632–c.1695
Born in Scotland where he first developed his skills as a painter. Earliest work, now in the Hermitage, Leningrad, is dated 1650. Lived in Holland and travelled to Italy and France. Last known work painted in 1684. His still-life paintings clearly show the influence of Dutch artists.

Fergusson, Christian Jane 1876–1957
Born Dumfries, she studied at GSA under FRA NEWBERY and at Crystal Palace School of Art. Became Principal Art Mistress at Glasgow High School for Girls and won the Lauder Award at the Glasgow Society of Lady Artists in 1933, 1938 and 1954.
With E.A. HORNEL, JESSIE KING and E.A. TAYLOR and others, she founded the Dumfries and Galloway Fine Art Society whose first exhibition was in 1922. Painted Scottish landscape and architectural subjects in oil and watercolour.

Fergusson, John Duncan 1874–1961
RBA 1903
Born Leith, he was educated in Edinburgh but abandoned medical studies in order to paint. Began to visit Paris in the 1890s where he studied the Impressionists and attended life-classes at the Académie Colarossi. His watercolours of this period show the influence of MELVILLE and the 'blottesque'

Glasgow technique. Fergusson's first one-man show was in London in 1905 and two years later he settled in Paris, painting at first in a Fauve style and later in a more Cubist manner.
The Chinese Coat, for which the sitter was the Irish-American painter Anne Estelle Rice, is one of a number of studies painted by Fergusson between 1907 and 1909. It is Fauve in conception and colouring and compares favourably with portraits by Van Dongen and Marquet painted around the same time.
Four paintings by Fergusson were shown at the Post Impressionist and Futuristic Exhibition in London in 1913. His work reflected his interest in modern music and dance, in particular the *Ballets Russes*, which he saw in Paris. In 1913 he met the dancer MARGARET MORRIS, who was to become his wife.
During the First World War Fergusson lived in London and Edinburgh. He began to paint powerful Scottish landscapes and in 1918 worked on studies of ships and submarines at Portsmouth.
The 1920s were successful for Fergusson. He held his first one-man show in Scotland in 1923 followed by exhibitions in London and Paris with PEPLOE, HUNTER and CADELL. Exhibited in New York. In 1923 he returned to France, to Antibes for a holiday and in 1925 settled in Paris, where he remained until 1939.
On his return to Scotland during the war became actively involved not only with younger Scottish artists, but also with exiles from Europe such as Herman and Adler. In 1940 he was a founder-member of the New Art Club, from which developed the NEW SCOTTISH GROUP in 1942. He also wrote *Modern Scottish Painting* in 1943.

J D Fergusson *The Chinese Coat* (Anne Estelle Rice) oil 1908, Bourne Fine Art

Fergusson was one of the most versatile of the Colourists. He was an excellent draughtsman as his stylish and often witty Parisian watercolours reveal; he was able to adapt the various new influences he came across in Paris and make of them something personal and unique. He was also interested in music, dance and literature.

James Ferrier *Washday by the Mill Stream* watercolour, private collection

Fergusson, Nan (Mrs. James Henderson) 1910–84
Lived in Dumfries and painted still-life and landscapes, particularly of Arran and Galloway. Married JAMES HENDERSON 1937. Taught at George Watson's Ladies College 1963–71.

Ferrier, George Straton 1852–1912
RSW 1881, RI 1898
The third son of JAMES FERRIER, he painted fine, broad landscapes and seascapes influenced by the Hague School. He travelled widely, was largely self-taught and was honoured by the Paris Salon. His skies can be particularly successful, with touches of grey, yellow and pink. Lived Edinburgh and, latterly, in London.

Ferrier, James fl.1843–83
Edinburgh landscape artist who first exhibited at the RSA in 1843. Worked mostly in watercolour, sometimes on a large scale, painting in Perthshire, on the west coast, on Arran and in Cumberland. His watercolours are full of detail and incident, often with hunters, harvesters or deer; colours are strong and compositions intricate, but the results are usually successful. He was interested in detailed observation and sharp delineation.

Findlay, Anna R 1885–1968
Woodcut and linocut printer, she studied at GSA 1912–14.

Findlay, William fl.1888–1929
Lived in Glasgow and painted portraits and landscapes. Worked in Paris in 1895, painting some pleasant Impressionist scenes along the Seine.

Findlayson, James A. b.1901
Portrait painter working in Perth and Hawick areas. Portrait of the poet William Soutar in Perth Art Gallery.

Finlay, Alexander fl.1860s–1893
Lived in Glasgow and painted coastal, beach and marine scenes; also landscapes.

Finlay, Anne fl.1920–35
ASWA 1939

George Straton Ferrier *Dutch Fishing Boats at Dusk* grey wash 1897, Alan W Cope Esq

Jack Firth *Polperro with Gulls* watercolour, private collection

Studied at ECA and painted in Kirkcudbright with MAY BROWN, ANNA HOTCHKIS, CECILE WALTON and DOROTHY JOHNSTONE. Moved to London in the late 1930s.

Finlay, Ian Hamilton b.1925
Although not a painter in terms of having produced a body of work in oil and watercolour, mention must be made of the man who is today one of Scotland's leading internationally recognised artists. At Little Sparta, Dunsyre, he has created a garden temple in the classical tradition giving concrete expression to his poetry and art. His imagery is nautical and military and although this often seems in remarkable contrast to his classical settings, he has produced an environment of remarkable artistic power in an uncompromisingly bleak Scottish setting. His work is constantly surrounded by controversy.

Finlay, J. Kirkman fl.1854–80s
Painter of landscapes and frequent exhibitor.

Finnie, John 1829–1907
Born Aberdeen, he moved to London in 1853 where he met WILLIAM BELL SCOTT. Became Headmaster of the Mechanics Institute and School of Art in Liverpool from 1856 to 1898. Painted detailed watercolours of the mountains of North Wales and the landscape around Liverpool, although his style broadened in later years. Also produced etchings and mezzotints.

Firth, Jack b.1917
RSW 1961
Born Edinburgh, studied at ECA 1935–39 under GILLIES, LINTOTT, MAXWELL and BRUCE THOMSON. Taught art 1946–63 and Lothian Region Adviser in Art 1963–82. Part-time lecturer at ECA 1955–70. Earlier paintings in oil and watercolour but painted exclusively in watercolour from late 60s. Paints in Paris, Edinburgh and Cornwall with many maritime and harbour subjects. Exhibited widely: RSA, SSA, RSW and one-man shows. Author of *Scottish Watercolour Painting* (1979).

Flattely, Alastair b. 1922
Born Inverness and studied at ECA. Developed his interest in landscape painting during war service as an artillery spotter. Head of Fine Art and Vice-Principal at Gloucestershire College of Art and Design and later Head of Gray's School of Art, Aberdeen, retiring in 1987. Paints landscapes and harbour scenes in oil, watercolour and in pen and ink in a style in the tradition of GILLIES, especially in his earlier work such as *Concert at the Usher Hall*. Lives and works in Aberdeen and Spain. Member RWA and past President Aberdeen Artists' Society and the Cheltenham Group óf Artists.

Fleming, Ian b.1906
RSW 1946, ARSA 1947, RSA 1956
Born Glasgow he studied at GSA 1924–29, specializing in lithography, colour woodcut and engraving. Then travelled to London, Paris, the south of France and Spain. Taught at GSA 1931–48, while working on his own prints and watercolours. He is one of the leading modern Scottish engravers and etchers and produced a dramatic series of etchings of Glasgow during the blitzes of 1941–42. Etchings, watercolours

Alastair Flattely *Concert at the Usher Hall, Edinburgh* pen, ink & wash drawing July 1953 for *The Illustrated London News*

and oils were worked up from sketches made in the course of his work as a police 'Special'. His best work of this period is stark and dramatic and shows the influence of Goya and Picasso. He taught at HOSPITALFIELD 1948–54 and was Principal of Gray's School of Art 1954–72.

Fleming, John 1792–1845
Born and lived in Greenock on the Clyde. Exhibited in Glasgow and became a member of the WSA. Painted Highland and Ayrshire landscapes in oil and watercolour, and illustrated books on Scottish scenery including Swan's *Scottish Lochs* (1834). His work is rare.'

Fleming, J.S. fl.1900–20
Stirling architect who painted the old buildings of Stirling and Cambuskenneth.

Fletcher, Alan 1936–58
Born Glasgow and studied at GSA 1952–55. Studied sculpture under BENNO SCHOTZ at GSA. His paintings, most of which were produced 1956–8, were influenced by de Staël. Awarded travelling scholarship to Italy and died there in an accident in 1958. Exhibited in London and New York and his work is in a number of Scottish public collections.

John Fleming *Extensive View of the Clyde from Dalnottar Hill* oil, Robert Fleming Holdings Ltd

Flint, Francis Wrighton fl.1880–1910
Father of WILLIAM RUSSELL and ROBERT PURVES FLINT, he worked as a graphic artist and designer, but also painted watercolours. Lived in Portobello.

Flint, Robert Purves 1883–1947
RSW 1918, ARWS 1932, RWS 1937
Born Edinburgh, the younger brother of WILLIAM RUSSELL FLINT, he studied at ECA. In 1900 visited the Continent with his brother, painting in Holland. Served in the Army during the First World War and was wounded in Flanders, 1917. After a period in London, settled in Whitstable, Kent. Flint painted

Ian Fleming *Rescue Party, Kilmun Street, Maryhill, March 14 1941* oil, Paul Harris Esq

quiet, restrained views of landscapes and estuaries in thin washes over pencil outlines.

Flint, Sir William Russell 1880–1969
ROI 1912, RSW 1913, ARWS 1914, RWS 1917, ARA 1924, ARE 1931, RE 1933, RA 1933

Born Edinburgh, the son of a graphic artist, he trained as a lithographic draughtsman in an Edinburgh firm, studying at the Royal Institution School in the evenings. After a visit to the Continent in 1900 with his brother, settled in London and worked with a firm of medical book illustrators. Also worked as an illustrator for magazines. In 1905 he exhibited a watercolour at the Royal Academy for the first time, and began to produce colour illustrations. Following a meeting with Phillip Lee Warner of the Medici Society, he produced a series of fine colour illustrations for the Riccardi Press. These included *Morte d'Arthur*, *Theocritus* and *The Song of Solomon*. His series of illustrations for *The Savoy Operas* published by George Bell and Sons 1909–10 were bought by Marcus Huish and exhibited at the Fine Art Society. They represent some of the finest book illustrations of the period. In the years prior to the First World War, Flint began painting watercolours in France, Scotland and, in 1912, in Italy. His watercolour style was strongly influenced by the 'wet' technique of MELVILLE and the Glasgow School. During the 1920s and 30s, his reputation grew rapidly and his dashing watercolours of Spain, France, Italy and Scotland, all brilliant displays of virtuosity, were keenly sought by collectors. He was able to sum up the heat of the Mediterranean as successfully as the snow of the Alps, and his success led to many imitations. Died London.

Foggie, David 1878–1948
RSW 1918, ARSA 1926, RSA 1930

Sir William Russell Flint *Idlers at Burgos* watercolour, B Di Rollo Ltd.

Born Dundee, he studied in Paris, Antwerp and Italy. He was a close friend of GEORGE DUTCH DAVIDSON in Dundee, although was less influenced by the Celtic and Symbolist movements. Painted portraits and figures in an assured manner, and was in demand as a robust yet elegant portrait painter between the wars. His watercolour style was also effective, using MELVILLE's 'wet' technique. Foggie was an accomplished draughtsman and taught drawing at ECA. He was considered a painter's painter.

Fonie, Jane see Ednie, John

Forbes, Anne 1745–1834
Granddaughter of WILLIAM AIKMAN, studied in Rome where in 1770 she was copying Old Masters. Returned to London and developed a portrait practice, sitters including Lady Elizabeth Hamilton, Lord Polwarth, the Duke of Queensberry and other members of the Scottish aristocracy.

Forbes, Alexander 1802–39
ARSA 1830

Painter of animals, in particular of dogs and horses, he also produced some genre. Lived in Edinburgh.

Forbes, James 1797–1881
Born Lonmay, Aberdeenshire. A self taught artist, he lived variously in Brora, London, Peterhead

David Foggie *Girl with Book* pastel, Peter Bowles Esq.

and Aberdeen. His skill as a portrait painter steadily developed and when living in Aberdeen instructed JOHN PHILLIP in painting, artist and pupil often working together. Emigrated to USA, lived in Chicago and lost most of his paintings in the Great Fire. Died Plainwell, USA.

Ford, John A. fl.1880–1923
Successful Leith figure, portrait and genre painter. Town and mill scenes, often with farm animals and workers. Works in collections of City of Edinburgh, Scottish Arts Club and New Club. President SCOTTISH ARTS CLUB 1919–22.

Forrest, Robert S d.1943
Edinburgh portrait painter and etcher. Portraits included King George V and the Lord Provost of Edinburgh, Sir William J. Thomson. Devoted himself to etching later in life. Died Edinburgh.

Forrest, William 1805–89
HRSA 1877
Painted landscapes and also worked as an engraver.

Forster, J.
Late eighteenth-century Edinburgh topographical artist.

Forster, Percy fl.1830s
HRSA 1828
Worked in East Lothian in the 1830s. Itinerant portrait painter, reputedly the son of the Duke of Northumberland. Also painted still-life and game.

Forsyth, Amelia B (Mrs William Johnston) fl.1930s–40s.
Studied at GSA 1931–4, and won the Glasgow Society of Lady Artists' Lauder Award in 1937. Married in 1945.

Forsyth, Gordon Mitchell 1879–1952
RI 1927
Born Fraserburgh, studied Gray's School of Art, Aberdeen and RCA. Pottery designer and painter who is famous for his work for Pilkington Tile and Pottery Company. He painted watercolours of landscape and ceramics which he signed with a monogram.

Fortescue, The Hon. Mrs Henrietta Anne (neé Hoare) c.1765–1841
Amateur topographical painter in pen, pencil and watercolour who lived in Edinburgh for a period. Later Lady Acland.

Fortie, John fl.1840s–50s
Lived in Edinburgh and painted genre, rural scenes, woodland views and portraits, often of children.

Foulis Academy 1753–1775
Robert and Andrew Foulis were Glasgow painters who established an Academy of Fine Arts housed in the College of Glasgow in 1753. Robert Foulis (1707–1776) had built up a substantial collection of Dutch, Venetian and Renaissance paintings which the students were encouraged to study. The Academy was based on continental models and French and Italian teachers were employed. History painting was the principal subject and anatomy, perspective, geometry and classical rules of proportion were taught. Students copied pictures from the Foulis Collection as well as prints and classical sculpture. Robert Foulis had bought a large number of engravings and copying these filled in gaps in the Old Master Collection. It is unlikely that students drew from nude life models as this practice was unheard of in Scotland at this time. However, students probably went into the surrounding countryside to draw directly from nature. Students paid no fees, but were treated instead like apprentices, being paid a small wage. Their participation in the Grand Tour, considered essential to a proper art education, was paid for by the Academy, which relied upon a number of Glasgow benefactors. When, during the 1770s their patronage declined, the Academy ran into financial problems and finally closed in 1775 on the death of Robert Foulis. The collection was subsequently sold in London.

Despite the excellent intentions and enlightened philosophy of the Foulis brothers, their Academy made little impact. The two outstanding

Alexander Fraser Sr. *Sampling the Brew* oil, private collection

students were DAVID ALLAN and the medallionist JAMES TASSIE, although CHARLES CORDINER and ROBERT PAUL produced some fine work. Another student was the 11th Earl of Buchan who later became a senior patron of history painting. Possibly the Academy was in advance of its time for Glasgow lacked the cultural life of Edinburgh at this stage: there was a lack of inspired teachers with too much emphasis on mechanical copying. Despite this, the Foulis Academy was a fascinating indication of an awakening of cultural interest and patronage on the west coast.

Fowler, George fl.1892–1902
Painter of landscapes and seascapes in oil.

Fowler, Robert 1853–1926
RI 1891
Born Anstruther, he studied at Liverpool College of Art, remaining in Liverpool until 1904 when he moved to London. Fowler painted allegorical and classical compositions which reveal many influences including Whistler and the Japanese aesthetic, Puvis de Chavannes, Albert Moore and Lord Leighton. His compositions have a dream-like quality, painted in a restrained palette with little contrast, and their closest equivalent in Scotland

are the works of THOMAS MILLIE DOW. In his later years he turned increasingly towards landscape painting.

Frain, Robert fl.1840–75
Edinburgh portrait and figure painter. Friend of D.O. HILL who made an early calotype photograph of him, 1843.

Fraser, Alec fl.1900–14
Aberdeen painter of seascapes, coastal scenes and landscapes in a broad manner.

Fraser, Alexander Senior 1786–1865
ARSA 1840
Born Edinburgh and studied at the Trustees' Academy with DAVID WILKIE as a fellow student. In 1813 moved to London where Wilkie employed him as an assistant, passing on commissions for which he had no time. Not surprisingly his style is close to that of Wilkie, although he sets more scenes outside and often limits the number of figures. Colours tend towards rich brown tones, and of Wilkie's many followers he stands out as the most capable.

Alexander Fraser Jr. *At Barncleuth* oil, Royal Scottish Academy (Diploma Collection)

William Miller Frazer *On the Tyne, East Linton* oil, private collection

Fraser, Alexander Junior 1828–99
ARSA 1858, RSA 1862, RSW 1878
Born Linlithgow, the son of WILKIE's associate,
he spent much of his youth on the Argyll coast.
He took an interest in art from a very early
age, encouraged by his father, and although he
studied at the Trustees' Academy, he believed
that he really learnt his profession by going
on painting expeditions with his fellow student
FETTES DOUGLAS, and SAM BOUGH. Together they
sketched in Cadzow Forest and on the banks of
Loch Lomond.

Annie French *The Five Princesses* watercolour, private
collection

Fraser believed in *plein-air* painting and the fresh-
ness of his colours and accuracy of observation
bear witness to this practice. He painted land-
scapes not only in Scotland, but also in East
Anglia, Wales and Surrey. He was interested in
rural life, observing people working on the land.
He was extremely good at painting evening scenes,
with buildings and trees dark against a glowing
sky. In some respects, Fraser looks back to the
earlier style of MCCULLOCH and MILNE DONALD
as well as David Cox whom he particularly
admired; but in other respects his work was
more progressive, his detailed observation reflects
the influence of the Pre-Raphaelites, while his
fresh colours look towards the freer style of
the 1870s.

Fraser, Annie fl. 1880s–90s
Edinburgh painter of landscapes and figures.

Fraser, James fl. 1830s
Landscape painter who worked in the Perth area
painting local scenes.

Fraser, James fl. 1880s
Perth amateur artist. Painted local scenes including Perth town views.

Fraser, John Simpson fl. 1870–1900
RSW 1878
Painted seascapes and coastal scenes in watercolour.

Frazer, William Miller 1864–1961
PSSA 1908, ARSA 1909, RSA 1924, President of the Scottish Arts Club 1926
Born Scone, Perthshire, he studied at the RSA Schools, winning the Keith Prize. Painted English and Scottish landscapes in a broad, Impressionist style and also worked in Venice. He lived for a time at St. Iver in Huntingtonshire and painted river scenes both there and in Norfolk. He was extremely prolific. He first exhibited at the RSA in 1884 and achieved a record by exhibiting for 73 consecutive years. Associated with the EAST LINTON School, and a prominent member of the SCOTTISH ARTS CLUB. Died Edinburgh.

French, Annie (Mrs George Woolliscroft Rhead) 1872–1965
Born Glasgow, she studied at GSA 1896–1902 when Jean Delville was on the staff. From 1906 to 1914 she shared a studio with BESSIE INNES YOUNG and JANE YOUNGER at 227 West George Street. Jane Younger was known as 'Faith', Annie French as 'Hope', but Bessie Innes Young remained 'B.I.' From 1909 to 1912 she taught on the design side of the Ceramics Department at GSA and in 1914 married George Woolliscroft Rhead RE and they settled in London. Known for her illustrations of fairy tales, poems, postcards and greeting cards. Her style was not unlike that of JESSIE KING, although her forms were more exaggerated. She also painted in watercolour. Died Jersey.

Frew, Alexander d. 1908
Glasgow doctor who took up painting as a profession. He sailed his own yacht around the coast, painting in the open air. His oil technique involved rich impasto and deep tones. In 1899 he married BESSIE MACNICOL, but by then he had already resumed his practice as a doctor in Glasgow. Fishing and harbour scenes.

Frier, Jessie fl. 1870–1912
Edinburgh painter who painted interiors and landscapes in a tight but delicate manner, probably influenced by the Pre-Raphaelite movement. Work was mostly in watercolour.

Frier, Robert fl. 1870–1910
Edinburgh artist who painted landscapes and figures in a style influenced by the Pre-Raphaelites.

Frood, Millie fl. 1940s–1950s
Born in Motherwell and studied at GSA. A founder member of the NEW ART CLUB and NEW SCOTTISH GROUP. Painted landscapes and townscapes using bold colours and thick impasto.

Fulton, David 1848–1930
RSW 1890
Born Parkhead, near Glasgow, studied GSA. Painted in oil and watercolour. His best landscapes depict figures in fields or beside streams, often bathed in sunlight. He also painted children in the open air, sometimes with animals. His genre scenes of interiors are less successful.

Fulton, James Black 1875–1922
FRIBA
Architect and watercolourist. Painted views of Venice and Constantinople, influenced by MACKINTOSH and KEPPIE, also painted flower watercolours where the influence of Mackintosh is particularly strong.

Fulton, Samuel 1855–1941
Born Glasgow, travelled in South Africa and settled in Renfrewshire. Painted animals, particularly dogs, mostly in oil but some watercolour work.

Fyfe, William Baxter Collier 1836–1882
Born Dundee and studied at the RSA Schools. Painted portraits and domestic subjects. Also produced woodcuts.

G

Gage, Edward Arthur b.1925
RSW 1963, PSSA
Born Gullane, East Lothian, he studied at ECA 1941–2 and again after the war 1947–52. He paints French watercolour landscapes, often of the south of France or Mediterranean countries with simplified designs and a wet technique. Has also worked as an illustrator and as art critic of *The Scotsman*. Wrote an important study of modern Scottish art, *The Eye in the Wind* (1977).

Gahan, George Wilkie 1871–?
Born Newcastle-on-Tyne, he studied at Dundee School of Art. Painted and etched coastal views, shipyard scenes and landscapes from his home at Broughty Ferry.

Gair, Alice fl.1884–1902
Lived in Falkirk and painted landscapes. Exhibited SSA.

Gallacher, William 1920–78
Born New York. Trained at GSA and later joined the staff. Painted portraits and landscapes but especially noted for his many self-portraits and figure studies. Died Glasgow.

Gallaway, Alexander fl.1794–1812
Portrait painter and miniaturist working in Glasgow 1801 and in Edinburgh 1811–12

Galloway, Elspeth S. 1889–1980
Edinburgh landscape watercolourist, who also worked in Italy. Educated ECA and London. Exhibited SSA.

Galloway, Everett fl.1918–40
Landscape artist who worked in Perth and Belfast.

Painted views of the Highlands in a 'wet' technique with effective colours.

Gamley, Andrew Archer 1869–1949
RSW 1924, VPRSW
Born Johnshaven, Kincardineshire, studied ECA and gained Carnegie Travelling Scholarship. After further training in Paris and Italy. He lived on the east coast in Pittenweem, and later in East Lothian, painting harbour scenes which capture the effects of light on water, using a light watercolour technique. Sometimes his watercolours lack firm drawing and composition, appearing somewhat flimsy. Also worked in Spain. Exhibited RSA and RSW.

Gauld, David 1865–1936
ARSA 1918, RSA 1924
Born Glasgow, he was apprenticed to a lithographer and first attracted attention with his pen-and-ink illustrations which appeared in the *Glasgow Weekly Citizen* during the later 1880s. Also studied part-time at GSA 1882–5
Gauld stands on the edge of the Glasgow School; his interest was more in the decorative possibilities of a painting, rather than in any social comment, and he was attracted by the decorative aspects of the KIRKCUDBRIGHT SCHOOL – in particular HENRY and HORNEL.
Gauld was a friend of C.R. MACKINTOSH and his paintings of the late 1880s and early 1890s have a strong Symbolist theme, in particular *St Agnes* 1889–90, which also shows his interest in stained-glass windows. He designed a number

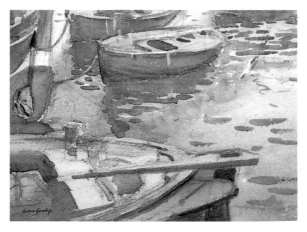

Andrew Gamley *Boat Study* watercolour, private collection

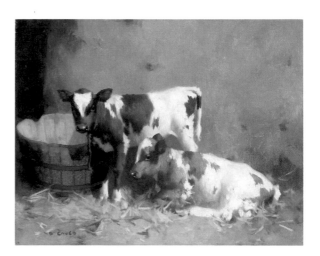

David Gauld *Ayrshire Calves* oil, Barclay Lennie

of windows for churches, revealing a fine sense of design and lustrous colours. These decorative elements influenced a series of paintings of single heads, nymphs and dryads executed at this time.

In the mid 1890s, he visited France and Grez and painted landscapes in restrained colours. His reputation, however, was established with his painting of cattle and calves in landscape, painted freely and *alla prima*. While many of these are excellent in their bravura and sense of colour, he later tended to work to a formula, and the later paintings lack the interest of his earlier work. Died Glasgow.

Gavin, Malcolm 1874–1956
RP 1919, ARSA 1920, SSA
Portrait painter, he studied at South Kensington and the RA Schools.

Gavin, Robert 1827–83
ARSA 1854, RSA 1879
Born Leith, he studied at the Trustees' Academy. In 1810 visited America and painted a series of pictures depicting life on the plantations with negroes working or relaxing. He executed many portraits of negroes. During the early 1870s he travelled to Tangiers, painting its inhabitants and the landscape. His RSA diploma work *The Moorish Maiden's First Love* demonstrates his fascination with the foreign and the exotic. Gavin

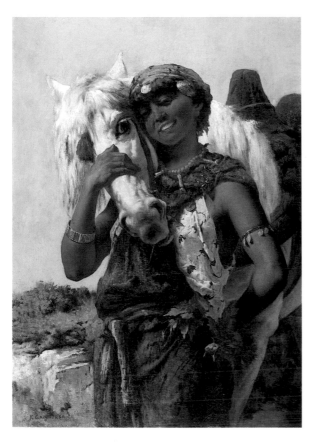

Robert Gavin *The Moorish Maiden's First Love* oil, Royal Scottish Academy (Diploma Collection)

was a fluent oil painter, with a dashing style and an eye for unusual costume or an interesting face. Died Newhaven.

Gear, William b.1915
Born Methil, Fife, and studied at ECA 1932–6 followed by a year at Edinburgh University studying history of art. Travelled in Europe in 1937, studying with Fernand Léger in Paris for several months.

He served in the Signals during the War, but found time to paint and exhibit. In 1946–7 he worked in Germany mounting exhibitions for the Allies, and in 1948 joined the COBRA group of Northern European artists with a common interest in abstract and folk art. Lived in Paris 1947–50, developing a strong abstract style based on a framework of black outlines. Became a leading member of the Ecole de Paris and also showed at the major COBRA exhibitions in Amsterdam and Copenhagen (1949) and Luik (1951). Settled in England in 1950, becoming Curator of the Towner Art Gallery, Eastbourne in 1958 and Head of Fine Art at Birmingham College of Art in 1964.

Geddes, Andrew 1783–1844
ARA 1832
Born Edinburgh and attended Edinburgh University before moving to London around 1807 to attend the RA Schools, having spent some frustrating years as a junior clerk in the Excise Office in Edinburgh. Returned to Edinburgh to establish a reputation as a portrait painter, and his desire to study the Old Masters abroad could only be fulfilled with the Peace of Amiens in 1814. He then spent time copying pictures in the Louvre and the influence of Rubens, in particular, became vital to his work. In his Edinburgh exhibition of 1821 Geddes showed nine pasticcio compositions in the style of artists like Watteau, Giorgione, Canaletto, Rembrandt and the

William Gear *Landscape* oil March 1949, Scottish National Gallery of Modern Art

Dutch masters. His companion in Paris had been JOHN BURNET and his first major composition on his return was for an altarpiece *The Ascension* for St James Garlickhythe where Burnet's brother was curate. The main influence here was Titian whose *Assumption of the Virgin* he had seen in the Louvre. Geddes' reputation as a portrait painter grew, and he was able to incorporate more fanciful costume, often based upon his art-historical knowledge, into compositions. In 1828 he finally managed to visit Italy, after earlier attempts had been abandoned, and he settled in Rome with his new wife. Here he worked on portraits and copies of the Masters. He returned in 1831 via Venice and Munich to London where he had been based since the early 1820s.

In 1839 visited Holland to admire the painted and etched work of Rembrandt. In addition to painting portraits Geddes also produced some fine landscapes painted broadly and with verve. He was interested in the effects of light and atmosphere, and it has been suggested that he discussed these with Turner whom he knew in Rome in 1828. He also looked carefully at Rubens' dramatic landscapes. His subject paintings were probably less successful and he found it difficult to compose well on a large scale; on the other hand his etchings, both portraits and landscapes, are excellent, as are his drawings. In many respects Geddes and WILKIE were instrumental in the revival of the art of etching during the early 19th century. Died London.

Geddes, Ewan 1866–1935
RSW 1902

Edinburgh artist who painted in Perthshire. Painted quiet, but poetical, landscapes which are sensitive in their subdued tonality. His snow scenes combine Scottish 'wet' watercolour technique with fine detail. Died Blairgowrie.

Geddes, William 1841–84

Painted in the Blairgowrie area. Oil of *Two Salmon* in Perth Art Gallery. Exhibited RSA 1865–84

Geikie, Walter 1783–1837
ARSA 1831, RSA 1834

Brought up in Edinburgh, he was deaf and dumb from the age of two, but had attended a special school which enabled him to read and write. In 1812 joined the Trustees' Academy under ANDREW WILSON, who introduced him to the Earl of Hopetoun. This introduction resulted in a commission for three canvases, although it was as a draughtsman that Geikie became known. He had a keen eye for Edinburgh's poor and unfortunate, and he produced brilliant satirical sketches of Scottish life, such as *A Village Fight* in which the whole community is at war, and scenes of drunkenness. His drawings are often witty, but never become caricatures, while others depict the real poverty of Scotland with sympathy and understanding.

Geissler, William 1896–1963
RSW

A fellow student of GILLIES and CROZIER at ECA, he joined the 1922 Group on its foundation. In 1923 visited Italy and France with GILLIES and CROZIER, enrolling in André Lhote's Paris studio. Although Gillies rejected Lhote's instruction, Geissler was influenced by his bright colours and bold design.

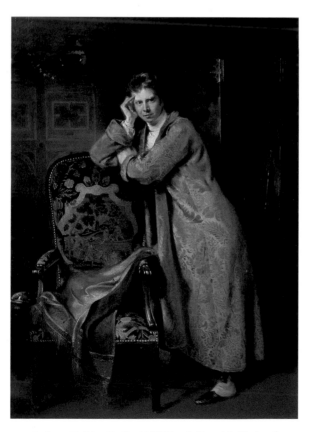

Andrew Geddes *Sir David Wilkie* oil, Scottish National Portrait Gallery

Walter Geikie *Our Gudeman's a Drunken Carle* 1830, etching, private collection

Geissler had a bold approach to his watercolours of the Scottish landscape. Head of the Art Department at Moray House, Edinburgh, and elected President SSA (1957).

Gellatly, William fl.1840s–60s
Edinburgh landscape painter. Exhibited RSA.

Gibb, Robert 1801–37
ARSA 1826
Born Dundee, he was a foundation member of the Scottish Academy in 1826. He painted landscapes in oil and watercolour, the latter probably being more successful. His oils tend to be crude in colour, 'wholly artless' according to Caw, while ALEXANDER NASMYTH described him as chief of the 'docken school'. His watercolours, on the other hand, are fresh in colour and technique and reveal an early attempt at outdoor naturalism.

Gibb, Robert 1845–1932
ARSA 1878, RSA 1882, Keeper of the National Gallery of Scotland 1895–1907, King's Limner to Scotland 1908
Born Laurieston, he trained at the RSA Schools. His early work was devoted to historical and literary themes, often with a romantic undertone, but he later turned to military scenes such as *Retreat from Moscow* and *The Thin Red Line* which established his reputation. He also painted a number of canvases about the Crimean war including *The Alma*. He was a capable portrait painter.

Gibb, William 1839–1929
Born Laurieston, the elder brother of ROBERT GIBB. Trained as a lithographer, but became known for his accurate watercolours of objects of applied art: church gold and silver, relics, Oriental porcelain. His work is superbly detailed but, as MARTIN HARDIE points out, 'they cannot be called inspiring'. Illustrated *Dundee: Its Quaint and Historic Buildings* by A.C. Lamb (1895). Died London.

Gibson, David Cooke 1827–56
Born Edinburgh, Scottish portrait and genre painter, he settled in London in the 1850s. An account of his life was published in 1858 under the title *The Struggles of a Young Artist : Being a Memoir of David C. Gibson, by a Brother Artist* (W. MacDuff).

Gibson, James Brown 1880–?
Studied GSA. Painter in oil and watercolour, etcher, designer and sculptor. Exhibited landscapes at the RSA, RSW.

Gibson, Mary Stewart fl.1930s–40s
Studied at GSA and in Paris. Painted rural views with farm workers. Some of her best work was done in France.

Gibson, Patrick 1782–1829
RSA 1826
Born Edinburgh, he studied with ALEXANDER NASMYTH in York Place before moving on to the Trustees' Academy. Spent 1805–9 in London, returning to Edinburgh where he became a water-colourist of some success and a writer on art matters. His *View of the Progress and Present State of the Arts and Design* was published in the Edinburgh Annual Register 1816, and in 1817 *Selected Views of Edinburgh with Historical and Explanatory Notes* appeared with etchings by Gibson. In 1824 was appointed Head of Painting at Dollar Academy. Gibson's watercolour style is controlled and a little wooden, but his sense of colour was good. In 1812 he accompanied Sir George MacKenzie on a visit to the Faroe Islands, and a volume of 26 views by Gibson is in the British Museum. His accurate and careful manner was well suited to this kind of topographical work. He was a Foundation Member of the RSA 1826.

Gibson, William Alfred 1866–1931
Born Glasgow. Spent ten years in the Royal

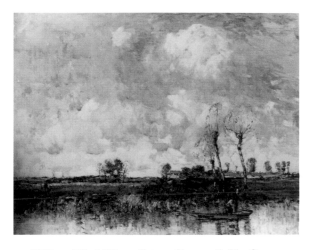

William Alfred Gibson *Between Showers* oil, The George Street Gallery, Perth

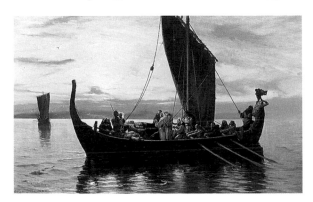

Robert Gibb *Last Voyage of the Viking* oil, Bourne Fine Art

Glasgow Queen's Own Yeomanry and saw service in the Boer War, but after a short business career turned to art. Painted landscapes, mostly in oil, and was strongly influenced by the Dutch School and Corot, both in subject matter and in the subdued tones of silvery greys, greens and browns he used. His favourite subjects were river views in Scotland and in Holland characterised by powerful leaden grey skies and broken brushwork. Died Glasgow.

Giles, James 1801–70
RSA 1830
Born Aberdeen, the son of Peter Giles, a calico designer, artist and art teacher. Giles learnt much from his father and by the time he was 15 he was himself teaching drawing in Aberdeen. In 1824–5 Giles made an extended trip through Europe, through France via Toulon and Marseilles to Genoa, Florence, Siena and Rome where he spent Christmas 1824, moving down to Naples before returning via Venice and Switzerland. The many watercolours he made on this trip reveal his ability as an artist with a delicate but sure touch and a sense of light and shade.
On his return to Scotland, Giles continued to produce topographical watercolours. In 1839 the 2nd Duke of Sutherland commissioned him to paint watercolours of his huge estate, while Queen Victoria appointed him to paint the original castle of Balmoral to help the Royal couple decide on its purchase. He also worked up his Italian

sketches into larger watercolours and oils. Giles' patrons also wanted animal and sporting pictures, and as he struggled to produced these with the required 'finish' so his earlier verve and spontaneity deserted him.

Giles, John West fl.1830–64
Aberdeen painter of animals and hunting scenes.

Gilfillan, John A. fl.1820–40
Served in the Navy before turning to art; Professor of Painting in Glasgow c.1830–40, but emigrated to New Zealand where he died. Painted marine subjects and views of Glasgow in watercolour, using a cool style with silvery colours and clear drawing.

Gilfillan, Tom fl.1940s–50
Lived in Troon and Ayr and painted landscapes and townscapes in the west of Scotland. Successfully captured the flavour of life in this period, especially in his golfing scenes.

Gillespie, Alexander Bryson fl 1900–40
Edinburgh artist who worked in oil, watercolour and also as an etcher.

Gillespie, Floris Mary 1882–1967
Born Bonnybridge, studied GSA, taught at Stranraer High School. Watercolour painter. Died Edinburgh.

Gillespie, Janetta S. 1876–1956
RSW 1943

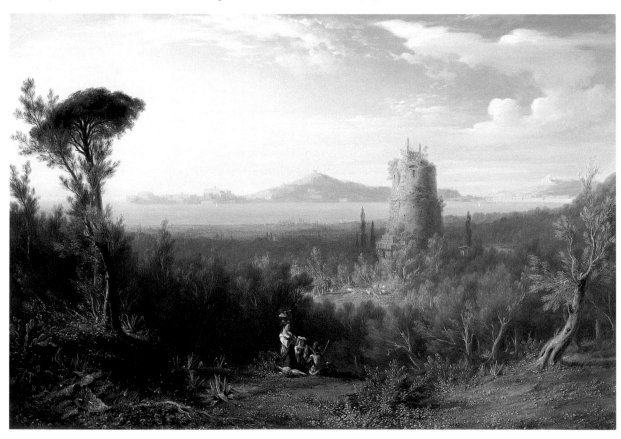

James Giles *Cicero's Tomb at the Bay of Gaeta* oil, Aberdeen Art Gallery, Aberdeen City Arts Department

Sister of FLORIS GILLESPIE, studied GSA, taught Bonnybridge School, Stirlingshire. Painted still life and flowers in watercolour.

Gillies, Margaret 1805–87
ARWS 1852

The daughter of a Scottish merchant who settled in London, she was orphaned when young and brought up by Lord Gillies in Edinburgh. She returned to London in 1823 and studied under Frederick Cruikshank and later in Paris. She painted miniatures and watercolours of single figures, often Scottish, in landscape settings. Her figures are often sentimental, somewhat like those of ROBERT HERDMAN, and she was influenced by Pre-Raphaelite detail. Although she lived in London and later in Hampshire, she made regular visits to Scotland.

Gillies, Sir William George 1898–1973
ARSA 1940, RSA 1947, RSW 1950, CBE 1957, ARA 1965, Knighted 1970, RA 1971, PRSW 1963–69

Born Haddington, East Lothian, his interest in art was encouraged by his uncle WILLIAM RYLE SMITH, an art teacher and watercolourist from Broughty Ferry. He enrolled at ECA in 1916 but after two terms was called up in 1917, resuming his studies in 1919. His teachers at ECA included D.M. SUTHERLAND who influenced his use of colour, DAVID ALISON who influenced his handling of oil, ADAM BRUCE THOMSON and DONALD MOODIE. In 1922 Gillies graduated and became a founder member of the 1922 Group with MACTAGGART, GEISSLER, CROZIER and others. In 1923 he received a Travelling Scholarship and visited Paris with Geissler, studying with André Lhote. Lhote's decorative Cubism did little for Gillies and he made his way to Florence. After a year teaching at Inverness Academy, Gillies joined ECA's staff which now included MACTAGGART with MAXWELL joining in 1929.

During the late 1920s and 1930s Gillies developed a loose, almost Expressionist style, painting the Scottish landscape on-the-spot showing the influence of Edvard Munch. He loved the changing skies and colours of Scotland and aimed at direct expression. He often spent painting holidays with JOHN MAXWELL and others.

In 1939 Gillies moved to the Midlothian village of Temple where the surrounding landscape provided the subject for many of his later works. He visited the villages of East Linton, Haddington, Howgate and Gifford on his motorcycle, painting in oil and watercolour. In the post war period his landscapes became more complex, using intricate patterns of roofs, winding roads, fences, trees and hedges as constructive elements. Pencil and ink outlines became important in his watercolours. He also enjoyed the east coast fishing villages whose nets and boats provided similar fascination. In 1946 he was appointed Head of Painting at ECA, becoming Principal 1960–6. Despite his full-time teaching job his art never suffered and he continued to paint landscapes, interiors and still-lifes right up to his death.

W.G.G. W Gillies.

Gilmour, James fl.1885–1937
Glasgow artist who painted landscape watercolours in a fresh, loose style with sparkling colours. Also Fife harbour scenes.

Glasgow Art Club
The prime mover behind its foundation in 1867 was WILLIAM DENNISTOUN; other founder members included PETER S. BUCHANAN, DUNCAN MCLAURIN and ROBERT MUNRO. In 1876 JAMES DOCHARTY was elected and, at the time, was regarded as being the leading artist member. ALEXANDER KELLOCK BROWN, a future President, declared in 1877 that it 'comprises in its membership all the leading artists in Glasgow and the West of Scotland.' Notwithstanding that boast, the Club rejected the applications of JAMES GUTHRIE, W.Y. MACGREGOR, E.A. WALTON and JAMES PATERSON. ARCHIBALD MCGLASHAN was only admitted on condition that he formally withdrew 'any statement he had made about the club or any of its members.'

The Club moved to its present premises in 1893. John Keppie was engaged as architect and the two adjoining houses at no. 187 and 191 Bath Street were combined in a scheme which involved the building of the Long Gallery where the gardens were situated at the back. The young architect C.R. MACKINTOSH, is believed to have designed the two fireplaces and the detailing for doors and ventilators.

The Glasgow 'Boys' or School
The Glasgow School was formed when a group of young Glasgow artists came together to challenge the pre-eminence of Edinburgh and the RSA. Many had trained in Paris and were influenced by the new ideas of social realism in art as expressed by Bastien-Lepage, and they also admired the work of Whistler who had rejected historical or moralistic subjects to concentrate on tonal harmonies and decorative effects. The School evolved out

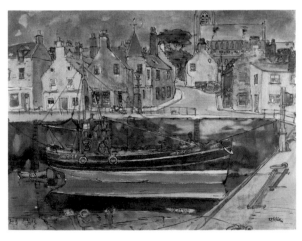

W G Gillies *East Neuk Fishing Village* watercolour, The Ellis Campbell Collection

of three groups: one consisting of PATERSON and MACGREGOR, who in 1877–8 worked during the summer months at St Andrews and Stonehaven on the east coast. At the time Paterson was studying in Paris (1878–1882), but returned to Scotland to paint in the summers. The second was composed of WALTON and CRAWHALL, who were related by marriage, and GUTHRIE. They painted at Rosneath on the Clyde in the summer of 1879 and in 1881 they worked at BRIG O TURK in the Trossachs where they were joined by HENRY. The third group had all studied in Paris and spent the summer months at Grez-sur-Loing where they were influenced by William Stott of Oldham, who was himself influenced by Bastien-Lepage and Whistler. This group consisted of LAVERY, KENNEDY, MILLIE DOW and ROCHE. Grez was a village in Fontainebleau favoured by American and Irish artists including Frank O'Meara whose work left a considerable impression on the young Scottish painters.

During the early 1880s MacGregor ran a life-drawing class in his Glasgow studio and many of the young artists met here. The summer months were usually spent working in small villages in the country such as COCKBURNSPATH near Dunbar. The idea of working in a small rural community stemmed from Bastien-Lepage's work in Damvillers, and had its parallel in the Newlyn School. 'The Boys' recorded farming life in canvases such as *A Hind's Daughter, Playmates*

Glasgow School of Art photograph by Victor Albrow

and *A Daydream* using strong verticals, a high horizon with a flattened background space, and an emphasis upon decorative qualities enhanced by the use of square-brush technique.

Around 1885 most of 'The Boys' returned to work in Glasgow where Lavery painted *The Tennis Party* and Walton the streets of Helensburgh, both painting middle class urban views rather than scenes from rural life. Outings were made to KIRKCUDBRIGHT where HORNEL continued to live and work and to CAMBUSKENNETH near Stirling where Kennedy had a property. In 1888 the *Scottish Art Review* was established as the mouthpiece of the group, and MACAULAY STEVENSON, who was well connected in Glasgow, acted as unofficial spokesman. During this period 'The Boys' became recognized in London, where they were invited to exhibit at the New English Art Club, and in Scotland, where they were well represented at the 1888 Glasgow International Exhibition, and abroad, particularly in Germany and Austria. In 1888 Guthrie was elected ARSA, followed by Walton in 1889.

During the 1890s Guthrie, Walton and Lavery moved towards more conventional art and were to become establishment figures. Henry and Hornel continued to produce more revolutionary work in Kirkcudbright as seen in Henry's *Galloway Landscape* which has interesting parallels to Gauguin's work in Pont-Aven. Henry and Hornel cooperated on *The Druids* (1890) combining decorative and figurative elements, and in 1893 they visited Japan together producing some of the most interesting work of the Glasgow School. Other artists were also travelling – MELVILLE in Spain, North Africa and the Middle East, Crawhall, Lavery and Kennedy in North Africa and GAULD in France.

By 1900 the great period of the School was past, and some of the members, like Lavery, Henry and Guthrie, had painted their best works. Others, like Paterson, Walton, Melville and Crawhall continued to paint fine and often original works, although Melville died young in 1904 and Crawhall in 1913. Guthrie was to become President of the RSA and both he and Lavery were knighted. The School was loosely constituted with no official membership nor annual exhibitions, and there are even discrepancies as to who was actually a member. The following are generally considered as 'The Glasgow Boys': Crawhall, Millie Dow, Gauld, Guthrie, WHITE-LAW HAMILTON, Henry, Hornel, Kennedy, Lavery, MacGregor, HARRINGTON MANN, Melville, CORSAN MORTON, Paterson, Roche, Macaulay Stevenson, GROSVENOR THOMAS, and Walton. Closely associated with the School at various times were CHRISTIE ALEXANDER MANN, NAIRN, PARK and PIRIE.

The Glasgow Institute

The Glasgow Institute (latterly the Royal Glasgow Institute) was founded in 1861 with the aim of encouraging contemporary art and artists and promoting patronage as well as production of art. In its early years it showed work by Millet and other members of the Barbizon School; the Hague School;

the Pre-Raphaelites and other emergent, influential schools. The successful exhibitions rivalled those of the RSA and encouraged THE GLASGOW BOYS and other young painters to travel abroad and develop new styles. The annual exhibitions became the largest in Scotland. Although separate from the GLASGOW ART CLUB, there have always been close links, including an annual 'Varnishing Dinner' at the Art Club, and, in recent times, the RGI Exhibition has been held within the Club's Bath Street premises.

The Glasgow School of Art

From the mid 1860s, GSA classes were held in the Corporation Galleries (latterly Treron's department store) and in 1885 FRANCIS H NEWBERY was appointed Headmaster (see entry NEWBERY, FRANCIS H). Under his energetic direction, the activities at GSA were expanded and accommodation at the Galleries was effectively outgrown. In September 1895 the Governors met to formulate plans for a new building and a competition was launched for a suitable design.

The successful design came from the firm of Honeyman & Keppie although it was, in fact, the sole design of the young architect and designer CHARLES RENNIE MACKINTOSH. The granting of the commission to a young and untried architect was as controversial as his design but Newbery was Mackintosh's former teacher, his friend and unreserved admirer. The bold scheme was an outstanding success despite the critics. 'The new School of Art was by no means a superficial essay by an art nouveau decorator as the critics contended, but a building designed by an architect with a superb grasp of the three-dimensional nature of his art; a building designed primarily to fulfil its purpose well, with, of course, some artist's licence, for the time of the functionalist pure and simple had not yet come. It was and it remains Mackintosh's most representative work, and it is undoubtedly his most important contribution to the new movement'. (Thomas Howarth: *Charles Rennie Mackintosh and the Modern Movement*, 1952).

The Glasgow Society of Lady Artists

In 1882 eight women painters, teachers and art workers, all former students of ROBERT GREENLEES at GSA met at Greenlees' studio at 136 Wellington Street and formed the Glasgow Society of Lady Artists. In 1883 the first Annual exhibition took place and a further 30 artists joined the Society. The first President died shortly after taking office and GEORGINA GREENLEES was appointed in her place. The entrance fee was 10s 6d as was the annual subscription, but Honorary members paid 5s. The aim of the Society was to organize members' exhibitions, hold classes and lectures.

Mrs Jessie Paterson Wingate suggested that the Society should form itself into a club along the lines of the GLASGOW ART CLUB, and a house in Blythswood Square was leased and the name expanded to the Glasgow Society of Lady Artists' Club. The name was changed in 1893 and the official opening took place in December. This was the first Woman's Club in Scotland and in 1895 a special exhibition and fancy dress party was held to raise money to build a gallery extension, and to buy the freehold of the building. £2777 was raised and 5 Blythswood Square was bought. Disaster struck in 1901 when a fire destroyed the Gallery and its pictures including two watercolours by MARGARET MACDONALD MACKINTOSH. A new gallery was built, again designed by George Walton, and was opened in October 1902.

There was considerable controversy in 1908 when the newly arisen young architect C.R. MACKINTOSH was commissioned to redecorate hall and staircase and to redesign the entrance to the Club. The Council of the Club rejected the design as out of keeping with the classical elegance of the Square but, during the Summer holidays, Mackintosh proceeded with the work to the general approval of the membership!

The Club became extremely popular and a long waiting list for lay membership built up. Three annual exhibitions took place – of oils, watercolours and crafts – while special exhibitions were also arranged, such as *The Art of the Book* (1934).

After the Second World War membership began to fall and in 1970 the Club was dissolved, its building being sold to the Scottish Arts Council in 1971. In

Doorway at 5 Blythswood Square by C R Mackintosh for the Glasgow Society of Lady Artists (1908)

1975, however, a new Glasgow Society of Women Artists was established. The Glasgow Society of Lady Artists' Club was an essential ingredient in the flowering of art in Glasgow and its members included ANN MACBETH, KATHERINE CAMERON, MAY MARSHALL BROWN, JESSIE KEPPIE, MAGGIE HAMILTON, NORAH NIELSON GRAY, JESSIE KING and many other leading Glasgow women artists.

Glass, John 1820–85
ARSA 1849
Born Edinburgh and entered Trustees' Academy 1838. Edinburgh painter of horses, ponies and other animals. He later emigrated to Australia and gave up painting.

Glass, John Hamilton fl.1890–1925
Prolific painter of coastal views in Scotland and Holland. Lived in Musselburgh and often worked on the east coast in Angus and Fife, but also painted on Iona. His watercolours vary greatly in quality due to a propensity for heavy drinking; some can be effective in a breezy, open style while others lose all sense of structure. His figures tend to be rather dumpy, and his colours grey and green. His wife MARY WILLIAMS produced watercolours in a similar style. He occasionally painted signing his work 'C. Williams.'

Glass, William Mervyn 1885–1965
ARSA 1934, RSA 1959, PSSA 1930–3.
Studied at Gray's School of Art and the RSA Schools and in Paris and Italy. In 1913 he settled in Edinburgh and then served in the war. A painter of coastal scenes, seascapes and landscapes, he usually signs with his initials. Particularly fond of Iona. Had firm views on commitment to painting and refused to teach: 'The thing that gets me is that nine-tenths of the painters in Scotland have to beg for their bread and butter. In their spare time and during holidays they squeeze in enough time to do some real painting.' (1959)

Glen, Graham fl.1897–1915
Edinburgh portrait painter whom Caw praises for his 'fine taste and good colours'. Moved to London c.1914.

Glover, John fl.ca.1900
Dumfries artist who also painted on the continent. Landscapes in oil.

Glover, William fl.1875–1900
RSW 1878
Amateur Glasgow landscape painter who was a theatre manager and scene painter by profession. Painted coastal scenes and landscapes of the west coast, often with rather weak drawing.

Glover, Edmund fl.1830s–50s
Lived in Edinburgh and painted seascapes and Highland landscapes.

Godby, Frederick fl.1840s–50s
Lived in Edinburgh and painted Scottish landscape. Exhibited RSA.

Good, Thomas Sword 1789–1872
HRSA 1828
Born Berwick-on-Tweed, he studied under SIR DAVID WILKIE and painted domestic genre, fisherfolk and coastal scenes around Berwick. Inherited a legacy c. 1830 and ceased painting.

Goodfellow, David 1871–1941
A baker from Broughty Ferry who painted watercolours of flowers and landscapes.

Gordon, Esme Alexander b.1910
ARSA 1957, RSA 1967
Born Edinburgh and studied architecture at ECA. Set up in practice as an architect 1937 and became instructor in School of Architecture at ECA. Exhibited watercolours at RSA from 1931; principally architectural subjects. Hon. Secretary RSA 1972–7. Author of *The Royal Scottish Academy 1826–1976* (1976).

Gordon, James fl.1840s–50s.
Painted views of Edinburgh. Exhibited RSA.

Gordon, James fl.1820–50
Aberdeen artist who painted views of Aberdeen, often for reproduction. A sound draughtsman, he used a mixture of charcoal, pencil and wash in a

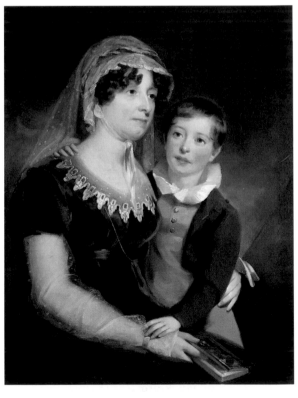

Sir John Watson Gordon *Lady Nairne and her Son* oil, National Gallery of Scotland

fluent style. His work was used for Nichols' *Cities and Towns of Scotland*.

Gordon, John Ross 1890–?
Studied at Gray's School of Art, Aberdeen and became a landscape etcher and watchmaker.

Gordon, Sir John Watson 1788–1864
RSA 1830, ARA 1841, RA 1851, PRSA 1850–64
Son of a Royal Navy captain, he embarked on a training for the Royal Engineers, but having met WILKIE at the Trustees' Academy, where he was studying drawing, he decided to turn to art. His uncle GEORGE WATSON, and RAEBURN, who was a friend of the family, encouraged him. He produced some historical subjects as a young man, but made his reputation in portraiture. During the 1820s, Raeburn was the main influence on his portrait style, although Lawrence was also important to Gordon. Velasquez was to become another important influence in later years. In 1826 he added the name Gordon to Watson to distinguish himself from his uncle, and cousin who were both Edinburgh portrait painters. He became the most successful mid-century portrait painter and his sitters included Sir Walter Scott, David Cox and the Earl of Hopetoun. His reputation in London was also considerable. His colours were silvery in tone, reflecting his love of Velasquez, and his brushwork fluent and expressive. Died Edinburgh.

Goudie, Isobel Turner Maxwell b.1903
Studied at GSA; she was noted as a potter and stained-glass window designer.

Goudie, Alexander b.1933
RP
Born Paisley and studied at GSA where he was awarded the Newbery medal. Influenced by the teaching of DAVID DONALDSON and carries on a portrait painting practice in the Glasgow tradition stretching back to Lavery. Lives and works in Glasgow for the main part and also paints landscapes and harbour scenes in Brittany. Exhibits widely and has been the subject of television documentary coverage.

Gourdie, Thomas b.1913
Born Cowdenbeath and studied at ECA 1932–37. Painter in oil and watercolour as well as designer and calligrapher. Has exhibited at RSA, RSW and SSA. Has painted in Orkney and lives in Kirkcaldy.

Govan, Mary Maitland fl.1884–1925
Born Gibraltar, she studied in Birkenhead, Antwerp and Edinburgh where she settled in the 1880s. Painted marine subjects, flowers and romantic genre in oil and watercolour.

Gow, James F. Mackintosh fl.1881–98
Edinburgh landscape painter, who painted Scottish scenes mostly but also worked in Holland.

Gowans, George Russell 1843–1924
RSW 1893
Aberdeen artist who painted watercolour landscapes and some portraits in oil. His large and often powerful landscapes of the north east of Scotland have broad skies and wide expanses of fields and moors.

Graeme, Colin fl.1900
Painter of hunting and shooting scenes with dogs.

Graham, James B. fl.1870s–80s
Lived in Merchiston, Edinburgh, and painted rural landscapes and seascapes.

Graham, John 1754–1817
Born Edinburgh, he was apprenticed to a coach painter before moving to London to study at the RA Schools. Remained in London, apart from a trip to Italy, until 1798, painting historical scenes and literary subjects. He achieved some success as Boydell commissioned two works from him for his Shakespeare Gallery. In 1798 he returned to Edinburgh to establish a new Drawing Academy whose aim was to provide a parallel to the Trustees' Academy, but which would concentrate upon the fine arts. In 1800 the two courses were fused into one, with Graham as the Master. The Trustees' Academy was modelled upon the RA Schools, and Graham introduced history painting and drawing from the Antique. There was, however, no life drawing at this stage. Graham was greatly admired by his students and his contribution to the training of many successful Scottish artists was considerable. These included WILKIE, ALLAN, GEIKIE, CARSE, FRASER and DAVID ROBERTS. He remained Master until his death in 1817.

Graham, Peter 1836–1921
ARSA 1860, ARA 1877, HRA 1877, RA 1881
Born Edinburgh. The son of an accountant, he studied at the Trustees' Academy under SCOTT LAUDER. His earliest pictures were figure compositions, but in the 1860s he turned to landscape.
In 1866 he settled in London and achieved a notable success at the Royal Academy with *The Spate*. This led to a commission from Queen Victoria: *Bowman's Pass: Balmoral Forest* (1868). Although living in the South, he returned each year to Scotland and painted many landscapes of the most rugged and inaccessible terrain. His success was great and his dealer, Sir William Agnew, kept a waiting list for his work. His best work was done from the late 1860s to 1890, and he captured well the brooding melancholy of the Highlands. His subjects were somewhat mundane but were skilfully executed.

Graham, Robert B. fl.1850s–60s
Edinburgh landscape painter. Exhibited RSA.

Peter Graham *Moorland and Mist* oil 1893, Dundee Art Galleries & Museums

Graham, Thomas Alexander Ferguson 1840–1906
HRSA 1883
Born Kirkwall and went to the Trustees' Academy aged just 15. His fellow students included ORCHARDSON, PETTIE, MCTAGGART and MACWHIRTER. In 1860 he visited Paris with McTaggart and PETTIE and in 1862 he visited Brittany.

Graham moved to London in 1863, sharing a house in Fitzroy Square with Orchardson and Pettie, and in the following year visited Venice. His earlier work was influenced by the Pre-Raphaelite interest in detail; he admired the work of Millais. His style gradually broadened following the same pattern as McTaggart and MacWhirter.

His best work combines an insight into the human predicament with a painterly technique. Best known of these are *The Landing Stage* and *Alone in London*. He also painted figures out-of-doors set in French harbours, hayfields or by the sea. His best pictures have a high key and luminous colours.

He was a man of great charm and good looks, but he never quite achieved the success of his fellow pupils at the Trustees' Academy.

Graham-Gilbert, John 1794–1866
RSA 1830
Born Glasgow, the son of a wealthy Glasgow merchant, who opposed his desire to paint as a career,

he studied at the RA Schools, winning a gold medal in 1821. Painted portraits in London 1820–3 before departing to Italy for two years. His Italian experience greatly influenced his art, especially his love of the Venetian masters. He settled in Edinburgh in 1827 although most of his commissions came from the west coast. Like RAEBURN he married one of his sitters, Miss Gilbert of Yorkhill, a wealthy heiress, and when she succeeded to the estates, he added her name to his own.

In 1834 they settled in Glasgow where he painted portraits, travelled extensively abroad and collected Old Masters, including works by Rubens and Rembrandt now in Glasgow Art Gallery. Not only did he paint portraits, but also single figures in fancy costume or dressed as Scottish peasants and beggars. Caw suggests that he was more successful painting women than men. His tendency not to work too hard was reinforced by his marriage, but he became a major figure in artistic circles in Glasgow. He was President of the WSA (1840–1853) and one of the founders of the Glasgow Institute. Caw notes that despite being resident in Glasgow he missed election as President of the RSA only by the casting vote of the Chairman in 1864. Died Glasgow.

Graham-Yooll, Helen Annie fl.1880–98
Figure and genre painter in oil.

Grahame, John B. fl.1866–79
Edinburgh painter of landscape and mural scenes genre.

Thomas Graham *Idle Hours* oil 1862, private collection

Grant, Sir Francis 1803-78
ARA 1842, RA 1851, PRA 1866–78
Born Kilgraston, Perthshire, he painted at first as an amateur but turned to art as a living when he had spent his inheritance. At first he painted hunting scenes including *The Melton Hunt* for the Duke of Wellington (1839) but he was also in demand as a portrait painter. His *Queen Victoria riding at Windsor Castle with her Gentlemen* (RA 1840) earned the approval of the Queen and his future success was assured. This was followed by an equestrian portrait in 1845, which created a fashionable image of the Queen. Other sitters included Melbourne, Palmerston, Macaulay and Landseer.

Grant's success was partially due to his social position and his tendency to flatter his sitters. He had never been trained as an artist and he never visited Italy nor studied the Old Masters. His portraits are competent, if not inspired, although his preparatory drawings show ability. He remained a keen huntsman and after his election as President of the Royal Academy a fellow artist W.P. Frith recalled his speech at the annual banquet: 'There was a rollicking, fox-hunting kind of flavour about his speeches; he leapt over all questions, and just shook his whip at the students, or the short comings of exhibitors'.

Francis Grant

Grant, John fl.1830–40
Known as John Grant of Kilgraston, he was the elder brother of SIR FRANCIS GRANT. Portraits and society subjects in oil.

Grant, Thomas fl.1880s
Glasgow painter of landscapes and townscapes in oil.

Grant, Thomas F fl.1868–79
Painter of Highland scenes.

Gray, Alasdair b.1934
Born Glasgow and studied mural painting at GSA. Exhibited in Glasgow and Edinburgh and painted portraits and murals. Works as a writer and probably best known as author of the monumental novel *Lanark* (1981), which he also illustrated, as well as for being a genuine eccentric.

Gray, Alice fl.1880s–1904
Lived in Edinburgh and painted portraits, flowers, figures and miniatures on ivory.

Gray, George fl.1880–1910
Edinburgh landscape painter who produced some tightly composed and well executed watercolours, often with a luminous use of colour. He also painted landscapes in oil.

Gray, James d.1947
RSW 1936
A flower painter who worked in Edinburgh. His work is often free and effective; he also painted landscapes in watercolour. Was Head of Art Department, Moray House. His wife JEAN LYAL CHRISTIE was also a watercolourist. Died Edinburgh.

Gray, Jessie Dixon (Mrs. George Gray) fl.1880s–90s
Lived in Edinburgh and painted rural genre and

figure subjects, often with romantic titles. Married to the artist GEORGE GRAY.

Gray, John 1877–1957
RSW 1941, PRSW 1952–57
Born Angus, he later taught at Grove Academy, Broughty Ferry and was a governor of Jordanstone College of Art, Dundee. Known as a flower painter in watercolour, he often painted with charm and verve. His earlier watercolours depict sand-swept harbours and coast scenes, often with fishing boats. These are sometimes painted on a large scale, in a direct manner onto rough paper.

Gray, Norah Nielson 1882–1931
RSW 1914
Born Helensburgh, she studied at GSA under FRA NEWBERY and Jean Delville from 1901 to 1906. Joined the staff in 1906 as a fashion designer, also teaching art at a school in Kilmacolm. During the period prior to the war established a reputation as a portrait painter in oil and watercolour, and she also painted some fine symbolist watercolours in a style which owed little to the Glasgow Four.
During the war she painted two important works: *The Belgian Refugee* and *The Country's Charge*, the latter being reproduced in *Bibby's Annual* of 1915. After the war continued to paint portraits, her child portraits being particularly successful. She continued to produce watercolours imbued with her own very personal Symbolist imagination. She was influenced by both Maxfield Parrish and Adrian Stokes, especially in nocturnal landscapes. She died of cancer in her 49th year.

Gray, Rosalie 1883–1955
Born Glasgow, née Rosalie Campbell, studied GSA. Watercolourist and embroiderer.

Greenlees, Georgina Mossman (Mrs Graham Kinloch Wylie) 1849–1932
RSW 1878
Born Glasgow, the daughter of ROBERT GREENLEES, studied GSA, taught GSA 1875–1880. A somewhat weak watercolourist, she painted views of Venice, Rome, Capri and Assisi, as well as Switzerland and Belgium.

Greenlees, James fl.1860–1903
Glasgow painter of landscapes and coastal scenes, often along the Clyde.

Greenlees, Marion c. 1850–?
Daughter of ROBERT GREENLEES and sister of GEORGINA. Lived in Glasgow and painted fruit and flowers.

Greenlees, Robert 1820–96
RSW 1878
Head of GSA prior to FRA NEWBERY. Produced landscapes and domestic scenes in watercolour.

Greiffenhagen, Maurice William 1862–1931
NEAC 1886, RP 1909, ARA 1916, RA 1922
Born London and trained at the RA Schools, Greiffenhagen's connection with the Glasgow School came as a result of his appointment as Director of the Glasgow School of Art (1906–1929). He himself painted rather uninspiring portraits in a Whistlerian manner, but more interesting is his work as a graphic artist, in particular his book illustrations, posters and cartoons.

Greig, George M. d.1867
Edinburgh artist who painted watercolours of interiors, picturesque buildings and views of Edinburgh. He also painted children and seaside scenes. During his lifetime he had a considerable reputation as a watercolourist.

Greig, James 1861–1941
RBA 1898
Born Arbroath, he settled in London in 1890, working as an illustrator and satirical watercolourist. Worked in Paris 1895–6, and later became the art critic of *The Morning Post*. He also wrote art historical books including *Life of Gainsborough* and *Life of Raeburn*.

Greig, John Russell 1870–?
Studied Gray's School of Art, Aberdeen, the RSA Schools and in Paris; later joined the staff at Gray's School. Painted figures and landscapes, but was particularly noted for his portraits which reflect the influence of Whistler and BOUGH.

Greville, Robert Kaye 1794–1866
HRSA 1829
Botanist and painter who worked in Scotland and Wales. Painted landscapes and rural scenes and exhibited 1831–59.

Grey, John fl.1860s–80s
Glasgow landscape painter.

Grieve, Alec 1864–1933
Born Dundee, studied at Dundee Art College and Colarossi's, Paris. In the circle of DUTCH DAVIDSON, he later painted powerful watercolours of Tayport and Dundee. A founder of the Tayport Art Circle.

Grieve, Marion fl.1880–1911
Glasgow painter of flowers and fruit.

Grieve, Walter Graham 1872–1937
ARSA 1920, RSA 1929, RSW 1934
Born Kirkliston, West Lothian and studied Royal Institution and at RSA Life School, 1896–99. Began his career as a lithographer. Art Adviser to Thos. Nelson & Sons, he painted many striking pictures of groups of people in unusual situations. *The Cribbage Players* was his highly effective Diploma work for the RSA. Died Edinburgh.

Grimmond, William fl.1880–1914
Glasgow figure painter. Leading Member of GLASGOW ART CLUB.

Grubb, William Mortimer fl.1875–1900
Art Master at Dundee High School in the 1880s.

A.G.

Painted attractive domestic scenes and local views in watercolour.

Gudgeon, Ralston b.1910
RSW 1937
Born Ayr. Painter of birds and animals mostly in watercolour. His paintings vary in quality; at times he combines careful observation and striking design, but on occasions his colours and composition appear to miss the mark.

Gunn, Gordon 1916–ca.1979
Born Glasgow and trained GSA 1934–7 under W.O. HUTCHISON and IAN FLEMING. An early interest in architectural drawing led to many watercolour studies of dams, bridges and buildings generally. Throughout his life maintained a studio in the Highlands and painted watercolours there every year. Interest in astronomy led to a provocative series of 'cosmic paintings' of the planets. Exhibited RGI, 1945; RBA from 1961; RA from 1962; United Society of Artists, Royal Society of Marine Artists and FBA. Died Blackheath, London.

Gunn, Sir Herbert James 1893–1964
RP 1945, PRP 1953, ARA 1953, RA 1961
Born Glasgow, he studied at GSA and at the Academie Julian in Paris under J.P. Laurens. He lived in Paris until 1914 and painted some exquisite views both there and in London. He settled in London in the 1920s, and became a successful portrait painter, although he also painted some landscapes.

Gunn, William Archibald 1877–?
Studied at GSA 1897–1901. Painted landscapes and town scenes in watercolour and pastel. He lived mostly in England.

Guthrie, Sir James 1859–1930
ARSA 1888, NEAC 1889, RSW 1890, RSA 1892, RP 1893, President Glasgow Art Club 1896–8, PRSA 1902–19, Knighted 1903, HROI 1903, HRSW 1903, RBA 1907, HRA 1912
Born Greenock, the son of a minister of the Evangelical Union Church, and studied law at Glasgow University, turning to art in 1877. In 1879 moved to London meeting JOHN PETTIE who influenced his early work, but soon the influence of JOHN R REID and George Clausen, themselves strongly influenced by Bastien-Lepage, could be seen in Guthrie's work.
In the summer of 1879 Guthrie painted with WALTON and CRAWHALL at Rosneath on the Clyde, and in 1881 the three were joined by GEORGE HENRY to paint at BRIG O'TURK. Here Guthrie painted *A Funeral Service in the Highlands* whose social realism made an impact at the 1882 RA. In 1882 Guthrie and Crawhall worked together in Lincolnshire and Guthrie painted *To Pastures New*, exhibited at the 1883 RA. Thus by 1883 Guthrie had become a central figure in the group to be known as THE GLASGOW BOYS. In 1883–85 Guthrie painted at COCKBURNSPATH near Dunbar, joined by WALTON, Crawhall, MELVILLE, Henry and other Glasgow School artists. Guthrie spent three successful years living and working in the village

Walter Grieve *The Cribbage Players* oil, Royal Scottish Academy (Diploma Collection)

Sir James Guthrie *The Cottar's Garden* oil, private collection

recording the life of its inhabitants, and some of his most memorable paintings were executed at this time including *A Hind's Daughter* and *School-mates*. The latter picture was rejected by the RA in 1885 and thereafter Guthrie did not submit to the Summer Exhibition. In 1885 Guthrie turned to portrait painting, avoiding the superficial technical virtuosity of Sargent and attempting to capture the character of his sitters. He also began working in pastels, and became an accomplished practitioner rivalled only by Whistler.

In the late 1880s, Guthrie lived in Glasgow along with other Glasgow Boys and launched his assault upon the 'art establishment' in Edinburgh and London. Success came in 1888 with his election ARSA and with the Glasgow Boys' strong presence at the Glasgow International Exhibition. In 1889 Guthrie visited Paris with Walton and Melville, his second visit as he had made a short trip in 1882, and by the 1890s, Guthrie was an accepted and respected painter. His innovative period was past: his portraits become less inquisitive and he appears to have abandoned pastels. His later years brought success and financial reward as a leading portrait painter, and President of the RSA.

the Arts and Crafts Society and the Barcelona International Exhibition, where he won a gold medal for his graphic work. His book plates were also noted. He moved to south east England around the turn of the century.

Guthrie, James Joshua 1874–1952
Born Glasgow, he was a painter, designer and illustrator as well as author and poet. He established the Pear Tree Press in 1899 and published his own and other people's books and illustrations. Produced bold engravings of landscapes, and exhibited at

H

Hackstoun, William 1855–1921
Born Kennoway, Fife, and trained in Glasgow as an architect. Attracted the attention of Ruskin who taught him for a period. Lived for a time in London, but worked mostly in Scotland, particularly in Fife and Perthshire. Some of his watercolours are straightforward landscapes, but others have a distinctive stylization using strange linear patterns for hills and clouds, often combined with strong colours.

Haig, George Alexander Eugene Douglas, The Earl b.1918
ARSA
Born Kingston Hill, London, the son of the famous Field Marshall, and educated at Stowe School and Christ Church, Oxford. Art education at Camberwell School of Art (1945–7) under WILLIAM JOHNSTONE. Exhibited extensively in UK and abroad since 1945. Paints landscapes and figure studies in oil and watercolour. Lives and works at Bemersyde, Melrose.

Haig, Evelyn Cotton fl.1886–1908
Edinburgh figure and miniature portrait painter.

Haig, Florence E. fl.1886–1929
SWA 1923, ARBA 1925, RBA 1926
Edinburgh portrait and figure painter, she moved to London c.1911.

Haigh, J. Hermiston fl.1887–1919
Lived in Glasgow and Berwickshire and painted landscapes.

Halkerston, Charles d.1899
Edinburgh painter of idyllic landscapes and mythological subjects.

Halkett, George Roland 1855–1918
Born Edinburgh, he studied in Paris before becoming art critic of the *Edinburgh Evening News* in 1876. Moved to London in 1892 to work as an illustrator on the *Pall Mall Gazette* and also worked for *Punch*. He was known as a political cartoonist and also wrote humorous political comment.

Hall, George Wright 1895–1974
Studied ECA and RSA Schools, later taught at Manchester School of Art. His watercolours were influenced by the work of GILLIES and WILSON, and his fluent penwork is combined with rich colours. He was well known as the Director of the City of Edinburgh Art Centre. Died Edinburgh.

Halliday, John b.1933
Born Kirkcudbright and studied at GSA 1949–53; then in France and Italy on an RSA travelling scholarship. Landscapes, townscapes and some portraits. Exhibited RSA and RGI. Mural panels at Prestwick Airport, Scottish & Newcastle Breweries and for National Trust for Scotland at Culzean Castle.

Halswelle, Keeley 1832–91
ARSA 1865, RI 1882
Born Edinburgh and studied with HORATIO MCCULLOCH. Began his career as an illustrator for the Edinburgh publishers Nelson and *The Illustrated London News*. His early paintings often depict fishermen of the east coast villages, but in 1868 went to Rome for the first time and turned to Italian landscapes and people for his subjects. Settled in London in 1872 and painted many views on the Thames, although he returned regularly to Scotland to paint Highland scenes. Died Paris.

Hannah, George b.1896
Born Renfrewshire, he was self-taught and was a founder member of the NEW ART CLUB and the NEW SCOTTISH GROUP in Glasgow in the early 1940s. Painted landscapes and town scenes.

Hamilton, Catherine 1854–1948
Wife of JAMES HAMILTON. Studied at Art School on the Mound and exhibited at the RSA during the 1890s. Died Newbattle.

Hamilton, Gavin 1723–98
Born Lanark and studied at Glasgow University. Travelled to Italy c. 1745 and trained under Masucci. Returned to London where he worked as a portrait painter. Showed skill as a portrait painter but moved on to the painting of historic and classical scenes. Travelled in England and Scotland but spent most of his life in Rome where he became absorbed in the worlds of archaeology and antiquities. He enjoyed a considerable reputation and his popularity tended to equal the quality of much of his work. Much of his influence may be attributed to the dispersal of engravings of his work. Died Rome.

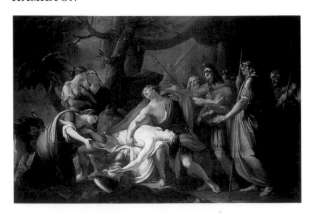

Gavin Hamilton *Achilles Lamenting the Death of Patroclus* oil,
National Gallery of Scotland

Hamilton, Gawen ca.1697–1737
Born near Hamilton. Most of his painting was done in London. Group portraits and conversation pieces.

Hamilton, James fl.1640–1720
Born Murdieston, Fife, and worked as a portrait painter in Edinburgh before settling in Europe. Later painted still-life and fruit in Brussels and Germany. Died Brussels.

Hamilton, James 1853–94
ARSA 1886
Edinburgh painter of genre and historical subjects, he was known for his Jacobite subjects.

Hamilton, James Whitelaw 1860–1932
RSW 1895, ARSA 1911, RSA 1922
Born Glasgow where he studied before going to Paris to train under Dagnan-Bouveret and Aimé Morot. In 1884 he joined GUTHRIE, HENRY, CRAWHALL and MELVILLE at COCKBURNSPATH. His landscapes have a rugged quality and his best work is of fishing villages with people gathered on the quays. He worked in oil, pastel and watercolour, his nocturnes being amongst his most sensitive work.

James Whitelaw Hamilton *Down Among the Herring Fishers*
oil, private collection

His paintings were appreciated abroad; he became a member of the Munich Secession and won a prize at the 1897 International Exhibition in Munich. He was a close friend of the GLASGOW BOYS, but his paintings stand outside the mainstream of the School, possibly lacking their originality. Died Helensburgh.

Hamilton, Maggie (Mrs A N Paterson) 1867–1952
Sister of JAMES WHITELAW HAMILTON, she visited COCKBURNSPATH in the summer of 1883–5 with her brother to help James Guthrie's mother keep house. Her portrait was painted several times by Guthrie. In 1897 she married ALEXANDER NISBET PATERSON, the brother of JAMES PATERSON, who was an architect and painter. She was an artist member of the Lady Artists Club, and Vice-President in 1928 and 1937. Painted landscapes and still-life in oil, and she was also a fine embroideress.

Hamilton, Mary Elizabeth fl.1898–1936
Born Skene, Aberdeenshire, she studied at the Byam Shaw School of Art in London before returning to Murtle in Aberdeenshire. Painted landscapes in oil and watercolour.

Hamilton, Thomas 1785–1858
RSA 1826
Important Edinburgh architect responsible for Edinburgh Royal High School, the Burns Memorial, Ayr and many other buildings. A particularly fine architectural watercolourist.

Hamilton, Thomas Crawford fl.1880–1900
Painter of portraits, figures and religious subjects in oil and watercolour.

Hanginschaw, Mungo fl.1620s
Glasgow decorative painter who worked during the first quarter of the 17th century.

Hannah, Andrew G. fl.1906–40
Glasgow landscape painter who exhibited at the Glasgow Institute.

Hannah, Robert 1812–1909
Born Creetown, Wigtownshire. Painted historical and genre subjects in a style similar to the Faeds. Charles Dickens bought two paintings by him. Exhibited London, Liverpool and Rome.

Hansen, Hans 1853–1947
RSW 1906–13
Born Leith, the son of a merchant and shipbroker, and brought up in Leith and Edinburgh where he studied art under R.B. NISBET and J. ROSS, developing a style superficially similar to MELVILLE. Worked extensively abroad, in the Middle East, North Africa and Spain, visiting Russia in the 1870s. Exhibited RA 1891–1918. The quality of his work varies greatly; at his best he could produce attractive, decorative views of Eastern markets or

bull fights, but at times his work is weak in drawing and crude in colour. Died Southend-on-Sea.

Charles Martin Hardie *The Friendly Critics* oil 1883, National Gallery of Scotland

Hansen, Lys b.ca.1940

Born Stirlingshire, trained ECA under GILLIES and PHILIPSON and later at the British School of Painting, Rome. Studied Fine Art at Edinburgh University. Paints boldly executed female figures and nude studies. Exhibits RSA, SSA, RSW and SSWA. Lives and paints at Blairlogie, Stirlingshire.

Harcourt, George 1869–1947

RA 1926

Born Dumbartonshire. For many years director at HOSPITALFIELD, Arbroath. Painted portraits. Exhibited RA. President Royal Society of Portrait Painters. Died Bushey, Hertfordshire.

Hardie, Charles Martin 1858–1916

ARSA 1886, RSA 1895

Born East Linton, he studied at the RSA Schools. Became popular for his pictures of Scottish life such as *Burns in Edinburgh* (1887) or *The Childhood of Sir Walter Scott* (1893). Also painted delightful rural scenes with pretty girls feeding hens or sitting in idyllic landscapes, but he cannot be considered a social realist, for, as Caw points out, his 'Scottish peasant is rather apt to be endowed with the airs and graces of drawing-room comedy, and in consequence the natural piquancy of the situation becomes tinged with artificiality'. Also painted portraits and some pleasant watercolour landscape studies. One of Hardie's most interesting pictures, *The Friendly Critics*, was exhibited at the RSA in 1883. It caused something of a stir at the time, being seen as a rare glimpse into Bohemian life at Hardie's Picardy Place studio in Edinburgh. Hardie himself is showing off a new oil which is being assessed by a group of his fellow artists including ROBERT NOBLE (seated nearest) and GEORGE WHITTON JOHNSTONE (leaning over his shoulder). Died Edinburgh.

Hardie, Martin 1875–1952

ARE 1907, RE 1920, RI 1924, VPRI 1934, RSW 1934, CBE 1935

Educated at St Paul's School and Trinity, Cambridge he studied under Sir Frank Short. Was the nephew of CHARLES MARTIN HARDIE and retained strong links with Scotland and Scottish painters. A fine watercolourist, he painted views in France and Italy and East Anglia, using a firm pen outline and a fluid watercolour technique – a style not unlike that of his close friend, MCBEY. Keeper of Prints and Drawings, VAM 1921–35 and author of books on the history of watercolours. Often signs with initials.

Hans Hansen *North African Scene* watercolour, private collection

Hargitt, Edward 1835–95

ARI 1865, RI 1867, ROI 1883

Born Edinburgh, Hargitt studied under HORATIO

Edward Hargitt *Hoy from the Black Craig, Orkney* watercolour, The Robertson Collection, Orkney

MCCULLOCH at the Trustees' Academy. Moved to London as a young man and his name is associated with the English School. During the 1850s he painted detailed watercolours, influenced by the Pre-Raphaelite Movement, and his views of Scottish streams and coasts, which he executed throughout his life, are crisply painted and well constructed. His best work was in watercolour. He was a noted ornithologist.

EH

Hargitt, George F. fl.1850s–60s
Related to EDWARD HARGITT, probably a brother. Painted landscapes. Exhibited RSA.

Harper, Malcolm Maclachlan. fl.1888–1908
Worked as a bank manager in Dumfries and painted landscapes and interiors. Exhibited RGI and RSA. Was a friend of E.A. HORNEL and WILLIAM STEWART MACGEORGE. Wrote *Rambling in Galloway* (1876).

Harris, Arthur fl.1890s
Lived in Newport, Fife, and Blairgowrie. Landscape painter.

Harrison, Edward Stroud 1879–?
Born Edinburgh, he exhibited at the RSA. Lived in Elgin.

Hartrick, Archibald Standish 1864–1950
NEAC 1894, ARWS 1910, RWS 1922 OBE
Born Bangalore, India, he returned with his army family to Scotland in 1866. On the death of his father, his mother married CHARLES BLATHERWICK, a doctor and amateur watercolourist who was closely involved with the foundation of the RSW. Studied at Edinburgh University before going to the Slade School in London and the Academie Julian in Paris. In 1886 he spent the summer in Brittany meeting Gauguin and his circle. He was greatly influenced by developments in French painting and illustration.
He returned to Glasgow and came to know the GLASGOW BOYS, but soon moved to London, joining

the staff of *The Daily Graphic* in 1890 and the *Pall Mall Magazine* in 1893. His illustrative work was very accomplished, being elegant and decorative and well up with developments in France. In particular he was an excellent lithographer.
In 1896 he married the watercolourist LILY BLATHERWICK, the daughter of Charles Blatherwick by his first marriage, and they settled in Gloucestershire. Hartrick was a prolific painter, showing 229 watercolours at the RWS. He painted figures in landscapes, landscapes and flowers. In later years he taught at Camberwell School of Art and at the Central.
He wrote *Lithography as a Fine Art* (1932) and the fascinating account of his interesting life *A Painter's Pilgrimage through Fifty Years* (1939).

A·SH ASH

Harvey, Sir George 1806–76
ARSA 1826, RSA 1830, PRSA 1864–76, Knighted 1867
Born St Ninians, Perthshire, he studied at the

A S Hartrick *The Morning News 1897* oil (grisaille), Paul Harris Esq

Sir George Harvey *Quitting the Manse* oil, Scottish National Portrait Gallery

Trustees' Academy under SIR WILLIAM ALLAN. Harvey's reputation was made with his large historical canvases, often depicting scenes from the lives of the Covenanters. Today these large works have little interest or appeal, but Harvey was also a genre and landscape painter, and in these fields he excelled. His work *Quitting the Manse* (1847) showed the pain caused by the Disruption, with a minister and his family forced to leave their house. His witty observations in *The Curlers* (1835) are similar to GEIKIE's view of Scottish life and it was as a painter of everyday life rather than historical reconstruction that Harvey shone. His landscapes painted in both oil and watercolour capture the atmosphere of the Scottish landscape. Caw commented that Harvey 'realized the pensive charms and pastoral melancholy of the Highland straths and the Lowland hills with . . . insight and sympathy.'

Harvey was active in the formation of the RSA and became its fourth President in 1864.

Harvey, Marion Rodger Hamilton 1886–?
Animal painter born in Ayr, she lived and exhibited in Glasgow. Painted animals – particularly dogs – in oil and pastel

Harvey, Nellie Ellen d.1949
Stirling artist, the niece of SIR GEORGE HARVEY, studied under J. DENOVAN ADAM at Craigmill and in Paris. Painted watercolours of genre scenes, birds and domestic fowl.

Harwood, Henry 1803–68
Born Ireland and brought up in Dundee where he lived throughout his life. Portrait and landscape painter. His work was much esteemed in the Dundee area.

Hay, Andrew fl.1720s–30s
Minor portrait painter principally recorded as a founder of the ACADEMY OF ST. LUKE and as an early art dealer in Edinburgh.

Hay, Constance Drummond fl.1880–1900
Watercolour painter of flower pieces most probably working in the area around Perth.

Hay, George 1831–1912
ARSA 1869, RSA 1876, RSW 1878, Secretary of the RSA 1881–1907
Born Leith, a pupil of SCOTT LAUDER at the Trustees' Academy, he specialised in scenes from the past or literature. Painted figures in 17th or 18th century costume, mostly in oil, but sometimes in watercolour. He also painted the occasional landscape. Lived and worked in Edinburgh.

Hay, James fl.1887–1914
Edinburgh painter of genre and still life in oil and watercolour.

Hay, John Arthur Machray 1887–1960
Born Aberdeen and trained at HOSPITALFIELD. Exhibited RSA from 1919. A society portrait painter, much in the style of LAVERY, he painted a stylish series of portraits of the Wolridge-Gordons in Aberdeenshire.

Hay, Peter Alexander 1866–1952
RSW 1891, RI 1917
Born Edinburgh, he studied at the RSA Schools, in Paris at the Académie Julian, and in Antwerp. His early portraits were influenced by the GLASGOW SCHOOL, but he moved to London c.1893 and his work came under the influence of Sargent, with loose brushwork and technical bravura. His portraits are not unlike his compatriot SHOLTO DOUGLAS who also worked in London. Hay was also an accomplished watercolourist, painting landscapes, often of Perthshire and in the 1920s in France. He also painted effective portraits and interiors in watercolour.

Hay, Ralph W. fl.1920s
Lived in Edinburgh and painted fishing and harbour scenes on the east coast of Scotland in a sombre Dutch influenced style. Taught at George Watson's School, Edinburgh.

Hay, Robert 1799–1863
RSA 1841
An Egyptologist who painted detailed watercolours of Egypt.

Hay, Thomas Marjoribanks 1862–1921
RSW 1895
Edinburgh landscape painter who worked largely in watercolour. His earlier works have a detailed precision which soon broadened into a looser, wetter style. He worked in the east coast villages, in Perthshire and in the Central Highlands. He was good at painting hills and mountains shrouded in cloud or mist, in restrained colours. He also

painted a certain number of 'pot-boilers'. Died Edinburgh.

Hay, William Hardie 1859–?
Born Birkenhead, son of John Hay the architect, studied GSA. Painted Highland and west coast scenes in watercolour and oil, and also worked in Belgium. Lived in Glasgow and was a member of the GLASGOW ART CLUB.

Hayes, Charles fl.1860s–70s
Lived in Paisley and painted still-life, fruit and flowers.

Hector, James A. H. fl.1894–1938
Aberdeen landscape painter.

Hector, W. Cunningham fl.1900–15
Glasgow painter of landscapes and genre.

Hemingway, Charles W. fl.1930s
Lived in Aberdeen and painted portraits and head studies.

Henderson, James 1871–1951
Born Glasgow, he studied at GSA. Painted landscapes and portraits and also worked as a lithographer. Emigrated to Canada in 1916.

Henderson, James b.1908
Born North Berwick and studied at ECA. Travelling scholarship to France and Italy 1936. Exhibited with his future wife, NAN FERGUSSON, from 1936. Head of Art, Galashiels Academy, 1938–1949, and George Watson's Ladies College, Edinburgh, 1949–1967. With his wife helped to found Galashiels Arts Club in 1949. Painted portraits and landscapes in oil and watercolour.

Henderson, James C. 1858–81
Eldest son of JOSEPH HENDERSON, he studied at the Haldane Academy, Glasgow, and RSA Schools. About to continue his training in Paris when he died, age 23. Painted small rural scenes with figures.

Henderson, John 1754–1845
Born Glasgow, he painted landscapes and stage scenery. Died in Dublin.

Henderson, John 1860–1924
Born Glasgow, the son of JOSEPH HENDERSON, he studied at GSA and, like his brother JOSEPH MORRIS HENDERSON, was influenced by his father's style and subject matter. Later became Director of GSA.

Henderson, Joseph 1832–1908
RSW 1878
Born Stanley, Perthshire, and studied at the Trustees' Academy, but in 1852 moved to Glasgow where he was to live for the rest of his life, becoming a well-known figure in the GLASGOW ART CLUB. Early work consisted of genre and commissioned portraits, but in the early 1870s he discovered his talent for painting the sea, possibly influenced by the work of MCTAGGART. His early seascapes are dark in tone, but by the 1880s his work had become lighter and atmospheric. Some of his watercolours, depicting girls shrimping by a luminous opalescent sea, with light radiating from the sky, are exquisite and stand close comparison with McTaggart. McTaggart was a close friend of Henderson, and on the death of his first wife, Henderson married McTaggart's daughter in 1886. Henderson was instrumental in the development of Glasgow as an artistic centre. Died Ballantrae.

Henderson, Joseph Morris 1863–1936
ARSA 1928, RSA 1936
Born Glasgow, the son of JOSEPH HENDERSON, studied GSA, and was influenced by his father's later style and subject matter. Painted mostly seascapes and coastal scenes in oil, but also used watercolour. Died Glasgow

Henderson, Mary Reid 1882–1964
Studied at GSA, she subsequently taught art and embroidery at Motherwell, Helensburgh and Stirling. Worked as a painter, etcher, embroiderer, enameller and metal worker.

Henderson, Keith 1883–1982
RP 1912, ARWS 1930, ROI 1934, RSW 1936, RWS 1937, OBE
Although an English artist, Henderson is associated with the Scottish school having spent many years at Fort William and at nearby Spean Bridge. Studied

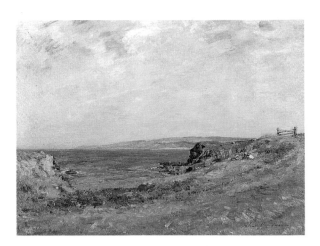

John Henderson *Croy Bay* oil, private collection

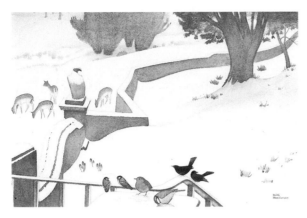

Keith Henderson *Birds in the Garden, Deer in the Park* watercolour exh. RSA 1951, Dundee Art Galleries & Museums

at the Slade Schools and in Paris: his earlier work was often of figures, later turning to Scottish landscape. He also worked in France, South Africa, Cyprus and Egypt. In addition to painting in both oil and watercolour, Henderson wrote and illustrated several books.

Henry, Barclay d.1946
Minor marine artist, connected with the CRAIGMILL SCHOOL. He worked in oil and watercolour.

Henry, George 1858–1943
NEAC 1887, ARSA 1892, RSW 1900, RP 1900, RSA 1902, ARA 1907, RA 1920
Born Ayrshire, he studied at GSA for a short period in the early 1880s and attended informal classes at W.Y. MACGREGOR's studio in Bath Street. In 1881 Henry joined GUTHRIE, WALTON and CRAWHALL to paint at BRIG O'TURK in the Trossachs. He worked with the GLASGOW BOYS in 1882, but in 1883 he

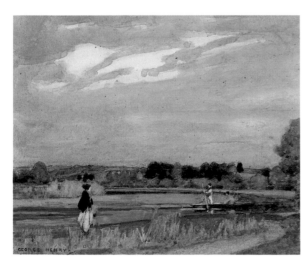

George Henry *On the River* watercolour, The Robertson Collection, Orkney

worked at Eyemouth near Cockburnspath. His style at this stage was influenced by Guthrie and the square-brush technique. In 1884 Henry worked at COCKBURNSPATH along with Walton, Guthrie and MELVILLE and his art made great progress. His principal work that summer was *Playmates* painted mostly *plein-air*.

In 1885 Henry met E.A. HORNEL who persuaded him to paint in Galloway, and in the following year they painted together in Kirkcudbright. The landscape suited Henry and he was to paint many of his most successful works there. He was also working in watercolour, a medium in which he was naturally gifted.

In 1889 Henry painted *A Galloway Landscape* which summed up many aspects of the Kirkcudbright group, in particular an emphasis upon rich colour and a regard for the decorative patterns of a flattened picture plane. *A Galloway Landscape* represents the most progressive aspect of the Glasgow School, and although Henry had no contact with France, it approaches the work of the Pont-Aven group. In 1890 Hornel and Henry worked together on *The Druids* in which incised gesso and overlaid gold provide a strong decorative element, while Celtic mythology provides the subject. A work of the following year *The Star in the East* was also a collaboration, but less successful.

In February 1893 Henry and Hornel set off for Japan, a trip financed by Alexander Reid, the Glasgow dealer, and William Burrell, the collector. During their 19 months away both Henry and Hornel produced some of their finest work. Henry's Japanese period is mostly represented by watercolours, as many of his oils stuck together and were destroyed on the journey home. These watercolours are masterpieces of drawing, composition and technique, and the many of the oils that Henry later worked up in his studio lack the spontaneity and freshness of the watercolours. During the 1890s Henry painted fine portraits both in oil and watercolour, executed with great panache, and with a strong sense of colour. After 1900, however, his work becomes less interesting. He settled in London painting portraits and figures in landscape. Died London.

Henry, John fl.1826–33
Edinburgh based portrait painter.

Herald, James Watterston 1859–1914
Born Forfar he worked as a house painter and clerk in a Forfar textile mill, before moving to Edinburgh in 1884 with his family. Rather than studying at the RSA Schools, Herald went out and painted views of Edinburgh. His only formal art training was at Herkomer's School in Bushey (1891) where he met WILLIAM NICHOLSON and JAMES PRYDE.

During the 1890s Herald lived in Croydon and had considerable success selling his work, but in 1901 he returned to Arbroath. Had he remained in London he might have achieved artistic and financial success, but progressive drinking combined with artistic isolation in Arbroath made it impossible to achieve eminence as an artist.

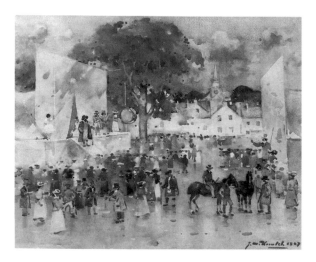

James Watterston Herald *The Travelling Theatre, Buffalo Bill at Arbroath* watercolour 1907, The Robertson Collection, Orkney

Herald worked mostly in watercolour and pastel. His watercolour technique was based upon the 'blottesque' manner of MELVILLE, although his colours were more restrained. He liked to paint seaside towns – Arbroath, Auchmithie, and Hastings in the South – capturing the patterns created by masts and sails. His colours, although restrained, were often imaginative and unrelated to nature. He also liked to paint town scenes with figures on wet pavements, or in parks at dusk. His pastels often depict cattle or figures in fields or orchards. There was a Symbolist side to Herald's work as can be seen in his watercolours and pastels of religious mysticism or Mephistopheles. Herald died comparatively young of cirrhosis of the liver. It is only recently that the wayward genius of his work has been recognised.

Herdman, Robert Duddingstone 1863–1922
ARSA 1908
The son of ROBERT HERDMAN, studied RSA Schools and Paris. Painted romantic scenes often inspired by poetry or literature, as well as genre. Painted some landscapes in Holland and Spain. Worked mostly in oil, but exhibited some watercolours at the RSW.

Herdman, Robert Inerarity 1828–88
ARSA 1858, RSA 1863, RSW 1878
Born Rattray, Perthshire, the youngest son of a minister, he studied at St Andrews University before moving to the Trustees' Academy (1847–53) where he came under the influence of ROBERT SCOTT LAUDER, who became master in 1852. He won a prize for history painting and for the rest of his life produced competent historical canvases. In 1855–6 visited Italy making copies of Italian Renaissance Masters in watercolour, and also painting Italian

peasant scenes in both oil and watercolour. He visited Italy again in 1868–9 also painting watercolours in Venice. During the 1860s Herdman was influenced by the Pre-Raphaelite Movement. He was a friend of J.A. HOUSTON and WALLER HUGH PATON and sketched with them during working holidays on Arran and Mull. The influence can be seen in his paintings of single girls in landscape, such as *Evening Thoughts* or *The Fern Gatherer*. The figures themselves are sometimes provocative in their beauty and owe much to THOMAS FAED, but the handling of the details, in particular the landscape, reveals the current Scottish interest in Pre-Raphaelitism. Herdman painted some exquisite watercolours while on holiday on Arran and Mull, often studying rocks, ferns and brambles in great detail. He was one of the finest draughtsmen of his period, being equally at home with landscape, figures, costume and plants. A charming and cultured man, Herdman was a popular portrait painter. Died Edinburgh.

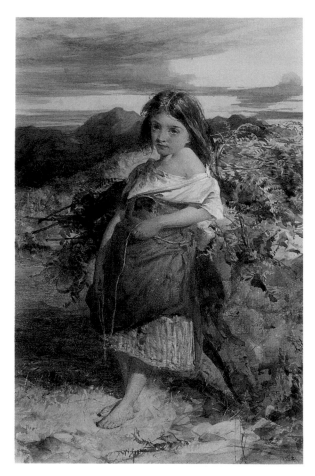

Robert I Herdman *The Fern Gatherer* watercolour, Julian Halsby Esq

Heriot, George 1766–1844
Amateur artist, the son of the Sheriff-Clerk of East Lothian and himself a civil servant, later becoming Deputy Post-Master General of Canada (1799–1816). On his retirement he returned to Scotland and painted views of Spain, France, Wales, Scotland and the Thames Valley. He was influenced by the work of Paul Sandby. Published *Travels through Canada* which he illustrated himself.

Heron, James fl.1873–1919
Edinburgh watercolourist who painted west coast scenes and views of Edinburgh. His colour is restrained and often silvery in tone, and his compositions are effective despite his rather weak drawing of figures.

Heude, Nicolas 1672–1703
Brought to Scotland by the 1st Duke of Queensberry and painted portraits and several ceilings at Caroline Park, Edinburgh, and at Drumlanrig. Died Edinburgh.

Hill, Alexander Stuart 1888–1948
Born Perth, the son of a fishmonger, he took up portrait painting. Exhibited regularly at the RA. Died Chelsea.

Hill, David Octavius 1802–70
ARSA 1826, RSA 1830
Born Perth and studied at the Trustees' Academy under ANDREW WILSON. He was involved with the Foundation of the RSA, attending the inaugural meeting in 1826, and acted as Secretary until his death. Also helped found the National Gallery of Scotland in 1850. As a painter, Hill was known for *The Land of Burns*, a series of 60 illustrations engraved from his oil landscapes and published in 1841; and for his huge group portrait *The Signing of the Deed of Demission* (1843–65). While working on the 474 portraits involved in this commission, he began to use photography, working with Robert Adamson.
Between 1843 and 1847 Hill and Adamson produced many calotypes of eminent Scots and these portraits became better known than Hill's oil paintings. In 1847, on Adamson's retirement, Hill returned to painting, producing mostly landscapes where his handling could be broad and effective. He was also a very able watercolourist, but as Caw pointed out, his duties at the RSA encroached upon the time he could devote to painting.

Hislop, Andrew Healey 1887–1954
Studied at ECA 1908–13 and at the British School in Rome. Later joined the staff of ECA as a teacher of drawing. He painted landscapes in oil and watercolour and also worked extensively in pen and ink and travelled on the Continent. Some of his work is similar to that of JAMES MCINTOSH PATRICK, but not as distinguished.

Hislop, Margaret Ross 1894–1972
ARSA 1950, RSA 1964, RBA 1950
Born West Calder, née Grant, she studied at ECA

and in 1921 married ANDREW HEALEY HISLOP. She painted figures and still-life in both oil and watercolour.

Hislop, Walter B. d.1915
Studied at ECA and began exhibiting landscapes at the RSA in 1912. Killed at Gallipoli while serving as 2nd Lieutenant in 5th Battalion of the Royal Scots.

Hog, William fl.1695–1717
Apprenticed to THOMAS WARRENDER in 1695. Recorded as painting a landscape (1709).

Hogg, Archibald W. fl.1885–1903
Lived in Edinburgh and painted landscapes, especially on the west coast of Scotland.

Hole, William Brassey 1867–1917
ARSA 1878, RE 1885, RSW 1885, RSA 1889
Born Salisbury, he was brought up in Edinburgh and painted scenes from Scottish history including the Jacobite Rebellion. Also a muralist, painting a historical cycle in the Central Hall of the SCOTTISH NATIONAL PORTRAIT GALLERY. A religious man, he visited Palestine and produced a series of watercolours depicting the Life of Christ. Hole was well known as an etcher, reproducing the work

William Hole *Leith Docks* etching, private collection

of the Barbizon painters and the 19th century Dutch School. Also etched the work of JOHN THOMSON OF DUDDINGSTON (1889). Landscape did not feature in his main work, but he painted a number of west coast views in watercolour. Died Edinburgh.

Holms, Alexander Campbell 1862–98
RSW 1893
Paisley watercolourist, studied GSA and Paris. Illustrated the poems of Spencer, Tennyson and Rossetti.

Holt, Edmund d.1892
Painter of Edinburgh characters and scenes in watercolour. Volume of watercolour caricatures by him in Edinburgh Public Library.

Home, Bruce James 1830–1912
Topographical artist, studied Trustees' Academy under ROBERT SCOTT LAUDER. Curator of the Outlook Tower and first Curator of Edinburgh Municipal Museums. Painted pen-and-wash views of Edinburgh streets and courts.

Home, Robert 1865–?
Born Edinburgh, he painted portraits and landscapes. Also worked as a book decorator, a manuscript illuminator and stained glass designer. Lived in Fife.

Hood, Ernest Burnett 1932–88
Born Edinburgh, educated in Glasgow and after apprenticeship as a lithographer went to GSA where he was greatly encouraged by WILLIAM and MARY ARMOUR. In the early 1960s taught life drawing and lithography at GSA. Best known for his work in oil depicting the changing face of Glasgow in the 1960s

and 70s, although he also made accomplished drawings and etchings. Street scenes, shipyards, pubs, the opera and vanishing architecture provided the inspiration for his most atmospheric canvases, often reminiscent of Sickert and Whistler. As a prominent member of GLASGOW ART CLUB, he was a close friend of ALEXANDER GOUDIE and JAMES D ROBERTSON. Died Glasgow.

Hope, Jane 1766-1829
Probably the daughter of the 2nd Earl of Hopetoun, she married Henry Dundas, later Viscount Melville, in 1793. Her second marriage was to Thomas, 1st Lord Wallace. Described by a contemporary as 'a rather elegant woman, possessing a good figure over which drapery might be thrown with good effect', she was taught by DAVID ALLAN and produced a number of somewhat naive watercolours, mostly landscapes.

Hope, Robert 1869–1936
ARSA 1911, RSA 1925
Born Edinburgh, he studied at the Edinburgh School of Design, the RSA Schools and Académie Julian, Paris. He started as a lithographic draughtsman but soon turned to painting. His portraits were suavely painted, and he also painted landscapes and views of Edinburgh in oil. Associated with the EAST LINTON group of painters and most of his landscapes are of East Lothian. He was in addition a muralist and book illustrator. Died Edinburgh.

Hope-Stewart, James d.1881
Born Edinburgh and studied art in Italy. Recorded as having a studio in York but he had many Scottish connections and painted Scottish landscapes and some portraits. Died Edinburgh.

Hornel, Edward Atkinson 1864–1933
Born Bacchus Marsh, New South Wales, and moved to Scotland with his parents to settle at Kirkcudbright in 1866. He spent three somewhat unsuccessful years at the Trustees' Academy before going to Antwerp to study under Verlat, and on his return he met GEORGE HENRY in the autumn

Ernest Burnett Hood *St. Vincent Place, Glasgow* oil 1974, private collection

Robert Hope *East Linton* oil, Bourne Fine Art

of 1885. Henry introduced Hornel to GUTHRIE and soon the influence could be seen in Hornel's work, especially in his adoption of a square brush technique. Hornel's art quickly developed, and he became interested in rich colour, dense pattern and an emphasis upon the decorative elements of a picture. A critic later described this as 'the Persian Carpet School'.

In 1886 Hornel and Henry worked together in Kirkcudbright, where Hornel remained, avoiding the art establishment in Glasgow and Edinburgh. Hornel had seen the mosaic-like pictures of Monticelli at the 1886 Edinburgh International Exhibition and his own work was made up of flattened, decorative areas of colour, with little depth and no distant horizons. He painted figures, often in woods. In 1890 Henry and Hornel collaborated on *The Druids*, a painting in which the decorative elements of incised gesso and overlaid gold co-exist with Celtic mythology, which fascinated Hornel at this time. A further co-operative effort resulted in *The Star in the East* (1891). Hornel's work was already showing a Japanese influence when in February 1893 he set off for Japan with George Henry, financially supported by Alexander Reid and William Burrell. Hornel produced some of his finest oils during the 19 month visit, successfully balancing his feeling for decorative work with figurative drawing and composition. An exhibition of his Japanese works held in Glasgow was a success, but he nevertheless returned to Kirkcudbright to paint children in fancy dress, figures in flower-decked woods, autumnal forests and flowers, and girls by the sea. The 1890s saw Hornel at his most artistically successful, but after 1910 a certain repetition and lack of consistency crept in with a resultant lowering of standards. He visited Ceylon in 1907, and Burma in 1918 but this did not have the same inspirational effect as Japan. He was commercially successful and purchased a fine 18th century townhouse in Kirkcudbright before the First Worlds War for £400 with the sale of one painting. He bequeathed Broughton Home and the contents of his studio to the town, and it is now the Hornel Museum, with a fascinating Japanese Garden. His work was much in demand and he died a wealthy man. In 1901 he was elected ARSA but declined the honour. Died Kirkcudbright.

EAH. 81 E A Hornel

Horsburgh, John 1791–1869
An engraver, he was a Foundation Associate Engraver of the Scottish Academy in 1826 but withdrew after the first meeting.

Horsburgh, John A. fl.1880s and 1890s
Edinburgh portrait painter in oil.

Hospitalfield
Hospitalfield House, Arbroath, was built by the wealthy art collector and artist PATRICK ALLAN-FRASER. The neo-Gothic mansion was filled with his own collection of Victorian paintings and he had many artist friends who visited him there and whom he encouraged to undertake a series of self-portraits. The wealthy Fraser endowed a Trust to allow art students to study at Hospitalfield and many important figures have been associated with it, including JAMES COWIE, who was warden 1937–48, and pupils JOAN EARDLEY, COLQUHOUN and MACBRYDE. Hospitalfield remains in existence as an art school to this day.

Hotchkis, Anna Mary fl.1920s–30s
Studied at GSA 1906–1910, in Munich and at Edinburgh College of Art under ROBERT BURNS. She lived in China 1926–37, taught at Yenching University, Peking (1922–4), and wrote books on Chinese art.
She painted in watercolour and oil, often working alongside DOROTHY JOHNSTONE, MAY BROWN, CECILE WALTON and JESSIE KING in Kirkcudbright.

Hotchkis, Isobel 1879–1947
Sister of ANNA HOTCHKIS, born Crookston, studied GSA. Painter portraits in oil, and later, because of ill health, in watercolour.

Housman, James fl.1683
Recorded as painting a picture for the Earl of Moray.

Houston, Charles fl.1880–1936
The brother of JOHN MACKENZIE HOUSTON he lived

E A Hornel *In the Orchard '94* oil, Whitford and Hughes, London

George Houston *North Ayrshire Landscape* oil, private collection

in Rutherglen and painted landscapes in oil and watercolour.

Houston, George 1869–1947
RSW 1908, ARSA 1909, RI 1920, RSA 1921

Born Dalry, Ayrshire, Houston was a prolific painter in both oil and watercolour. He specialized in the landscapes of Ayrshire and Argyllshire and his talent lay in creating the atmosphere, climatic conditions and season of each scene. His construction was usually simple and direct with wide expanses of pastures or a loch, set against distant hills. He was particularly good with snow scenes, and was expert at catching the bright greens of spring. He sometimes worked on a large scale, and unlike many artists, the quality of his work remains constant.

His style was uninfluenced by modernist trends and can be best described as 'late Impressionism'. He also produced etchings. Died Dalry, Ayrshire.

John Houston *The Aviary* watercolour & gouache, Patrick Bourne Esq

Houston, John b.1930
ARSA 1964, RSA 1972

Born Buckhaven, Fife, he studied at ECA 1948–54. After a year spent travelling, returned to Edinburgh and joined the staff of the College and in 1956 married his fellow student ELIZABETH BLACKADDER. He paints landscapes and seascapes in broad areas of powerful colour which evoke atmosphere and changing light. His work reveals some influence of Emil Nolde and, like Nolde, is equally effective in oil and watercolour. His more recent work has included the human figure.

Houston, John Adam P. 1813–84
ARSA 1842, RSA 1845

Born in Wales of a Scottish family, he studied at the Trustees' Academy and established a reputation as a painter of historical canvases often on a large scale. He was particularly noted for his scenes of battles between Cavaliers and Parliamentarians.

During the 1840s he began painting watercolour landscapes in France, Germany and Italy as well as Scotland and England, which were exhibited at the RSA, and in the 1850s he was well enough known as a watercolourist for HUGH PATON to take lessons with him.

During the 1860s he became interested in the Pre-Raphaelite Movement, probably meeting Ruskin through his friend Paton. In 1858 he moved to London for health reasons and was able to see the emergence of the Pre-Raphaelite Brotherhood at first hand.

He continued to paint watercolours of the Scottish Highlands incorporating many of Ruskin's principles, and he particularly liked working on Skye. These watercolours with their insistence upon detail and precision represent his best work. He sometimes painted historical scenes within these landscapes, such as encounters between the English

John Adam Houston *A Summer Day in the Highlands* oil, private collection

and the Highlanders of the '45 or single standing figures, similar to those of HERDMAN.

Houston continued to produce large historical canvases, but they are often tedious and over-blown. His watercolours on the other hand, with their Pre-Raphaelite influence, are more significant. Died London.

JAH RSA

Houston, John Rennie Mackenzie 1856–1932
RSW 1886
Born and trained in Glasgow, he lived and worked at Rutherglen near Glasgow. Houston was one of the last Scottish genre painters. He specialised in figures in interiors and was influenced by the Dutch Schools. He tended to rework the formula of the FAEDS, but it is evident that by the 1920s genre painting had lost its impetus. Died Rutherglen.

Houston, Lilias c.1920–78
Landscape painter. Exhibited RSA and Glasgow Institute. One woman show in 1976 at Lillie Art Gallery, Milngavie.

Houston, Robert 1891–1942
RSW 1936
Born Kilbirnie, Ayrshire, he studied at GSA. Specialised in landscapes, often of the west coast and Isles, painted in a strong manner with a pronounced sense of design. He often worked in watercolour using charcoal outlines, rich colours and dramatic compositions. Houston was also noted as a poster artist and produced some excellent railway posters, his strong sense of design being well suited to the medium.

Howe, James 1780–1836
Born Skirling, Peeblesshire, the son of a parish minister, he was apprenticed to the NORIES in Edinburgh. The Nories regarded him highly and Lord Buchan was a enthusiastic supporter. In 1806 Howe went to London on the advice of Buchan to paint some horses of George III, but no regular royal patronage was forthcoming, so he returned to Edinburgh, where he made a good career painting horses, dogs, cattle, huntsmen, gamekeepers and grooms. Also executed many pen and ink drawings which are vigorous and often humorous. He attempted large-scale compositions with varying degrees of success, usually depicting country fairs. Painted a huge panorama of the battlefield of Waterloo.

Howie, James b.1931
Born Dundee and studied at Dundee College of Art 1949–54. Subsequently lived in Angus, London and Spain, settling in Dundee 1962 for a number of years. Exhibited widely from 1957 with works in many public collections.

Howie, William c.1829–?
Born Kilmarnock and studied Trustees' Academy 1851–4. Portrait painter.

Howison, Thomas fl.1830s–40s
Edinburgh landscape painter.

Howison, William 1798–1850
ARSA 1838
Born Edinburgh. Worked as an engraver after WILLIAM ALLAN, SIR GEORGE HARVEY, THOMAS FAED and other leading painters. Contributed to the volumes published by the Association for the Promotion of the Fine Arts in Scotland.

Huck, James fl.1911–39
Landscape painter in oil and watercolour working in Glasgow.

Hume, Robert 1861–1937
RBA 1896
Edinburgh painter of rustic genre and landscape, often depicting farm workers and harvesters. Studied RSA Schools. Moved to London c.1892. Returned to Edinburgh 1913. Exhibited RSA, SSA.

Humble, Stephen fl.1820–40
Painter of flowers in watercolour.

Hunt, Thomas 1854–1929
RSW 1885, ARSA 1914
Born Skipton, studied Leeds and GSA, became President of the GLASGOW ART CLUB 1906–08. Painted animals and local characters, with some landscapes. His watercolour style is vigorous and unsophisticated, but has an energy and scale which can be successful. Died Glasgow.

Hunter, Alexander fl.1840s–50s
Painted landscapes, views of Edinburgh and children.

Hunter, Colin 1841–1904
RSW 1879, RE 1881, RI 1882, ROI 1883, ARA 1884
Born Glasgow, he was brought up in Helensburgh and studied with MILNE DONALD in Glasgow. His early work was influenced by Donald and represented landscapes of the Trossachs area.

In the late 1860s he turned towards seascape and settled in Edinburgh c.1868. In 1872 he moved to London and became one of the leading marine painters of his day. His first major success was *Trawlers Waiting for Darkness* (RSA 1873).

James Howe *Perth Races* pen and ink, Perth Museum & Art Gallery

97

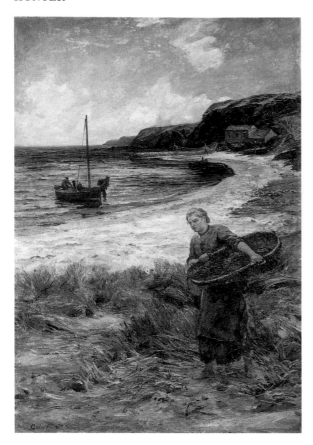

Colin Hunter *The Lass that baits the Line* oil 1885, Dundee
Art Galleries & Museums

Although based in London, Hunter returned every
summer to Scotland to paint. In the late 1860s
he had worked alongside MCTAGGART on Loch
Tarbert and it is possible they worked together
during the 1870s. In 1882 Hunter chartered a
small steamer and for two months painted at sea
in order to be in direct contact with nature. In
this respect he was similar to the English marine
artist Henry Moore. Hunter's seascapes possess a
quality of brooding melancholy; of romantic nos-
talgia. Rather than choosing sparkling sunlight, he
preferred to paint sunsets, evenings or approaching
storms. He painted mostly on the west coast of Scot-
land and in the Hebrides, and depicted fishermen
hard at work or their families unloading the catch or
gathering seaweed. His work met with great success
in England. Died Kensington.

San Francisco in 1906, beginning to amass paint-
ings for a one-man exhibition, but everything was
destroyed in the great earthquake. Undeterred, he
returned to Glasgow to continue his self-education
as a painter, and in 1913 his work was brought
to the attention of Alexander Reid, the Glasgow
dealer, who gave him his first one-man show. In
1914 he visited France, returning only after the
outbreak of war. During the war, Hunter worked
on his uncle's farm in Lanarkshire and continued
to paint, holding a further one-man with Reid in
1916. During this period he was influenced by the
modern French painters he had seen in Paris, in
particular Matisse, Cézanne and van Gogh. His
pen and ink drawings, very important to his work,
reflect the lessons of van Gogh, although Hunter
creates something original and very personal.

In 1922 he returned to Europe, visiting the French
Riviera, Florence and Venice and in the follow-
ing year showed with PEPLOE and CADELL at
the Leicester Galleries, London, being joined by
FERGUSSON for the group exhibitions in Paris (1924)
and London (1925).

Hunter worked mostly in Scotland 1924–7, painting
successfully in Fife and on Loch Lomond, but in
1927, restless and unsettled, he returned to France
where he moved from village to village in the South,
drawing on the spot, using charcoal, pen-and-ink,
watercolour or pastel. These he used as the basis
of later oils.

In 1929 he returned to Glasgow in poor health
and was cared for by his sister. His last years
were spent working around Loch Lomond and
in London where he produced a number of
drawings and watercolours of Hyde Park in
preparation for a series of canvases of London
which were never realised. Hunter was in New
York in 1929 for his exhibition at the Ferargil
Galleries and in 1931 visited Paris for the highly
successful exhibition *Les Peintres Ecossais* where
the French government bought a Loch Lomond
painting.

He planned to settle in London which he believed
to be more lively than Glasgow but died in Decem-
ber 1931.

Hunter was the least consistent of the COLOUR-
ISTS yet in some respects the most interesting.
His work is never repetitive, he appears to be
constantly searching, through his drawings, for a
new approach. Died Glasgow.

Hunter, George Leslie 1879–1931
Born Rothesay, Hunter was taken by his parents
to California where they settled. He became an
illustrator working for several local magazines,
but a visit to Paris in 1904 led him to take up
oil painting, even though he continued to work as
an illustrator for many years. Hunter returned to

Hunter, George Sherwood d. 1920
RBA 1889
Born Aberdeen, he studied in Edinburgh and later
travelled widely, painting landscapes in oil. He
worked in Holland, France, Spain, Italy, Egypt
and the Middle East. Settled in London on the
1880s, moving to Penzance around 1900.

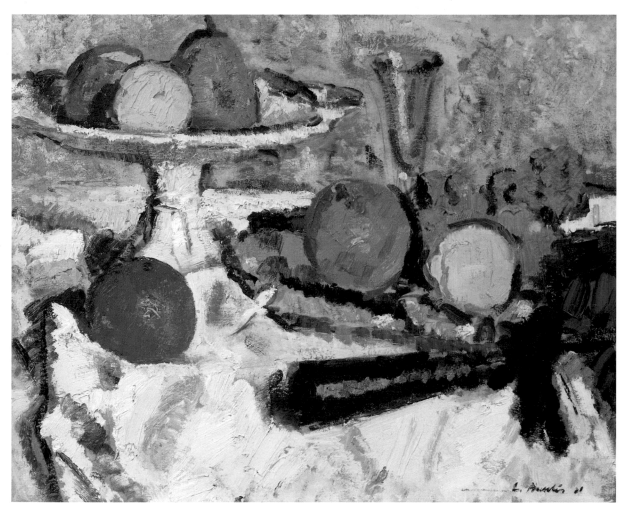

George Leslie Hunter *Still Life of Fruit on a White Tablecloth* oil 1921, The Ellis Campbell Collection

Hunter, James Brownlie fl. 1880–1920
Edinburgh artist and engraver, painted landscapes and coastal scenes.

Hunter, John Kelso 1802–73
Born Dankeith, Ayrshire, a shoemaker by profession. Self-taught portrait painter. His self-portrait as a cobbler was hung at the RA 1847. Exhibited portraits regularly at the RSA 1849–72. Published *The Retrospect of an Artist's Life* (1868). Died Glasgow.

Hunter, John Young 1874–1955
RBA 1914
The son of COLIN HUNTER, born Glasgow, studied RSA Schools, London. Painted romantic scenes of figures in gardens and interiors in oil and watercolour. Went to USA c.1925. Lived in Suffolk for many years.
His wife MARY YOUNG HUNTER (1878–1936) also painted in watercolour and they jointly illustrated *The Clyde* by Neil Munro (1907).

Hunter, Mary Sutherland 1899–?
Born Lanarkshire and studied at ECA and the RSA Schools. She painted portraits, landscapes and interiors, and lived in Edinburgh. Also worked as a sculptor.

Hunter, Mason 1854–1921
RSW 1889, ARSA 1913
Born Linlithgowshire, studied Edinburgh School of Design. He painted seascapes and coastal views in watercolour and oil in a style similar to R. CLOUSTON YOUNG.

Hunter, William fl. 1802–33
Edinburgh portrait painter trained under John More. Was a Burgess of Edinburgh 1802.

Hunter, William fl. 1913–40
Studied GSA and lived in Glasgow, often painting on Skye. Painted landscapes, flowers and some figure compositions. His landscape style is broad and decisive.

Hunter, William d. 1967
ROI 1928

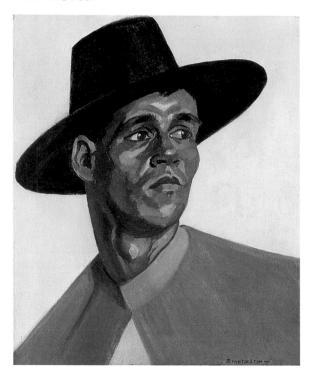

Beatrice Huntington *The Andulasian Muleteer* oil, private
collection

Born Glasgow, he studied at GSA under FRA
NEWBERY. Won a travelling scholarship and vis-
ited European cities including Brussels where he
studied. He was primarily a figure painter and
helped GREIFFENHAGEN and Anning Bell in paint-
ing murals.

Huntington, Beatrice 1889–1988
Born St Andrews and studied painting in Paris and
Munich from 1905. Painted portraits and exhibited
at the Paris International, RA and RSA. Married
WILLIAM MACDONALD 1928 and they painted
together abroad in France, Spain and Canada
for much of their lives. Interesting influences are

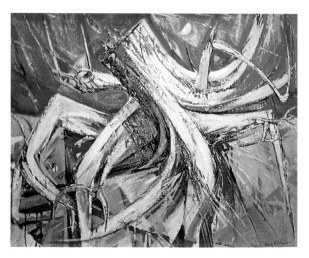

Shand Hutchison *Bleached Tree-form* oil, private collection

Robert Gemmell Hutchison *The Ladybird* oil, Bourne
Fine Art

evident in her work which is strongly coloured
and intriguingly stylized. Lived and worked in
Edinburgh from 1963.

Hurt, Louis Bosworth 1856–1929
Born Ashbourne, Kent, and became well known
for his large oils of Highland scenes, mist laden
mountains and morose Highland cattle. In his
time he successfully captured the romance of the
Highlands for the Victorian picture buying public.
Died Matlock.

Husband, Miss Eliza Stewart fl.1889–1913
Lived in Edinburgh and painted figures, portraits
and children. Exhibited SSA.

Hutcheson, J.A. fl.1830s–40s
Lived in Edinburgh and painted portraits, histori-
cal and biblical subjects.

Hutcheson, Tom b.1922
Born Uddingston, Lanarkshire, he studied at GSA
1941–2 and 1946–9. He paints landscapes in both
oil and watercolour and lives in Ayrshire.

Hutcheson, Walter d.1910
Glasgow artist who lived at Crosshill and exhibited
at RSA and Glasgow Institute.

Hutchison, George Jackson 1896–1918
The son of ROBERT GEMMELL HUTCHISON, he exhib-
ited at the RSA, RA and RSW 1915–1918, but was
killed in action in 1918.

Hutchison, Isobel Wylie (Mrs H. Morley)
fl.1897–1939
Landscape painter, she often depicted the rugged
mountains of Greenland in a broad style, making
good use of the whiteness of bare paper. She
also painted the lochs of Scotland and views in
America.

Hutchison, J.A. fl.1850s–70s
Glasgow landscape painter. Member of the West
of Scotland Academy.

Hutchison, Robert Gemmell 1855–1936
RSW 1895, ARSA 1901, RSA 1911

Born Edinburgh, he studied at the RSA Schools, and was strongly influenced by the Dutch School and by the work of the FAEDS. Painted interiors and genre in watercolour, similar to the sentimental approach of the Faeds, and using a wetter, looser technique, which was influenced by Dutch painters like Israels and Maris. Maybe more interesting than his genre are his fine evocations of the seaside, painted in oil and watercolour. Influenced to a certain extent by MCTAGGART, Hutchison painted breezy seascapes and beach scenes with children playing or shrimping. He was also a master at painting children in sun-dappled landscapes.

Hutchison, Shand Campbell b.1920
Born Dalkeith and studied ECA 1939–40, 1946–9. Exhibited from 1951 at SSA, RSA and RSW as well as one man shows and group exhibitions in Edinburgh and London. Works in many private and public collections. Works in oil, watercolour and pastel based on landscape and the animate within inanimate. Influenced by neo-romantics like Nash and Sutherland. Taught art and lectured part time at ECA, Heriot Watt and Edinburgh University. President SCOTTISH ARTS CLUB 1968–70.

Hutchison, Sir William Oliphant 1889–1970
ARSA 1937, RSA 1943, RP 1948, PRSA 1950, Knighted 1953, VPRP 1960
Born Kirkcaldy, he studied at ECA 1909–12 and subsequently in Paris. In 1912 he joined ERIC ROBERTSON, D.M. SUTHERLAND, A.R. STURROCK, G. SPENCE SMITH and others to form the EDINBURGH GROUP, exhibiting in Glasgow in 1912 and in Edinburgh in 1913.
Hutchison painted interiors, landscapes and portraits but his style was not as progressive as others in the Edinburgh Group. For ten years from 1933–43 Hutchison was Director of GSA and later split his time between London and Edinburgh. Later, he painted portraits for the main part: these were highly accomplished.
For illustration see SCOTTISH ARTS CLUB entry.

Hutton, James 1894–1957
Born Broughty Ferry. Marine watercolourist.

W O Hutchison *Lindsay Jamieson* oil 1920, Gilly Kinloch

I

Imlach, Archibald M. fl.1880s–90s
Lived in Edinburgh and painted genre, interiors and still-life.

Inglis, Alexander ('Sandy') b.ca.1920
RSW, MBE
Trained at ECA and works as a potter and in watercolour and collage. Formerly art master at Sedbergh School. Married to the artist Alice R. Lake. Lives in Kendal.

Inglis, Esther 1571–1624
Thought to have been born Dieppe. Father settled Edinburgh 1578 and she married 1596. Calligrapher and miniaturist. Moved to England 1607.

Innes, Robert fl.1839–43
Edinburgh portrait painter who exhibited with the Edinburgh Society of Artists; became President, 1843.

Irvine, James 1833–89
Born Menmuir, Forfarshire, he had lessons from the portrait painter COLVIN SMITH. Subsequently studied at the Edinburgh Academy and worked as a portrait painter in Arbroath and Montrose. After a period of hardship, his talents were recognised and he settled in Edinburgh painting portraits and the occasional landscape. His portrait style was powerful with strong light and shades and expressive brushwork. He was a close friend of G.P. CHALMERS. Died Hillside, Montrose.

Irvine, John 1805–88
Edinburgh portrait and genre painter, moved to London around 1858. Also painted a number of landscapes in watercolour but his drawing was somewhat wooden.

Irvine, Robert Scott ('Otto') 1906–88
RSW 1934
Born Edinburgh and trained at ECA under LINTOTT, ALISON, D.M. SUTHERLAND and JOHN DUNCAN. Painted mostly in watercolour creating a mood of frozen stillness closer to English artists like Paul Nash, Bawden and Ravilious than to the Scottish school. Painted in Tetuan with A.G. MUNRO. 'Demonstrated an ability to abstract from a landscape subject and to formalise and compose' (Jack Firth, RSW Catalogue, 1989).

Robert Scott Irvine *North Sannox, Arran* watercolour, The Scottish Arts Club

J

Jack, John fl.1880–91
Edinburgh painter of coastal scenes and landscape.

Jack, Patti fl.1880s–90s
Lived in St. Andrews and painted flowers, landscapes and historical subjects.

Jameson, William fl.1638
Recorded as painting portrait of Sir Thomas Hope.

Jamesone, George 158990–1644
Born Aberdeen, he was apprenticed to JOHN ANDERSON in Edinburgh in 1612. Following the demise of ADAM DE COLONE in 1628, he dominated the market in portraiture in Scotland and in 1634 attracted the patronage of Sir Colin Campbell of Glenorchy, who commissioned a series of portraits. Horace Walpole referred to him as 'the Van Dyck of Scotland'. From modest beginnings painting the burgesses and academics of Aberdeen, his fame rapidly spread and he worked throughout Scotland. The quality of his work – especially that of his later years – varied greatly but he remained in demand and is believed to have died a rich man in Edinburgh.

Jamieson, Alexander 1873–1937
IS 1904, ROI 1927
Born Glasgow and studied at the Haldane Academy in Glasgow, winning a scholarship to Paris in 1898. French painting strongly influenced his style and he worked in a broad Impressionistic manner in oil. He often painted continental towns. He visited Spain in 1911, held his first one-man at the Carfax

George Jamesone *Self portrait in a Room hung with Pictures* oil, Scottish National Portrait Gallery

Alexander Johnston *The Ghillie* oil, private collection

Gallery in London in 1912 and served in France during the 1914–18 war. Settled in London around 1901, moving to Buckinghamshire after the war.

Jamieson, Florence b.1925
RSW
Born Glasgow and studied GSA. Wife of ROBERT SINCLAIR THOMSON; paints figures, interiors and still-life.

Jamieson, Robert Kirkland 1881–1950
ARBA 1922, RBA 1925, ROI 1932
Born Lanark and apprenticed to a coach painter, 1894. Studied Glasgow, London and Paris. Lived in London and exhibited landscapes at the RA and with the London Group.

Jardine, Jet fl.1914–40
Helensburgh watercolour painter influenced by the watercolours of JAMES PATERSON.

Jardine, Sir William 1800–74
HRSA 1827
Born Edinburgh, painter of natural history subjects, including fruit and game. Published (with Prideaux Selby) *Illustrations of Ornithology* (1830) and edited the *Naturalists' Library* (1833–45).

Jefferson, Charles George fl.1870–1902
Glasgow landscape painter.

Jenkins, Arthur Henry 1871–?
Born Galashiels, he studied at ECA and at Colarossi in Paris. Taught art at Trinity College, Glenalmond, and at Edinburgh Academy before moving south to become art master at King's School, Bruton. Jenkins painted in both oil and watercolour in a broad painterly style with rich colours. Often worked abroad, particularly in Italy and Spain.

Johnson, Charles Edward 1832–1913
Born Stockport, Cheshire, and studied at RA Schools. Spent the first part of his career as a landscape and marine painter in Edinburgh. Moved to London in 1864.

Johnston, Alexander 1815–91
Born Edinburgh, the son of an architect, and studied at the Trustees' Academy 1831–4, moving to London to enter the RSA Schools in 1836. Painted historical canvases which Caw described as 'austere and grave in feeling and dwelling upon the pathos of life'. His most important work *Archbishop Tillotson Administering the Sacrament to Lord William Russell in the Tower* is in the Tate. His career was spent in London. Died Hampstead.

A.J.

Johnston, A.D. fl.1830s
Glasgow landscape painter. Exhibited RSA.

Johnston, Charles E. fl.1850s–60s
Lived in Edinburgh and painted landscapes, Highland views and fishing scenes. Also worked in Germany and Italy and on the Thames.

Johnston, Helen S. 1888–1931
Born Troon and studied at GSA 1907–15. She won a Haldane Travelling Scholarship and studied in Paris. Returned to Glasgow and painted figures, landscapes and beach scenes. In 1913 she executed a mural *The Arts* for Possilpark Library. Later worked in Kirkcudbright and travelled in Corsica and Brittany producing strong and decisive paintings of peasants and Breton lacemakers.

Johnston, Miss Janet fl.1880s–90s
Edinburgh painter of flower pieces. Exhibited SSA.

Johnston, J.H. fl.1828–35
Dumfries artist recorded as holding drawing and painting classes at an address in the town's High Street (1828). Painted local scenes.

Johnston, Robert fl.1780–90
Watercolour painter of landscape and coastal scenes.

Johnston, Stuart 1891–?
Born Cupar, Fife he studied at GSA. Painter and etcher.

Johnston, William fl.1830s–40s
Painter of animals, often dogs, still-life, coastal scenes and landscape.

Johnston, William Borthwick 1804–68
ARSA 1840 RSA 1848
Trained in Edinburgh as a lawyer before taking up painting. Studied in Rome and, in 1858, was appointed the first Principal Curator and Keeper

of the Scotch National Gallery (sic.). Self-portrait hangs at Hospitalfield.

An academic painter of historical scenes, portraits and miniatures, he was the first curator of the NGS. Like many of his contemporary Academicians he was also a sensitive watercolourist, although he painted few. *Landscape with Peasant Girl carrying a Pitcher* (VAM) is a delicate example set in an Italian landscape reminiscent of early Turner. Died Edinburgh.

Johnston, William Myles 1893–1974

Born Edinburgh, studied ECA under WILLIAM WALLS, he spent five years in America painting pastels. Returned to Edinburgh and taught at John Watson's College. Decorated pottery with animal designs. Moved to Kirkcudbright in 1940 where E.A. TAYLOR and JESSIE KING were friends. Worked with Sir Robert Lorimer on the Scottish National War Memorial in Edinburgh Castle, where he executed the heraldic blazoning. Died in a fishing accident.

Johnstone, Dorothy (Mrs D.M. Sutherland) 1892–1980
ARSA 1962

The daughter of GEORGE WHITTON JOHNSTONE, Dorothy was born in Edinburgh. Her uncle was the landscape painter JAMES HERON. Entered ECA in 1908 and won a travelling scholarship to Italy in 1910. Also visited Paris. Her close friend CECILE WALTON (see illustration) introduced her to her father E.A. WALTON, the NEWBERY family and other members of the GLASGOW SCHOOL, and in 1914 she was appointed to the staff of ECA. In the summer of 1915 she made the first of many visits to Kirkcudbright to paint, being joined in later years by ANNA HOTCHKIS, MAY BROWN, Cecile Walton and, after their return from Paris, JESSIE KING and E.A. TAYLOR. In 1919 Johnstone joined the re-formed EDINBURGH GROUP, exhibiting with them in 1919, 1920 and 1921, and in 1924 held a joint exhibition with Cecile Walton.

In 1924 she married D.M. SUTHERLAND whom she had met when he returned to his post at ECA after the war. As a married woman she was obliged to relinquish her teaching post. During the early 1920s Johnstone painted some fine portraits and figure studies. She was an accomplished draughtsman and her paintings appear effortless and relaxed; she was above all able to sum up complex spaces, poses and even facial characteristics in broad brushstrokes. Combined with this freedom is an interest in pattern and an eye for fashion.

During the summers of the late 1920s and early 1930s Johnstone spent painting holidays with her husband and friends including ADAM B. THOMSON around Scotland, and in 1933 the family moved to Aberdeen where D.M. Sutherland had been appointed Head of Gray's School of Art. During holidays they painted in the village of Plockton and

Dorothy Johnstone *Cecile Walton* oil, Robert Fleming Holdings Ltd

William Johnstone from *Reynolds Discourses* watercolour 1943, Patrick Bourne Esq

on the east coast. Johnstone painted landscapes in oil and watercolour and was also highly regarded for her portraits of children.

After D.M. Sutherland's death in 1973 she continued to paint portraits and landscapes in North Wales and Kirkcudbright which she revisited in 1974 after over 30 years' absence. Dorothy Johnstone shows herself a most accomplished painter although her work declined in quality in the 1930s. Equally at home in oil, watercolour, pencil or chalk, she painted with great bravura, but never fell into the dangerous trap of becoming flashy and superficial.

Johnstone, George Whitton 1849–1901
ARSA 1883, RSW 1885, RSA 1895
Born Glamis, studied RSA Schools, having been apprenticed to a cabinet maker. He painted quiet landscapes with rivers and trees which are serene rather than powerful, and show a Dutch influence. Painted in Fife and in Northern France, and worked in oil and watercolour. The father of DOROTHY JOHNSTONE.

George Whitton Johnstone *The Falls of Tummel* oil 1887, Dundee Art Galleries & Museums

Johnstone, Joan b.1937
ARSA
Born Falkirk and trained at ECA. Joined staff of ECA in 1963.

Johnstone, William 1897–1981
Born Denholm, Roxburghshire, he left school early to help his parents run their farm. In 1912 he met TOM SCOTT, the Borders watercolourist, who encouraged Johnstone to paint. Studied at ECA 1919–23, winning a travelling scholarship in 1925 which enabled him to visit Paris, where he was influenced by the work of André Lhote. Lack of money and recognition forced Johnstone and his wife to lead a peripatetic life, living in California (1927–9), Scotland (1929–31) and settling in London in 1931 where he taught in schools and colleges.

In London Johnstone met many of the *avant-garde* painters and writers and became Principal of Camberwell School of Art 1938–46 and of the Central School of Arts and Crafts 1947–60. He retired to Scotland to take up sheep farming. During the 1930s Johnstone painted abstracts based upon biomorphic forms, influenced by French and Spanish surrealism. After the war his work became more geometrical and the influence of oriental calligraphy can be seen in his later oils and ink drawings.

Johnstone was a close friend of the poet Hugh MacDiarmid, who wrote a series of poems based on Johnstone's paintings in 1933, although they were not published until 1963. Johnstone's most significant work was done in the 1930s, when he produced a form of abstract surrealism painting which raised many seemingly unanswerable questions. *Ode to the North Wind* and *A Point in Time* are unique in Scottish art of the time.

Junor, David 1773–1835
Perth based portrait painter.

K

Kay, Alexander fl.1813–40
Edinburgh topographical and landscape artist, exhibited at the Society of Dilettantes and the RSA. A prolific watercolourist painter of Scottish landscape, shipping and coastal scenes, his style was influenced by 'GRECIAN' WILLIAMS, although his drawing is weaker.

Kay, Archibald 1860–1935
RSW 1892, ARSA 1916, RSA 1930
Born Glasgow of a Caithness family, he studied at GSA and at the Académie Julian, Paris. A prolific painter of landscapes in oil and watercolour, he worked in Scotland, Belgium, France, Italy, Denmark and Holland, in a style influenced by the Dutch School. His watercolour technique was broad and wet, while his oil paint was vigorously handled. Died Glasgow.

Kay, James 1858–1942
RSW 1896, ARSA 1933, RSA 1938

Born on Arran, he studied at GSA. Became a friend to members of the GLASGOW SCHOOL and for a time shared a studio with DAVID GAULD and STUART PARK, but he was never one of the 'Boys'. His work lacked the decorative and design elements often associated with the Glasgow School. He loved the bustle of the Clyde with its steamers, fishing boats and square riggers. He also painted the Thames and river scenes in Brittany and Normandy, and his views of cities and market places in France can be excellent. His work is dynamic with lively clouds and strong colours. Kay worked in oil as well as in an unusual mixture of pastel, gouache and watercolour on different coloured papers. Died Whistlefield.

James Kay *The Pool of London* watercolour, The George Street Gallery, Perth

Kay, John 1742–1826
Born Dalkeith, apprenticed to a barber before turning to miniature painting and caricature in 1784. His etchings in *Edinburgh Portraits* 1837 depict all the local characters of the day and form a unique record of life in the capital. Died Edinburgh.

Kay, Robertson fl.1898–9
Edinburgh based portrait painter. Moved to London 1892.

Kay, Violet McNeish 1914–71
RSW 1947
Born Glasgow, the daughter of JAMES KAY, studied GSA. She painted watercolours of the west coast in a bold manner, using large blobs of strong colour.

Keir, Henry 1902–77
Glasgow artist who left school at 14 to become a house painter and sign writer while attending GSA evening classes. He painted the working-class areas of Glasgow – tenements, back-streets and pubs – in sombre style. He also sketched gypsies and travellers, and did illustrations for Edward Gaiten's Gorbals stories, recording a fast-disappearing aspect of Glasgow.

Keith, Alexander, fl.1840s–60s
Lived in Portobello and painted rural genre and portraits. Member of the West of Scotland Academy.

Kellock, David Taylor b.1913
Studied at ECA 1932–6, he paints mostly in watercolour.

John Kay *Self Portrait* oil, Scottish National Portrait Gallery

Kelly, John Turner fl.1890–1907
Lived in Edinburgh and painted landscapes, often with autumnal or evening themes.

Kemp, George Meikle 1794–1844
Architect, famous for Edinburgh's Scott Monument, who also worked in watercolour in a style similar to that of THOMAS HAMILTON.

Kemp, Jeka (Jacobina) 1876–1966
Born Bellahouston, Glasgow, she studied art in London and Paris before travelling to Italy, Holland and North Africa. Exhibited her French landscapes at the Glasgow Society of Lady Artists, the Glasgow Institute and in 1912 held her first one-man exhibition at Macindoe's Gallery, Glasgow. A critic described her in 1914 as a 'distinguished disciple of Melville' and her colour and technique are derived from MELVILLE, although her style is somewhat cruder. She remained in France until 1939, although she had given up painting in 1927, and returned to Dorset. Her most successful watercolours are of figures on beaches or in interiors flooded with the light of southern France.

Kendrick, Emma Eleanora fl.1820s–30s
Painted watercolours of faces, figures, historical composition and flowers. Exhibited RSA.

Kennaway, Charles G. 1860–1925
ARSA
Worked in Perth and Glasgow; landscapes and figure studies.

Kennedy, John fl.1850s
Landscape painter who was Master of the School of Art in Dundee. His watercolours are delicately drawn and have fresh colours. A group of watercolours painted in 1855 related to Burns's life (NGS).

Kennedy, Robert A. 1890–1951
Born West Kilbride. An amateur artist who worked in the drapery trade. Exhibited RSA. Died Edinburgh.

Kennedy, William 1859–1918
Born Hutchesontown, Glasgow, and studied in Paisley and later in Paris where he came across the work of Bastien-Lepage. A group of young Scots studied in Paris during the early 1880s and included LAVERY, DOW and ROCHE. Together they worked at Grez-sur-Loing, all influenced by Bastien-Lepage. Virtually none of Kennedy's Grez paintings survive, although there is a Paris scene from the early 1880s, and it reveals the influence of Whistler's nocturnes. The influence of Whistler can be seen in Kennedy's most famous painting *Stirling Station* (c.1888) although there is also a strong sense of urban realism. Kennedy painted many

rural scenes in the later 1880s and 1890s, showing harvesters, children playing in fields and woods and evening scenes in the country. He also liked to paint the Army seen in camps and manoeuvres around Stirling and as a result was called 'The Colonel' by his friends. In the 1890s Kennedy settled in Berkshire, continuing to paint rural scenes and in 1912 he moved to Tangiers for health reasons. Here he painted some very successful Arab scenes and horses in oil and watercolour. He also experimented in pastel. Kennedy died in Tangiers in 1918.

Kennedy, William Denholm 1813–65

Born Dumfries, studied RSA Schools in London. Became a friend of William Etty, and thus belongs more to the English School than to Scotland, from which he had permanently emigrated. He was an excellent watercolourist and painted fresh and delicate landscapes often relating to his visits to Italy.

Keppie, Jessie 1868–1951
RSW 1934

The sister of JOHN KEPPIE, Mackintosh's partner, she was originally engaged to MACKINTOSH but the engagement fell through when he met MARGARET MACDONALD. She studied at GSA under FRA NEWBERY and James Dunlop. Worked in watercolour, painting landscapes, flowers and architectural subjects in a 'wet' manner, probably influenced by MELVILLE and by her brother's watercolours.

Keppie, John 1863–1945
ARSA 1920, RSA 1937, FRIBA

Born Glasgow, studied Glasgow University and Paris. Worked in the architectural firm of Campbell, Douglas and Sellars before going into partnership with Honeyman, being joined later by C. R. MACKINTOSH. His watercolours are particularly effective, at times showing the influence of MELVILLE in his blottesque handling of the medium, at other times revealing E.A. WALTON's influence, especially in his landscapes. Died Ayrshire.

Kerr, Henry Wright 1857–1936
RSW 1891, ARSA 1893, RSA 1909

Born Edinburgh and studied at the RSA Schools. His main artistic influence came from the Hague School which he first studied seriously in a trip to Holland. The watercolour technique of Israels, Mauve and the Maris brothers as well as their subject matter – studies of peasants, figures by the sea, church interiors – were important to Kerr.
He painted portraits of Scottish fishermen, crofters and elderly ladies in a loose 'wet' watercolour manner. He also painted scenes of Scottish life in watercolour. His work was very popular during his lifetime. Died Edinburgh.

Kerr, Peter 1857–1940

Greenock artist trained at ECA. A regular exhibitor in Edinburgh and Glasgow, his life studies were exhibited in Paris. Painted landscapes and portraits in oil and watercolour. Also made etchings. Hon. President Greenock Art Club.

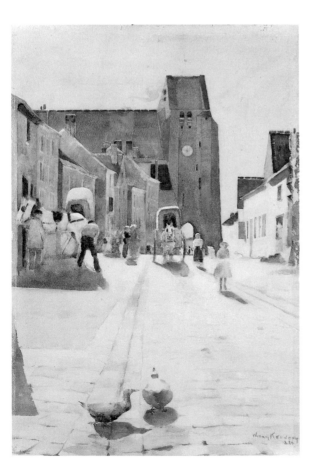

William Kennedy *The Main Street, Grez-sur-Loing* watercolour 1884, Ewan Mundy Fine Art, Glasgow & London

Jessie Keppie *Sweetheart Abbey* watercolour, Julian Halsby Esq

Kerr-Lawson, James 1865–1939

Born Anstruther, Fife, and after a childhood in Canada returned to study art in Paris and Rome. An interesting artist of many talents – painter of figures, landscapes and portraits in oil and watercolour, decorative artist and lithographer. His oils were influenced by the New English Art Club painters and by the subdued colours of the Camden Town School, while his watercolours of Spanish and Italian towns and markets often sparkle. Lived in Glasgow and was a leading member of GLASGOW ART CLUB.

Kidd, Joseph Bartholomew 1808–89

Landscape painter, a pupil of JOHN THOMSON OF DUDDINGSTON, he was a Foundation Associate of the RSA in 1826. In 1858 moved to London and resigned from the RSA. He painted mostly Scottish Highland landscape and some portraits.

Kidd, William 1790–1863

HRSA 1829

Studied under the animal painter JAMES HOWE and seems to have achieved early success, exhibiting his first picture *A Cobbler's Shop* in 1809. Although a good animal and portrait painter he preferred genre and was influenced by ALEXANDER CARSE and DAVID WILKIE. He painted humorous and often pathetic scenes of Scottish life such as *The Cottar's Saturday Night* (1845) and *The Highland Reel* (1842). Settled in London in 1817, exhibiting at the RA and British Institute and in 1829 was

James Kerr-Lawson *The Artist's Wife Reading at Home* oil, Christie's Scotland

made HRSA. He was prolific, talented and fluent as an artist, but despite his success he managed his financial affairs badly and lived in poverty. He was one of a small group of acolytes of Wilkie possibly deserving of reappraisal. On his return to Scotland around 1853 he was supported by an Academy pension and help from his friends.

Kidston, Annabel A. 1896–1981

Studied at GSA 1914–20, and with André L'Hote in Paris: in 1927 she studied wood engraving at the Slade School. Worked as a painter and wood engraver. Painted portraits and Paris scenes in watercolour. A leading member of the ST. ANDREWS SCHOOL.

Kilgour, Robert W. fl.1830s–60s

Prolific Edinburgh landscape painter. Exhibited RSA.

King, Jessie Marion (Mrs E.A. Taylor) 1875–1949

Born New Kilpatrick, Dunbartonshire, and studied

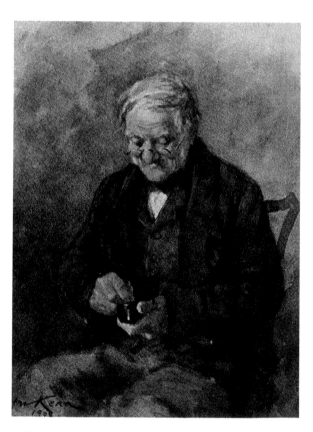

Henry Wright Kerr *Front Cover for 'Some Stories of Wit and Humour'* (T N Foulis, Edinburgh) 1909, private collection

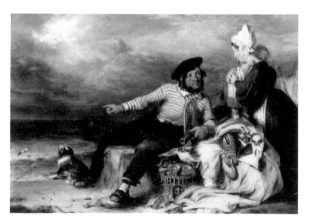

William Kidd *A Fisherman's Tale* oil, private collection

at Glasgow University and GSA where, during the 1890s, she was influenced by the work of JESSIE NEWBERY and the Four. Her work developed quickly and she won a Queen's prize in the South Kensington National Art Competition of 1898 for her design work. She had developed a highly individual illustrative style based upon exquisite pen-and-ink drawing, using lines and dots in a manner reminiscent of Beardsley whom she admired. Her work, however, lacked the sensuality of Beardsley and the tormented anguish of FRANCES MACDONALD. In 1902 she joined the staff of GSA to teach book-cover design and in the same year she was recognised by a full-length article in *The Studio* by Walter Watson. In 1904 King was commissioned to produce 95 illustrations for William Morris's *The Defence of Guinevere and Other Poems*, but even when not working on specific commissions she would illustrate literature which had caught her imagination. The late 19th century believed in the concept of the total work of art, bringing together various branches of art, and in this respect Jessie King was part of the Symbolist movement. She worked as a designer of jewellery, tiles, fabrics, wallpapers and book covers.

In 1909 an exhibition was held of her watercolours and drawings of France, Germany and Scotland including Kirkcudbright which represented a move away from her earlier illustrative work.

In 1908 she married E.A. TAYLOR and in 1911 they moved to Paris, establishing an art school – the Shealing Atelier. King was impressed by the designs of Bakst for the Ballets Russes and her designs became stronger and more colourful. She also experimented with batik.

On the outbreak of war they returned to Scotland, setting up a summer school at High Corrie on Arran and working from their home near Kirkcudbright. King's later watercolours show a bold, colourful approach, influenced to some extent by her husband. She experimented with acid dyes to give more brilliant colours: she also worked on ceramic.

Jessie M King *Kind Fates Attend thy Voyaging* watercolour, pen, ink and gold on vellum, Barclay Lennie

Jessie King was widely talented, and all periods of her work are interesting, but her exquisitely detailed and executed drawings and illustrations of 1898–1905, often painted on vellum and sometimes heightened with gold, have few rivals in British art of the period. Died Kirkcudbright.

Kininmonth, Caroline fl.1940s–50s
Edinburgh painter of flowers and landscape.

Kinloch-Smyth, George W.A. 1835–96
Born Meigle, Perthshire, and painted local scenes including landscapes with figures.

Kinnear, James fl.1875–1917
Edinburgh landscape painter who worked in a style similar to that of JAMES HERON. Painted landscapes and views of Edinburgh, some of which were reproduced in the *Art Journal*.

Kinnear, Leslie Gordon 1901–76
Dundee landscape and figure painter who worked largely in watercolour.

Kirk, James 1817–?
Born Tweedshaws. Trained Trustees' Academy 1840–9, 50–1. Portrait painter. Exhibited RA 1847–54. Lived Dumfries area.

Kirkcudbright School
It was E.A. HORNEL who drew his contemporaries to Kirkcudbright, either to visit or to stay. In many respects the Kirkcudbright School was the Glasgow School in the country. Hornel's friendship

Annabel A Kidston *February* wood engraving, private collection

with GEORGE HENRY effectively began the School when they worked together in Kirkcudbright, and this was followed by a visit from GUTHRIE.

Other names become associated with the School, particularly BESSIE MACNICOL and W.S. MAC-GEORGE. Both developed under Hornel's influence, MacNicol painting a rare portrait of Hornel. WILLIAM MOUNCEY married one of Hornel's sisters and as a result came under his influence, although he worked in what might be considered an innovative form of the Kirkcudbright style. THOMAS BROMLEY BLACKLOCK, although initially a more traditional Victorian painter, developed a distinctive 'Kirkcudbright style' in his later work. JOHN COPLAND followed in Mouncey's footsteps and in 1884 CHARLES HODGE MACKIE, on a visit to Kirkcudbright, painted a small portrait of Copland.

As the influence of Kirkcudbright developed other artists gathered round. JESSIE M. KING's purchase of 'Greengate' in the High Street in 1908 was a direct result of the growing influence of Kirkcudbright on contemporary Scottish artists. Later, E.A. TAYLOR and Jessie M. King were to set up home at 'Greengate' and lived there until their deaths.

CHARLES OPPENHEIMER moved to Kirkcudbright in 1908 to live next door to Hornel and WILLIAM ROBSON came in 1904 to live in 'The Auld King's Arms', just along from Hornel. Bertram Priestman shared Robson's studio on his many visits and produced a fine view of Kirkcudbright harbour in moonlight. ROBERT MACAULAY STEVENSON later set up his studio in Kirkcudbright having been drawn by the continuing reputation of the School in the 1920s.

The visits of E.A. WALTON led to his daughter CECILE WALTON's friendship with the King-Taylors and DOROTHY JOHNSTONE during and after the Great War. S.J. PEPLOE was also a great friend and frequent visitor to the King-Taylor household, where he painted several views of Kirkcudbright.

As Kirkcudbright developed into an active colony of artists other names arrived on the scene. David Sassoon developed his own style based largely on E.A. Taylor's oils of the period; WILLIAM MYLES JOHNSTON and his wife DOROTHY NESBITT became resident; Phyllis Mary Bone (1896–1972) the sculptress; WILLIAM HANNA CLARKE (1882–1924) and visitors like HARRY MACGREGOR and ROBERT BURNS who spent the summer months in Kirkcudbright from 1900 onwards. KATHARINE CAMERON and her husband ARTHUR KAY were also drawn to the town to spend their summer holidays in the Selkirk Arms.

DAVID GAULD painted many of his calf pictures around Kirkcudbright, the Cannee and Low Boreland being among his favourite places. ROBERT SIVELL came to live and work in Kirkcudbright after marrying a local girl. Robert Hannah came from Creetown and may have influenced other minor talents such as MALCOLM MACLACHLAN HARPER, who was a close friend of Hornel, Blacklock and MacGeorge.

Artists who have been influenced by the traditions of Kirkcudbright included A.R. STURROCK, who married Francis Newbery's daughter Mary, and who had his studio in nearby Gatehouse of Fleet. JOHN MAXWELL lived and worked in Dalbeattie and W.G. GILLIES was his friend and a frequent visitor to Galloway.

The growth of Kirkcudbright as a 'Mecca' for artists has most probably been influenced by the effect of light on a hilly land, facing south, which produces both soft colours and the whole spectrum of grey. It was this light and colour which has most attracted some of Scotland's greatest artists. (*Niall Duncan*)

Kirkwood, Thomson fl.1860s–80s
Glasgow painter of landscape and rural scenes.

Knott, Taverner fl.1840–90
Lived Edinburgh and Glasgow. Painter of portraits, figures and family groups; also landscapes and coastal scenes. Member of the WSA. Exhibited Carlisle Academy (1846) and later at RSA.

Knox, Jack b.1936
ARSA 1972, RSA 1979
Born Kirkintilloch and studied GSA 1953–57. Studied in Paris under André Lhote 1958–59. Became a lecturer at Duncan of Jordanstone College of Art 1965–81 (now Head of Painting at GSA)and started to exhibit in 1960. Has moved from an abstract expressionism to more representational still-lifes in an off-beat dead pan style somewhat reminiscent of the work of Patrick Caulfield.

Knox, John 1778–1845
Born Paisley, the son of a yarn merchant, the family moved to Glasgow in 1799. In 1809 his name appears as a portrait painter living at 34 Millet Street, and in 1817 his name appears as a teacher of drawing at 40 Dunlop Street. In 1821 the title 'Landscape Painter' was added to this entry in the Glasgow Street Directory, and we know that DANIEL MACNEE, HORATIO MCCULLOCH, and W L LEITCH came to his Dunlop Street studio as pupils. Between 1828 and 1836 Knox lived in London and exhibited works at the RA and British Institute. He returned to Glasgow in 1836, but moved to Keswick in 1840, dying there in January 1845.

John Knox *Sunset in the Western Highlands* oil, Bourne Fine Art

Knox is known for his panoramic landscapes; in particular two views from the top of Loch Lomond and his earlier view *Old Glasgow Bridge*. He also painted more Claudian landscapes including views of Loch Katrine and the historically interesting *The First Steamboat on the Clyde*. Knox travelled around the west coast of Scotland as shown by a collection of lithographs *Scottish Scenery drawn upon Stone by John Knox* which was published in 1823. Knox was possibly influenced by William Daniell's *A Voyage round Great Britain* (1813–25). He also worked in the Lake District, probably because his wife Sarah Scott came from Cumberland. Also painted some of the earliest views of Glasgow. Although some of the details are scarce, Knox was certainly an important influence in the development of art in Glasgow, both as a teacher and as a painter.

Knox, Thomas fl. 1840s
Glasgow landscape painter, he worked in the Lake District and Borders.

Kirkcudbright School: Harry MacGregor *Kirkcudbright from the Stell* oil, private collection.

L

Laidlaw, Nicol 1886–?
Born Edinburgh, studied ECA and Paris. Painted watercolour landscapes of the Lothians, portraits in oil and illustrations.

Laing, Annie Rose 1869–1946
Born Glasgow née Low, studied GSA, married JAMES GARDEN LAING. Painted landscapes, interiors and children, mostly in oil.

Laing, Frank 1862–1907
ARE 1892
Born Dundee, he studied in Edinburgh and in Paris under J.P. Laurens. He liked Paris and spent time there both as a student and later as an artist, and he made a reputation as an etcher of Parisian views. Also etched views of Edinburgh, St. Andrews, Dundee, Tayport, Antwerp and Venice. His etchings are refined and understated, influenced to some extent by Whistler, who also admired Laing's work. Laing also painted in oil and watercolour; most notable are his confidently executed views of Paris. He was a good portrait painter influenced by the French portraitists of the 1890s like Paul Helle.

Laing, James Garden 1852–1915
RSW 1885
Born Aberdeen and trained as an architect. He practised for many years before settling in Glasgow to work as an artist. Like many Scottish artists of his generation, he was influenced by the Dutch 19th century school and his coastal and marine watercolours reveal a debt to Maris, Weissenbruch and Roelofs in their 'wet' technique and restrained colours. He painted Scottish fishing villages, Dutch coastal scenes and canals, market-places and church interiors. He worked largely in watercolour. Died Glasgow.

Laing, Margaret J. fl.1920s–40s
Edinburgh painter of interiors, flowers and portraits. During the war, painted bomb-damaged houses.

Laing, Tomson fl.1890–1904
Glasgow based painter of landscape and coastal scenes.

Laird, Miss A.H. fl.1830s–50s
Lived in Edinburgh and painted miniatures.

Lamb, Helen Adelaide d.1981
Born Prestwick, she studied at GSA 1907–15. She was an illustrator of manuscripts, but also worked in

Frank Laing *The Yellow Girl* watercolour 1894, Dundee Art Galleries & Museums

J Garden Laing *Winter Scene* watercolour, Peter Howarth Esq

watercolour and as a pencil draughtsman. Taught at St. Colomba's School, Kilmacolm.

Lamb, J. fl.1890s
Little is known of this Edinburgh based portrait painter although there are some very competent portraits in oil in existence.

Lamb, Mildred Richley (Mrs Walter Connor) 1900–1947
The sister of HELEN LAMB, she studied at GSA 1922–5, and illustrated many books 1923–37 as well as painting in watercolour.

Lamond, William Bradley 1857–1924
RBA 1904
Born Newtyle, near Dundee, he worked for many years on the Caledonian Railway. He developed a talent for portrait painting at which he made a reputation, but later turned to landscapes and, especially, seascapes. His vigorously painted harbour scenes are often effective, and his lack of formal training resulted in a direct and powerful style. Died Dundee.

Lamont, John Charles 1894–1948
ARSA 1941
Born Lanarkshire and studied at GSA where he became a friend of SIVELL and COWIE. Landscape and figure work. Exhibited RSA, GI, Kirkcudbright and Dumfries. The *Scotsman* obituary noted, 'His painting was low toned, with a curiously happy ability to ally low tone with colouring so intense as to be almost acid.' He was wounded while serving in the Tank Corps during the First World War and his health was permanently damaged. After the war he settled in Kirkcudbright near SIVELL, whose wife was Lamont's sister-in-law. He painted interiors, figures, portraits and some landscapes in a dark tonal manner. He was probably influenced by the work of ARCHIBALD MCGLASHAN, who was a close friend. His output was small because of his poor health. Died Kirkcudbright.

Lamont, Thomas Reynolds 1826–1898
ARWS 1866
Born Greenock, he studied in Paris along with

Du Maurier and Poynter at the Atelier Gleyre. These student days are recalled by Du Maurier in *Trilby* in which Lamont is The Laird. He painted period pieces in watercolour, with figures dressed in elegant 18th-century costume, often posed in beautiful gardens. His technique is fine: he is obsessed by detail and at the same time he creates luminous colours, which may have been influenced by Pre-Raphaelitism. His subject-matter does not always do justice to his technique.

Langlands, George Andrew Nasmyth, d.1939
RSW 1896
Trained in Edinburgh and Paris, he was a prolific artist both in oil and watercolour, painting Scottish east coast and Highland scenes, but also working abroad, in Belgium and Holland. His work is quietly competent.

GNL

Latimer, Elizabeth Osborne fl.1899–1940
Lived in Edinburgh and exhibited SSA. Painted landscapes with figures.

Lauder, Charles James 1841–1920
RSW 1885, resigned 1913
The son of JAMES THOMPSON LAUDER, he studied art under HEATH WILSON at Glasgow School of Design. He was an elegant draughtsman with an ability to paint towns and cities. His earlier work is of the Clyde and Glasgow, but he settled in England in the late 1890s, often visiting Italy and in particular the Sorrento peninsula and Venice. Also worked in Paris. His watercolours were executed with great panache for not only was he a proficient draughtsman, he also had a feeling for the textures and effects of watercolour. His second wife Gertrude Lauder (1855–1918) was a member of the GLASGOW SOCIETY OF LADY ARTISTS and bequeathed £250 to establish the Lauder Prize for the best work in the annual exhibition. Died Glasgow.

Lauder, James Eckford 1811–1869
ARSA 1839, RSA 1846
Born Edinburgh, the younger brother of ROBERT SCOTT LAUDER, he studied at the Trustees' Academy

W B Lamond *Dundee and Broughty Ferry from the South* oil, Robert Fleming Holdings Ltd

Charles James Lauder *Register House and the East end of Princes Street, Edinburgh* watercolour ca. 1895, Paul Harris Esq

under SIR WILLIAM ALLAN and THOMAS DUNCAN, 1830–33, before spending four years in Rome with his brother 1834–8.

In 1847 he won a £200 prize in the Westminster Hall competition with his *Parable of Forgiveness* which revealed his knowledge of the Italian High Renaissance. During the 1850s he produced his most successful historical and biblical paintings, but his work was inconsistent in quality and he received less acclaim than his contemporaries. In 1857 he turned towards landscape painting, but he still failed to achieve public recognition. Later work failed to live up to his earlier promise. Died Edinburgh.

Lauder, James Thompson fl.1830–50
Glasgow portrait painter and father of the more talented CHARLES JAMES LAUDER.

Lauder, Kenneth b.1918
ARCA
Born Edinburgh and studied at Chelsea School of Art and RCA after boyhood in Scotland which gave him a background of country and coastline. Watercolour painter influenced by the remoter areas of Britain. Lived in Berkshire and the Isle of Man.

Lauder, Nancy 1880–?
Glasgow painter of flowers in oil and watercolour.

Lauder, Robert Scott 1803–1869
RSA 1830
Born Edinburgh, he studied at the Trustees' Academy under the mastership of ANDREW WILSON. Then spent a further three years in London where he drew at the British Museum and attended private life classes, returning to Edinburgh in 1826. He painted portraits and taught at the Trustees' Academy, where WILLIAM ALLAN had succeeded Wilson. He became a friend of JOHN THOMSON OF DUDDINGSTON and married his daughter.

In 1833 the couple set out for Italy where they remained until 1838, based in Rome, but also visiting Florence and Venice. In Rome, Lauder

Robert Scott Lauder *St John the Baptist Preaching in the Wilderness* oil 1845-50, James Holloway Esq

painted portraits and genre, often studies of Italian peasants and bandits.

On his return he settled in London where he remained until 1852 achieving success as a history and biblical painter. In the latter, both Rubens and Rembrandt were an influence, for Lauder was widely knowledgeable of art historical periods. Had he stayed in London, Lauder might have achieved great fame, but in 1852 he accepted the post of Master of the Trustees' Academy and returned to Edinburgh. He was to become one of the greatest teachers of his period, but at the expense of his own career as an artist.

As Master, Lauder gave great encouragement to his students, urging them to start painting as soon as possible and not to restrict themselves only to drawing. He also stressed the need for composition, grouping antique sculpture in interesting ways. Officially Lauder was Director of the Antique, while BALLANTYNE ran the painting classes, but Lauder's interest in the role of colour in painting greatly influenced the students. The greatest disappointment for Lauder came with the establishment of the RSA Life Classes, which were run on more academic and less imaginative lines. It reduced Lauder's role and in 1861 he ceased teaching, and following a stroke, he was unable to paint. Although Lauder died embittered by lack of commercial success and by his fight against the teaching methods of the RSA Life School, his pupils owed much to him. It is difficult to assess exactly how much influence his methods had, but his main pupils – MCTAGGART, ORCHARDSON, PETTIE, CHALMERS, HERDMAN, CAMERON, PETER GRAHAM, THOMAS GRAHAM, MACWHIRTER and the BURR brothers – all benefited from their years at the Trustees' Academy. Died Edinburgh.

Lauder, William fl.1698
Born Haddington, son of the Provost. Apprenticed to THOMAS WARRENDER.

Laurie, John b.1916
Born Shrewsbury and studied at GSA, 1933–6, and at Hospitalfield 1938–40, where COLQUHOUN and MACBRYDE were fellow students. Works in Glasgow.

Lavery, Sir John 1856–1941
NEAC 1887, ARSA 1893, RP 1893, RSA 1896, ARHA 1906, RHA 1907, HROI 1910, ARA 1911, Knighted 1918, RA 1921
Born Belfast, he studied at the Haldane Academy in Glasgow, Heatherley's in London and at the Académie Julian and Atelier Colarossi in Paris. His fellow students in Paris included DOW, WILLIAM KENNEDY, ROCHE, William Stott of Oldham and Frank O'Meara. In the summer of 1883 Lavery visited Grez-sur-Loing, a village near Fontainebleau, where English and Scottish students from Paris were working. Here in 1884–5 Lavery produced some of his first landscapes including *Under a Cherry Tree* and *A Grey Summer's Day, Grez*.

In 1885 Lavery returned to Glasgow and started

Sir John Lavery *Lady in Black* oil, private collection

work on *The Tennis Party*, intended to be a painting about modern middle-class life. It is a complex painting in terms of composition and space, and is a major achievement of the Glasgow School. Whereas Bastien-Lepage had been an important influence on Lavery in France and in *The Tennis Party*, Whistler was to become a stronger force. *A Visit to the Studio* (1885) reveals Lavery's debt to Whistler as did the portraits he began painting in the late 1880s. In 1888 Lavery painted a series of views of the 1888 International Exhibition in Glasgow and a huge canvas *The State Visit of Queen Victoria to the International Exhibition, Glasgow 1888*. As soon as this work was completed in October 1890, Lavery visited Morocco, the first of many visits. In 1903 he established a winter retreat outside the walls of Tangier and North African scenes were to play a growing role in his art.

In 1896 Lavery moved to London helping to found the International Society with Whistler in 1898. Lavery was well established as a portrait painter, but he managed to work abroad in France, Italy and North Africa. He also painted landscapes in Scotland and some fine snow scenes in the Swiss Alps. His greatest commission came in 1913 when he was invited to paint the Royal Family for £2000.

During the war Lavery worked as an Official War Artist attached to the Navy; was knighted in 1918 and during the Irish Troubles his position was delicate, striving to remain impartial. He recorded his horror at the assassination of Michael Collins in the moving portrait *Michael Collins' Love of Ireland*. Although occupied between the wars with official portraits and commissions, he found time to paint *plein-air* sketches, interiors, horse-racing scenes and figures in landscapes. He and his wife were society figures, but this did not stop his flow of fresh, vibrantly painted oils.

Lavery's work after 1890 owed much to the example of Velasquez and Manet who also manipulated oil paint in a dashing yet controlled manner. He moved far from the Glasgow School and its aims, but despite inevitable criticism of shallowness, his wide range of subjects combined with an extraordinary technique make him one of the most interesting artists of his period. Died Kilmanganny.

Law, Andrew 1873–1967
Born Crosshouse, Kilmarnock, trained Haldane Academy, Glasgow, and under Delacluse in Paris. Teacher at GSA until his retirement in 1938. Noted portrait painter who exhibited RSA, RGI and Paisley. Also landscapes, townscapes, still-life and animal studies. His early work can be reminiscent of HENRY and LAVERY.

Law, David 1831–1902
RE 1881, RSW 1882, RBA 1884, HRBA 1893
Born Edinburgh, studied Trustees' Academy, he worked as an engraver producing detailed maps, eventually working for the Ordnance Office in Southampton. Later devoted himself entirely to watercolour painting, being influenced by Birket Foster and the later Pre-Raphaelites. He painted landscapes in England, Scotland, Wales and had a particular love for detailed shipping scenes, which he found in Venice. His watercolours are often large with fine drawing and detail.

Law, Helen fl.1880s
Lived and worked in Pollokshields. Painted domestic scenes, interiors and genre in pastel and watercolour.

Andrew Law *The Guinea Fowl* oil, Angus Grossart Esq.

Lawrie, Hamish 1919–87
Born Dunfermline and studied art at Aberdeen. Went to London in 1941 and joined the film industry as a cameraman. Painted scenes in the film studio and on location, selling his first picture to Dylan Thomas for £5. First major exhibition, of Scottish landscapes and Irish gouaches, in 1947 at Wolf Mankowitz's Little Gallery. Worked in Africa 1949–51 and returned to Scotland where his old friend J. D. FERGUSSON persuaded him to go to France. He lived there for nine years at St Paul de Vence, returning to Edinburgh in 1960. In Scotland his favourite subjects were in the western Highlands and the Outer Hebrides. He painted these scenes with the great gusto, brilliant colours and heavy impasto which characterised so much of his work. A regular exhibitor in Edinburgh, he was a popular figure in the SCOTTISH ARTS CLUB.

Lawson, Cecil Gordon 1851–82
Lawson's links with Scotland are through his parents. He was born in Shropshire, the son of WILLIAM LAWSON an Edinburgh portrait painter, and in 1861 the family moved to London where Lawson was to remain. His early work was tight and detailed, often studies of flowers and fruit, but his style later broadened. His landscapes were painted in a free, loose style both in oil and watercolour, capturing brilliantly the sun, clouds and wind of an English summer.
He retained many Scottish characteristics in his personality and in his approach to landscape painting. His death aged 31 cut short a promising career. His work was admired in Scotland and he was well represented in the 1888 Glasgow International Exhibition. His work was highly praised by Caw who adjudged him 'one of the greatest landscape painters of the century.'

Lawson, Francis Wilfred 1842–1935
The brother of CECIL GORDON LAWSON, he was born in Shropshire of Scottish parents and lived all his life in England. He worked as an illustrator and a painter of poor city children.

Lawson, John 1868–1909
Landscape painter of Highland and Welsh scenes. Exhibited SSA.

Lawson, William fl.1814–64
Edinburgh painter of rustic scenes and portraits, he moved to Shropshire in the 1850s and to London in 1861. The father of CECIL GORDON and FRANCIS WILFRED LAWSON.

Lawson, William fl.1830s–40s
Lived in Edinburgh and painted portraits, figures, rural scenes and historical scenes, often with Shakespearian themes.

Lawson, William Rawson b.1900
Studied at ECA under ROBERT BURNS and exhibited SSA. Painted landscapes of the west coast and figure compositions.

Leadbitter, Margaret Fletcher fl.1908–c.1950
Born at Dunans, Argyllshire, she studied at London, Paris and Italy. Lived in London and Harrogate, but painted often in the Scottish Highlands. She was also known for her Italian views generally and, specifically, for her Venetian views.

Le Conte, John 1816–87
Edinburgh topographical artist who studied under ROBERT SCOTT, the engraver, before setting up on his own as a watercolourist and engraver. He recorded many of the old buildings of Edinburgh before the great redevelopments of the 19th century.

Lee, Arthur fl.1860s–1890s
Dundee painter of landscape and local views.

Lee, Joseph 1878–1949
Born Dundee. Illustrator and graphic artist. He illustrated *Lochee as it was, and as it is* by Alexander Elliot (1911) and published a volume of war poems *Ballads of Battle* (1916) illustrated by himself. Worked with Thomson-Leng in Dundee and London. Died Dundee.

Lees, Charles 1800–80
RSA 1830
Born Cupar, Fife, studied under RAEBURN and spent six months in Rome before returning to Edinburgh where he was to work for the rest of his life. He painted portraits and landscapes, but is best known for his delightful sporting scenes, especially skating. He acted as Treasurer of the RSA for some years.

Leggatt, Alexander 1827–?
Born Edinburgh, studied Trustees' Academy to which he was recommended by WILLIAM BONNAR. Landscape and portrait painter. Exhibited RSA.

Leggett, Alexander fl.1870s–80s
Edinburgh based topographical painter. Also painted coastal scenes with figures, often fishermen.

Robert W Leishman *A Fairy Tale* watercolour, Julian Halsby Esq

Leishman, Robert 1916–1989
RSW
An unusual and original painter of a personal fantasy world, he worked in oil and watercolour using floating figures and objects and rich colours. He was influenced by MAXWELL, Chagall and Miro, and there is also a strong sense of wit in his work.

Leiper, William 1839–1916
RSW 1879, ARSA 1892, RSA 1896
Distinguished architect who moved from a Gothic style towards the Free School approach of Norman Shaw, designing many houses in Helensburgh. Also painted watercolours of the west coast.

Leitch, Richard Principal d.1882
Born Glasgow, the brother of W. LEIGHTON LEITCH, he settled in London and taught drawing. Travelled extensively in Italy and Switzerland, and visited Egypt. His watercolour style is somewhat heavy, although his best work can be effective.

Leitch, William Leighton 1804–1883
RI 1862
Born Glasgow, he was trained for the law, but disliking this choice of career, spent much time with his friends HORATIO MCCULLOCH and DANIEL MACNEE, who were both painting. In 1824 he became a scene painter at the Theatre Royal, Glasgow, but within a year he had moved to Cumnock, Ayrshire, where he worked decorating snuff boxes.
In 1830 Leitch moved to London where he was to be based for the rest of his life supporting his wife and three children by working for theatres. He became a friend of DAVID ROBERTS and Clarkson Stanfield, both of whom also painted scenery. A wealthy stockbroker recognized Leitch's talent and sent him to take lessons with Copley Fielding; and between 1833 and 1837 he was in Italy where his style developed rapidly. He later described these years as 'the most interesting part of all my artistic life'. Supported by his patron he visited Rome, Venice, Sicily and the Salerno peninsula, which deeply impressed him. He did not return to Italy until 1854, but continued to paint Italian views.

Leitch was introduced to the Royal Family and for 22 years he taught at Windsor, Osborne, Balmoral and Buckingham Palace, his pupils including Queen Victoria, Princes Arthur and Leopold and Princesses Louise and Helena.
In 1854 he was accompanied by SIR COUTTS LINDSAY to Rome and the Italian lakes, which, being an admirer of Turner, he particularly wanted to see. Leitch was a watercolourist of the old school – he disapproved of the use of body colour and used the white of the paper to create light. He believed in working on the spot, attempting to capture a specific atmospheric effect. Leitch's work has charm and spontaneity: his Italian scenes are painted in fresh blues, purples and greens, the buildings holding the sunlight. His Scottish watercolours are mistier and more atmospheric. Died London.

Leyde, Otto Theodore 1835–1897
ARSA 1870, RSW 1879, RSA 1880, RE 1881
Born in Wehlau, East Prussia, he came to Edinburgh in 1854 and worked as a lithographic artist. Painted oils and watercolours depicting Scottish landscape and scenes from rural life, often with well-drawn figures. His handling of children, painted with fresh colours and sympathy, is particularly fine. He also painted portraits in watercolour. Died Edinburgh.

Lindsay, Sir Coutts 1824–1913
Talented amateur who executed portraits and figure

William Leighton Leitch *The Toolshed* watercolour, private collection

Otto Leyde *Schiller* pencil drawing, private collection

studies. In 1854 he went to Rome with WILLIAM
LEIGHTON LEITCH.

Lindsay, George fl.1820s–40s
Edinburgh painter of genre and portraits.

Linen, George 1802–88
Born Greenlaw, Berwickshire, and studied at
the Trustees' Academy. Worked as a portrait
painter and emigrated to North America: work
by him in the Metropolitan Museum of Art. Died
New York.

Lintott, Henry John 1877–1965
ARSA 1916, RSA 1923
Born Brighton, he studied at Brighton, South
Kensington, Paris and Italy. He is associated with
the Scottish School as he was appointed to the staff
of EDINBURGH COLLEGE OF ART in 1902 and became
an important member of staff during the years of
great development and creativity. He was known
for his large canvases of women in graceful dance or
song, but he also painted more intimate landscapes.
His second wife Mrs Audrey Lintott also painted.
There was a large memorial exhibition shortly after
his death. Died Edinburgh.

Henry Lintott

Henry Lintott *From my Studio Window* oil, Robert Fleming
Holdings Ltd

Little, James fl.1880–1910
Edinburgh artist who painted townscapes and sea-
scapes in a proficient style, his colours tending
towards a restrained grey-green tonality. Painted
in Paris in the mid-1880s.

Little, Robert 1854–1944
RSW 1885 (resigned 1904, re-elected 1910), ARWS
1892, RWS 1899, ROI 1901, VPRWS 1913–16, HRSW
1936
Born Greenock, the son of a wealthy Glasgow
shipping merchant, he studied at the RSA schools.
His father encouraged him to study abroad and
spent 1882 at the British Academy in Rome
and 1886 in Paris working under Courtois and
Dagnan-Bouveret. As a child he travelled exten-
sively with his father visiting much of Europe,
Egypt, Palestine and Turkey and acquiring a
taste for the Mediterranean coastline. His ear-
lier works are detailed and show the influence of
the Pre-Raphaelites, but he later broadened his
style, introducing decorative elements. Although he
worked in both oil and watercolour, his later reputa-
tion was based on his large, decorative watercolours
often depicting the French or Scottish landscape.

Littlejohn, William M. b.1929
ARSA 1966, RSA 1973, RSW
Born Arbroath. Studied at Dundee College of Art
1945–51. Art teacher in Angus 1953–66 and then
became Head of Drawing and Painting, Gray's
School of Art, Aberdeen. Later Head of Gray's,
living in Aberdeen and Arbroath. Works principally
in watercolour and collage.

Littleton, Lucy Ann fl.1860s
Glasgow painter of flower pieces. Exhibited RSA.

Livingston, Mrs. N.C. 1876–1952
Born East Lothian and studied art in Paris in the
1890s. Early work includes studies of Paris but
nature, including floral subjects and landscapes,
was her preferred area. Painted in oil using a
knife. The *Scotsman* obituary noted: 'The style
was so delicate that at first sight her pictures
were taken to be watercolours.' Member SSWA.
Died Edinburgh.

Lizars, William Home 1788–1859
The son of an engraver, Lizars studied at the Trus-
tees' Academy and would probably have developed
into a history and portrait painter had his father
not died in 1812, leaving Lizars to run the family
business.
Lizars' early work reveals his aspirations as a history
painter, but the success of WILKIE's genre, tempted
him towards genre, his most famous work being *The
Reading of the Will* and *A Scottish Wedding* (both RA
1812). He did not totally abandon painting, but
devoted most of his energies to engraving the work
of others. Died Jedburgh.

Lochhead, John 1866–1921
RBA 1911
Born Glasgow, studied RSA Schools. Landscape
painter who worked mostly in oils, often utilising

an elongated format, but did some watercolours; connected with CRAIGMILL SCHOOL in Stirling. Travelled widely abroad.

Lock (or Loch), James 1774–1828
Born in Scotland but left in 1812 for India where he worked as a portrait painter. Lived in Madras, Calcutta and Lucknow.

Lockhart, John Harold Bruce 1889–1956
Born Beith, Ayrshire. Teacher and sportsman who became Headmaster of Sedburgh after a period at Rugby. Painted landscapes in watercolour, often relating to his visits abroad.

Lockhart, William Ewart 1844–1900
ARSA 1871, RSA 1878, RSW 1878, ARWS 1878, RE 1881, RP 1897
Born Eaglesfield, Dumfriesshire, he studied at the Trustees' Academy where J.B. MACDONALD was his main instructor. The most important influence on Lockhart was that of JOHN 'SPANISH' PHILLIP. In 1867 he made the first of several trips to Spain and painted many Phillip-like canvases with all Phillip's bravura of technique and execution. He also found inspiration in Spanish literature and history, as well as in Scottish history. Lockhart's most important commission came in 1887 when Queen Victoria invited him to record the Jubilee Ceremony at Westminster Abbey. Despite the difficulties of painting such a large and detailed canvas, Lockhart produced a successful work. His reputation greatly enhanced, Lockhart remained in London with many portrait commissions to execute. Lockhart's reputation declined after his death, and it is easy to overlook his excellent watercolours.

He painted fluent, richly coloured watercolours of Spanish scenes, and Scottish east coast villages and landscapes. For these he used a free, loose technique which links his work to that of SAM BOUGH. Died London.

Lockhart, W.M. fl.c.1870–1912
Pupil of THOMAS FAIRBAIRN, he was a topographical artist who worked in Glasgow.

Lodder, Charles fl.1880s–1902
Son of CHARLES A. LODDER. Painted landscapes. Exhibited RSA.

Lodder, Charles A., Captain fl.1860s–80s
Lived in Ayrshire and painted marine and harbour scenes. Exhibited RSA. A sea captain and friend of SAM BOUGH, who influenced his work.

Logan, George fl.1900–10
Lived in Greenock. Well-known designer of furniture and interiors for Wylie and Lochhead Ltd. Also painted fine watercolours of interiors which show how well many of the Glasgow designers could handle watercolour. Exhibited occasionally at the Glasgow Institute. Watercolours of his decorative schemes were reproduced in magazines of the period, including *The Studio*.

Long, John O. d.1882
RSW 1878
Scottish landscape painter, probably from Glasgow, who moved to London c.1860. Painted landscapes of Arran and Highlands.

Lorimer, John Henry 1856–1936
ARSA 1882, RSW 1885, ROI 1890, RP 1892, RSA 1900, ARWS 1908, RWS 1934

William Ewart Lockhart *Durham* watercolour 1884, Atholl Robson Esq

John Henry Lorimer *Spring Moonlight* oil, Kirkcaldy Museum & Art Gallery

Born Edinburgh, he studied at Edinburgh University then at the RSA Schools under MCTAGGART and CHALMERS followed by a period in Paris with Carolus-Duran. His father was Professor James Lorimer L.L.D. and his brother, the architect Sir Robert Lorimer.

His earlier works were mostly portraits and flower paintings, but it was as a painter of Scottish life that he was to become known. Lorimer worked within a restrained palette, favouring tones of grey, white and cream with the occasional touch of stronger colour, and in this he resembles Whistler. He used light extremely well, especially in his cool interiors with their luminous tones. In some respects his studies of girls in light coloured rooms, dressed in pale shades, reflects the influence of the Arts and Crafts Movement on interior design, and shows a break from the heavier, darker interiors of the mid-Victorian period. Lorimer had close contact with the development of lighter Arts and Crafts Interiors through his brother. He lived at Kellie Castle, where many of his interiors and garden scenes were painted.

Lorimer travelled abroad visiting Spain (1877), Italy (1882), Algiers (1891), Holland, Belgium and France painting landscapes, architectural views and figures. Although he often worked in oil, Lorimer was also an excellent watercolourist. Lorimer was not part of the Glasgow School but his work was often exhibited abroad with the GLASGOW BOYS and his reputation in Europe was considerable. Died Pittenweem.

Lothian, George fl.1840s–50s
Painted landscapes and coastal scenes. Exhibited RSA.

Loudon, Laura (née Bennie) 1871–1945
Studied at GSA 1888–97 before marrying John Loudon, Art Master, Hamilton Academy, and later Chief Inspector in Art for Scotland. Exhibited at the RSA.

Love, Robert fl.1860s
Glasgow landscape painter, he exhibited at the Glasgow Institute.

Low, Bet b.1924
RSW 1974
Born Gourock and studied GSA 1942–45. Then at Hospitalfield with JAMES COWIE. Initially worked with Unity Theatre designing sets and painting portraits. In 1967 she discovered Orkney which has inspired recent work. Specializes in calm scenes of sea and lochs with still water and reflection playing a major part. Exhibited extensively from 1947. Married TOM MACDONALD in 1947.

Lowe, Isabella Wylie 1855–1925
Perthshire miniature painter who also did landscapes in watercolour in a fresh and professional style.

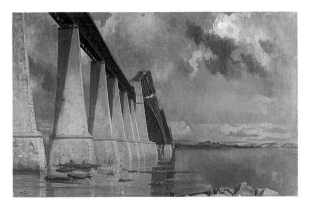
E S Lumsden *The Forth Railway Bridge* oil, private collection

Lucas, Marjorie A. b.1911
SSA 1946
She studied at the RCA under Osborne and Robert Austin, graduating in 1933. In 1938 she married the Scottish artist MURRAY MIDDLETON TOD and settled in Edinburgh. She works as an illustrator, engraver and wood engraver and also paints in watercolour.

Lumsden, Ernest Stephen 1883–1948
ARE 1909, RE 1915, ARSA 1923, RSA 1934
Born London, trained Reading School of Art, Paris and ECA, he settled in Edinburgh and became associated with many progressive Edinburgh artists between the wars. Married MABEL ROYDS, the artist and printmaker. His reputation was established through his etchings, but as a younger man he had painted many good watercolours, particularly those relating to his travels abroad. In particular his watercolours of India are fine, but he also painted in China, Japan, Korea, Canada, France and Spain. His book on the technique of etching is still regarded as a standard work.

Lyon, Andrew fl.1860s–'70s
Glasgow painter of seascapes and fishing subjects.

Lyon, George P. fl.1880s–1890s
Glasgow landscape painter.

Lyon, John Howard d.1921
Lived in Edinburgh and later in Strathyre. Painted grouse moors and Highland scenes in oil and watercolour.

Lyon, Thomas Bonar 1873–?
Born Glasgow. Studied at GSA and in France, Belgium and Holland before becoming art master at Irvine Academy. Lived in Ayrshire and painted its landscape in both oil and watercolour, the latter being influenced by Glasgow marine and coastal painters like MACMASTER and BLACK. Lyon's oils are lively and energetic, and often depict French or Belgian market scenes or squares.

MacAdam, Walter 1866–1935
RSW 1894
Born and lived in Glasgow and had a summer studio in Lochwinnoch, Renfrewshire. Painted Highland and west coast views in oil and watercolour in a style which is sound rather than exciting, with colours tending towards browns. Also worked after 1918 on Majorca. Died Peebles.

McArthney, William fl.1810–30s
Lived in Edinburgh and painted genre subjects. Exhibited RSA.

MacArthur, Sheila b.1915
Studied at GSA and Jordanhill College, and was a founder member of the NEW SCOTTISH GROUP in Glasgow in the early 1940's. Exhibited with DICK ANNAND and NOËL SLANEY in 1945.

Macaulay, Kate fl.1870–1900
RSW 1878, resigned 1898, ASWA 1880, SWA 1890
Landscape watercolour artist, she moved from Scotland to Capel Curig, North Wales. Watercolours are carefully composed and drawn, but not overworked. Particularly enjoyed coastal scenes.

Macbeth, Ann 1875–1948
Born Little Bolton, she attended JESSIE NEWBERYS embroidery classes at GSA 1897–1900, becoming assistant to Newbery in 1901 and Head of Department in 1908. Macbeth was a good draughtsman and many of her embroideries are based on figures in a style close to JESSIE KING – such as *The Sleeping Beauty*.
In 1911 she published *Educational Needlecraft*, which put emphasis upon craftsmanship without loss of creativity. This was followed by *The Playwork Book* (1918) aimed at children. Like the Newberys, Macbeth believed that 'beauty must come back to the useful arts and the distinction between fine and useful arts be forgotten.' Ann Macbeth also worked as an illustrator; her style is less delicate and ethereal than Jessie King or ANNIE FRENCH, with more emphasis upon outline and less variation in her use of penwork. She retired from the School of Art in 1928.

MacBeth, James 1847–91
Born Glasgow, portrait painter working from 1872. Exhibited in London but painted in Scotland.

Macbeth, Norman 1821–1888
ARSA 1870, RSA 1880
He was apprenticed to an engraver in Glasgow before moving to London to study at the RA Schools and in Paris. Returned to Greenock to paint portraits, moving into Glasgow and in 1861 to Edinburgh. He produced a large number of competent portraits.

Macbeth, Robert Walker 1848–1910
ARWS 1871, RE 1880, RI 1882, ARA 1883, ROI 1883, RWS 1901, RA 1903, HRE 1909
Born Glasgow, the son of NORMAN MACBETH, he moved to London in 1870 to work as an illustrator for *The Graphic* and his work really belongs to the English school, although his use of colour and his brushwork reveal his Scottish background.
Macbeth made a reputation with his scenes of rural life such as *The Lincolnshire Gang* or *In a Somerset Cider Mill*. He worked in the Fenlands and in Somerset, observing the life of country people, and painting them in an optimistic rather than realistic light. He also painted fishermen, gypsies and pretty girls set in landscapes. His earlier work was influenced by Fred Walker and Pinwell, but his technique later broadened. He was an excellent watercolourist and etcher.

Macbeth-Raeburn, Henry 1860–1947
RE 1899, ARA 1921, RA 1933
The brother of ROBERT WALKER MACBETH, he was born in Helensburgh and studied at the RSA Schools and Académie Julian, Paris. Like his brother he moved to London where his reputation was made. He was known as a painter of flowers and figures, often attractive girls. He also worked as an etcher of well-known artists' work. Gave up painting for etching in 1900.

McBey, James 1883–1959
Born Newburgh near Aberdeen, he joined the North of Scotland Bank in Aberdeen aged 15. He attended evening classes at Gray's School of Art and taught himself etching, building his own press. His first etching made on this press was *Boys Fishing*.
In 1910 he left the bank, visiting Amsterdam

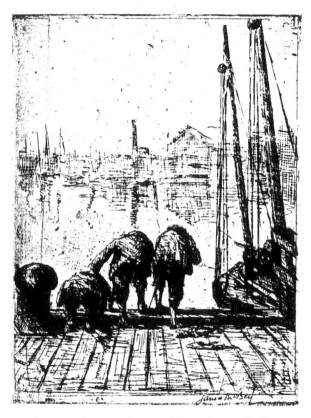

James McBey *Boys Fishing* etching, private collection

McBey's etchings are varied in subject and treatment, but all reveal his excellent and sensitive draughtmanship, and his sense of light. His watercolours are based upon a pen-and-ink framework, with washes freely run in. Apart from the North African desert, he was particularly good at depicting water scenes and cities like Venice and Rotterdam suited his talents. Died Tangiers.

MacBrayne, Madge 1883–1949
Born Glasgow, she studied at GSA. She was a landscape painter and sculptress and won the Lauder Award in 1931.

MacBride, Alexander 1859–1955
RSW 1887, RI 1899
Born Cathcart, studied GSA and Paris. Painted landscapes in oil and watercolour, choosing tranquil rural scenes often with sunlight coming through trees, or figures by a river. Influenced by Impressionism, he worked in Scotland, England and Italy. Dicd Cathcart.

MacBride, William d.1913
Glasgow landscape painter who worked mostly in

to see the etchings of Rembrandt and also visiting Spain. In 1911 he moved to London to prepare for a one-man at Goupil's which was a great success. In 1912 he travelled to Morocco with JAMES KERR LAWSON, beginning a long association with North Africa. It was here that McBey began to work in watercolour by adding coloured washes to his pen-and-ink drawings. In 1916 he enlisted and his etchings of the Somme led to his appointment as an Official War Artist. In 1917 he was sent to Egypt and during an intensely active two years he produced some 300 watercolours of the campaign in Egypt and Palestine. Many of these he later developed as etchings. He also painted the portrait of King Feisal and T.E. Lawrence in oil.

In 1924 and 1925 McBey worked in Venice producing bold etchings and watercolours. In 1929 he visited America, returning in 1930 when he married Marguerite Loeb from Philadelphia. He introduced his wife to Morocco in 1932 and they bought a house near Tangier, later buying a second property in Marrakesh. McBey felt at home in North Africa and many of his best works were executed there. During the Second World War the McBeys lived in America, and despite immigration problems he was able to work, but in 1946 they returned to Tangier where McBey continued to work, with regular trips to America and Britain, until his death in 1959.

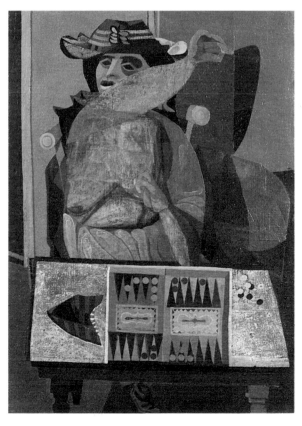

Robert MacBryde *The Backgammon Player* oil, City of Glasgow Art Galleries & Museums

oil, but did some watercolours, often depicting leafy valleys or wood scenes.

MacBryde, Robert 1913–1966
Born Maybole, Ayrshire he entered GSA in 1932 where he met COLQUHOUN. The two 'Roberts' became inseparable and travelled together to France and Italy 1937–9.
MacBryde was exempted from military service on health grounds, and after Colquhoun's release in 1941 they moved to London together. MacBryde was, like Colquhoun, influenced by the angular style of Jankel Adler, but his work remained more colourful and decorative than that of Colquhoun. He painted mostly still-life with a strong sense of design and colour.
In 1943 he held his first and only one-man at the Lefevre Gallery, and in 1947 moved with Colquhoun to Lewes where they both worked on lithographs and monotypes for Miller's Press. Between 1949 and 1954 they lived in Dunmow, Essex, and MacBryde took part in the 1951 Festival of Britain exhibition *Sixty Paintings for '51*. The two Roberts collaborated on designs for a production of Messine's ballet *Donald of the Burthens* for Covent Garden in 1951, and in the same year MacBryde was commissioned to design murals for the Orient liner SS *Oronsay*. He was devastated by Colquhoun's death and moved to Dublin where he was killed by a car in 1966.

McCall, Charles James 1907–89
NEAC, ROI
Studied ECA under S.J. PEPLOE and moved to London. Painted intimate interiors, town scenes, landscapes and portraits in oil and pastel. Died London.

Macallum, Hamilton 1841–1896
RSW 1878, RI 1882, ROI 1883
Born on the Kyles of Bute, Macallum became a painter of the sea like his close friend COLIN HUNTER. He was a good sailor, and cruised around the west coast painting views of the sea, beach scenes with boys bathing and fishing boats. At times he has the sparkle of JOSEPH HENDERSON, but his figures can be rather weak and sentimental. In addition to Scotland, Macallum painted in Southern Italy including Capri and Salerno in the 1880s. He worked mostly in oil, but did execute some watercolours. He moved to London in 1865 hoping to emulate Hunter's success, but this he never really achieved.

McCance, William 1894–1970
Born Cambuslang and studied at GSA. He married a fellow student AGNES MILLER PARKER and moved to London in 1920. His earliest work was influenced by PRYDE and Nicholson, but in London his style developed rapidly, influenced by the Vorticists and Cubism. His work is not abstract for there are recognizable elements such as skies and landscape structures; he bases his imagery on the machine age suggesting a knowledge of Léger. McCance was widely knowledgeable of modern art and wrote art criticism for *The Spectator* and other art journals. He also taught and he did not rely upon his painting as a main source of income. This meant that his painting could be more personal and experimental, and indeed his work of the 1920s has no comparison in Scottish art.
In 1930 he became Controller of the Gregynog Press in Wales and began a distinguished career as a typographer and book designer, later lecturing on the subject at Reading University. This inevitably reduced his output of paintings, although he did continue to produce very private works such as the pacificist *Hiroshima* (1947). He also continued to write art criticism for several newspapers including *Picture Post*. His first one-man took place in 1960 in Reading, and he rarely exhibited during his lifetime. This meant that his work was virtually unknown until a touring retrospective took place in Scotland in 1975.

McCann, Charles fl. 1860s–70s
Glasgow painter of landscapes and seascapes in colour.

McCheyne, Alistair Walker 1918–81
Born Perth, he studied at ECA 1935–40, London and in Paris at the Académie Grande Chaumière 1947. Lived in Edinburgh and worked in oil.

William McCance *Mediterranean Hill Town* oil, Dundee Art ·Galleries & Museums

David McClure *Black Interior* oil, private collection

McClintock, Mary Howard ('Maidhi') 1888–?

Born Surrey and studied at the Slade. Lived in Edinburgh during the 1920s and 30s. Painted landscapes in watercolour with subject matter often drawn from travels in Mediterranean countries.

McClure, David b.1926

ARSA 1963, RSW 1965, RSA 1971

Born Lochwinnoch, he studied at ECA 1947–52, winning a travelling scholarship which took him to Spain and Italy 1952–3. His earlier work was often landscape, but he turned more towards painting interiors with still-lifes, flowers, studio furniture or nudes. His still-life, painted in vibrant colours influenced by the French Fauves, shows him to be a talented colourist. Executed murals at Falkland Palace (King's Bedchamber) and at the University of St. Andrews.

He often painted in Fife with ANNE REDPATH whose influence can be seen in his work.

MacColl, Dugald Sutherland 1859–1948

NEAC 1896, RSW 1938

Born Glasgow, he studied at London University, Lincoln College, Oxford, Westminster School of Art and the Slade under Legros 1884–1892. He painted landscapes and town scenes mostly in watercolour and travelled in Italy and Greece.

MacColl became known as a writer and lecturer on art, lecturing at University College London, and becoming Keeper of the Tate 1906–11 and Wallace Collection 1911–24.

MacConchie, John G. fl.1890s

Ayrshire painter of coastal scenes and harbours.

McClymont, John I. fl.1880s–90s

Lived in Edinburgh and painted landscapes and harbour scenes. Exhibited SSA.

McCracken, Francis fl.1920s–30s

Born New Zealand, he came to Edinburgh in 1921. Studied RSA Schools and in 1923 won the Carnegie Award. Painted landscapes and still-life. Strongly influenced by the Cubists and the COLOURISTS.

Macree, Maxwell fl.1850s–60s

Edinburgh landscape painter. Exhibited RSA.

McCulloch, Horatio 1805–1867

ARSA 1834, RSA 1838

Born Glasgow and named in memory of Horatio Nelson, he was apprenticed to a house painter but attended lessons with JOHN KNOX. In about 1824 he left Glasgow and spent a period with LEITCH and MACNEE decorating snuffboxes in Cumnock before joining the Edinburgh firm of engravers, W.H. Lizars. Here he worked colouring prints by hand and gained valuable experience. Lizars introduced McCulloch to the work of GRECIAN WILLIAMS and JOHN THOMSON OF DUDDINGSTON whose free style and keen interest in nature influenced McCulloch.

Between about 1828–38 he lived in Glasgow, but then settled in Edinburgh's New Town. He loved the Scottish landscape and would set out on painting trips to all parts of the country – especially the Highlands and Western Isles and Skye. Here, after his marriage in 1848 to Marcella McLennan, he had family. Apart from some visits to the English Lakes, Wales and London he rarely left Scotland.

McCulloch's painting was unencumbered by academic tradition: he painted fresh, breezy watercolours on the spot which he worked up into larger oils without losing the vitality and freshness of the original sketch. His landscapes became very popular in Scotland and were often engraved and sold in great numbers. Unlike the later Pre-Raphaelites he was not interested in detail, and he often worked quite freely on a large scale.

In some respects McCulloch was a progressive painter especially in his unacademic approach to his subjects and in his work on-the-spot. In other respects he remained very much a mid-century painter, especially in his use of colour and even in his composition. McCulloch and Landseer together created the Victorian image of the Highlands and although he was a 'gluepot', as far as the GLASGOW BOYS, were concerned, he did much to popularize Scottish landscape painting. He was the subject of

Horatio McCulloch *Hills in Skye* oil, Andrew Kerr Esq

a major exhibition at Glasgow Art Gallery in 1988. Died Edinburgh.

McCulloch, Ian b.1935
Born Glasgow and studied at GSA and Hospitalfield 1953–57. Won RSA Travelling Scholarship. Exhibited from 1959. Founder member of The Glasgow Group. Took up post as Lecturer in Fine Art at University of Strathclyde in 1967. Linear work underpinned by use of vibrant colour.

MacCulloch, James d.1915
RBA 1884, RSW 1885
Landscape artist who worked in oil and watercolour. Lived in London for many years, although his subjects are almost entirely of the Highlands and islands. His watercolour style is tight and his colours tend to be sweet, with purple mountains and pinks and yellows in the sky.

Macdonald, A.M. fl.1870–1888
A painter of children and rustic scenes in the style of HUGH CAMERON. He appears to have died young.

MacDonald, Arthur fl.1895–1940
Lived in Pittenweem and painted seascapes, coastal scenes, children and landscapes. Most of his work is in oil, but he did watercolours in a style similar to that of ANDREW BLACK and JAMES MACMASTER.

Macdonald, Biddy (Mrs Alexander Jamieson) fl.1895–1938
Married to the artist ALEXANDER JAMIESON. Portrait painter before their marriage and continued to paint, later in London.

Macdonald, Frances 1874–1921
Frances Macdonald was introduced to HERBERT MACNAIR and C.R. MACKINTOSH by FRA NEWBERY at GSA where she and her sister Margaret were attending classes. They became good friends and worked together on watercolours and design projects becoming known as the Glasgow 'Four' in 1899. Frances Macdonald married Herbert MacNair and in 1900 her sister married Mackintosh.
On several occasions between 1893 and 1897 Frances and Margaret Macdonald collaborated on watercolours, and it is difficult at times to tell their work apart, but Frances's watercolours are on the whole more tortured and sadder than those of her sister. Her *Omen* (1893) has a morbidity and fascination with death and suffering.
Frances Macdonald lived in Liverpool while her husband taught at the School of Art and Applied Art, but they returned to Glasgow in 1905 penniless and ignored by Macdonald's family. Many of her later watercolours reflect her own personal problems such as *The Choice* and *'Tis a long path which wanders to desire* which

appear to depict herself isolated in Munch-like introspection. She held a joint exhibition with MacNair in London in 1911, but it was not a success.
Frances Macdonald's best work dates to the 1890s. There were beautifully executed watercolours, often painted on vellum and framed in exquisite Arts and Crafts copper, and represent some of the finest examples of Scottish symbolism. One of the most effective of these is *Ophelia* (1898).

Macdonald, John fl.1840s–60s
Lived in Edinburgh and painted rural scenes, genre and interiors. Exhibited RSA.

MacDonald, John Blake 1829–1901
ARSA 1862, RSA 1877, RSW 1878
Born Boharm, Morayshire, studied RSA Schools, he became known for paintings of incidents during the Jacobite Rebellions. He later turned to pure landscape in both oil and watercolour and painted Highland and coastal views. During the 1870s he visited Venice and exhibited watercolours of Venice at the RSA. At its best, his work was fresh and effective, despite somewhat weak drawing. Died Edinburgh.

Macdonald, Margaret 1865–1933
RSW 1898, resigned 1923
Margaret Macdonald was introduced to her future husband CR MACKINTOSH at GSA, where she was attending classes with her sister, by FRA NEWBERY in 1892. Together with HERBERT MACNAIR they formed the 'Four' producing watercolours, posters and architectural designs. Margaret and FRANCES MACDONALD collaborated in several watercolours 1893–7 and their work is often difficult to distinguish, but Margaret's work tended to be less tortured and more decorative than that of her sister. In 1897–8 the two sisters painted four watercolours depicting the seasons: these, painted on vellum, reveal a delicacy of drawing and an inventiveness of design which is complemented by the elaborated beaten lead frames which they designed and made.
In 1900 Margaret Macdonald married Mackintosh, who was made a partner in Honeyman and Keppie in 1901. She was inevitably drawn into the decorative aspects of his work, helping with gesso panels and painted murals. Thus many of her watercolours between 1900 and 1910 are related to her husband's commissions. *The Mysterious Garden* (c.1905) is related to a series of gesso panels installed in the Music Room of the Warndorfer Villa in Vienna based on Maeterlinck's story *The Seven Princesses*. Many of her watercolours of this later period reach a high point of elegance, design and decoration and represent some of the finest examples of Scottish Symbolism. This quality can be seen in *The Pool of Silence* (1913) and another version of *The Mysterious Garden* (1911).

Mackintosh resigned his partnership in 1913 amidst recriminations. He was accused of arrogance, idleness and drunken behaviour, but at heart he longed for the independence to pursue his calling as an artist. For Mackintosh this bold decision was vindicated by his French watercolours, which must be considered amongst the most progressive Scottish painting of the period. For his wife, the move away from Glasgow spelled the end of her career as a painter. She continued to work with her husband designing fabrics and decorative schemes in London, and did some watercolours, but after their move to France in 1923 she produced no further work.

MacDonald, Murray fl.1889–1914
Lived in Edinburgh and painted hunting scenes, animals and landscapes.

MacDonald, Somerled 1869–1948
Painted portraits and landscapes, particularly of the Highlands. Exhibited RA. Died Inverness.

Macdonald, Tom 1914–85
Born Glasgow and trained as a marine engineer. With the exception of one year at GSA 1937–8, self-taught artist. Undertook theatre design during the War and was influenced by J.D. FERGUSSON, Adler and Herman. After the War, painted with BET LOW, whom he married in 1947. Worked in the theatre in Glasgow and with Scottish Opera 1965–76. Easel works in a wide range of media characterised by vigorous expressionism and surrealism. Died Glasgow.

Macdonald, William 1883–1960
Often known as 'Spanish' Macdonald, he was born in Scotland but trained in Paris and Madrid, learning etching and painting. His best work was inspired by his love of Spain and he was particularly successful at capturing the harsh, arid landscape. Returned to Scotland before the First War and lived in Dundee where he met and taught BEATRICE HUNTINGTON: they married in 1928. After the First War he became friendly with CADELL and PEPLOE. Exhibited widely including SSA and RSA and produced striking and bold portraits. An active member of the SCOTTISH ARTS CLUB. Died Edinburgh.

McDougall, Allan fl.1840s–50s
Glasgow landscape painter who often worked in Ayrshire.

McDougall, Lily Martha Maud 1875–1958
Born Glasgow and trained in Edinburgh, The Hague, Antwerp and Paris. Worked in Paris 1904–6 and exhibited at the RSA from 1900. Painted still-life and flowers in oil and watercolour. Lived in Edinburgh most of her life and was a founder member of the SSWA which was, in fact, started by her father who felt that the interests of women artists were poorly represented in Scotland.

McDougall, Norman M. 1852–1939
Trained in London as figure painter to Daniel Cottier, the stained glass artist. Continued studies later in Glasgow and lived at Carmunnock. Painted landscapes and figures in oil and watercolour. Exhibited RSA and RGI.

Macdougall, William Brown d.1936
Born Glasgow, he studied at the Académie Julian in Paris. Painted landscapes and river scenes in oil and pastel and was elected NEAC for these, but he also worked as an illustrator using very decorative patterns and effects. Lived in Essex for many years.

McDowall, William 1905–88
Born in Ayrshire and abandoned an early career in engineering for the stage. Studied painting at ECA under S. J. PEPLOE and moved to London in 1932. Worked as a commercial artist in the newspaper industry and exhibited at the RA and RSA. His work shows influence of the SCOTTISH COLOURISTS.

MacDuff, William 1824–81
Perthshire artist who painted local views and historical subjects.

McEwan, Rory 1932–1982
Born into a wealthy family in Berwickshire, he was educated at Eton and Cambridge. He worked as a musician before turning to art in 1951. During the 1950s and early 60s he produced highly detailed botanical watercolours, but in 1964 he began to paint abstracts which were developed into standing sculptures in glass, metal and perspex.

McEwan, Tom 1846–1914
RSW 1883
Born into an artistic but impoverished family near Glasgow, his father was a textile designer and amateur artist, a friend of JAMES DOCHARTY. McEwan was apprenticed to a pattern designer in Glasgow and took evening classes at GSA under ROBERT GREENLESS.
During the 1860s he began exhibiting at the Glasgow Institute and in 1872 spent six months with James Docharty painting in Islay and Jura. This trip finally determined McEwan to turn to art as a profession and over the next 40 years he produced a large number of genre and historical works, mostly painted in watercolour. His watercolour technique was meticulous with carefully worked and scrubbed areas. His subject matter was influenced by WILKIE's genre and Dutch 19th century painting. McEwan was President of GLASGOW ART CLUB.

McEwan, William fl.1820s–30s
Painted coastal scenes and landscapes. Exhibited RSA.

McEwen, Charles fl.1880s–90s
Lived in Glasgow and painted landscapes and coastal scenes in oil and watercolour.

McGeehan, Jessie M. 1872–c.1962
Born Airdrie, she studied at GSA 1888–1895 and in Paris. She travelled abroad working in Holland. She was a landscape and figure painter and also a glass mosaic designer.

McGeoch, Anderson James b.1913
Born in Paisley, he studied at GSA 1932–7 and in Paris 1938. He works in oil and pastel and as a sculptor in clay, wood and stone.

MacGeorge, Andrew 1810–1891
Glasgow lawyer and local historian who painted meticulous views of Glasgow and caricatures of local characters in pencil and watercolour.

MacGeorge, Mabel Victoria (née Munro) 1885–1960
RSW 1930
The niece of the Earl of Minto, she caused a minor sensation in 1916 by marrying the artist HUGH MUNRO, at that time a penniless painter cutting woodblocks for CHARLES MACKIE. Married WILLIAM STEWART MACGEORGE in 1929, a year after Munro's death, and began to paint watercolours seriously. She had been trained by J. CAMPBELL NOBLE and had acquired a proficient technique. Painted many parts of Scotland, including the Western Isles, the Lothians (where she lived for many years) and Perthshire. Her watercolours, which are often quite large, are painted with spirit and confidence.

MacGeorge, William Stewart 1861–1931
ARSA 1898, RSA 1910
Born Castle Douglas he attended the Royal Institution Art School in Edinburgh before going to Antwerp where he studied under Verlat 1884–5. On his return he painted subjects which involved children at play, executed in low-toned colours, but he soon came under the influence of HORNEL, who persuaded him to use brighter colours and greater impasto. MacGeorge's work thus belongs to the KIRKCUDBRIGHT SCHOOL, sharing their subject matter and technique. He continued to paint children at play, fields of flowers, woods, rivers with fishermen and some evening scenes. He also was inspired by the ballads of the Borders. He painted in Venice c. 1912. In 1929 he married the widow of HUGH MUNRO, the watercolourist MABEL VICTORIA MACGEORGE. Died Gifford.

McGhie, John 1867–1952
Glasgow artist, he studied at GSA, the RA Schools

W S MacGeorge *Children by the Solway Coast* oil, private collection

John McGhie *A Fresh Breeze* oil, private collection

and in Paris. Painted seascapes, coastal and harbour scenes in oil and watercolour. He was also an etcher.

McGill, Duncan T.G. 1896–?
Edinburgh landscape painter in oil and watercolour, he studied at ECA.

Macgillivray, George fl.1830–50
Dundee artist who painted local topographical scenes.

Macgillivray, James Pittendrigh 1856–1938
ARSA 1892, RSA 1901
Born at Inverurie in Aberdeenshire and moved with his family to Edinburgh in 1868. Served an apprenticeship at the studio of William Brodie, the sculptor. He then studied at the RSA Schools and worked with John Mossman in Glasgow. He became His Majesty's Sculptor for Scotland in 1921 but he also painted landscape and architectural subjects and produced lithographs.

McGlashan, Archibald A. 1888–1980
ARSA 1936, RSA 1939
Born Paisley, he studied at GSA. He painted portraits and figures and travelled widely abroad. He was a member of the SOCIETY OF EIGHT. Greatly influenced by Renaissance painters, he painted figures and portraits in a bold style and was particularly good at painting children. President GLASGOW ART CLUB 1959–61.

McGlashan, Daisy A. (Mrs. William S. Anderson) 1879–1968
Studied at GSA 1903–4, she married in 1909 and

took up painting later in life encouraged by HENRY Y ALISON.

MacGoun, Hannah Clarke Preston 1867–1913
RSW 1903
Lived Edinburgh. Painted children in watercolour in a soft style influenced by the Dutch School; also painted interiors and genre in watercolour. Illustrated children's books.

MacGregor, Harry fl.1894–1935
Associated with the KIRKCUDBRIGHT SCHOOL, he painted landscapes in a free, loose style.

MacGregor, John Douglas 1892–1951
RSW c.1949
Born St. Andrews. Interesting Glasgow watercolourist whose work was strongly influenced by Surrealism. Inspector of Art in Schools. Died Glasgow.

McGregor, Robert 1847–1922
ARSA 1882, RSA 1889
Born Bradford, the son of Scottish parents, he returned to Dunfermline to train as a textile designer before settling in Edinburgh where he worked for a period for Nelsons as an illustrator. Then studied at the RSA Schools and quickly made his mark as an oil painter of pastoral scenes.

H C Preston-Macgoun *Rob Lindsay and his School* (1905) Title page drawing

Robert McGregor *The Knife Grinder* oil, Dundee Art Galleries & Museums

He liked to paint labourers in the fields, the farm-yard and harvesters. His work suggests that he knew the paintings of Millet and Bastien-Lepage as well as the Dutch School, but although he more than once visited Brittany, there is no evidence that he visited either Paris or Holland. The handling of his figures, of the background trees and landscape and his use of a diffused grey light are akin to Bastien-Lepage and his work was, in many respects, advanced for its time, looking forward to the early works of the Glasgow School. His choice of subject – labourers, village scenes, children in rural settings – were similar to that of artists like Clausen and REID who were also interested in rural Realism. He was an early influence on the Glasgow School. Died Portobello.

RMy

Macgregor, William York 1855–1923
RSW 1885, NEAC 1892, ARSA 1898, RSA 1921
Born Finnart, the son of a Glasgow shipbuilder, he studied under JAMES DOCHARTY and later under Legros at the Slade. In 1878 he spent the summer with JAMES PATERSON painting on the east coast at St Andrews, Nairn and Stonehaven. Paterson was studying in Paris (1878–1882) and he had a considerable influence upon MacGregor. MacGregor's work broadened and he began using larger brushes and thicker paint. In 1881 he opened a life class in his Bath Street Studio, and this was to become the meeting place of the GLASGOW BOYS. Macgregor, being older and with a more resolved style, was known as the 'father' of the group.

Macgregor encouraged artists to take a direct approach. 'Hack the subject out as you would were you using an axe, and try to realize it, get its bigness. Don't follow any school, there are no schools in art.' His painting *The Vegetable Stall* (1883–4) illustrates his principles with the paint brilliantly handled in an almost sculptured manner. Macgregor had originally included a standing figure, but he painted it out, feeling it to be clumsy. *The Vegetable Stall* is one of the major Glasgow paintings and is MacGregor's masterpiece. When Kokoschka saw it he exclaimed 'And to think it was painted before I was born!'
In 1886 ill health forced Macgregor to leave Glasgow and settle in Bridge of Allan. He lost touch with the developments of the Boys and

W Y Macgregor *Cambuskenneth Abbey* oil, Bourne Fine Art

found himself out of sympathy with their practice of working on the spot. He attempted to move away from naturalism, but his later work is generally disappointing.

He visited South Africa 1888–90 and on his return worked more in watercolour. These are often powerfully constructed with charcoal outlines and strongly drawn trees with flat areas of colour. They can be somewhat lifeless, but nevertheless look forward to later styles. He also painted oils, often of hilly landscape with rock faces or quarries, using thickly applied paint. Died Bridge of Allan.

McGuffie, Thomas fl.1860s
Glasgow painter of architectural subjects and townscapes, he usually worked in watercolour. He painted in Scotland, England and Italy and exhibited at the GI.

McIan, Fanny 1814–1897
HRSA 1854
The wife of ROBERT MCIAN, she painted and taught at the Government School of Design. She was the first woman artist in Scotland to be honoured, becoming an Honorary RSA in 1854.

McIan, Robert Ranald 1803–1856
ARSA 1852
An actor who gave up the stage to paint Scottish history and legends. He had a studio in London and Fort William, where he painted figures in Highland costume and local traditions in both oil and watercolour. He illustrated the *The Clans of the Scottish Highlands Displaying their Dress, Tartans, Arms and Social Occupations*, which became recognised as his *tour de force*.

McIlwraith, Andrew fl.1715–53
Lived in Edinburgh where he worked as a painter of portraits. Signed the Charter of THE ACADEMY OF ST LUKE in 1729 and became a Burgess of Edinburgh 1735.

McInnes, Alexander fl.1840s
Inverness artist who painted local scenes and exhibited RSA.

McInnes, Robert 1801–1886
Painter of rural life, genre and portraits. His watercolour style was influenced by the later work of WILKIE and the work of JOHN PHILIP, although he lacked their draughtsmanship. A friend of WILLIAM BELL SCOTT, McInnes worked in London, Scotland and Italy.

MacIntyre, Donald Edward b.1900
Born Edinburgh, he studied at ECA and painted landscapes, figures and architectural subjects in oils. He also etched. Taught at George Watson's Boys College and took evening classes at ECA.

Macintyre, Edith A. fl.1925–1939
Landscape painter from Broughty Ferry who worked in watercolour and pastel.

McIsaac, J. Nigel b.1911
Born Edinburgh, trained ECA under S.J. PEPLOE and studied fine art at University of Edinburgh under Herbert Read. Worked as an art teacher, latterly Assistant Rector Royal High School, Edinburgh. Paints and exhibits extensively including RSA, SSA, RGI and many one-man shows.

MacKay, Alastair G.O. fl.1913–37
Glasgow based painter of the Scottish Highlands. Exhibited SSA and RSA. Also painted some portraits and fishing scenes.

McKay, Alexander S. c.1830–?
Born Kilmarnock and trained at the Trustees' Academy 1849–51 and 1852–6. His brother James was also at the Academy 1851–4. Portrait painter.

Mackay, Charles 1868–?
Glasgow furniture designer who also painted watercolours. Studied GSA and in Paris at Académie Delacluse.

MacKay, Robert fl.1840–50s
Lived in Edinburgh and painted Scottish and Yorkshire landscapes. Exhibited RSA.

McKay, Thomas Hope fl.1900–1930
Glasgow painter of fishing boats, harbours, Highland and coastal scenes in oil and watercolour.

R R McIan *Macalister* lithograph, private collection

W D McKay *The Firing Range* oil, The Ellis Campbell Collection

His style was influenced by the 'wet' Glasgow technique.

MacKay, William Darling 1844–1924
ARSA 1877, RSA 1883
Born Gifford, East Lothian, he trained at the Trustees' Academy. Painted rural scenes with farm workers and cattle, often working on the spot. His colours were fresh and he avoided muddy tones. He acted as Secretary of the RSA 1906–1924 and published a book *The Scottish School of Painting* (1906). Died Edinburgh.

McKechnie, Alexander Balfour 1860–1930
RSW 1900
Born Paisley, studied GSA, he painted mostly in watercolour, travelling in North Africa, Egypt and Europe as well as in Scotland. Died Milliken Park.

MacKechnie, R.G.S. fl.1920–50
RBA 1930
Taught at GSA in the 1920s before settling in London c. 1929 and Rye c. 1935.

MacKellar, Duncan 1849–1908
RSW 1885
Born Inverary, studied GSA and London. Worked in

a photographer's studio tinting prints before turning to full-time painting in 1875. He painted genre and historical scenes in oil and watercolour, his speciality being figures in interiors, either of quaint country cottages or of stately baronial halls. His technique is sensitive and delicate. Died Glasgow.

McKenna, Hugh fl.1930s
Glasgow painter of landscapes in oil and watercolour.

MacKenzie, A. Marshall fl.1860s–70s
Lived in Edinburgh and painted landscapes.

MacKenzie, Alexander 1850–90
Born Aberdeen. Worked as a genre painter.

McKenzie, Alison, b.1907
RSW 1952
Born Bombay, she studied at GSA 1925–31 and at the Grosvenor School of Modern Art in London where IAIN MACNAB stimulated her interest in wood engraving. She was on the staff of Dundee College of Art 1946–58. She paints still-life, often in watercolour, influenced by the later stages of Cubism. Her colours are restrained greens, greys, ochres and blacks.

McKenzie, Andrew 1886–?
Glasgow architect, studied GSA and Glasgow School of Architecture. Also worked in watercolour.

McKenzie, David 1832–75
Dundee topographical and landscape painter.

MacKenzie, David Maitland fl.1820–40
ARSA 1826, RSA 1829
Lived in Edinburgh and painted landscapes of Scotland. Foundation Associate of the Scottish Academy

J Hamilton Mackenzie *The Motor Transport Repair Workshop, South Africa 1917* oil, Patrick Bourne Esq'

in 1826, becoming a member in 1829. Membership forfeited 1832. Exhibited at the Academy 1826–30. Exhibited WSA 1830s–40s.

Mackenzie, James Hamilton 1875–1926
RSW 1910, ARE 1910, ARSA 1923
Born Glasgow, he studied at GSA, winning a Haldane Travelling Scholarship which he spent in Florence. He enjoyed Italy and returned to both Italy and Belgium in later years to paint. During the war Mackenzie worked in East Africa and his drawings and watercolours were reproduced in *The Studio Special War Number* of 1918.
His approach to landscape was bold and assured. He had a strong sense of composition and often outlined in black, possibly later influenced by the COLOURISTS. In addition to working abroad, he painted Scottish landscape and fishing villages, working in oil, watercolour and pastel, and also as an etcher. Died in a train crash outside Glasgow aged 51.

MacKenzie, Samuel 1785–1847
RSA 1830

Born Cromarty, he trained as a stonemason and moved to Edinburgh for work, but was encouraged by RAEBURN to turn to painting. His portraits are greatly influenced by Raeburn although they lack his spontaneity and sureness of touch.

Mackenzie, William M. fl.1880–1908
Lived in Edinburgh and exhibited SSA. Painted landscapes and coastal scenes, often with figures bathing.

McKenzie, Winifred b.1905
The sister of ALISON MCKENZIE, she was born in Bombay and studied at GSA 1923–1931 and at the Grosvenor School of Modern Art under IAIN MACNAB. She was on the staff of Dundee Art College 1944–58 and worked as a wood engraver. During the war ran classes for the forces (Polish, Norwegian and British) in St. Andrews in wood engraving and drawing, from which grew the group known as the ST. ANDREWS SCHOOL.

MacKenzie, W.M. fl.1870s–1908
Edinburgh painter of landscape and figures in historical costume.

Mackie, Annie fl.1885–1934
The sister of CHARLES H MACKIE, she painted flowers and landscape in both oil and watercolour.

Mackie, Charles Hodge 1862–1920
RSW 1901, ARSA 1902, RSA 1917
Born Aldershot, the son of an army officer from Edinburgh, he was brought up in Edinburgh and studied at the RSA Schools. His early works were based on the current pastoral Realism such as *Weaning Time* (1888) but in the 1890s he turned

Winifred Mackenzie *Railway Bridge, Bath* wood engraving, private collection

Charles H Mackie *At the End of the Day* oil, Bourne Fine Art

away from Realism. Whilst on honeymoon in Paris, he met Gauguin and visited his studio. The influence of Professor Geddes was important, as was a visit to Pont-Aven where he met followers of Gaugin including Le Sidaner and Serusier, and he became a friend of Maurice Denis. The influence of the Nabis can be clearly seen in his small oils and watercolours of this period with their flattened areas of colour. He also produced woodcuts, again influenced by Pont-Aven.

MacKie contributed to Geddes' review *The Evergreen* and designed the covers in embossed leather with a pattern of stylized trees. He also executed a mural for Geddes. By about 1905 Mackie's Symbolist phase had ended, and in 1908 he was in Venice with ADAM BRUCE THOMSON where he produced a number of bold watercolours as well as some interesting wood block prints. His later work consisted of rich watercolours painted strongly and loosely. He had a large circle of artistic friends in Edinburgh and was the brother-in-law of WILLIAM WALLS with whom he collaborated on lithographs. He was a close friend of Laura and Harold Knight, working with them at Staithes, Yorkshire. In her auto-biography, Laura Knight wrote, 'I hardly ever paint a picture without thinking of Charles Mackie and what he taught me.' Mackie was a deeply religious man: his career was prematurely terminated by cancer. Died Edinburgh.

Mackie, George b.1920
RSW 1970, ROI 1974
Born Cupar, Fife, he studied at Dundee College of Art 1937–40 and ECA 1946–8. Paints in watercolour and oil. Subjects include boats and shipping in Aberdeen and other east coast harbours in a sensitive, draughtsman-like approach. Married to the watercolourist BARBARA BALMER and works as an illustrator and designer. Formerly Head of Design at Grays School of Art, Aberdeen 1956–80. Consultant in book design to Edinburgh University Press 1953–82.

Mackie, Peter Robert Macleod 1867–1959
ARSA 1933, HRSW
Born Edinburgh, Mackie studied at the RSA Schools and in Paris. Spent two years in France, painting in Dieppe in the summers and Paris in the winters. Served in the Red Cross during the 1914–18 war and in 1919 settled in Egypt for two years. He painted landscapes in oil and pastel which show the influence of Whistler. He particularly enjoyed evening effects, often by the sea or loch, painted in silvery grey tones. He also worked in stained glass. He was Curator of Kirkcaldy Art Gallery and Museum from 1929–48.

Mackie, Thomas Callender Campbell 1887–1952
Interior designer and decorator, he studied at GSA and later became Head of Design. Painted landscapes and architectural subjects in oil. Painted in Italy. Exhibited RSA, and RGI and Twenty Club. Member GLASGOW ART CLUB. Died Milngavie.

MacKinlay, Duncan fl.1880s–1890s
Glasgow painter of seascapes and landscapes. He worked in Scotland but also in France and Venice and exhibited at GI.

MacKinnon, Esther Blaikie 1885–1935
Born Aberdeen, she painted landscapes and produced etchings and lithographs.

Mackinnon, Finlay d.1935
Landscape painter born and lived at Poolewe, Ross-shire, studied South Kensington and Paris. Exhibited Scottish landscapes from the 1890s at the Fine Art Society, Walker's and the Bruton Gallery. He was very Scottish in his dress and speech, and was considered a character in the London art world. His watercolours are, however, less distinguished, with pale colours and rather ordinary composition.

Mackintosh, Charles Rennie 1868–1928
RSW 1898
Born Glasgow, Mackintosh started an apprenticeship with the architect John Hutchinson in 1884: at the same time he attended evening classes in architecture at GSA. In 1889 he joined the practice of Honeyman and Keppie and in 1891 he won a travelling scholarship from Glasgow School of Art. He used this opportunity to visit France, Italy and Belgium making watercolour sketches of buildings. On his return FRA NEWBERY introduced him to the MACDONALD sisters and, together with HERBERT MACNAIR, they were to form the 'Glasgow Four'. In 1892 Mackintosh painted *The Harvest Moon*, the

Charles Rennie Mackintosh *Boultenère* watercolour c. 1924-7, private collection

first of a series of Symbolist watercolours which he was to produce during the 1890s. He also painted three watercolours depicting the seasons for *Glasgow School of Art Magazine*, which was circulated amongst the students. These watercolours suggest the seasons through the use of symbols such as flower buds and underground stems, rather than being definite statements.

Two watercolours for the 1895 magazine *The Tree of Personal Effort* and *The Tree of Influence* represent Mackintosh's most complex and inaccessible symbolism. He did not pursue this avenue further and in 1896 his watercolours were related to various architectural projects in hand. Thus *Part Seen, Imagined Part* (1896) is related to the Cranston Tea Room frieze and *The Wassail* (1900) is a study for the gesso panel in the Ingram Street Tea Rooms. These watercolours are more overtly decorative and art nouveau in spirit. During this period Mackintosh was fully involved in his major architectural and decorative schemes including the Glasgow School of Art (1897–1902), Hill House (1902) and the Willow Tea Rooms (1904). Between 1901 and 1915 Mackintosh painted many flower studies in watercolour, usually single stems with a cartouche including the name of the flower, the date, the place and other details. Many of these were executed on holiday in Walberswick.

Mackintosh had for several years hoped to devote more time to painting and in 1914 he finally broke with his practice in Glasgow. It was a bold move and he realized that he would have to make his painting more saleable. Not only did Mackintosh start painting more composed flower pieces, he also turned to landscape. The result was some of the most successful Scottish watercolours of the century. Mackintosh's flower compositions of 1915–20 have a dynamism of composition and execution which looks forward to the art deco style of the '20s and '30s, reinforced by his reference to Viennese Secessionist style background, fabrics and vases.

In 1920 Mackintosh spent a holiday in Dorset with Randolph Schwabe, who encouraged him to turn to landscape. He applied his sense of design to the Dorset landscape using fields, hedgerows, roads and walls to create dynamic patterns. During this period Mackintosh and his wife, Margaret Macdonald, had been designing furniture and textiles; few of their architectural projects materialized so in 1923 they decided to spend a long holiday in France. In the event, they remained until 1927 around Villefranche, working mostly south. Mackintosh produced many superb watercolours of the Mediterranean villages and mountains. His sense of design and colour is used to the full, combining two dimensional areas of pattern within traditional perspective. He returned to England in 1927 and died of cancer.

MacIntyre, James C fl.1880s
Perth artist who painted local views in oil; also worked as a copyist.

McLachlan, John fl.1881–92
Painted landscapes and figures and exhibited RSA.

McLachlan, Thomas Hope 1845–1897
NEAC 1887, ROI 1890, RI 1897.
Born Darlington of Scottish parents and studied at Trinity College Cambridge and Lincoln's Inn before being called to the bar. After a few years he gave up law in 1878 to paint. He had no formal art training, but was influenced by Millet and the Barbizon School. He painted restrained landscapes with figures of labourers and farm-workers, set against rather bleak backgrounds. He also painted single figures set against the sea or on a beach, giving an air of solemn romanticism. He lived in England for most of his life.

McLaren, Charlotte Gordon (Charlotte O'Flaherty) 1869–1940
Born in Glasgow, she studied at GSA 1894–99, at the Slade and in Munich and Paris. From 1929–39 lived in Millport where her husband was Provost of the Cathedral. Painted miniatures and portraits.

MacLaren, John Stewart 1860–ca.1930
Born Edinburgh, he studied at the RSA School and in Paris. Exhibited landscapes, figure studies and architectural subjects in oil and watercolour. Worked much abroad including France and Spain.

McLauchlan, Archibald fl.1760s–70s
Studied at Glasgow University and in Rome in the 1760s. Painted a group study of Glasgow merchant William Glassford and family.

McLauchlan, A. fl.1820s
Perth painter of local views.

McLauchlan, William fl. late 19c
Late-nineteeenth-century watercolour landscape painter from Paisley, probably amateur.

McLaurin, Duncan 1849–1921
Born Glasgow, studied Edinburgh School of Design and Heatherley's. Lived in Helensburgh, painting cattle and Highland landscape. His earlier work can be good – his watercolours have rich, glowing colours with a romantic appeal, but his later work tends to be less impressive.

McLea, John Watson. fl.1840s–60s
Lived Edinburgh and painted landscapes and country scenes with figures in a similar style to GEIKIE. Painting of *Granton Harbour during the Regatta*, 1859, in collection of the Royal Forth Yacht Club.

McLeay, Kenneth 1802–1878
ARSA 1826, resigned and re-elected 1829, RSW 1878
Born Oban, the son of a doctor and Antiquarian, he studied at the Trustees' Academy and in 1826 was involved with the founding of the RSA. He made his reputation for portraits painted in watercolour.

These vary greatly in size from miniatures printed on ivory or paper, to large full-length portraits of Highland chiefs.

Like GILES he worked for the Royal Family producing a series of watercolours of the Highland Clans later lithographed and published as *Highlanders of Scotland* (1870). He also painted Prince Albert and the Royal Family at Balmoral. His extensive portrait practice was severely eroded by the development of photography in the 1850s and 1860s. McLeay was a fine draughtsman capturing not only the sitter's likeness but also details of clothing and jewellery.

McLeay, Macneil d.1848
ARSA 1836
The brother of KENNETH MCLEAY, he was born in Oban and became a landscape painter concentrating on Highland and west Coast scenes. These are mostly in oil and sometimes on a grand scale, but he also worked in gouache and watercolour.

McLellan, Alexander Matheson 1872–1957
RBA 1910, RSW 1910
Born Greenock, studied RA Schools and Paris. Landscape, portrait and decorative painter and stained-glass designer. Painted classical and historical themes in watercolour, as well as landscapes in Scotland and Europe, in particular Holland. His style is careful and deliberate, and sometimes lacks sparkle. His success led him abroad and he worked in London, Paris and New York.

McLeod, John fl.1857–70
Perthshire artist who specialised in cows and horses. Also woodland scenes, rural genre and landscape.

MacLeod, Torquil J fl.1950s–60s
Born Inverness, trained Gray's School of Art, Aberdeen, and became art master at Strathallan School. Painted landscapes and seascapes, particularly of Fife fishing villages.

MacLeod, William Douglas 1892–1963
Born Clarkston, Renfrewshire, he worked in a bank and served in the war before enrolling at GSA 1919–23. He painted landscapes in Scotland and Europe and etched views in many countries abroad, including Spain and North Africa. He worked as

cartoonist for Glasgow *Evening News* 1920–30. Also produced flower pieces in pastel.

MacMaster, James 1856–1913
RSW 1885, RBA 1890
Glasgow landscape and coastal painter, he specialized in fishing scenes with boats in harbour, fishing villages and scenes of unloading the catch. He worked in both oil and watercolour, the latter being painted in a 'wet' Glasgow manner. His work is similar to that of ANDREW BLACK and JAMES MCNIVEN.

MacMillan, Hamilton fl.1880–1906
Helensburgh landscape painter, he exhibited at RSA, RHS, GI.

MacMillan, J. Hamilton fl.1886–1908
Landscape painter, possibly the son of HAMILTON MACMILLAN, he lived in Dumbarton and later Edinburgh. He exhibited at RSA, RMA, GI.

MacMorland, Patrick 1741–ca.1809
Born in Scotland and painted miniatures. Worked in Edinburgh, Manchester and Liverpool.

Macnab, Chica (Mrs. James I. Munro) 1889–1980
The sister of IAIN MACNAB, she was born in the Phillipines and studied at GSA, joining the staff 1926–7.

Macnab, Iain 1890–1967
ARE 1923, ROI 1932, RE 1935, PROI 1959–67
Born at Iliolo in the Philippines, the son of an

James MacMaster *Wet Weather, Tayport* watercolour ca. 1885, private collection

McNeil Macleay *The Head of Loch Eil* oil, Robert Fleming Holdings Ltd

official of the Hong Kong and Shanghai Bank, his family moved to Kilmacolm in 1894. He studied accountancy and enlisted in 1914; later wounded and invalided out of the army. In 1917 he studied at GSA, moving to Heatherley School in London in the following year, and Paris the year after. Macnab became Joint Principal of Heatherley (1919–25) and in 1925 he opened the Grosvenor School of Modern Art in Warwick Square. His staff included Claude Flight, Blair Hughes–Stanton and Graham Sutherland.

Until 1926 Macnab had worked as an etcher, but he turned to wood engraving, a medium in which he was to excel. He taught a generation of younger wood engravers and influenced many others. His prints are stylish but never mannered, strong but never crude, and he was able to coax great sensitivity out of a wood block. He often worked in Spain, Corsica and the South of France and produced many book illustrations.

The Grosvenor School closed in 1940 and Macnab joined the RAF in 1941. After the war he continued working until 1961 and fulfilled a number of official appointments, including President of the ROI.

He published *The Student's Book of Wood Engraving* (1938) and *Figure Drawing*.

Macnab, Peter fl.1850s–60s
Lived in Glasgow and painted landscapes, Highland scenes and woodland views. Frequently painted in Argyllshire.

MacNair, J. Herbert 1868–1955
Born into a military family living at Skelmorlie, his

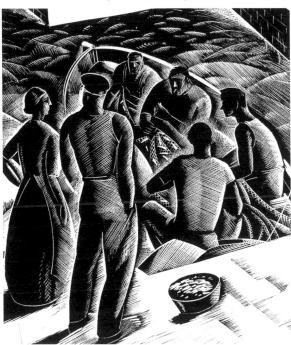

Iain Macnab *The Waterfront, Calvi* wood engraving 1930, private collection

first artistic training was in Rouen where he spent a year studying under a local watercolourist. On his return to Glasgow he joined John Honeyman, the architect, as an apprentice, but architecture did not suit him, and he gained more from attending evening classes at Glasgow School of Art, where he met the MACDONALD sisters and MACKINTOSH c.1892.

MacNair left his apprenticeship and in 1894 set up his own office as designer and decorator. He worked in watercolour, strongly influenced by the Macdonalds and Mackintosh, becoming more and more interested in Celtic and Medieval imagery. A strong sense of melancholy and the sinister pervaded his later work.

In 1897 a fire destroyed his office in Glasgow and with it many of his watercolours. His *oeuvre* is therefore small, although some photographs of his work exist. He illustrated *Border Ballads* and *The Legend of the Birds*.

As a result of Gleeson White's articles *Some Glasgow Designers and their work* in *The Studio* of 1897, MacNair was offered a job at Liverpool University in the School of Art and Applied Art. Between 1898 and 1905 he produced many architectural schemes, decorative panels, posters, book plates and furniture designs, but when the School was closed in 1905 he returned with his wife Frances Macdonald to Glasgow. He was penniless and his wife had been disowned by her family. They held a joint exhibition of their watercolours in London in 1911 at the Baillie Gallery which had shown many Scottish painters, but the show was not a success.

In 1921 Frances died and Herbert, who was devastated, destroyed most of his watercolours. He lived until 1955, but never painted again.

McNairn, John 1881–1946
Glasgow painter influenced by the COLOURISTS and by contemporary French paintings. His watercolours are bold and colourful. Publisher of the *Hawick News*.

J H MacNair *Design for a poster* 1904

McNairn, John b.1910
Born Hawick, elder son of JOHN MCNAIRN, and studied at ECA 1926–30 under GILLIES and SUTHERLAND. In Paris 1933 at the Academie Scandinave. After war service in India, returned to Scotland to live and work at Selkirk which provided a base for his landscape painting of the Borders countryside.

Macnaughton, Colin fl.1920s–30s
Studied at ECA and painted still-life and abstractions. Exhibited SSA.

Macnee, Sir Daniel 1806–1882
RSA 1830, PRSA 1876–1882
Born Fintry, Stirlingshire, he attended lessons in Glasgow under JOHN KNOX where he met HORATIO MCCULLOCH and W.L. LEITCH. After a short period painting snuff boxes he moved to Edinburgh to work for W.H. Lizars, the Edinburgh engraver. He also attended classes at the Trustees' Academy and soon discovered that his real talents lay in portraiture. Returned to Glasgow in 1832 and built up a portrait practice, at first using chalks, and then extending to oils. His protraits were very competent although they lacked the bravura of RAEBURN or even WATSON GORDON. His heads were always well handled, but the clothing and background could be dull. After the death of Watson Gordon (1864) and GRAHAM GILBERT (1866) Macnee became the leading portraitist of the day, although his best work had probably been done before 1860.
On the death of SIR GEORGE HARVEY in 1876, Macnee was elected President of the RSA and his tenure was very successful.

MacNee, Robert Russell 1880–1952
Born Milngavie, and studied at GSA. He specialized in paintings of domestic animals and fowls, often in farmyard settings. His oils, watercolours and occasional pastels of chickens, dappled in sunlight in a farmyard, are reminiscent of Impressionism.

McNeil, Andrew fl.1920s
Twentieth-century Glasgow artist who painted views of Glasgow, Edinburgh and other towns in oil, watercolour and pen-and-ink.

MacNicol, Bessie (Mrs. Alexander Frew) 1869–1904
Born Glasgow, she studied at GSA (1887–1892) where the NEWBERYS encouraged her to go to Paris. She found the teaching at Colarossi's oppressive, and spent her time studying the Old Masters in the Louvre.
In 1895 she set up her own studio in St. Vincent

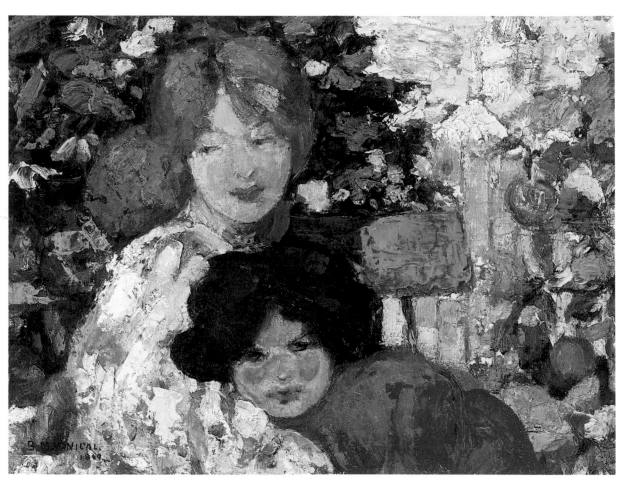

Bessie Macnicol *Two Sisters* oil 1899, Bourne Fine Art

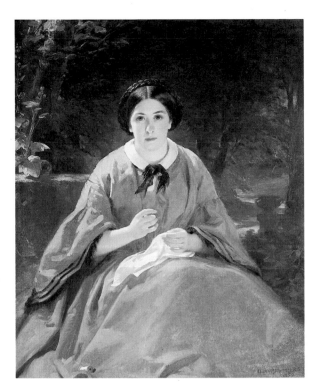
Sir Daniel MacNee *Lady in Grey* oil, Scottish National
Portrait Gallery

Street, Glasgow and produced portraits and sensitive maternity scenes influenced by GUTHRIE, HENRY and HORNEL, whose portrait she painted in Kirkcudbright in 1896.

In 1899 she married Dr Alexander Frew and moved into a house previously owned by D.Y. CAMERON. She had there a studio which Cameron had built with an interior designed by MACKINTOSH. Here she painted several large canvases including *Vanity*, but she died aged 35 in childbirth just as her work was gaining recognition.

McNicol, John 1862–?
Landscape painter and master gilder, born Glasgow, lived Ayrshire. His landscape watercolours can be attractive with light colours and a sensitive touch. His son, Ian McNicol, the Glasgow art dealer, also painted landscapes in oil and watercolour.

MacNiven, John d.1895
RSW 1891
Born Glasgow, worked with Glasgow Corporation Water Department for several years before turning to art, having had no formal training. Painted coastal views, the Clyde and the Highlands.

MacPherson, Alexander 1904–1970
RSW 1932, VPRSW
Studied at GSA where he was a contemporary of MARY ARMOUR and JAMES MCINTOSH PATRICK. Landscape painter in watercolour lived Paisley, worked on the west coast, often on Arran. His watercolours have a firm construction with pencil or charcoal outlines.

McPherson, John fl.1840s–60s
Edinburgh landscape painter. Exhibited RSA.

Macpherson, John fl.1870s–80s
Late-nineteenth-century landscape watercolourist, press artist and illustrator who settled in London in the 1870s. His style was tight and carefully executed, with some freedom in the skies. His son Douglas was also a press illustrator.

MacPherson, Margaret Campbell fl.1885–1904
Lived in Edinburgh and painted children and figures in landscape. Worked in Paris c.1901.

MacPherson, William b.1905
Born Glasgow, he studied at GSA. Painted landscapes, portraits and figures.

MacQueen, Jane Una fl.1905–35
Aberdeen landscape painter.

McTaggart, William 1835–1910
ARSA 1859, RSA 1870, RSW 1878
The son of a crofter, McTaggart was born near Campbeltown and entered the Trustees Academy in 1852. His fellow students included MACWHIRTER, CHALMERS, CAMERON and ORCHARDSON and like them he benefited from the teaching of JOHN BALLANTYNE and the inspiration of ROBERT SCOTT LAUDER.

McTaggart visited the Manchester Art Treasures Exhibition with Chalmers in 1857 and like many artists was struck by the Italian Primitives. His early work shows the influence of the Pre-Raphaelite Movement and his oil *The Thorn in the Foot* was illustrated in Percy Bates' *The English Pre-Raphaelite Painters* (1901). However, *The Past and Present*, a canvas of 1860, was attacked by critics for its lack of finish, and by 1864 his oil *Spring* is handled in a broader, more atmospheric way.

By the early 1870s McTaggart's broad style had been established, but although some writers have pointed to the influence of French Impressionism, there is no evidence that McTaggart had any contact with them despite visits to Paris.

After his marriage in 1863 he moved to Fairlie near Largs from where he could see the peaks of Arran. His working pattern had evolved into periods in Edinburgh working on large oils, followed by summers spent working in the open by the sea. He enjoyed the area around Lochranza and in 1868 worked on Loch Fyne with his friend COLIN HUNTER. He discovered Carnoustie on the east coast near Dundee where in 1875 he witnessed and painted a great storm. By the late 1870s he was working in Carnoustie in the spring and early summer, and moving to Machrihanish on the West coast for August, September and October. In 1889 he moved to a house in Broomieknowe, Midlothian where he painted landscapes as opposed to seascapes, returning to the sea during the summer.

William McTaggart *Fisherchildren* oil, Bill Smith Esq

McTaggart's oils developed a freedom of expression and technique which was quite unique at that time. It is likely that his watercolour technique, using large brushes and rough paper and painting on-the-spot, influenced the development of the oils. Many of his oils have anecdotal or historical subjects as the theme such as *The Coming of St. Columba* or *The Slave Ship*, but their real interest is the study of the northern seas and skies. Although some of McTaggart's fresh and most powerful canvases depict storms, he also captured those exquisite days of calm and heat on the west coast when the clear waters turn opal and pink. McTaggart's direct method of painting, unencumbered by academic theory, had a great influence on younger Scottish painters, to whom his advice was 'the simpler and more direct the method, the finer the picture'. Died Broomieknowe, Midlothian.

MacTaggart, Sir William 1903–1981
ARSA 1937, RSW 1946, RSA 1948, PRSA 1959–69, Knighted 1963

Born Loanhead, the grandson of WILLIAM MCTAGGART, he studied at ECA with GILLIES CROZIER and GEISSLER as fellow-students. Crozier was ten years older than MacTaggart and knew France and Italy and their languages, and had a considerable influence on MacTaggart.

On graduating, he visited Paris to study under Lhote, then started a studio in Edinburgh with Crozier and later with Gillies. He became a founder member of the 1922 Group, and in 1924 held his first one-man in Cannes. He joined the SOCIETY OF EIGHT

Sir William MacTaggart *Harvest by the Sea* oil, private collection

John MacWhirter *Lochranza* oil, Robert Fleming Holdings Ltd

in 1927 and in 1929 held his first Scottish one-man in Edinburgh.

He was greatly impressed by the Munich exhibition which was organized by the SSA in Edinburgh in 1931 and this added to the Expressionist influence already evident in his work. In 1937 he married the Norwegian Fanny Aavatsmark, organizer of the Munch exhibition.

After the war he painted much in France, being influenced by the 1952 Rouault restrospective in Paris. His later still-lifes, flower paintings, landscapes and seascapes have rich glowing colours set against dark backgrounds. Died Edinburgh.

McVittie, Gilbert c.1832–?
Glasgow artist who attended the Trustees' Academy 1849–50.

MacWhirter, Agnes Eliza 1837–?
The sister of JOHN MACWHIRTER. She exhibited highly detailed watercolours mostly of still-life, plants and flowers. She moved to London around 1870 and exhibited no work after 1879.

MacWhirter, John 1839–1911
ARSA 1867, RSW 1878, ARA 1879, RE 1881, RI 1882, HRSA 1882, RA 1893
Born Slateford, Edinburgh, he ran away from his job in a bookshop to take up art. At the age of 16 he made the first of many trips abroad, travelling mostly on foot to Germany, Austria, Italy and the Alps. He also spent two summers in Norway making detailed studies of wild flowers which attracted the attention of John Ruskin who used them for teaching students. A number of these detailed studies are in the Ashmolean, donated by Ruskin.

MacWhirter enrolled at the Trustees' Academy and came under the influence of ROBERT SCOTT LAUDER and JOHN BALLANTYNE. After graduating he remained for a period in Edinburgh, being elected ARSA in 1867. In the following year he

and G.P. CHALMERS exhibited a joint work *The Convent Garden, San Miniato, Florence* at the RSA, in which MacWhirter was responsible for the landscape. In 1869 MacWhirter settled in London and established a considerable reputation and wealth over the following decades.

His earlier Pre-Raphaelite tightness gave way to a much broader handling of both oil and watercolour, and he became a brilliant colourist using pure, vivid blues, greens, purples and reds. He was essentially a landscape painter, working in Scotland, the Italian and Swiss Lakes, the Tyrol and the South of France. He also visited America.

MacWhirter's work was popular, as were his books on painting: *The MacWhirter Sketchbook* (1906), *Landscape Painting in Watercolour* (1907) and *Sketches from Nature* (1913). Died London.

Mainds, Allan Douglas 1881–1945
ARSA 1929
Born Helensburgh, the son of an artist William Reid Mainds, he studied at GSA, winning the Haldane Travelling Scholarship which took him to Brussels to study under Jean Delville and Rome. He taught at GSA 1909–31 and was Professor of Fine Art, Durham University, specialising in the History of Art.

He painted landscape and still-life, designed costumes and posters. His work was bold and colourful, influenced by his knowledge of modern French art.

Maitland, Alister fl.1930s
Glasgow painter of fishing villages and harbours.

Malcolm, Ellen b.1923
ARSA 1968, RSA 1976
Painter of interiors, garden scenes and landscapes, she is married to the artist GORDON S. CAMERON.

Maliphant, H. fl. early19c
Early-nineteenth-century painter working in oil and watercolour. His watercolours usually include architectural subjects, drawn with considerable skill and with a dramatic use of light and shade.

Malloch, Stirling J. 1865–1901
Perth artist, trained ECA, Paris, Holland and Italy. Because of ill health, he took a cruise in the Baltic in the 1880s and painted some interesting watercolour sketches. Later painted views in Perthshire in a 'wet' style, often effectively fresh. Drowned while bathing in New Jersey, USA.

Mann, Alexander 1853–1908
NEAC 1888, ROI 1893

Born Glasgow, he studied in Paris under Carolus Duran. During the 1880s he produced a number of fine figure paintings such as *A Bead Stringer, Venice* (1884) which received an Honourable Mention at the Paris Salon and *Tapestry Workers of Paris* (1883). He learnt much from the example of Bastien–Lepage which he applied to his earlier rural scenes such as *Hop-Pickers Returning*. He was associated with the Glasgow School but was never considered one of the 'Boys'. He had his own income, travelled much including long periods in Venice, the only Glasgow painter to work there in the 1880s and in 1887 he married and settled in England.

Alexander Mann *Whitby* pencil drawing, private collection

In the later 1880s he returned to pure landscape painting, with figures playing a smaller role. He had great facility of touch; his brushwork is effective and never overworked, and he also had a great ability with colour, being able to portray strong sunlight and shadows most convincingly. He painted a number of nocturnal and evening views probably influenced by Whistler, and enjoyed French and Moroccan landscapes.

His later work, painted in the English landscape, is possibly less effective. Mann's painting is assured and confident rather than impassioned. Died London.

Mann, Florence Sabine (née Pasley) fl. 1895–1925
First wife of HARRINGTON MANN and herself a painter, she was the mother of Cathleen Mann (1869–1959).

Mann, Harrington 1864–1937
RE 1885, resigned 1891, RP 1900, NPS 1911, NEAC 1891
Born Glasgow, he studied at GSA and at the Slade under Legros, followed by a period at Académie Julian with Boulanger and Lefebvre. During the late 1880s and early 1890s he painted the work of fishermen in Yorkshire villages such as *Packing Fish at Staithes*. He also worked on a large historically based canvas *Attack of the MacDonalds at Killiecrankie* (1891).

From about 1892 he turned towards portrait painting at which he made his reputation. His style was based on a combination of Whistler's tonal approach and Sargent's more bravura brushwork. He also painted groups of children and mother and child groups, domestic scenes with titles such as *Good Morning* (1905) and *Fairy Tale* (1904). Mann's portrait practice was very successful: he moved to London in 1900 and had many American commissions, maintaining a home and studio in New York. In addition to portraiture, Mann painted in Italy, mostly studies of Italian people in landscape, and he also worked on decorative panels, the most important being nine large canvases illustrating *A Scottish Song* at a girls' school in the Vale of Leven, Dumbartonshire. He also worked earlier in his career as a designer of stained glass and a pen-and-ink illustrator.

Harrington Mann was included in David Martin's book *The Glasgow School* (1897) but he was on the periphery of the movement and after 1892 distanced himself from their aims and subjects. His daughter was Cathleen Mann, Marchioness of Queensberry and a painter. Died New York.

Manson, George 1850–1876
Trained as a wood engraver, he turned to watercolour painting aged 21, and had only five further years in which to establish his reputation. While an apprentice to W. and R. Chambers he attended evening classes and copied pictures in the National Gallery of Scotland. He is best known for his delicate watercolours of children, painted in great detail with much stippling, but never overworked and never losing his rich sense of colour. His two best known watercolours are *The Cottage Door* and *What is It?*, both of which could be, but are not, over-sentimental. He also painted some exquisite landscapes in watercolour using a wet technique.

In some respects Manson's work is similar to that of HUGH CAMERON in subject matter and sentiment, but his closest parallel is possibly the English watercolourist Fred Walker. Died Lympstone.

Mark, Brenda 1922–60
RSW 1956
Born Hull and lived from early childhood in Edinburgh. Trained at ECA 1939–43 and travelled in France, Italy and Germany. Taught art in Edinburgh and married ROBIN PHILIPSON in 1949. Painted still-life, figures and landscapes in oil and watercolour. Was a close friend of ANNE REDPATH and they often painted together.

Harrington Mann *Mardi Gras* oil 1913, Sotheby's

Marshall, Maude G. c.1877–1967
Born County Antrim, she studied at GSA and at the Frank Calderon School of animal painting in London and in Paris. She was commissioned by the Imperial War Museum to paint horses in wartime and later raised money as director of Glasgow and West of Scotland SPCA to help

Brenda Mark *Assisi* watercolour, private collection

wounded horses. She painted and sculpted horses and dogs.

Marten, Elliot fl.1886–1910
Landscape watercolourist who lived at Hawick and painted the Borders, Northumberland and Westmorland.

Martin, Agnes Fulton 1904–?
She studied at GSA and specialized in townscapes and figures.

Martin, David 1737–98
Born Anstruther and trained as an assistant to ALLAN RAMSAY in London. Travelled to Rome and set up in Edinburgh in 1775. Appointed Painter to the Prince of Wales in Scotland. Became recognised as the leading portrait painter of his day until the emergence of SIR HENRY RAEBURN. Died Edinburgh.

Martin, David fl.1887–1935
Glasgow painter of landscapes and seascapes in oil and watercolour. Particularly known for his watercolours of Fife harbours and fishing villages. Exhibited in Glasgow and Edinburgh. Author of *The Glasgow School of Painting* (1897).

Martin, David McLeod b.1922
SSA 1949, RSW 1961

145

David Martin *Old Harbour, Pittenweem, 1921* watercolour, private collection

Born Glasgow, he studied at GSA 1940–2 and 1946–8. He paints very personalized landscapes in oil, gouache and watercolour. Also still life and flowers. Has worked as an art teacher and lives at Eybsham

Martin, David Owen fl.1884–97
Painted landscapes and seascapes, particularly of Fife fishing villages.

Martin, Edwin fl.1913–38
Born Forfar, he studied at GSA and painted landscapes and portraits.

Martin, Francis Patrick ('Franc') 1883–1966
Born Anstruther, he studied at GSA where he responded to the influence of FORRESTER WILSON. Painted genre in oil and watercolour and exhibited RGI. Executed posters for the Post Office. President Glasgow Art Club and Secretary RGI.

Marquis, Alexander fl.1830s–40s
Lived in Edinburgh and painted portraits, rural scenes and cottage interiors.

Masson, A.S. d.1834/5
Early-nineteenth-century landscape painter working in oil and watercolour. Rural scenes, views from nature, paintings of Edinburgh and Portobello. Edinburgh teacher of drawing. Exhibited RSA.

Mather, George H. c.1808–?
Edinburgh miniature painter. Trained at Trustees' Academy 1847–49.

Mathieson, James Muir fl.1890–1925
Musician who painted watercolours of marine and coastal scenes.

Mathieson, John George fl.1918–1940
Stirling artist influenced by D.Y. CAMERON. Painted and etched landscapes and views of towns in a tightly constructed style.

Mavor, Osborne Henry 1888–1951
Glasgow playwright who wrote under the name of James Bridie. Also painted caricatures and illustrations to plays in a lively, colourful style; signs OHM.

Maxton, John Kidd 1878–1942
Born Perth, studied GSA, worked in Glasgow as a stained glass artist and interior designer. Later moved to Edinburgh where he painted in watercolour using a free style which is not always successful. His subjects are Scottish landscapes.

Maxwell, Hamilton 1830–1923
RSW 1885
Painter of landscapes and architectural views, he was born in Glasgow but went to Australia in 1852 to dig for gold, moving to Bombay as a banker. Returned to Glasgow in 1881 and took up painting. He worked much in France and North Africa in a style which is sometimes clumsy and somewhat insensitive, possibly as the result of attempting large-scale watercolours with insufficient draughtsmanship.

Maxwell, John 1905–1962
ARSA 1945, RSA 1949
Born Dalbeattie, Kirkcudbrightshire, he began to study at ECA in 1921 together with GILLIES, who was in his last year as a student. In 1926 he won a travelling scholarship and spent a period working in Paris under Lèger and Ozenfat at the Académie Moderne. French Symbolist art fascinated him, especially the drawings and lithographs of Odilon Redon, and he was also deeply impressed by the vivid, evocative work of Marc Chagall. In 1929 he joined the staff at ECA, and assisted the Principal, GERALD MOIRA, on murals for St. Cuthbert's Church. He saw Moira's fluent handling of watercolour and his vivid sense of colour. In 1934–5 Maxwell executed a series of murals for Craigmillar School, Niddrie. Maxwell and Gillies went on many painting trips together, the first being to Kirkcudbrightshire in the late 1920s followed by visits to Morar, Ardnamurchan and the Kyle of Lochalsh in the 1930s. Their approach to painting was very different: Gillies worked in a spontaneous manner, whereas Maxwell created, slowly and painstakingly, his own inner vision. He experimented with mixtures of watercolour, pen-and-ink, chalk and gouache and during the 1930s moved away from landscape towards single figures or heads set in imaginary landscapes.
In 1943 Maxwell left the College on grounds of ill health and retired to Dalbeattie to concentrate on his own work. William Gillies persuaded him to return to teach in Edinburgh in 1955, taking the post of Senior Lecturer in Composition, but he died aged 57 after a long period of ill-health.

Maxwell, Sir John Stirling 1866–1956
RSW 1936, HRSW 1938
Amateur watercolour painter who lived in Pollock House, Glasgow and was an expert on rhododendrons. His watercolours have an unusual frozen

style which can be charming at times, especially when he is concerned over detail. Painted views in Scotland and on the Continent. Trustee of the Wallace Collection and NGS.

Maxwell, Joseph b.1923
RSW
Trained at ECA. Painter of domestic interiors, portraits, harbours and coastal views in oil, and a landscape painter in oil and watercolour. Lecturer Dundee College of Education.

Maxwell, Tom d.1937
Born Glasgow, self taught artist known for his drawings and etchings of streetscenes, buildings, harbours and landscapes. A regular exhibitor, he was also on the staff of the *Evening Times* in which his drawings appeared.

May, James fl.1860s–70s
Lived in Edinburgh and painted rural genre, fishing scenes, figures and Border landscapes.

Medina, John 1721–96
Born Edinburgh, the grandson of SIR JOHN DE MEDINA. Worked in Edinburgh and London as a portrait painter, copyist and picture restorer.

Medina, Sir John Baptiste De 1659–1710
Born Brussels, trained under François Duchâtel

and moved to London in 1686. Set up as a portrait painter and painted the Earl of Leven and the Earl and Countess of Melville (1691). Moved to Edinburgh 1693–4 under their patronage and that of the Countess of Rothes and established a successful portrait practice out of what was intended to be a short visit. There were few other competing portraitists and he painted the most important social and political figures. WILLIAM AIKMAN studied under Medina. From 1697 Medina worked on a large series of important paintings for the Royal College of Surgeons in Edinburgh. Died Edinburgh.

Mein, Margaret J. d.c.1897
Edinburgh painter who exhibited at RSA and Glasgow Institute.

Mein, Will G. fl.1886–1912
Edinburgh illustrator and decorative painter, he often worked in pen and ink.

Meldrum, William 1865–1942
Glasgow artist who painted views of the city in watercolour, using restrained tones of blues, purples and greys with some bodycolour. Befriended many of the GLASGOW BOYS and PRINGLE.

Mellis, Margaret b.1914
Born in China to Scottish parents, she returned to Britain aged one, and studied at ECA 1929–33. In 1933 she won a travelling scholarship and studied in Paris under André Lhote: she then travelled in Spain and Italy, returning to ECA where she had a Fellowship 1935–7.

John Maxwell *Head over Heels* pen, gouache and gold, Stephanie Donaldson

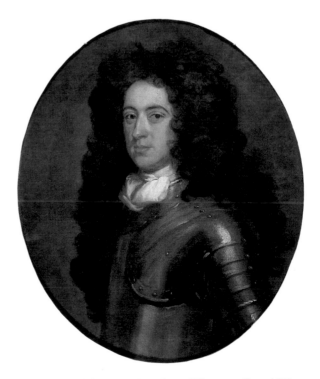

Sir John de Medina *William Law of Elvingston* oil ca. 1705, James Holloway Esq

147

In 1938 she moved to London and married the painter and writer Adrian Stokes, moving in 1939 to Cornwall where they became central figures in the emerging St Ives group. Mellis began to work in a Constructivist manner. After divorcing Stokes, she lived in France 1948–50 having remarried, and returned to England in 1950 where she now lives and works in Suffolk.

Melrose, Walter B. fl.1887–1910
Lived in Musselburgh and exhibited SSA. Painted landscapes and farm scenes.

Melville, Arthur 1855–1904
RSW 1885, ARSA 1886, ARWS 1888, RP 1891, RWS 1899
Born into a large family in Angus, he moved as a child to East Lothian. After attending evening classes in art in Edinburgh he enrolled as a full-time student at the RSA Schools under JOHN CAMPBELL NOBLE. In 1858 he visited Paris where he met ROBERT WEIR ALLAN who introduced him to the work of the Impressionists. He stayed for a while at Grez-sur-Loing where the GLASGOW BOYS were working and was influenced by the work of Bastien-Lepage. It was in Grez that he started experimenting with the transparent qualities of watercolour.

In the autumn of 1880 he set out for the Middle East visiting Istanbul, Cairo, Baghdad and Karachi, only returning to Scotland in August 1882. During this period his watercolour style developed rapidly and some of his most sparkling watercolours are of Eastern subjects. He continued working on these throughout the 1880s, making two trips to Paris in 1886 and 1889. In 1884 he worked at COCKBURNSPATH along with HENRY, GUTHRIE, WALTON and other 'Glasgow Boys' and in the summer of 1885 he painted some superb watercolours in Orkney with Guthrie. In 1890 he was drawn again to the Southern sun, visiting Spain and Algiers and returning in 1891 and 1892 this time with Frank Brangwyn whose watercolour style he influenced. In 1894 Melville visited Venice, but although he painted some important watercolours, he found it less interesting than Spain, North Africa and the Middle East. It is possible that Melville was influenced by Sargent – whom he met in London, especially in *The Music Boat*, a nocturnal scene in Venice with Chinese lanterns. Melville was by now living in London and moved in the artistic circle around Graham Robertson.

In 1899 Melville married and settled in Surrey: he did not stop travelling, however, working in Spain in 1899, Italy in 1902 and returning to Spain in 1904 where he contracted typhoid, dying shortly after his return to England. During the last six years, Melville had been working largely in oil.

Margaret Mellis *Musical Instrument No. 1* oil and board, The Scottish Gallery, London & Edinburgh

Arthur Melville *La Paysanne à Grez* oil, The Robertson Collection, Orkney

Melville is the greatest watercolourist of his period, lifting the medium, as Turner did, onto new planes. His technique is dazzling; he worked onto wet paper, sponging out superfluous detail and carefully allowing certain areas of colour to run together. Other touches of colour were added as the paper dried, sometimes calculated on glass laid onto the paper before committing himself. But Melville's watercolours are about more than just technique: he captures the heat and sun of the South, and moments of great drama, such as *The Capture of a Spy* or a bull fight. He manages to build up psychological tension within his pictures, which are often painted on a large scale, doubling their impact. As a colourist Melville had few rivals.

Melvin, Grace 1892–1977
Born Glasgow, she studied at GSA and taught needlecraft and embroidery in various posts. She taught lettering and illumination at GSA 1920–7 and was known as a leading expert on illumination. Died in Vancouver where a retrospective exhibition of her work was held.

Menzies, Donald c.1835–?
Edinburgh ornamental painter. Trained Trustees' Academy 1852–4.

Menzies, John d.1939
Lived Edinburgh and painted landscapes in oil and watercolour, as well as executing book illustrations and stage scenery. Joined staff of ECA and taught drawing and composition. Painted in EAST LINTON and at COCKBURNSPATH and exhibited RSA and SSA. Died Edinburgh.

Mercier, Philip fl.c.1780
Topographical artist in watercolour who worked in Edinburgh.

Michie, Alastair b.1921
Born in France, the elder son of ANNE REDPATH. He studied architecture at ECA and paints compositions in gouache and watercolour.

Michie, David Alan Redpath b.1928
RSW, ARSA, 1964 RSA 1972, PSSA 1961–3
Born in St. Raphael, France, the son of ANNE REDPATH, he studied at ECA 1947–53 and in Italy 1953–4. Lecturer in Painting and Drawing at ECA; 1973 Deputy Head of School; 1974 Vice Principal. Paints in oil and watercolour.

Michie, James Beattie 1891–1959
Born Inverness and entered at architectural practice in Hawick. Married ANNE REDPATH 1920. Designed cemeteries and memorials for War Graves Commission in northern France. Painted landscapes and architectural studies in tempera, often in the south of France. Painted murals at Chapelle St. Rosline in the Alps Maritimes together

James Coutts Michie *Old Aberdeen from the South-west* oil, Aberdeen Art Gallery, Aberdeen City Arts Department

with his wife. Lecturer in architecture at the RWA, Bristol. Died Bristol.

Michie, James Coutts 1861–1919
ARSA 1893, ROI 1901
Born Aboyne, Aberdeenshire, he studied under JOSEPH FARQUHARSON and then at the RSA Schools, followed by a period in Rome and Paris under Carolus Duran. He worked in Aberdeen until c.1894 when he moved to London. He painted landscapes with soft summer colours, often depicting harvest scenes, tranquil rivers and warm evening scenes. He enjoyed working in Spain and North Africa and lived for a period in Tangiers. He painted some portraits. He was a Founder Member of Aberdeen Arts Society and in 1909 married the widow of his friend George McCulloch, the Scottish art collector. Died Haslemere.

Michie, John D. fl.1860s–92
Edinburgh painter of historical subjects, seascapes and landscapes. Also worked in Brittany and Ireland.

Michie, John M. fl.1840s–70s
Lived in Edinburgh and painted landscapes and fishing scenes. Exhibited regularly at RSA.

Michie, Miss Mary Coutts fl.1890s
The sister of JAMES COUTTS MICHIE, she painted flowers and worked in Aberdeen.

Middleton, Alexander Bell, 1830–?
Born Edinburgh and trained Trustees' Academy 1850–56; recommended by PATRICK ALLAN-FRASER of HOSPITALFIELD. Painted portraits and genre. Lived in Arbroath and was associated with Hospitalfield.

Middleton, James Raeburn b.1855
Lived in Glasgow but travelled widely, painting portraits and flowers.

Millar, William fl.1750s–70s
Portrait painter working in Scotland.

Miller, Archibald Elliot Haswell 1887–1979
RSW 1924
Born Glasgow, he studied at GSA and in Munich, Berlin, Vienna and Paris. In 1910 he joined the staff of SSA and returned after serving in the war, remaining Assistant Professor until 1930 when he moved to Edinburgh to become Deputy Director, National Galleries of Scotland.
He is best known for his drawings of military costume and Highland dress, and a retrospective exhibition of these was held at the Imperial War Museum in 1971. He also painted powerful landscapes, often in watercolour.
He settled in Dorset with his wife in 1952.

Miller, James fl. early 19c.
Early-nineteenth-century Glasgow artist who painted still-life, animals and birds in watercolour.

Miller, James 1893–1987
RSW 1934, ARSA 1943, RSA 1964
Born Dennistoun, Glasgow, he studied at GSA under

GREIFFENHAGEN and Anning Bell. Continued his studies in Paris. 'Paris of 1913 was still the Paris of Toulouse-Lautrec with its horse-drawn *fiacres*, steam trams, cobbled streets and the Moulin Rouge.' He drew the streets and café life rather than copying Old Masters in the Louvre. Taught art for 30 years and during the 1920s and 1930s he travelled extensively abroad working in Spain, France, Italy and North Africa, while also painting on the west coast and Skye, where he later had a house. During the war he produced powerful watercolours of Glasgow's bomb damage. His watercolour and graphic style is dynamic with the use of strong outlines and deep contrasts. He particularly liked to paint in Spain. 'Spain above all countries attracted me. It is full of interest for its buildings and it is the only country I know that has jealously preserved its architectural heritage.'

Miller, John 1911–1975
RSW 1952, ARSA 1957, RSA 1966, PRSW 1970–4
Born Glasgow, he studied at GSA 1936–41 under W.O. HUTCHISON and later at Hospitalfield under

James Miller *The Artist in his Studio* oil, private collection

JAMES COWIE. Joined the staff at GSA in 1944 and remained until his death. Visited France and was greatly influenced by French painting and the French landscape, with a penchant for water and boats.

He painted landscapes and coastal scenes on the west coast, using forceful drawing and deep colours. He often painted on the Clyde. He was also known for his glowing flower pieces.

Miller, Josephine Haswell (née Cameron) 1890–1975
ARSA 1938
Born Glasgow she studied at GSA 1905–1914 and in London under Sickert. Married A.E. HASWELL MILLER in 1916 and between 1924 and 1930 taught etching at GSA. She moved to Edinburgh when her husband was appointed Keeper and Deputy Director of the National Galleries of Scotland in 1930. Elected ARSA in 1938, the first woman to be elected to this. Painted landscapes in oil and watercolour, and painted a mural at the Naval Canteen, Rosyth in 1941 with MARY ARMOUR and ANNE REDPATH. She settled in Dorset in 1952 where she died.

Miller, J.R. fl.1880–1910
Glasgow watercolourist who painted coastal scenes and harbours in Scotland and Holland in a wet watercolour style similar to that of MACMASTER and BLACK.

Miller, Nina (Mrs Charles Lamb Davidson) b.1895
Born Hamilton, she studied at GSA c.1920–1922 and in Paris and Italy. She married the cartoonist and stained glass designer CHARLES L DAVIDSON in 1926 and together worked on stained glass for Loretto Church, Musselburgh. Also painted murals.

Miller, Wat fl.1930s–40s
Lived in Glasgow and painted views of the city as well as landscapes and seascapes.

Miller, William 1796–1882
HRSA 1862
Born Edinburgh, watercolourist and engraver, studied under G. Cooke, the engraver, in London. Foundation Associate Member of the RSA in 1826, withdrew after the first meeting, later elected Hon. RSA in 1862. His best works are Turneresque landscapes of Scotland with delicate greens and blues.

Millar, William fl.1751–84
Recorded as working in Edinburgh. Worked as a copyist and portrait painter. Influenced by DENUNE

John Maclauchlan Milne *Paysage Lavardin* oil, The Ellis Campbell Collection

and DAVID MARTIN, he was an able imitator who managed to develop his own style.

Millmaker, John F. fl.1862–1885
Glasgow painter of genre, seascapes and landscapes, often of Italy. He also painted still-life and fruit and worked in both oil and watercolour.

Millons, Thomas b.1859
Born Edinburgh, he spent many years at sea becoming a ship's captain. He made studies of wave formations, effects of light on the sea, and clouds while at sea, and successfully used these in his oils and watercolours, the latter painted in a broad, wet style.

Mills, Charles S. 1859–1901
Dundee artist and original member of the Tayport Art Circle, he painted fresh landscapes with a good sense of light.

Milne, James fl.1890s
Aberdeen artist who painted local scenes.

Milne, John Maclauchlan 1886–1957
ARSA 1934, RSA 1938
Born Edinburgh, the son of JOSEPH MILNE. Studied at ECA and lived at Kingoodie near Dundee until the outbreak of the First World War. Served in the RFC and returned briefly to Dundee before going to Paris where he painted a series of street scenes. Also worked in the south of France with his French wife at Lavardin and benefited from a stipend paid

Joe Milne *The Yellow on the Broom* and *Poppies* pair of oils, private collection

by the Dundee marmalade manufacturers Keillers, who took up a proportion of his work. Often stayed at Cassis at the same time as CADELL, PEPLOE and Duncan Grant. On the outbreak of the Second World War he returned to Scotland and settled on Arran. He painted in a light and broad manner reflecting the influence of the THE COLOURISTS and van Gogh, especially in his flower paintings. Died Isle of Arran.

Milne, Joseph 1861–1911
The father of JOHN MACLAUCHLAN MILNE, he was born in Edinburgh and worked in Dundee, Perth and along the Tay. He painted landscapes in a broad, Impressionist manner mostly in oil but also in watercolour, using strong colours and added bodycolour. Died Edinburgh.

Milne, William fl.1880–1907
Painter of interiors and rural genre, he lived in Edinburgh, moving later to St. Monance, Fife.

Milne, William Watt fl.1900–1915
Landscape painter who worked in Cambuskenneth, Stirling and is associated with other artists working in the village.

Mitchell, Alexander ca.1830–?
Born Edinburgh and trained Trustees' Academy 1848–50. Portrait painter.

Mitchell, Charles L. 1860–1918
Born in Laurencekirk, he worked in Dundee as a portrait painter in oil.

Mitchell, Colin Gillespie d.1938
Trained at GSA and painted landscapes, particularly on the upper reaches of the Clyde and the Tweed. Also coastal scenes. Exhibited RSA and RGI. Hon. Sec. GLASGOW ART CLUB. Died Glasgow.

Mitchell, George fl. early 20c
Dundee watercolourist of the early twentieth century, his landscapes are successfully painted in a broad style.

Mitchell, Helen fl.1890s–1905
Lived in Edinburgh and exhibited SSA. Painted gardens, landscapes and harbour scenes.

Mitchell, John 1809–59
Lived at Peterhead and trained at the Trustees' Academy with JOHN PHILLIP. Painted portraits of north east Scotland notables.

Mitchell, John 1837–1929
Born Deeside, he attended evening classes under JAMES GILES. His uncle – JOHN MITCHELL – was a Peterhead artist, who had been a fellow pupil of JOHN PHILLIP at the Trustees' Academy, and, with P.C. AULD, he taught John Mitchell to paint. After an apprenticeship at a local lithographic company, Mitchell went to the Slade to study. He returned to Aberdeen and painted many scenes around the town, including Balmoral where Queen Victoria was a patron. He also gave lessons in painting to the Royal Family. His landscapes are highly coloured with strong blues and purples in the

John Campbell Mitchell *Kintallen Mill, Moonrise* oil 1917, private collection

Madge Y Mitchell *Aberdeen Beach* oil, private collection

mountains, and vivid green and yellows in the foreground fields. His talent as a colourist makes up for occasional weaknesses as a draughtsman.

Mitchell, John Campbell 1862–1922
ARSA 1904, RSA 1918
Born Campbeltown, he studied at the RSA Schools and settled in Edinburgh where he remained all his life. Painted broad expanses of moorland and rolling countryside seen under changeable skies – some areas bathed in strong sunlight, others turning from blue to purple as the clouds cast their shadows. He also painted wide expanses of blue sea and sand. Campbell Mitchell represents the best of this kind of Scottish landscape painting – pure, clear colours, a fluent oil technique and great sense of movement. He rarely used watercolour, but was nevertheless competent in the medium. Died Edinburgh.

J. Campbell Mitchell JCMRA·198

Mitchell, Madge Young 1892–1974
Born Uddingston, near Glasgow, trained at Gray's School of Art, Aberdeen, becoming a member of staff in 1911. Painted portraits, seascapes, harbour and beach scenes in oil and watercolour.

Mitchell, Peter McDowall 1879–c.1940
Born Galashiels, he studied at GSA. Painted in oil and watercolour and produced etchings, often depicting landscapes in the west Highlands.

Moffat, Arthur Elsell fl.1880s–90s
Lived in Edinburgh and painted landscapes of Scottish scenery including the Borders.

Moffat, Janet fl.1840s–50s
Lived in Leith and painted portraits in watercolours and as miniatures.

Moira, Gerald 1867–1959
ARA 1904, HON ARIBA 1908, ARWS 1917, RWS 1932, RWA 1918
Born London and trained at the RA Schools and in Paris. Exhibited RA from 1891. Professor at RCA 1900–22 and Principal ECA 1922–32. Thereafter returned to London. Died Northwood, Middlesex.

Molyneaux, Elizabeth Gowanlock 1887–1969
RSWR 1923, Lauder Award 1924
Lived in Edinburgh. Prolific watercolour painter of landscapes in Scotland, France and Italy. Often painted on Arran. Painted in a fluent, 'wet' style, not unlike that of EMILY PATERSON and ANNA DIXON.

Monro, Alexander Binning 1805–1891
HRSA 1835, resigned 1847.
Edinburgh painter of landscape, seascape and coastal scenes. Studied for law but turned to art, travelling to Italy to paint.

Monro, Charles Carmichael Binning 1851–c.1910
Fourth son of A.B. MONRO, he painted seascapes and probably settled in London in the mid-1870s.

Monro (or Munro), Robert c.1785–1829
Lived in Montrose and was a noted local portrait painter. Applied for the post of Master of the Edinburgh School of Design in 1817. Died Montrose.

Monro, Robert fl.1880–1920
Painter of moorland and Highland cattle.

Monteath, Catherine fl.1860s–98
Lived in Dunblane and painted flower pictures.

Moodie, Donald 1892–1963
ARSA 1943, RSA 1952, President SSA 1937–45, Secretary RSA 1959–1963
Born Edinburgh, he studied at ECA, joining the staff in 1919 for 36 years. A.B. THOMSON and, later, GILLIES, MAXWELL and BEATON were contemporaries and they made up a lively and energetic group. Moodie painted landscape and still-life in a broad, colourful manner. He was recognized as a superlative draughtsman.

Moore, Eleanor Allen see Robertson, Eleanor Moore.

More, Jacob 1740–1793
Trained under the NORIES and at the newly formed TRUSTEES' ACADEMY, he sketched in the open around Edinburgh. His reputation as a landscape painter developed during the 1760s and he probably turned to landscape as a full-time occupation

Donald Moodie *Border Landscape* oil, Scottish Arts Club

following the success of his stage scenery for *The Royal Shepherd* of 1769. In designing stage scenery he was following in the footsteps of ROBERT NORIE. The following years saw a series of oil paintings *The Falls of the Clyde*, which represent some of the most ambitious Scottish landscape painting of the period. More had learnt much from Claude Vernet but he instilled into Vernet's work his own vision of the Scottish landscape.

In 1773 More left for Rome where he was to paint a number of oils and watercolours of the Italian landscape ranging from Rome to Naples and Sicily. Tivoli was one of his favourite sketching grounds. In Rome he became friendly with ALAN RAMSAY, who was working on a treatise *An Enquiry into the Situation and Circumstances of Horace's Sabine Villa*, and together they sketched the landscape around Licenza where the villa had been situated.

More was successful in Rome, receiving good money for his landscapes. Some are based very closely on Claude Lorrain's formula, although they lack the depth of Lorrain's views. Other paintings such as *The Eruption of Mount Vesuvius* are more melodramatic, but he was at his best painting the effect of sunlight in a fresh and direct manner. He spent most of his life in Rome, where he died.

Morgan, Anne fl. 1900–40s
Lived and worked in Edinburgh, also painting on Iona. Exhibited SSA. Painted gardens, farm scenes, village life and landscape.

Jacob More *The Falls of Clyde* oil, National Gallery of Scotland

Morison, Colin c.1735–c.1814
Brought up in Deskford, Banffshire. Studied at King's College, Aberdeen, from 1748–52 and went to Rome in 1753. Trained in Mengs' studio under the patronage of Lord Deskford. Attempted classical painting but was not conspicuously successful and turned to sculpture and antiquarianism. Died Rome.

Morison, John fl.1880–1912
Landscape painter from Kilmacolm.

Morison, Miss Rosie fl.1889–1904
Lived in Edinburgh and painted domestic genre, interiors and landscapes.

Morley, Henry, 1869–1937
Born Nottingham, studied Nottingham School of Art, settled in Cambuskenneth, Stirling c.1894, where he painted landscapes in oil and watercolour. His wife, Isabel Morley (née Isabel Hutchison) also painted.

de Mornay, Charles 1902–69
Ayrshire landscape painter.

Morris, Andrew fl.1830s–40s
Painted genre and rural scenes. Exhibited RSA.

Morris, Margaret 1891–1980
A professional dancer, she married J. D. FERGUSSON. Established the Celtic Ballet in 1940 and schools of dance. She was influenced to paint by her husband. Author of *The Art of J D Fergusson* (1974) and founder of the J. D. Fergusson Art Foundation in 1963.

Morris, Mary fl.1893–1938
Based in Glasgow, she worked on Iona, Mull and around Machrihanish painting landscapes and coastal scenes.

Morrison, James 1778–1853
Born near Dumfries and studied in Edinburgh with ALEXANDER NASMYTH. Painted portraits in Dumfries area and became an assistant to the bridge-builder Thomas Telford. Made a plan of Sir Walter Scott's residence, Abbotsford, in 1821, and published a volume of poems (1832).

Morrison, James b.1932
RSW 1970, ARSA 1973
Born Glasgow. Trained at GSA 1950–4. On staff of Duncan of Jordanstone School of Art, Dundee. Landscape painter in oil and watercolour, he has painted complex studies of trees and vegetation, but he is better known for his prairie landscapes using thinned oil on paper. Painted in Canada in the 1980s.

Morrison, John 1904–?
Instrument maker by profession, he took part-time lessons at GSA and was a founder member of the NEW SCOTTISH GROUP in the early 1940s in Glasgow. He painted in a tonal manner.

Morrocco, Alberto b.1917
ARSA 1952, RSA 1963
Born Aberdeen, he studied at Gray's School of Art

1932–8 and in France, Italy and Switzerland. Paints landscapes in Scotland and abroad, still-life and interiors. Possibly best known for his beach scenes and views of Venice. He was Head of the School of Painting at Dundee College of Art.

Morton, Alastair 1910–1963
Born Carlisle, he moved with his family to Edinburgh in 1926. His father headed a firm of textile manufacturers, Morton Sundour, which he joined aged 21 having studied briefly at Edinburgh and Oxford Universities. In 1928 his father founded Edinburgh Weavers with the aim of producing contemporary textile designs. Joined in 1932 soon becoming Artistic Director. He had contact with many artists of the Modern Movement including Hepworth and Nicholson, who designed for Edinburgh Weavers. From 1936 onwards Morton produced his own paintings influenced by the Constructivists.

Morton, Annie Wilhelmina 1878–?
Edinburgh artist trained ECA, where she later taught, and Paris. Painted watercolours of landscapes and birds.

Morton, P.H. fl.1920s–30s
Lived in Corstorphine, Edinburgh, and painted landscapes of Scotland, France and Norway.

Morton, Robert Harold fl.1920s–30s
Lived in Edinburgh and painted landscapes.

Morton, Thomas Corsan 1859–1928
Born Glasgow, he studied at GSA and in Paris under Boulanger and Lefebvre. He attended W.Y. MACGREGORS Bath Street Studio classes and painted at COCKBURNSPATH with GUTHRIE, WALTON, CRAWHALL, HENRY and MELVILLE in the summer of 1884 and 1885.
Morton painted landscapes mostly in oil in

Alberto Morrocco *The Watermelon Vendor* oil, private collection

restricted colours and with a somewhat conservative approach. He was a member of the Glasgow School, but was never an innovator. He also worked in watercolour, his most notable being *The Valley of Destruction* (RSW 1897).

Morton later taught at the GSA under FRA NEWBERY

and in 1908 became Keeper of the National Gallery of Scotland. He later became Curator of Kirkcaldy Art Gallery. Died Kirkcaldy.

Mosman, William c.1700–71
Probably born in Aberdeen and trained in London

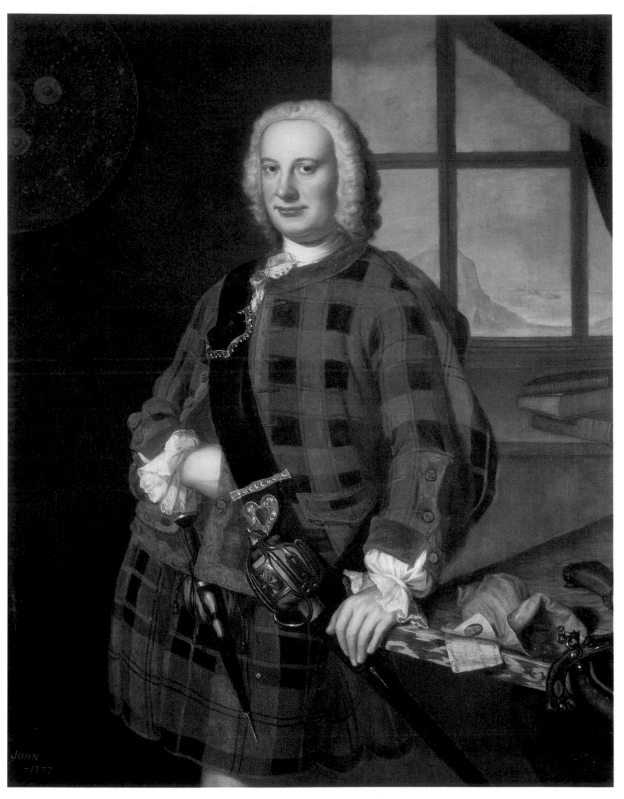

William Mosman *John Campbell of the Bank* oil, Royal Bank of Scotland Collection

and in Rome (1732–5). Returned to Aberdeen in 1738 and painted portraits of members of the Duff family. Worked in Edinburgh during the 1740s when many of his best known pictures were executed including *John Campbell of the Bank* and *The Macdonald Boys*. Probably moved back to Aberdeen shortly after 1750 and painted local views and portraits. Set up a drawing academy there in the early 1760s. Died Aberdeen.

Moules, George Frederic b.1918
RSW
Studied GSA. Paints in watercolour and also works as a wood engraver and designer.

Moultray, James Douglas fl.1860–80s
Lived in Edinburgh and painted Highland and Perthshire landscape.

Mouncey, William 1852–1901
Born Kirkcudbright and worked as a house painter, painting landscapes in his spare time. In 1886 he decided to paint full-time, his landscapes being strongly influenced by his brother-in-law, HORNEL. Like Hornel, Mouncey saw the decorative aspects of nature, painting with a full impasto, vigorous brushstrokes and warm tones. He painted the fields, woods and rivers of Kirkcudbright with a greater emphasis on atmospheric effects than Hornel. Died Kirkcudbright.

Muir, Anne Davidson 1875–1951
Born Hawick, studied ECA and Heriot Watt, moved to Glasgow 1905. Made her name as a flower painter in watercolour exhibiting with JESSIE KING, JESSIE ALGIE and LOUISE PERMAN in London at the Baillie Gallery, and in Glasgow. Her style is fluent and 'wet', similar to that of ANN SPENCE BLACK and ELIZABETH MOLYNEAUX.

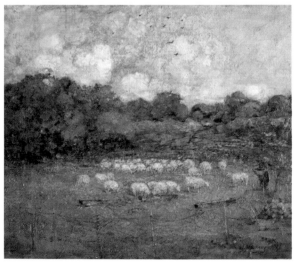

William Mouncey *Rural Idyll* oil, private collection

Muirhead, David Thomson 1867–1930
NEAC 1900, ARWS 1924, ARA 1928
Born Edinburgh, studied RSA Schools and Westminster School under Fred Brown. Moved to London in 1894, and became involved with the New English Art Club, being influenced by the restrained colours which often characterized watercolours of this group. He painted watercolours of estuaries, rolling fields and broad skies, often in East Anglia, in a style which is always effective, if, at times, somewhat unexciting. His work really belongs to the English School in spirit and style. Died London.

Muirhead, George 1861–?
Perth artist given some lessons by WILLIAM PROUDFOOT, he painted views of the landscape around Perth in watercolour. For many years he was employed to paint the fish casts in a local fish shop and he graduated onto small watercolours of fish.

Muirhead, John 1863–1927
RSW 1892
The brother of David, born Edinburgh, studied RSA Schools. Moved to London and painted landscape watercolours in a style similar, if a little broader, to that of his brother.

Munnoch, John d.1915
Edinburgh painter of landscape and genre, he enlisted in the Royal Scots and was killed in action in June 1915.

Munro, Alexander 1825–71
Born Inverness. Talented amateur artist who left for London in 1844 to train under Barry, the architect, under the patronage of the Duchess of Sutherland. Painted portraits, figures and interiors.

Munro, Alexander Graham 1903–85
RSW 1960
Born in Midlothian, he attended the RSA Life School where he won first prize in drawing. First exhibited at the RSA in 1923; in 1925 won the Chalmers-Jarvis Bursary Prize, the Keith Prize and the RSA's Carnegie Travelling Scholarship. Studied in Paris with Andre Lhote and worked in Italy, Holland, Norway, Denmark and Finland. In the late 1920s

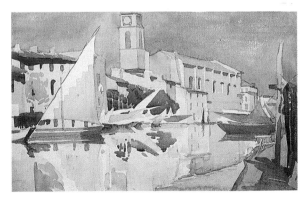

Alexander Graham Munro *Martigues* watercolour, private collection

worked in Morocco, Tunisia and Algiers. Married Ruth Morwood 1932 and they painted together in the western Mediterranean and North Africa. In his early career favoured watercolour and pastel, moving to oils in the 1930s. Art Master at Loretto and Trinity College, Glenalmond. A regular exhibitor at the RSA and RSW.

Munro, Daniel fl.1840s–70
Glasgow painter of portraits, landscapes and country people. member of the WSA.

Munro, Hugh 1873–1928
Born Glasgow, he worked for CHARLES MACKIE for a period cutting woodblocks. He married the niece of the Earl of Minto (who became MABEL VICTORIA MACGEORGE in 1929 when she married the artist W.S. MACGEORGE after Munro's death). Munro developed into a fine oil painter, his beach and riverside scenes with figures are often excellent and his figure painting captures the spirit of the period. He also painted good flower compositions in both oil and watercolour. He worked as an art critic for *The Glasgow Herald*.

Murdoch, William Duff fl.1899–1925
Born in Dumfriesshire, he studied at the Regent Street Polytechnic and the Slade. He painted landscape, portraits, still-life and worked also in pen-and-ink. He moved to London c.1899.

Murray, Alexander fl.c.1880–1910
Aberdeen watercolourist who painted local views.

Murray, Charles 1894–1954
Born Aberdeen and studied at GSA 1908–11. Won

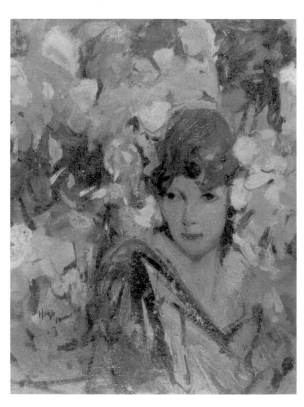

Hugh Munro *Girl Amongst the Blossom* oil, Bourne Fine Art

the Prix de Rome (1922) for etching and continued studies at the British School in Rome 1922–25. Travelled widely, including Russia (1918) and Iceland. Joined staff at GSA and taught etching, IAN FLEMING being one of his pupils. Exhibited RA and RSA and Paris in 1948. Retrospective held in Leeds in 1955. His prints of the late 1920s are full of mannerist forms, accentuated curved lines and reveal a dynamic sense of composition. His career was interrupted by a breakdown in his health in 1930, but in 1935, following his marriage and move to Pinner, he returned to landscape painting in oil and gouache and also painted religious subjects. His work often has a theatrical quality and was certainly influenced by contemporary stage design.

Murray, Sir David 1849–1933
RSW 1878, ARSA 1881, ARWS 1886, ROI 1886, RWS 1886, HRSW 1886, ARA 1891, RA 1905, RI 1916, PRI 1917, HRSA 1919
Born Glasgow, he spent 11 years in business before turning to art. He studied at GSA under ROBERT GREENLEES who influenced his early landscape style with his insistence upon careful observation and detail.
He travelled to France as a young man and painted delightful northern French landscapes with fresh colours delicately handled. Many of his best works were done before the turn of the century when he was painting fresh Scottish views with haymakers, trees in blossom, spring lambs and sparkling blue skies with puffy white clouds. In 1886 he moved south, spending time in France and also painting the English landscape. At first he maintained his vigorous and fresh approach, but gradually his colours became more restrained and metallic and his compositions more contrived. His watercolours also became less effervescent and it is possible that his use of tempera for larger works damaged his earlier fresh watercolour technique. Despite the facile quality of his later work, he was very popular and achieved great public recognition. Died London.

Murray, David Scott 1866–1935
Art Master, Perth Academy, and President of the Perth Art Association, he painted attractive landscapes in watercolour. He had a 'wet' style with subtle sense of colour.

Murray, George 1875–1933
ARCA
Born Blairgowrie, studied ECA and RCA. Specialized in decorative painting and mosaics, but also painted fine watercolours in a vibrant style. Used vertical and horizontal brushstrokes to create a pattern of colour, which, combined with his strong colours, gives a sense of movement to his landscapes of Scotland, Italy and Spain. Also painted figures in romantic settings influenced by the Symbolist movement.

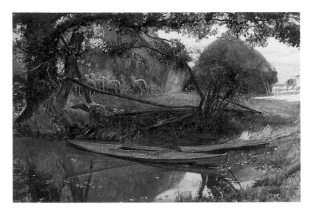

Sir David Murray *A Shady Pool* oil 1887, Bourne Fine Art

Murray, Graham fl.1920s–40s
Lived in Cambuslang and was influenced by the Colourists and by French painting. Painted landscapes and townscapes in a broad, colourful style.

Murray, James T. d.1931
RSW 1927
Edinburgh landscape painter who worked in oil and watercolour; painted coastal scenes on the east coast.

Murray, John Reid 1861–1906
Born Helensburgh, he studied in Edinburgh, Glasgow and Antwerp. He lived for many years in Glasgow painting Scottish landscape and his best work clearly demonstrates his early training on the continent.

Murray, Robert 1888–1967
Lived in Aberdeen and painted portraits and landscapes. Principal teacher of art at Robert Gordon's College. Exhibited RSA and SSA.

Murray, Thomas 1664–1735
Successful Scottish-born portrait painter who worked for much of his life in London, where he was taught by John Riley. A self-portrait (1708) in the Uffizi and clumsier portraits extant at Blair Castle (*John Murray, 1st Duke of Atholl*) and Middle Temple (*Queen Anne* and *William III*).

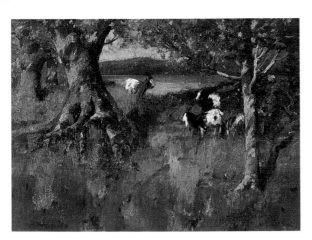

John Reid Murray *Landscape with Goats* oil, Lyn Newton

Murray, William Grant 1877–1950
Born Portsoy on the Banff coast, he studied at ECA and at the RCA where he graduated in 1904. He also studied in Paris at the Académie Julian. A successful art educationalist and administrator he was Principal of Swansea School of Art and Craft and Curator of Swansea Art Gallery. He painted watercolours of the coast of north-east Scotland in a fresh and colourful, yet delicate style. Died Swansea.

Musgrave, Louis R. c.1835–?
Portrait painter. Trained at Trustees' Academy 1853–4.

Musgrave, William Thomas, 1830s–50s
Successful Edinburgh painter of miniatures and portraits. His wife, Mrs I Musgrave, also painted portrait miniatures. They were typical of a group of artists whose trade was destroyed by the success of photography. Mrs Musgrave later turned to landscape, visiting America in 1850.

Mutch, G Kirton 1877–?
Born Strichen, Aberdeenshire, and recorded as painting portraits of local personalities.

Myles, John fl.1850s–60s
Lived in Edinburgh and painted sentimental genre pieces, also portraits. Painting of James Sinclair, Albany Herald, in collection of Lord Lyon King of Arms, Edinburgh.

Myles, William S. c.1850–1911
Born Forfar, painted in Broughty Ferry before moving to Arbroath in 1895. Painted Perthshire landscapes and view around Arbroath in oil and watercolour, and was friendly with JW HERALD.

N

Nairn, James M. fl.1880s
Glasgow landscape painter.

Napier, Charles Goddard 1889–1978
RSW 1913
Born Edinburgh, he studied at ECA 1911–14, where he was influenced by DAVID ALISON. Painted watercolours of landscape and town scenes with elegant composition and flat areas of colour. During the 1930s moved to Oxford and painted scenes of London, where he held an exhibition in 1934, and Devon. He later returned to Edinburgh.

Napier, George fl.1850–60s
Lived in Greenock, one of the Napier family of shipbuilders on the Clyde. Painted ship portraits and sometimes worked with his brother Alexander.

Napier, James Harold fl.1912–26
Born Edinburgh, the son of an artist James Brand Napier, he studied at Edinburgh University and wrote art criticism in addition to painting. Moved to London before the First World War.

Nasmyth, Alexander 1758–1840
Born in the Grassmarket, Edinburgh, the son of a successful builder. He attended some classes at the Trustees' Academy before moving to London to work in RAMSAY's studio.
In London, Ramsay introduced Nasmyth to Italian art, showing him his collection and no doubt discussing his experiences with his pupil. He returned to Edinburgh in 1778 and was soon involved with Patrick Miller's experiment with paddle-driven steamers on Dalswinton Loch. Nasmyth made working drawings for the project, in addition to painting a family portrait for Miller who encouraged Nasmyth to visit Italy and helped finance the trip which lasted from 1782–84.
Italy made a lasting impression on Nasmyth who

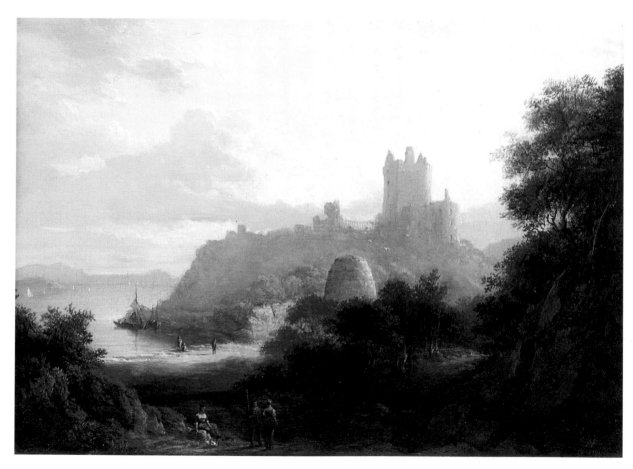

Alexander Nasmyth *On the Coast of Fife at Aberdour* oil, private collection

visited Florence, Bologna, Padua and Rome seeing the work of Claude Lorain and Jacob More. Nasmyth returned to Edinburgh determined to paint landscape, but wanted to paint Scotland and not Italy. He was encouraged in this by the poet Robert Burns and together they made walking tours through the Pentland Hills or along the River Nith.

His early landscapes are based upon Italian Seicento principles with a series of *repoussoirs* and framing trees or buildings to take the eye into the distance. He continued to paint Italian subjects right up to his death, presumably reworking drawings made in Italy, but the majority of his landscapes were of Scotland, however Italianate in feeling.

Nasmyth's landscape style began to change around 1807-10. He probably saw Dutch landscapes in London with his son Patrick who became an enthusiast of Hobbema and Ruisdael. Moreover, his Scottish contemporaries like JOHN THOMSON and 'GRECIAN' WILLIAMS were broadening their approach to landscape. Nasmyth began to paint cloudy skies capturing the movement of light across the ground beneath. His watercolours of this period show a growing interest in atmospheric conditions: cloudy skies, storms at sea, trees in the wind. His handling of paint, both oil and watercolour, also broadened in his later year. Nasmyth was also a topographical artist providing views of Edinburgh for his clients. In 1821, 16 drawings by Nasmyth depicting Scottish views associated with the Waverley Novels were engraved by W.H. Lizars and published. Nasmyth also worked on theatre design for the Theatre Royal, Glasgow and the Theatre Royal, Edinburgh. In addition to landscape Nasmyth painted portraits, although these mostly date to the year immediately after his return from Rome, before his landscapes provided a regular income.

At some stage between 1785 and 1792 he opened a landscape School at his house at 47 York Place, Edinburgh. At first he ran the school himself, but later his children, in particular Barbara and Jane, helped. He insisted upon drawing as a basic skill and took his pupils on sketching trips to Arthur's Seat, Salisbury Crags, Roslin Castle, Duddingston Loch, Craigmillar Castle, Hawthornden and the Pentlands. The concept of teaching pupils in the open air rather than copying antique casts was novel. Nasmyth stressed 'Graphic Eloquence' or good drawing. Composition was encouraged by using bricks or blocks of wood thrown down at random which the pupils had to draw noting their proportion and form. Nasmyth was an excellent teacher and his pupils included his son Patrick, 'Grecian' Williams, ANDREW WILSON and, for a short period, JOHN THOMSON OF DUDDINGSTON. Died Edinburgh.

Nasmyth, Anne 1798-1874
Daughter of ALEXANDER, married Manchester engineer William Bennett. Painted landscapes in oil and watercolour.

Nasmyth, Barbara 1790-1870
Daughter of ALEXANDER, taught at York Place School and moved to Patricoft on death of father in 1840. Settled in London c.1850. Painted views of the Lake District in oil and watercolour.

Nasmyth, Charlotte 1804-1884
Youngest daughter of ALEXANDER, worked in oil and watercolour. Exhibited Carlisle Academy. Probably the most prolific of the daughters.

Nasmyth, James 1808-1890
Youngest son of ALEXANDER, successful engineer who invented the steam hammer, his *Autobiography* remains the main source of information about the family. Retired to Penshurst, Kent in 1856 and devoted himself to painting landscapes, fantasies and foreign views in watercolour.

Nasmyth, Jane 1788-1867
Eldest daughter of ALEXANDER and organizer of the York Place School. Affectionately known as 'Old Solid', she painted views of Scotland in oil and watercolour.

Nasmyth, Patrick 1787-1831
The elder son of ALEXANDER NASMYTH, he was born in Edinburgh. 'My father was his best and almost only instructor,' his younger brother James wrote. He was a quiet man, rather isolated having become deaf aged about 17. During his earlier years he worked with his father, sometimes collaborating on pictures, and he had learnt the rudiments of Italianate landscape when he left for London in 1807. In London, Patrick Nasmyth saw landscapes of the Dutch School and over the next few years his style changed, becoming more interested in direct observation of nature and in the changing weather and moods of the northern climate. He worked along the Thames drawing pollard trees, rustic buildings, old jetties and becoming interested in plants, flowers and foliage. The Dutch artists he most admired were Hobbema, with his rustic cottages set in forests, and Jacob van Ruisdael whose enormous skies and changing light he admired. He was sometimes known as 'the English Hobbema'. Patrick never achieved his father's success. He was a poor businessman and was reputedly cheated by dealers. He worked hard, sketching in the open in the Thames Valley, Sussex, Hampshire and the Isle of Wight, but his oil paintings lacked that originality and sense of something new which would have brought him wider fame, although they were technically brilliant. Although he lived in London, he continued to paint Scottish subjects. He caught a cold while working outside and died in August 1831. Died Lambeth.

The National Galleries of Scotland
In 1850 a popular part of life in the capital was removed from its base at the foot of the Mound as a loftier endeavour took its place. Wombwell's Menagerie was closed and the foundation stone was laid for Playfair's new National Gallery. The new building was to be built in the same classical style

as the existing Royal Institution building (1822), housing the RSA. After Playfair's death in 1857, the National Gallery building was completed by his assistant, James Hamilton. The new galleries were opened on March 22, 1859. The collection of pictures grew so rapidly that the SCOTTISH NATIONAL PORTRAIT GALLERY was founded in 1882; and Hamilton's building was extended in 1912, and much later, in 1978.

A National Gallery of Modern Art was opened to the public in 1960, located in Inverleith House in the Royal Botanic Gardens. This, again, required new premises and opened in 1983 in a new location in the former John Watson's School building in Belford Road.

Neil, Angus b.1924

Born Kilbarchan and studied at GSA 1950–53. Received Chalmers Jarvis Prize and the RSA Award. Work in public collections in Scotland.

Neil, George fl.1885–1930

Glasgow artist painting watercolours in a fluent 'wet' style.

Neilson, E. Little fl.1850s

Lived in Edinburgh and attended the Trustees' Academy 1856. Painted landscapes.

Nesbitt, Dorothy 1893–1974

Trained ECA where she came into contact with D M SUTHERLAND, CECILE WALTON and other members of the EDINBURGH GROUP with whom she worked from 1916 for a couple of years. Married the artist WILLIAM MYLES JOHNSTON. Painted landscapes in oil and also some stylish watercolours.

Nesbitt, John 1831–1904

Marine painter, lived Edinburgh and painted in oil and watercolour on a subdued palette on the Clyde as well as the east coast.

New Art Club

Established in December 1940 in Glasgow as an informal and inexpensive place to meet and exhibit works. There were bi-weekly meetings and monthly exhibitions for which there was no jury and artists paid a modest hanging fee. Membership cost £1 and could be paid quarterly, as opposed to the 8 guinea fee at the older Glasgow Art Club.

New Scottish Group

A number of artists around FERGUSSON, Herman and Adler established a new group in 1942. There were regular exhibitions and artists could hang work for a modest fee; no selection jury was used. Fergusson was the President, and other artists included MARGARET BROWN, MARIE DE BANZIE, MILLIE FROOD, GEORGE HANNAH, and SHEILA MACARTHUR.

Newbery, Francis Henry 1855–1946

Born Membury, Devon he trained at Bridgport Art School and the RCA. In 1885 he was appointed Director of GSA and under his guidance the School developed rapidly from a provincial art school providing mostly evening classes into a significant centre of art training with a style and reputation of its own, and memorable buildings by C.R. MACKINTOSH. In 1889 he married Jessie Rowat, an expert on embroidery and interested in all areas of design. Together they created a formidable team. Fra Newbery was excellent at recognizing talent, often appointing very young ex-students to the staff and employing more women than was usual at the time. He also treated all areas of design as equal to the fine arts, putting the Arts and Crafts theories into practice. He had wide connections abroad and encouraged the staff and students to take part in exhibitions in Europe, in particular Munich, Vienna and Turin where in 1902 he organized the Scottish section of the International Exhibition, one of the high points of the Glasgow style.

Newbery befriended many of his students who remained like-long friends. It was largely due to their introductions that the MACDONALD sisters met C.R. Mackintosh and HERBERT MACNAIR, leading to a period of great artistic creativity within the School.

Newbery painted when he had time, often on holiday in Walberswick, Suffolk. He painted competent landscapes and interiors, but these have been overshadowed by his achievement at the School. Died Corfe, Dorset.

Newbery, Jessie (née Rowat) 1864–1948

Born Paisley, she studied at GSA 1884–1888 and married FRA NEWBERY in the year after leaving.

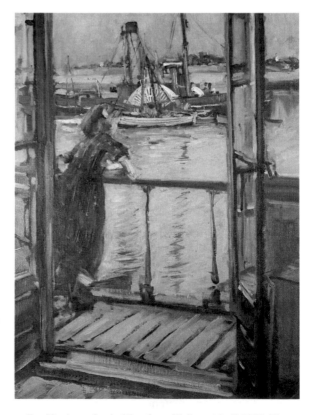

Fra Newbery *On the Waterfront, Walberswick* oil 1912, The Ellis Campbell Collection

In 1894 she joined the staff of the School and established a very successful embroidery class. Until her appointment embroidery had been considered a very minor branch of art, but under Jessie Newbery it was closely linked to drawing and painting, and given a major role in the School's teaching and exhibition programme. She supported the view of her husband that, 'Picture painting is for the few but beauty in the common surrounding of our daily lives, is or should be an absolute necessity to the many'. The classes were open to all with an interest in embroidery.

Jessie Newbery had long been interested in flowers and foliage as a basis of decoration, and she introduced such motifs into her embroidery. Thus the 'Glasgow Rose' became a trademark of the movement – originated in the embroidery department, as did the heart motif used by ANN MACBETH. Her sense of design influenced the Macdonald sisters, and MARGARET MACDONALD subsequently worked in appliqué and embroidery. When she retired in 1908, the department was taken over by her most gifted pupil, Ann Macbeth.

In 1918 she retired with her husband to Corfe Castle, Dorset, and in 1933 wrote the introduction to the catalogue of the Mackintosh Memorial Exhibition in Glasgow.

Newbery, Mary *see* **Sturrock, Mary Newbery**

Nicol, Erskine 1825–1904
ARSA 1855, RSA 1859, ARA 1866
Born Leith, he was apprenticed to a house-painter before entering the Trustees' Academy in 1838. After leaving, he became Drawing Master at Leith High School. In 1845 he moved to Ireland, where he obtained a teaching post in Dublin, and remained for four years. This trip, reinforced by subsequent annual trips to Ireland, formed the basis for many of Nicol's works. He painted humorous views of Irish life depicting the lighter side of the Irish character, including scenes of drinking, arguing and gambling. In 1862 he settled in London, continuing to return to Ireland most years, but in 1885 he returned to Scotland and in his later years painted mostly Scottish subjects. Nicol was a fine draughtsman, as his watercolours reveal, often using coarse brown paper with colour washes and white bodycolour. He was not a great colourist, keeping his oil paintings within a narrow tonal range. In addition to humorous subjects, he painted more serious pictures such as *The Missing Boat* but he managed to avoid the sentimentality of the Faeds. Died Feltham, Middlesex.

Nicol, Erskine E. d.1926
The son of ERSKINE NICOL, he painted landscapes in oil and watercolour influenced by the Dutch School. He occasionally ventured into figure subjects, but without his father's humorous approach.

Nicol, George Smith fl.1850–1880
Exhibited at the RSA 1851–79.

Nichol, G.S. fl.1870–1885
Edinburgh topographical artist who produced detailed and carefully drawn views of Edinburgh and its surroundings.

Nicolson, John 1843–1934
Born John O'Groats, a self-taught painter and sculptor who painted in oil. An obituary noted, 'In symbolism his oil paintings, especially those of an historical character, showed natural gifts.' For most of his life he farmed near Wick where he died.

Nicol, John Watson 1856–1926
The son of ERSKINE and brother of E.E. NICOL, he lived in London, painting genre, historical subjects and portraits. Many of his pictures dealt with Scottish history and legends. His *Lochaber No More* in the Fleming Collection is now possibly his most famous work.

Nicholson, John P. fl.1885–1909
Lived in Leith and painted Highland landscapes and farm scenes.

Nicholson, Mabel (née Pryde) 1871–1918
The sister of JAMES PRYDE, she was born in Edinburgh and married WILLIAM NICHOLSON in 1893. Worked as an artist and in 1920 a memorial exhibition was held at the Goupil Gallery. Painted portraits and figures.

Nicholson, Peter Walker 1856–1885
Trained as a lawyer, he turned to art aged 22 and studied at the Ruskin School, Oxford, in 1878 where he was influenced by Turner. He spent a winter in Paris in 1881 after which he had only three years to paint before drowning in a Highland loch, the result of a boating accident.

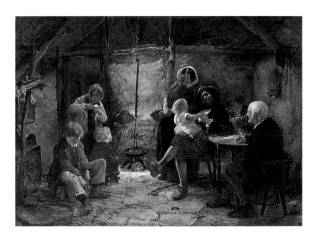
Erskine Nicol *Bliss* oil 1864, Bourne Fine Art

Nicholson's watercolours are intimate and lyrical, probably influenced not only by the Babrizon School but also by GEORGE MANSON and Fred Walker. He depicted farm workers, children and rural landscapes.

Nicholson, William 1781–1844
RSA 1826
Born Newcastle, he spent most of his life in Edinburgh and was a founder member of the RSA, acting as its Secretary in the early years. His oil paintings are less interesting than his portraits in pencil and watercolour, and he was a good portrait miniaturist. He painted some landscapes in watercolour. Died Edinburgh.

Nielson, Andrew P. b.1920
Born Dundee and paints views of Dundee in watercolour.

Nielson, Henry Ivan fl.1900–10
Landscape and animal painter associated with Kirkcudbright.

Nimmo, Robert fl.1820s–30s
Edinburgh portrait painter and lithographer.

Nisbet, Margaret Dempster fl.1886–1932
The wife of ROBERT BUCHAN NISBET, she studied at the Royal Institution in Edinburgh and in Paris. Painted portraits and miniatures.

Nisbet, Pollock Sinclair 1848–1922
RSW 1881, ARSA 1892
Born Edinburgh, the elder brother of R.B. NISBET, he painted landscapes and town scenes in oil and watercolour. Travelled widely in Italy, Spain, Morocco and Algeria, and worked in Venice in 1873 and c.1881. He also painted Scottish lochs and glens, but his best works are his watercolours of lively Arab or Venetian market places and buildings in the Mediterranean sunlight. Died Edinburgh.

Nisbet, Robert Buchan 1857–1942
RSW 1887, RBA 1890, RI 1892 (resigned 1907), ARSA 1893, RSA 1902s, HRSW 1934

Born Edinburgh, the son of a house painter, he worked at first in a shipping office before turning to art around 1880. Joined his older brother in Venice c.1881 before enrolling at the RSA Schools 1882–5. He later studied in Paris under Bouguereau.
For a short period he painted in oil, but soon gave this up to concentrate solely on watercolour, in which he was influenced by the broad styles of de Wint and Cox. He settled in Crieff, painting in Perthshire and on the east coast. His best works are his smaller landscapes in which he achieved rich, sonorous tones and great sense of light. His sunset views are striking with strong contrast of light and shade, revealing a knowledge of the Barbizon School. His larger works are possibly less intense and for them he adopted a technique of rubbing and scrubbing the surface, thereby losing the transparency of the medium. His work was extremely popular in his lifetime but has not remained so. Died Crieff.

R B N

Noble, Inglis fl.1880–1905
Lived in Edinburgh and painted rural landscapes, farm and harvest scenes.

Noble, James Campbell 1846–1913
ARSA 1879, RSA 1892
Born Edinburgh, he studied at the RSA Schools where he was influenced by GEORGE CHALMERS. After leaving the Schools he painted cottage interiors and figures set in landscape, often working alongside JOHN R. REID and JOHN WHITE, both of whom moved to London.
During the late 1870s his style changed and he began to paint broader landscapes with sweeping skies. He also painted coastal and river scenes along the Clyde with boatyards, wharves and shipping. He painted other rivers including the Tyne, Medway and the Seine.
In the early 1880s he settled in the Berwickshire village of Coldingham and began painting along the rocky coastline as well as in the rolling

Robert Buchan Nisbet *Landscape with Hail Cloud* oil, Royal Scottish Academy (Diploma Collection)

James Campbell Noble *Half tide Rocks East Coast, Berwickshire* oil, Royal Scottish Academy (Diploma Collection)

P S Nisbet *Plaza Larga, Granada* oil ca. 1875, Sotheby's

Berwickshire countryside. His *Half tide Rocks* is a very typical work from this period. His style was influenced by the Dutch 19th century School with vast, windy skies and broadly applied brushstrokes. He had visited Holland in 1875, and he returned in 1900 to paint the canals and estuaries which had inspired the Dutch landscape painters. Died Ledaig, Argyllshire.

Noble, Robert 1857–1917
ARSA 1892, RSA 1903

Robert Noble *Queen Mary's Bath House, Holyrood* oil, Robert Fleming Holdings Ltd

Born Edinburgh, the cousin of J.C. NOBLE, he studied at the RSA Schools. His earliest work depicted cottage interiors, but after a period in Paris studying under Carolus-Duran he turned to landscape. He settled in EAST LINTON and painted the East Lothian countryside. His work is softer and more colourful than that of his cousin, preferring richly wooded valleys, gardens and rivers to the starker coastal scenes and landscapes painted by his cousin. His colours are richer and more luminous, and he took an interest in painting techniques like glazing and underpainting to achieve his results. Died East Linton.

The Norie family
The Norie family ran a successful business in Edinburgh producing complete interior decoration for architects and their clients. This included house-painting, supplying decorative panels and frames and painting landscapes for use over doors, between windows and in other locations. JAMES NORIE Senior (1684–1757) built the business up and became a respected citizen and town councillor in

Edinburgh. He is known to have painted landscapes which were popular with collectors and architects, including the Adams who recommended his services. Mountains, waterfalls, classical ruins and rivers were the favourite motifs of the Nories, who created attractive pastiches of Italian and Dutch landscapes. Many Scottish noblemen returned from European tours with such landscapes, and the Nories painted decorative panels in similar styles to blend into the decoration. The quality of their work is often excellent, as the panels in Prestonfield House, Edinburgh reveal. These Italianate landscapes with their Roman ruins, waterfalls, hills and trees are bathed in a Claudian light. There is a good example, dated 1736, in the NGS. To what extent each member of the family was responsible for individual panels is not known, but it seems likely that they worked jointly on many projects. James Senior had two sons: JAMES NORIE Junior, 1711–36 and ROBERT NORIE, died 1766.

The firm took apprentices and several artists started their careers in this way including JAMES HOWE (1780–1836), JOHN WILSON (1774–1855) and ALEXANDER RUNCIMAN (1736–85). The role of the firm in the early years of art education in Scotland is important if still unclear. In 1729 the ACADEMY OF ST LUKE was established in Edinburgh but lasted only until 1731, but it is significant that James Norie Junior and his brother Robert were amongst the founders of the Academy which included ALLAN RAMSAY and RICHARD COOPER. Not only does it reveal their interest in art training, but also the fact that the Nories were considered artists. The firm continued until the mid-nineteenth century, although after the death of Robert in 1766 its importance artistically declined. Other institutions such as the FOULIS ACADEMY, the Nasmyth School and TRUSTEES' ACADEMY had been established, and many young artists were going to Italy for their education. Moreover, the taste in interior design moved towards a less decorated Neo-Classicism.

Norie, Marie L. fl.1880–90
RSW 1887
Landscape painter in watercolour, based in Edinburgh.

Norrie, Daisy M. 1899–?
Born Fraserburgh, she studied at Aberdeen College of Art. She worked in etching, aquatint and drypoint. Lived in Fraserburgh until c.1925 when she moved to Cheshire.

Novice, George W. fl.1830s–60s
Edinburgh painter of still-life and dead game.

James Norie *Biel House, East Lothian* oil (grisaille), Charles Spence Esq

Ogilvie, Frederick D. fl.1886–1917
Painter of landscape and coastal scenes in water-colour, he moved to England c.1900.

Ogilvie, George d.1723
First holder of the office of Her Majesty's Painter and Limner for Scotland (1703). Deaf and dumb artist who fell into disfavour after involvement in 1715 rebellion. No known works now extant.

Ogilvie, Lilian L. fl.1920s–40s
Lived in Edinburgh and painted flowers, west coast landscapes and views in France. Exhibited SSA.

Oliphant, John fl.1830s–40s
Painter of portraits who also worked in watercolour, painting landscapes, children and fisherfolk, often on Arran.

Oppenheimer, Charles 1875–1961
RSW 1912, ARSA 1927, RSA 1934

Born Manchester, he studied under Walter Crane at Manchester School of Art and in Italy. Settled in Kirkcudbright and for 52 years painted views in Kirkcudbright and Ayrshire. 'The Highlands are too sensational. Fine to visit. Fine to climb. But not adaptable enough for painting.' He was a keen fisherman and many of his paintings dealt with rivers and the effect of light on water: he was also a fine painter of snow and an acute observer of weather conditions. He painted both oils and watercolours in a fresh, direct and realistic manner and his popularity is due to his great sensitivity to landscape and light. He retained a love of Italy and produced some excellent canvases of Florence and Venice. Died Kirkcudbright.

Orchardson, Sir William Quiller 1832–1910
ARA 1868, HRSA 1871, RA 1877, RP 1897, HRMS 1900

Born Edinburgh, he entered the Trustees' Academy, a contemporary of THOMAS FAED. When LAUDER became Master in 1852, Orchardson stayed on as a senior student until 1855. His early work is based on the then current genre for historical painting, such as *Wishart's Last Exaltation* (RSA 1853).

In 1862 he moved to London and shared a house with JOHN PETTIE, painting subjects similar to those of Pettie – historical genre in accurate historical costume and interior decoration. Orchardson insisted upon very refined brushwork and 'polish', although his canvases were never overworked.

His best known works are the *Mariage de Convenance* series in which a bored young wife sits gloomily as far away from her elderly husband as possible. The interiors are usually French, and Orchardson visited Paris regularly buying pieces of Empire or Rococo furniture. He did not confine himself to domestic scenes, painting many anecdotal themes based on historical figures like Napoleon, Nelson, Beethoven and others.

Orchardson was immensely popular with the British public and he received honours, being a candidate for Presidency of RA in 1896 and receiving both a Knighthood (1907) and Chevalier of the Legion d'Honeur (1895). Unlike many successful Academicians, he was aware of, and interested in, developments in art: he admired Whistler and the

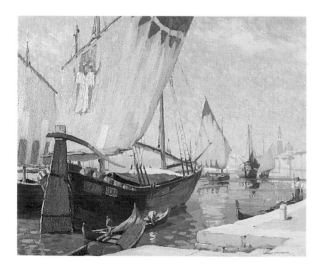

Charles Oppenheimer *Venetian Barges* oil, private collection

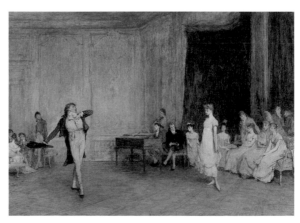

Sir William Quiller Orchardson *Her First Dance* oil 1889, Dundee Art Galleries & Museums (Orchar Collection)

younger GLASGOW BOYS. Although his subject matter was conventional, his technique was progressive in his use of colour and brushwork. Whistler, Degas and Sickert appreciated the painterly quality in his work.

Orr, Jack fl.1909–1939
Glasgow artist who specialized in painting birds in watercolour. His watercolours of parrots and exotic birds are often large and painted in a dashing style on silk or linen, probably influenced by JOSEPH CRAWHALL.

Orr, Monro Scott 1874–?
Glasgow artist, studied GSA. Produced decorative drawings and illustrations for books, using clear, bold outlines and a simplified style. Brother of STEWART ORR.

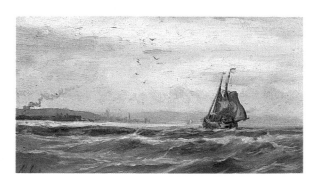

Orr, Patrick W. fl.1889–1932
Glasgow landscape and figure painter.

Orr, William Stewart 1872–1944
RSW 1925
Brother of MONRO ORR, studied GSA and initially produced illustrations, but later turned to landscape painting in watercolour. Lived for many years at Corrie House, Corrie, Arran and many of his landscapes are of the island. Used fresh colours, a fluid style and achieved sparkling effects.

Orrock, James 1829–1913
ARI 1871, RI 1875
Born Edinburgh, qualified as a dentist and practised in Nottingham before moving to London in 1866. His style was influenced by David Cox, and is similar to that of Claude Hayes, Thomas Collier and E.M. Wimperis with whom he made regular painting expeditions around England. His work belongs in spirit and style to the English School. He was also a lecturer on, and connoisseur and collector of, English watercolours.

Oswald, John Harvey fl.1870–1899
Edinburgh painter of landscapes and seascapes in watercolour and oil. His seascapes and coastal scenes are particularly effective. He was interested in the effects of sunsets, dawns and storms. Also painted some town views and worked in northern France.

J Harvey Oswald *Shipping in the Forth* oil 1888, private collection

Paddock, William fl.1892–1920
Glasgow flower painter in oil and watercolour.

Pairman, John 1788–1843
Born Biggar. Lived in Biggar and Edinburgh. Exhibited Carlisle Academy. Painted portraits, landscapes and rural genre, often with cattle. Died Edinburgh.

Paolozzi, Eduardo Sir b.1924
ARA 1972, RA 1979, HRSA 1987, KBE 1988
Born Leith of Italian parents. Studied at ECA 1943, as the Slade 1944–47 and worked in Paris 1947–50. Taught Textile Design at Central School of Art 1949–55 before moving on to mural and architectural work. Taught sculpture at St Martin's School of Art 1955–58. Has worked abroad extensively, in Germany and the USA. Principally a sculptor, Paolozzi has been a central figure in the development of Pop Art in Britain. 'Eduardo Paolozzi is a man whose art combines the passion of his Latin roots with the analytical canniness of the Scots, and yet above all he is a universal man' (Bill Jackson in the Scottish Gallery catalogue *Eduardo Paolozzi: Mythologies*, 1990).

The Paris Ateliers
From the 1870s onwards many Scottish art students spent at least one year working abroad. Although Antwerp, Munich and Dusseldorf were popular with students, Paris was the goal for most young artists. The French atelier system had been established at the Ecole des Beaux-Arts in 1863, based upon the idea of a famous artist directing his own studio. The hours were long and the conditions often cramped as students crowded around the model; although antique casts rather than live models were used for beginners. Progress from one studio to another was by competitive assessment, but the standard of teaching depended upon the involvement and enthusiasm of the professor, who usually attended twice a week. Bouguereau (taught 1878–1905) and Gérôme (taught 1865–1903) were significant artists and excellent teachers. Gérôme insisted upon good draughtsmanship, but he also encouraged students to develop their own personal vision. Both he and Bouguereau favoured 'finish', but this aspect of their teaching was ignored by many students, who preferred their spontaneous sketches. Many of the GLASGOW BOYS studied in Paris: LAVERY, CHRISTIE and KENNEDY under Bouguereau; ROCHE, PARK, CORSAN MORTON and HARRINGTON MANN under Boulanger and Lefèbvre; T. MILLIE DOW and ROCHE under Carolus-Duran; WHITELAW HAMILTON and

CRAWHALL under Aimé Morot. Other notable teachers at the Beaux-Arts included Bonnat, Breton, Meissonier and J-P Laurens, under whom JAMES PATERSON studied.
Many students attended the Académie Julian either in preparation for, or instead of, the Beaux-Arts. Rodolphe Julian established his first studio in 1873 and it was so successful that he opened others. He hired models and arranged for weekly visits from well-known artists including Bouguereau, Lefèbvre, Boulanger and Robert-Fleury. Julian charged the students an entrance fee and acted as a tutor, giving advice on their work and exhibitions. His academies attracted many foreigners, in particular English, Scottish and German. Colarossi's was a similar establishment; formerly the Académie Suisse, it was bought by an Italian and transferred to Montparnasse. Whistler, Rodin and Jongkind all taught briefly at Colarossi's and a progressive approach was favoured. It continued until 1957. The Atelier Benjamin-Constant was also a commercially-run school which had been established by an English art student.
Student life in Paris was both enjoyable and instructive. James Paterson recalled his years in Paris in an article in the first edition of the *Scottish Art Review*. It would be wrong, however, to suggest that students were influenced by the Impressionists, who neither taught in, nor visited, the ateliers. The main influences on the students were their own teachers and the social realist paintings of Breton and Bastien-Lepage. ROBERT WEIR ALLAN, who studied for five years in Paris (1875–80) came across some of the Impressionists at cafés such as *La Nouvelle Athènes* but this was an exception. Nevertheless, the value of a French training was immense, not only in terms of drawing, but also from the point of view of technique and tonal balance. It also aroused the interest of many young Scottish artists in working abroad, not only in Europe, but also, via the French fashion of Orientalism, in the Middle East and North Africa.
After the 1914–18 War the number of Scottish art students who visited Paris, if anything, increased. Travelling scholarships often permitted students to visit ateliers run by André Lhote and Ozenfant where they saw examples of avant-garde art. The Académie de la Grande Chaumière in Montparnasse, established in 1902 and still in existence, became a centre for students interested in the avant garde in the 1920s and 1930s, especially as the Ecole des Beaux-Arts had lapsed into academic orthodoxy. Many students, from Edinburgh

College of Art in particular, were deeply influenced by progressive French art as a result of their year in Paris during this period.

Park, Alistair 1930–1984
Born Edinburgh and studied at ECA 1949–52. Became an art lecturer, first in Edinburgh then at Bradford College of Art and Newcastle College of Art. His work in the 1950s was generally figurative, moving towards abstraction in the 1960s.

Park, George H. fl.1880s
Lived in Edinburgh and painted portraits, coastal scenes and landscape. Worked in Italy in the early 1880s.

Park, James Stuart 1862–1933
Born Kidderminster of Ayrshire parents, was brought up in Ayrshire. Painted in his spare time until 1888 when he turned to art as a profession. He studied at GSA and in Paris. Although he painted some portraits and figure studies, best known for his flower paintings. The best of these, painted in the late 1880s, are brilliant in the use of paint to create texture coupled with delicate tonal harmonies which capture the subtleties of light and shade. Some of Park's later flower pieces are less subtle, the dashing brushwork becoming rather slick and the exquisite tonal variations becoming more obvious. Park was associated with the GLASGOW BOYS and exhibited with them, but was never a central member of the group. Died Kilmarnock.

Parker, Agnes Miller 1895–1980
Born Irvine and studied at GSA 1911–17 joining the staff for a short period. Married the painter

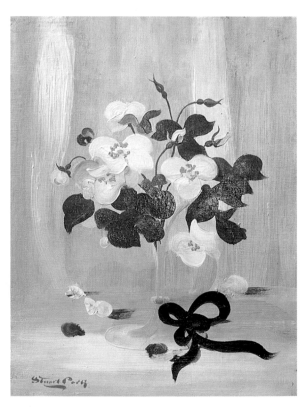

Stuart Park *Flowers: Red and White Roses* oil, Barclay Lennie

WILLIAM MCCANCE in 1918 and lived in England most of her life returning to Glasgow in 1955. Her early painting shares the same Vorticist influences as those of her husband but most of her work consists of wood engravings, many of which were executed for book illustrations, and which show a finely developed sense of draughtsmanship allied to the skilful use of black and white design. She illustrated *The Fables of Aesope* (1931), *Through the Woods* by H E Bates (1936), titles for the Limited Editions Club of New York and editions of the works of Shakespeare and Hardy. Lived at Lamlash on Arran and died at Greenock.

Parker, Elizabeth Rose 1868–1953
ARMS 1907
Born in Renfrewshire, she studied at GSA 1895–1901, in Paris, London and Edinburgh. Painted miniatures, mostly portraits and some landscapes.

Parsons, J.W. fl.1895–1902
Lived in Glasgow and painted marine and coastal scenes.

Partridge, John 1790–1872
Born Glasgow. Moved to London and became Painter Extraordinary to Queen Victoria and Prince Albert in 1845. Painted portraits and genre. Died London.

Paterson, Alexander Nisbet 1862–1947
ARSA 1911, RSW 1916, FRIBA
The younger brother of JAMES PATERSON, he was trained in architecture at Glasgow University and at the Ecole des Beaux-Arts in Paris (1883–6). Also visited Italy, Holland, and America before working in the practices of J. A. Campbell and Sir John Burnet. He set up his own architectural practice in Glasgow in 1891. Also worked in watercolour, having begun to paint while in Paris. His watercolours sometimes resemble those of his brother in colour, technique and subject, particularly his Tenerife works, but in other paintings his technique is softer with more rubbing of the paper, producing a more romantic overall effect. Often worked in the Highlands and France and liked architectural subjects. Was married to the artist and embroiderer MAGGIE HAMILTON.

Paterson, Anda b.ca.1938
Trained at GSA 1955–7. Married the artist James Spence in 1960. With her husband and JAMES MORRISON founded the Glasgow Group of young painters in 1958. Effective watercolours of figure subjects seen in terms of line and shape.

Paterson, Annie M. fl.1888–1925
Landscape and figure painter, exhibited RSA, Glasgow Institute and Baillie Gallery.

Paterson, Emily Murray 1855–1934
RSW 1904, ASWA 1910
Born Edinburgh of Ayrshire parents, she studied

in Edinburgh and Paris. In 1918 painted the Ypres battlefield and the watercolours were shown in a London exhibition. Settled in London at around that time, but continued to work abroad, regularly visiting Holland, France, Venice and the Alps. A person of great character, she was well known in London art circles. Was a keen Alpinist and set off for arduous walking and painting trips in the Swiss Alps and the Tyrol, usually exhibiting her work on her return at the Alpine Club. Her watercolours are painted in a 'wet' Glasgow manner which suited her love of water and snow subjects, and she often mixed bodycolour into the paint to create variations of texture and colour. Her luminous studies in the Bernese Oberland and her sparkling views of Venice or Bruges often incorporate unusual and striking colour combinations. Died London.

Paterson, George M fl.1880–1909
Lived in Edinburgh and painted genre, historical, landscape and coastal scenes. Later moved to Midlothian and also painted in France.

Paterson, G.W. Lennox b.1915
ARE
Studied at GSA, and later joined the staff, becoming Deputy Director (1947). Portrait painter and etcher.

Paterson, Hamish Constable 1890–1955
The third son of JAMES PATERSON. First trained

as an architect before turning to art, studying at ECA. Was seriously wounded in Mesopotamia in the First World War: on his return turned to portrait painting, in which he had natural gifts, but preferred landscape and moved to France where during the 1920s and 30s he produced oils and watercolours. As a result of his war experiences he suffered depressions which limited his output of work.

Paterson, James 1854–1932
RSW 1885, NEAC 1887, ARSA 1896, ARWS 1898, RWS 1908, RSA 1910, PRSW 1922–1932
Born Glasgow, the son of a successful manufacturer, he worked in business for four years while attending watercolour classes given by A.D. ROBERTSON. In 1877 his father agreed to his going to Paris to study first under Jacquessen de la Chevreuse, and then under Jean-Paul Laurens. Remained in Paris until 1882, spending the summer working on the Continent or returning to work in Scotland, and some summers he worked with MACGREGOR on the east coast (1877 or 78, 1880, 1881). Paterson's French training was very important and the tonal quality of his work reflects his Paris year. He wrote an article *The Art Student in Paris* in the *Scottish Art Review* which gives an insight into the *ateliers*.
Paterson had enjoyed painting in the Dumfriesshire village of Moniaive and in 1884 settled there with his new wife into a house 'Kilniess' enlarged by J.J. Burnet and given as a wedding present by his parents. Paterson painted the landscape around

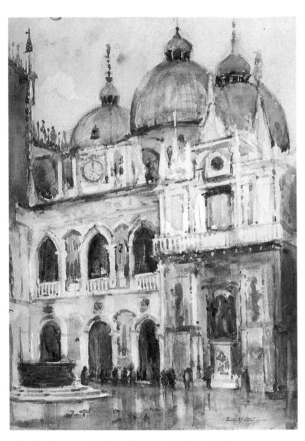

Emily Paterson *Cortile of the Doge's Palace, Venice* watercolour, Julian Halsby Esq

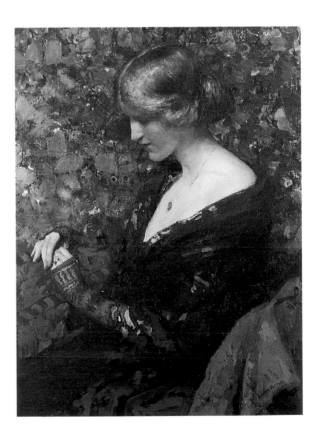

James Paterson *Constance* oil, Bourne Fine Art

171

Moniaive in oil and watercolour, working in the open air. In order to be able to paint snow scenes, he built a special studio nearby at Craigdarroch. Paterson was also a keen photographer. In 1888 Paterson was instrumental in establishing *The Scottish Art Review*, which became the mouthpiece of the GLASGOW SCHOOL, and he was also an early member of the New English Art Club. Paterson, however, remained slightly apart from the other GLASGOW BOYS, rarely painting alongside them. He had family responsibilities and he was also better off than the 'Boys.'

In the later 1890s Paterson began spending more time in Edinburgh, finally settling there in 1905. He was elected ARSA in 1896, and became Librarian and later Secretary of the Academy. Edinburgh began to feature in his work, often seen from Arthur's Seat or Craigleith Quarry. These views are handled tonally and reveal Paterson's very elegant painting style.

In 1910 his wife died, and Paterson began to travel more abroad, working regularly in Tenerife as well as Italy, Corsica and France. His colour, which had been restrained in Scotland, began to brighten and during his later years he produced many vivid and brilliant watercolours of southern landscapes. Unlike many of the other Glasgow Boys, Paterson's later work does not decline in quality remaining fresh and vibrant. Died Edinburgh.

Paterson, Mary Viola 1899–1981
Born Helensburgh. The daughter of ALEXANDER NISBET PATERSON and MAGGIE HAMILTON, she attended classes part-time at the Slade while at finishing school in London before studying at GSA 1918–21. Then studied in Paris at the Académie de la Grande Chaumiere and with André Lhote. She found France to her liking and spent many years living and working in southern France, as well as Malta and Venice. Painted in oil, watercolour and pastel and also produced lithographs and coloured prints, based on wood blocks. Returned from France on the outbreak of war in 1939 and worked for the Admiralty in Oxford. Also designed stained glass windows.

Paterson, Robert Stirling fl.1890–1940
Landscape painter working in oil and watercolour. Painted coastal views with boats in a sombre style.

Paton, David fl.1668–1708
Painted portraits in oil and miniatures. Recorded as travelling in Italy and on the Grand Tour in the 1670s and around 1700 moved from Scotland to London.

Paton, Donald fl.1897–1906
Watercolour painter of Highland landscapes.

Paton, Frederick Noel 1861–1914
The son of J. NOEL PATON, he painted landscapes in watercolour.

Paton, Sir Joseph Noel 1821–1901
ARSA 1846, RSA 1850
Born Dunfermline, the brother of WALLER HUGH

PATON, his father designed damasks. Worked as a textile designer in Paisley (1838–42) before going to London to study at the RA Schools (1842–3) where he met Millais, who became a life-long friend.

Paton's father was a collector of ancient Scottish armour and weapons, engravings and plaster casts from classical sculpture. He was also interested in Willam Blake and Swedenborgian mysticism. The background explains Paton's own interests in a wide range of subjects including literature, allegorical themes and spiritual concepts. He became a painter of ideas, more interested in the underlying concepts of a painting than in the surface technique.

Paton won a prize in the Westminster Hall competition for his *Spirit of Religion*, but he disliked living in London and returned to Scotland rarely venturing outside the country. There was a wide range of subjects: possibly his best known works are his fairy paintings such as *The Reconciliation of Oberon and Titania* (1847), which won a prize in the 1847 Westminster Hall Competition, and *The Quarrel of Oberon and Titania*. Paton's precise style is well suited to the subject.

Paton was also interested in old legends and ballads and produced illustrations for S.C. Hall's *Book of British Ballads*.

Paton's friendship with Millais was important. Millais tried unsuccessfully to get Paton back to London to benefit from contact with the young artists who were forming the Pre-Raphaelite Brotherhood. Paton refused, but through Millais he met Ruskin, who visited his studio. He attended Ruskin's Edinburgh lectures and attempted paintings of contemporary life such as *Home from the Crimea*. His most Pre-Raphaelite painting is *The Bluidie Tryste*, the background painted on the Isle of Arran. The two Paton brothers worked side-by-side on Arran in 1854 and 1855 and probably around Loch Lomond in 1858, and Noel painted a number of landscapes which reflect Pre-Raphaelite theory. However, he never became a member of the

David Paton *The Yester Lords* plumbago on vellum, National Gallery of Scotland

Sir Joseph Noel Paton *The Reconciliation of Oberon & Titania* oil, National Gallery of Scotland

Brotherhood, his ideals being far divorced from his London contemporaries.

After 1870 Paton turned to religious painting, often using an elaborate allegorical symbolism. Many of these later works are coldly academic while others are overtly sentimental or moralistic.

Paton was a man of wide interests and also published volumes of poetry. Died Edinburgh.

Paton, Peter fl. 1830–1850

Painted watercolours of Rome, Naples and Sicily, and views around Edinburgh. There are a group of sepia drawings (NGS) done for the Abbotsford edition of Sir Walter Scott's work (1842–47) where they appear as woodcuts. The drawings are finely executed with a good sense of light and shade.

Paton, Ranald Noel 1864–1943

One of SIR NOEL PATON's eleven children, he painted portraits and worked as an illustrator.

Paton, Waller Hugh 1828–1895

ARSA 1857, RSA 1865, RSW 1878

Born in Wooers-Alley, Dunfermline, he worked with his father designing damasks before taking lessons with JOHN ADAM HOUSTON. He was essentially self-taught and liked to paint an entire picture on-the-spot, a rare practice at that time. Was

influenced by Pre-Raphaelite theories and probably attended Ruskin's Edinburgh lectures of November 1853 with his brother NOEL PATON.

In a letter of 1858 Ruskin defends Paton's *Wild Water, Inveruglas*, attacking the generalized landscapes 'full of flourishes of brush' rather than accurate detail. The two Paton brothers worked side-by-side on Arran in 1854 and 1855 and probably around Loch Lomond in 1858. They no doubt discussed the Pre-Raphaelite Movement and their paintings of this period reflect this interest.

Waller Hugh Paton worked extensively on Arran, in Perthshire and in Aberdeenshire. He enjoyed dramatic effects of light, like sun reflected on rocks and sunsets, and worked up his watercolours using much body colour. He varied his scale from quite

Waller Hugh Paton *Dollar* oil, Robert Fleming Holdings Ltd

James McIntosh Patrick *General Wade's Bridge* oil ca. 1935, private collection

tiny watercolours to huge works up to 4 ft long, still in watercolour. Often followed the contemporary custom for oil, and used arched tops. He also worked in oil in a style often indistinguishable from his more finished watercolours.

Paton travelled outside Scotland: he was in London in 1860 and in Europe in 1861 and 1868, but his work deals almost entirely with Scotland. In 1862 he was commissioned by Queen Victoria to draw Holyrood Palace.

Paton was a prolific artist and popular in his time: this declined with the reaction against Pre-Raphaelitism but more recently the quality of his work has been appreciated. Died Edinburgh.

Paton, W. Hubert fl.1885–1932
Edinburgh landscape painter, probably the son of WALLER HUGH PATON.

Patrick, Elizabeth fl.1880–1900
Lived at Garnethill, Glasgow, and painted landscapes. On staff at GSA under ROBERT GREENLEES. Founder member of the GLASGOW SOCIETY OF LADY ARTISTS, she studied at GSA 1875–1880, exhibited at the Glasgow Institute and gave private lessons in her studio.

Patrick, James fl.1880–1905
Lived in Edinburgh and painted town scenes and village life. Influenced by ROBERT MCGREGOR.

Patrick, James McIntosh b.1907
ARE 1932, ARSA 1949, RSA 1957, ROI, RGI
Born Dundee the son of an architect, he studied at GSA and in Paris. Started his career as an etcher in 1927, but with the collapse of the etching market in the 1930s turned towards watercolour and oil. Early work is detailed and executed in a meticulous manner, being closer in spirit to English landscape painters of the 1930s than to the Expressionist tendencies of Edinburgh. He painted beautifully observed oils of the Angus landscape in all seasons,

after looking down from a hill with Breughel-like figures. In later years his landscapes, while showing the same observation and realism, are somewhat freer in handling. Lives in Dundee and paints local views which have become extremely popular in Scotland. Has also taught at Duncan of Jordanstone College of Art, Dundee.

Patrick, John fl.1840s
Glasgow painter of landscapes, genre and rural scenes, often with figures.

Patrick, J. Rutherford fl.1882–1904
Painted landscapes and exhibited at the SSA. Thought to be a brother of JAMES PATRICK.

Patrickson, Miss fl.1810–1830
Lived in Edinburgh where she worked as a popular portrait painter in pastel, crayon and watercolour.

Paul, Florence A.J. fl.1900–10
Painted in the Aberdeen area. An interesting example of an extremely talented lady artist of the period. Painted street scenes with figures, landscapes and flower pieces.

Paul, Robert 1739–1770
A student at the Foulis Academy in 1756 in Glasgow, he produced engravings of Glasgow and its environs. Also engraved the drawings of CHARLES CORDINER and was evidently a capable engraver. Some drawings by Paul exist revealing his ability as a topographical draughtsman.

Paul, Robert fl.1840s–50s
Painted and drew portraits in watercolour and in

Florence A J Paul *The Castlegate, Aberdeen* oil 1906, The City of Aberdeen

chalk of members of the Scottish aristocracy and other notables.

Peddie, Archibald b.1917
Born Helensburgh and studied at ECA. Painter of landscapes, figure subjects, historical subjects and murals in oil, watercolour and tempera.

Peddie, Barbara S. fl.1881–1908
Edinburgh flower and landscape painter.

Peddie, Christian (Mrs Henderson Tarbet) fl.1892–1937
Painted landscapes in watercolour.

Peddie, George S. 1883–1911
Dundee illustrator and watercolour painter.

Peddie, James Dick fl.1880–1918
Edinburgh landscape and portrait painter in oil and watercolour.

Penny, William fl.early 19c.
Engraver and topographical artist who lived in Midcalder, near Edinburgh. Painted views of Edinburgh in pen-and-ink, and engraved other artists' work.

Peploe, Denis Frederic Neal b.1914
ARSA 1958 Librarian RSA 1966–73
Son of S.J. PEPLOE, studied ECA and in Paris under André Lhote. Travelled in Greece, Yugoslavia and Italy, lived in Spain for a while and joined staff of ECA in 1954. Paints landscapes and still-life. Exhibits SSA and RSA as well as one-man shows.

Peploe, Samuel John 1871–1935
RSA
Born Edinburgh and educated at the Collegiate School in Charlotte Square, he had good academic ability but no interest in the professions, preferring to walk, sail or sketch. By 1893 he was enrolled for classes in the Trustees' Academy, the forerunner of Edinburgh College of Art, and the following year was in Paris at the Académie Julian under the neo-classicist William Bougereau, 'damned old fool', and later at the Académie Colarossi. Long study nurtured his natural ability and helped him perfect an early style based on the Dutch masters, particularly Franz Hals, and Manet. He began a lifelong habit of taking painting trips to northern France and to the Hebrides, with J.D. FERGUSSON, from 1901. He exhibited regularly in the RSA, RGI and SSA from 1900 and had his first one-man show at the Scottish Gallery in 1903. By 1906 his earlier still-life and figure paintings, characterised by dark

backgrounds, gave way to paler colours, greys and pinks. This was in part due to a move to a new, lighter studio in York Place from Shandwick Place. His second exhibition in 1909 was successful but his eyes were turning to Paris and the next year he moved and married Margaret MacKay whom he had met on a painting trip to Barra in 1894. France liberated his palette as evidenced by Fauvist panels painted in Royan (1910) Cassis (1911, 1913) and in Paris. His studio paintings show the influence of Van Gogh and de Segonzac. The Peploes came back to Edinburgh in 1912 with a young son, Willie, and dozens of paintings much too advanced for Edinburgh. Rejected by his old dealer, Peploe put on his own show at the New Gallery in Shandwick Place, where the SOCIETY OF EIGHT had their inaugural exhibition in the same year.

For the next 15 years Peploe retained a brilliant palette, evolving a mature style containing elements of Cezanne, the Jazz Age and Matisse. By the late 20s he had reverted to a more sonorous, tonal painting, still enlivened by brilliant colour chords, but weightier and cooler. In 1933 he taught two terms at the College of Art in Edinburgh, making a considerable impact.

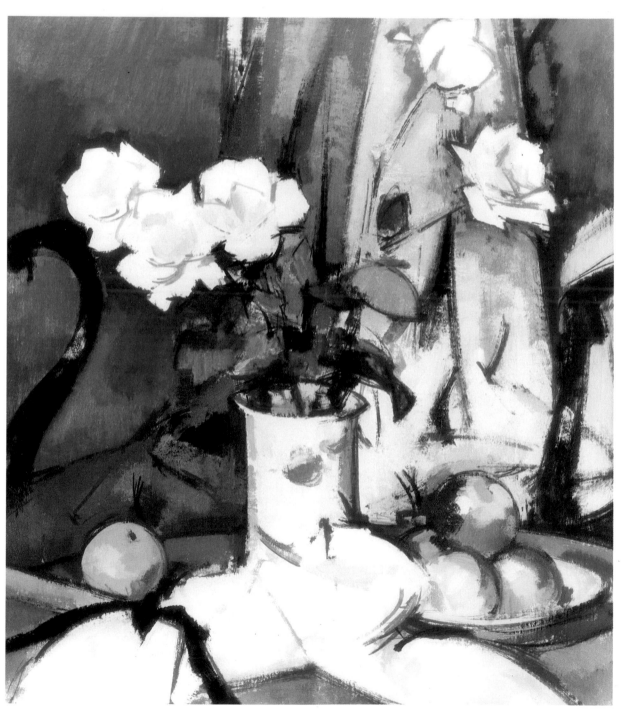

S J Peploe *Still Life: Pink Roses and Apples* oil ca. 1922, Bourne Fine Art

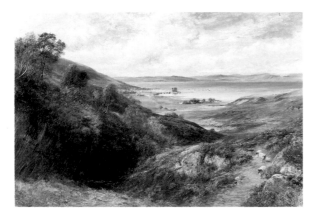

Arthur Perigal *The Head of Loch Lomond* oil, private collection

Best known for his still-lives of roses or tulips, Peploe had a wide range of subjects including figure painting and particularly landscape. He visited Kirkcudbrightshire regularly from 1914, Iona from 1919, at CADELL's recommendation, and Cassis in 1924, 1928 and 1930. His landscapes have a conviction and passion which belie the rather diffident shy public face of the artist. His family and closest friends knew a wickedly funny, compassionate and sincere man. Died Edinburgh. (*Guy Peploe*)

Peploe, William Watson 1869–1933
The elder brother of S.J. PEPLOE, he worked as a manager of an Edinburgh bank, but in the 1890s painted with his brother and R.C. ROBERTSON on Barra. In 1910 his brother married and moved to Paris, and W.W. Peploe wrote and published a volume of poetry dedicated to him. His earlier works are pen drawings satirising Aubrey Beardsley and his followers, but in 1918 he produced two small abstract paintings which show the influence of the Vorticists. These are possibly playful satires on modern art.

Perigal, Arthur 1784–1847
Edinburgh portrait painter, miniaturist and historical painter, the father of ARTHUR PERIGAL JUNIOR.

Perigal, Arthur 1816–1884
ARSA 1841, RSA 1868, RSW 1878
The son of an Edinburgh artist, he established himself early as a landscape painter in oil and watercolour. Was elected ARSA aged 25. He painted mostly Highland landscapes which show the influence of MCCULLOCH, but lack his freedom, but he also worked in Italy during the 1840s. Some English subjects, including watercolours of

Hampstead, occasionally feature in his work. Died Edinburgh.

Perman, Louise Ellen (Mrs James Torrance) 1854–1921
Born Glasgow and studied at GSA 1881–1890. A painter of flowers, especially of irises, she worked mainly in oil, but did some watercolours. In 1908 *White Roses* was bought by the Luxembourg in Paris and in 1911 she married the artist JAMES TORRANCE. They moved to Helensburgh where she lived until her death. She held several exhibitions, often showing in conjunction with JESSIE ALGIE, JESSIE KING and ANNE MUIR. Died Edinburgh.

Petrie, William McWhannel 1870–1937
Studied in Paris and Italy and joined staff at GSA. Worked in oil, watercolour, pastel and tempera; also etched and sculpted. Painted girls' heads in an art nouveau style with flowing forms and lines and with titles like *Autumn* and *Reflections*. Member of GLASGOW ART CLUB. Died Glasgow.

Pettie, John 1839–1893
ARA 1866, HRSA 1871, RA 1873
Born Edinburgh, he was brought up in EAST LINTON. Joined the Trustees' Academy aged 16 and became a close friend of MCTAGGART, ORCHARDSON and CHALMERS. In 1860 he was commissioned along with ORCHARDSON, MACWHIRTER and others, to produce illustrations for *Good Works* a new periodical which first appeared in Edinburgh. In 1862

John Pettie *The Rehearsal* oil, The Robertson Collection, Orkney

it moved to London and Pettie followed, moving into a house in Pimlico with Orchardson and TOM GRAHAM.

Pettie quickly made a reputation as a history painter, setting his pictures in a number of periods – medieval, Civil War, 17th and 18th centuries. His first success at the Royal Academy *A Drum-Head Court Martial* revealed his ability to handle figures, to compose well and to use colour effectively. In the following year, aged 27, he was elected ARA and over the next few years painted a series of historical canvases which were popular with the public. After 1870 he turned more towards scenes from Scottish history such as *Hunted Down* and *The Highland Outpost* and managed to create an atmosphere of excitement, at times almost theatrical. Pettie could also challenge Orchardson at his own game, as *Two Strings to her Bow* showed. Here he depicts a young girl with two admirers, all dressed in the Regency style which Orchardson had helped to popularise. In later years, Pettie painted many portraits, sometimes in historical costume.

By the time of his death, Pettie's work was outdated and even today 19th century history painting has few followers, but Pettie was a brilliant artist, and far better than many of his contemporary history painters. Died Hastings.

Philipson, Sir Robin b.1916
ARSA 1952, RSA 1962, ARA 1973, RA 1980 PRSA 1973–83
Born in Lancashire, his family moved to Gretna

Sir Robin Philipson *Interior, Anne Redpath's House, London Street, Edinburgh* oil, Sir Robin Philipson

when he was 14. He attended ECA 1936–40, joining the staff in 1947 after war service.

His earlier work was influenced by GILLIES, MAXWELL and Kokoschka, but during the 1950s and 60s he painted a series based on cock-fighting as a theme, using a more painterly Expressionism.

Later he painted series based upon cathedral interiors, crucifixions and the First World War. In each case he made an expressionist use of paint, with rich colours and jewel-like effects. He was elected President of the RSA in 1973, and was Head of the School of Drawing and Painting at Edinburgh College of Art 1960–1982.

John Phillip *La Gloria* oil, National Gallery of Scotland

178

Phillip, Colin Bent 1855–1932
ARWS 1886, RSW 1890 (resigned 1907), RSW 1898
The son of JOHN PHILLIP, studied in London and
RSA Schools. Lived in London and Devon for most
of his life, but returned regularly to Scotland to
paint. He produced large watercolours of Highland
scenes which can be effective, but at times appear
oversized for their subject matter and repetitious.

Phillip, John 1817–1867
ARA 1857, HRSA 1857, RA 1859
Born in Oldmeldrum, Aberdeenshire, the son of a
shoemaker, he was determined despite his humble
origins to become an artist. His work was brought
to the attention of Lord Panmure, who sent him
to London to enter the RA Schools in 1837. He
became a member of the 'Clique', a sketching
Club which included August Egg, W.P. Frith and
Richard Dadd, who later married Phillip's sister.
Phillip originally intended to become a history
painter, but the genre painting of WILKIE proved
a stronger attraction and during the later 1840s he
painted scenes from Scottish life.
In 1851, for reasons of health, Phillip visited Spain
returning in 1852 with a number of Spanish works,
one of which, *Spanish Gipsy Mother*, Queen Victoria
bought as a Christmas present for Prince Albert.
Not only had Phillip seen Mediterranean sun and
colours, he had also admired the romantic qualities
and rich colouring of Murillo and Velasquez. Before
returning to Spain in 1856–7 with Richard Ansdell,
Phillip continued to paint Scottish genre as well
as Spanish subjects, but the second visit radically
altered his style. His brushwork became looser, his
colours richer and a certain vulgarity entered his
art. During this second visit he worked in water-
colour on-the-spot producing a number of sparkling
works, some of which are in the NGS. These served
as the basis of more finished paintings of Spain. It
was during this period that he gained his nickname
'Spanish' Phillip.
He returned for a final visit in 1860 which resulted in
his most famous work *La Gloria: a Spanish Wake*. At
their best his Spanish canvases have life, energetic
brushwork, rich colours and good chiaroscuro, but
there is also a slight crudeness about the execution
and a repetition of the Spanish characters. Phillip
was an excellent draughtsman as his watercolours
and drawings of Spain reveal.
Queen Victoria favoured Phillip most amongst her
Scottish artists, buying not only his Spanish but
also his Scottish scenes, and also commissioning
portraits from him of Albert and of the marriage
of the Princes Royal.
Wilkie had been Phillip's model, both for his earlier
genre paintings and his later Spanish subjects, but
he was far more than a mere imitator of Wilkie,
producing some memorable and dashingly executed
canvases. Died London.

Phillips, Charles Gustav Louis 1864–1944
Born Montevideo, the son of Scottish parents, and
studied in Dundee under W.M. GRUBB and worked
in Dundee, painting local views in a competent
style. He recorded the Royal Visit to Dundee of
1914 in watercolour. Died Dundee.

Pickering, Ruby 1873–?
Born Glasgow, she studied at GSA 1889–1893 and
was a member of the circle around C.R. MACKIN-
TOSH and the MACDONALD sisters.

Pierce, Charles E. b.1908
Studied at ECA and he worked as a painter, etcher
and wood engraver.

Pirie, Sir George 1863–1946
ARSA 1913, RSA 1923, PRSA 1933–1944, HRSW
1934
Born Campbeltown, the son of a doctor, he attended
Glasgow University before turning to art. Studied
Slade and in Paris. He painted animals and birds,
as well as some landscape. As a draughtsman he
was excellent with a fluid and confident line but his
colour tends to the grey. To his pencil drawings he
often added watercolour in a free and 'wet' style, and
he also made extensive use of bodycolour and pastel.
In the 1880s he was associated with the GLASGOW
BOYS, and in the early 1890s he was in Texas for a
period, drawing horses and ranching scenes. Died
Torrance.

Pope, Perpetua b.1916
Born Solihull and trained at ECA. Has exhibited
extensively since 1951 with works in many public
collections. Paints landscapes, flower pieces and
still-life in oil and watercolour.

Porteous, William fl.1868–82
Lived in Edinburgh and painted landscape and
harbour views. Exhibited regularly at RSA.

Powell, Sir Francis 1833–1914
ARWS 1857, RWS 1876, PRSW 1878–1914
Born Pendleton, Manchester, he studied at Man-
chester School of Art and began exhibiting
watercolours around 1856. He moved to Scotland

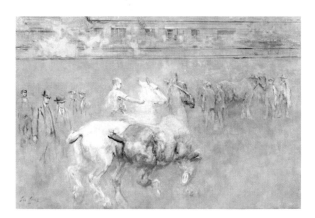

Sir George Pirie *In the Glasgow Market* oil, private collection

in the 1860s and became involved in the foundation of the Scottish Society of Watercolour Painters, being elected its first President in 1878. In 1888 the Society was granted a Royal Charter and five years later Powell was knighted. His watercolours are usually of loch scenes or seascapes, but he also painted mountain scenery. They tend to be carefully composed and executed with colours kept within a narrow range of ochres, grey, browns and blues. His role in the formation of the RSW is possibly more important than that as a painter.

Pratt, Mrs John Burnett fl.1860s
Lived at Cruden Bay, Aberdeenshire, and painted landscapes in oil and watercolour.

Pratt, William M. 1854–1936
Born Glasgow, he studied at GSA and at the Académie Julian under Bouguereau. He painted landscapes, pastoral scenes with figures and seascapes. Lived in Lenzie near Glasgow and worked in oil and watercolour. Died Lenzie.

Prehn, Eric Thornton 1894–1985
Born Moscow of English parents and fled Russia in 1922. Studied art in the 1930s in Florence under Professor Nicola Lochoff and was introduced to the techniques of the primitive Italian Masters, particularly of those painting in tempera. Moved to Scotland in 1941 and lived first of all in Oban, then in Edinburgh. His subject matter was drawn from the Western Highlands: from Argyll, Sutherland, Wester Ross and the islands. 'Prehn's love for the elegant birches of the Russia he had known was replaced by an equal devotion for Scotland's pines and birches' (Esme Gordon, 1986). He also made annual painting visits to Italy. Exhibited at the RSA, SSA and RGI in the 1940s but ceased exhibiting in the '50s and slipped from the public eye until his Fine Art Society memorial exhibition in 1986.

Pre-Raphaelitism in Scotland
Although no Scottish painter was actually included

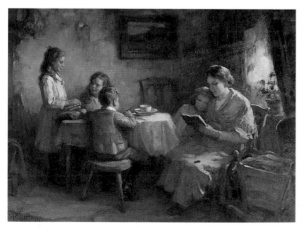

William Pratt *Home Lessons* oil, Phillips Scotland

in the Pre-Raphaelite Brotherhood, the Movement had a great influence in Scotland, and some of the more interesting events – such as Ruskin's Edinburgh Lectures of 1853 and Millais's involvement with Effie Ruskin – took place in Scotland. Ruskin visited Scotland in 1853, accompanied by Millais, who began work on the famous portrait of Ruskin at Glenfinlas that summer. Ruskin came to admire the Scottish landscape, making drawings of rocks and foliage, but spent much of the time preparing the lectures he was to give in Edinburgh in November. They are amongst the clearest expositions of the Pre-Raphaelite creed:

'Pre-Raphaelitism has but one principle, that of absolute, uncompromising truth in all that it does, obtained by working everything down to the most minute details, from nature and from nature only. Every Pre-Raphaelite landscape background is painted to the last touches, in the open air, from the thing itself. Every Pre-Raphaelite figure, however, studied in expression, is a true portrait of some living person.'

WILLIAM DYCE, although never a member of the Brotherhood, played a major role not only by introducing Ruskin to Millais's *Christ in the House of his Parents* at the Royal Academy of 1850, but also as a painter in his own right. His *Titian's First Essay in Colour*' (RA 1857) and *Pegwell Bay* are amongst the best known Pre-Raphaelite works, but he was a late convert to the Movement, being already 51 in 1857. Dyce spent a holiday on Arran in 1859 and the landscape became a Biblical backdrop for *Man of Sorrows* and *David in the Wilderness*.

SIR NOEL PATON was also involved with members of the Brotherhood through his friendship with Millais, who encouraged him in vain to return to London. Ruskin visited Paton at Dunfermline and both he and his brother, WALLER HUGH PATON, attended Ruskin's Edinburgh Lectures. Waller Hugh Paton's landscapes, both in oil and watercolour, encapsulate Pre-Raphaelite theories and practice and Ruskin defended his *Wild Water, Inveruglas* in a letter published in 1858:

'Such a lovely picture as that of Waller Hugh Paton's must either speak for itself, or nobody can speak for it . . . If, in that mighty wise town of Edinburgh, everybody still likes flourishes of brush better than ferns, and dots of paint better than birch leaves, surely there is nothing for it but to leave them in quietude of devotion to dot and faith in flourishes. . .'

JOHN ADAM HOUSTON, who had given lessons to Waller Hugh Paton, was himself influenced by the Movement in the later 1850s and he produced some fine Pre-Raphaelite watercolours of the Highlands. ROBERT HERDMAN was a friend of the Patons and Houstons and probably sketched with them on Arran, an island which featured much in Scottish Pre-Raphaelitism. Herdman painted some finely detailed landscape studies, and the background to his figures often reflect the Pre-Raphaelite

landscape. WILLIAM BELL SCOTT met Rossetti and Holman Hunt in London in the late 1840s and was sympathetic towards the Brotherhood. In 1853 he met Millais and Ruskin, but took a dislike to the latter's theories of art education. Although Scott never exhibited with the Brotherhood, their influence can be seen in his studies for the Wallington Hall decorations and in many of his watercolour landscapes. Other Scottish artists influenced by Pre-Raphaelitism include the young MCTAGGART and MACWHIRTER, and older artists like JAMES FERRIER.

Prentice, D.R. fl. 1868–1898
Landscape and coastal painter in watercolour, he worked in the Highlands and on the East coast.

Pringle, John Quinton 1864–1925
Born in the east end of Glasgow, he painted from an early age. His father was stationmaster at Langbank near Glasgow 1869–74 and Pringle would watch the many artists who liked to sketch at Langbank. He read art magazines avidly and visited the Glasgow Galleries. Studied art at evening classes 1883–5 and won a bursary which enabled him to attend evening classes at GSA 1886–95. Here he won several prizes and his work was admired by the NEWBERYS and many of the students.

In 1896 Pringle set up his own shop at 90 Saltmarket, carrying out general and optical repairs. A contemporary described the shop: 'It was probably not only the worst run shop in Glasgow, but perhaps the worst run shop in Europe. It was hard to pay Pringle anything . . . but it was also hard to get anything out of him if you had committed it for repair.'

Pringle painted at weekends and after hours,

painting sensitive oils, the paint applied in a mosaic of small brushstrokes and in watercolour. In 1910 he made his only trip abroad, to Normandy for 10 days, but in the following year his sister, who had kept house for him, died, and life became more difficult. Between 1911 and 1920 he worked only in watercolour, but returned to oil on a visit to Whalsay, Shetland, in 1921. In 1922 a one-man exhibition was arranged by SOMERVILLE SHANKS and ANDREW LAW, and a result of its success and his failing health, Pringle abandoned the shop to paint full-time. He died of cancer three years later.

Pringle was greatly admired by other artists, despite his small output. His best work, such as *Poultry Yard, Gartcosh* (1906), or *Whalsay Bay with Girl in White* (1924), has a haunting quality. He was influenced by Bastien-Lepage and the square-brush technique, but he worked in a unique and informal way. Died Glasgow.

Proudfoot, William 1822–1901
Perth painter, studied art in Italy. Painted landscapes and still-life, taking up watercolour (which he called 'diluted art') late in life, aged about 70. His landscape watercolours are effective and have freshness and verve, whereas his still-life watercolours are more highly finished.

Prowett, James Christie d. 1946
Born Bannockburn and trained at Paris School of Art where he was a prizewinner and medallist. Lived in Stirling and was a member of Stirling Fine Art Association and Glasgow Art Club. Exhibited regularly. Painter of wooded landscapes and pastoral subjects in oil in an individual style. Died Aberdeen.

John Quinton Pringle *Kruger with Tobacco Pouch* oil 1908, The Robertson Collection, Orkney

James Pryde *The Black Pillar* oil, Aberdeen Art Gallery, Aberdeen City Arts Department

Pryde, James Ferrier 1866–1941
Born Edinburgh, his father was Headmaster of
Queen Street Ladies College and a friend of many
theatrical personalities such as Henry Irving and
Ellen Terry. Pryde enjoyed the theatre and for a
period in the 1890s toured with Gordon Craig. He
studied at the Royal Institute where he was a con-
temporary of D.Y. CAMERON, and in Paris before
moving to Herkomer's School in Bushey where he
met William Nicholson. In 1894–96 he collaborated
with Nicholson, who had married Pryde's sister,
under the name 'Beggar staff Brothers', producing
highly original posters. Became a successful por-
trait painter and his sitters included Lady Ottoline
Morrell and Ellen Terry, but he is known for his
large canvases of streets, buildings and interiors
which have a theatrical quality. His images of
quiet corners in Venice, the buildings exaggerated
in scale, or of cavernous bedroom interiors, the
recesses in deep shadow, haunt the imagination.
Around 1909 he began a series inspired by Mary
Queen of Scots' bed at Holyrood Palace, but after
1925 produced little work, although he designed
sets for Paul Robeson's *Othello* in 1930.
Pryde had a wide circle of friends including Orpen,
Augustus John, Dudley Hardy, Whistler, Conder
and LAVERY. He lived a Bohemian life but his health
suffered in later years as the result of alcohol.

Pulsford, Charles 1913–1989
ARSA 1959
Born Leek, Staffordshire. Studied at ECA 1933–7
where he later taught. He painted timeless meta-
physical and mystical paintings based upon Greek
mythology or Christian belief. He moved to
Loughborough in 1960 to take up a teach-
ing post, later becoming Head of Fine Art at
Wolverhampton Polytechnic. He wrote *The Creative
Cells* – his unorthodox views on art education. Died
Cambridge.

Purves, James E. fl.1860s–70
Lived in Edinburgh and painted landscape and
architectural subjects.

Purvis, John Milne 1885–1961
Born Perth, studied GSA before travelling on the
Continent and North Africa. Head of Drawing and
Painting at Dundee College of Art. Exhibited oils
and watercolours based on his many trips abroad,
particularly to Spain, North Africa and Turkey.

R

Raeburn, Agnes Middleton 1872–1955
RSW 1901, Lauder Award 1927
Born Glasgow, studied GSA, member of the C.R. MACKINTOSH circle, contributing to *The Magazine* 1893–6. Her early work is influenced by Glasgow Symbolism, but her later watercolours of landscapes in France and Holland and of flowers are free and 'wet' in style. Art Mistress, Laurel Bank School and President, Glasgow Society of Lady Artists 1940–43. Her output of watercolours was large, but of a consistent quality.

Raeburn, Ethel Maud 1867–1953
Edinburgh artist, painted watercolours of landscapes, her best work being those painted in Venice.

Ethel Raeburn

Raeburn, Sir Henry 1756–1823
ARA 1812, RA 1815
Born Stockbridge, Edinburgh, and educated at George Heriot's Hospital. Apprenticed 1772 to James Gilliland, jeweller and goldsmith. His innate talent as a portrait painter was recognised early and he graduated from painting miniatures to full scale portraits.

His earliest known portrait in oil is *George Chalmers of Pittencrieff* (1776) and he was probably influenced by the work of JEREMIAH DAVISON and JOHN MEDINA. It is also likely that the young Raeburn had come into personal contact with DAVID MARTIN, who is believed to have encouraged him.

In the early 1780s he joined with ARCHIBALD ROBERTSON, WALTER WEIR and others in informal life drawing classes. He left Edinburgh in 1784 travelling to Rome by way of London where he met Sir Joshua Reynolds.

Little is known of his time in Rome and he was back in Edinburgh in the summer of 1786, bringing to an end the only productive period of his career spent outside Scotland. The next ten years saw dramatic and tangible development in the quality of his portraits: from bust size figures he moved to full length portraits and by the early 1790s he was confidently painting groups and setting them in landscape, possibly the finest being *Sir John and Lady Clerk of Penicuik* (1792). By this time he had become a direct competitor to his former mentor David Martin and was becoming established as the leading portrait painter of the day in Scotland.

The portrait of the Clerks also served to make his reputation in London. 'In this painting there is a boldness of touch and strength of effect which have seldom been equalled,' wrote the critic in the *Public Advertiser*.

Raeburn ordered a new studio and residence built in Edinburgh's New Town and moved there in 1798. His social ease and polish, allied to his artistic proficiency, meant that he was now without equal in the capital. Poor financial investment led to a brief flirtation with London but he was by now in demand in Edinburgh and able to command in excess of 100gns. a portrait from both aristocratic and professional clients. He also made copies of his own and other artists' work. He was particularly successful with older sitters and those of endeavour and intellect who were so often successfully captured on canvas. His talent at no time deserted him and later portraits such as *John, 2nd Marquis of Bute* (1821) show an equally sure touch. In 1822 he was knighted, having been appointed King's Limner and Painter for Scotland. Possibly as a result of having lived and painted for virtually all his life in Scotland, Raeburn had a purely local reputation

Sir Henry Raeburn *Mrs Elizabeth Stewart Richardson* oil, private collection

for a long period. There can be no doubt, however, of his standing as a world class portraitist. Died Edinburgh.

Raeburn p.t

Raeburn, Lucy (Mrs Alfred Spottiswoode Ritchie) 1869–1952
Born Glasgow, the sister of AGNES RAEBURN, she studied at GSA 1894–5 and edited *The Magazine*, the School's review, becoming closely associated with C.R. MACKINTOSH and his circle. Married in 1898 and moved to Edinburgh.

Ramage, James fl.1825–87
Studied with Lizars, Edinburgh, and became Head of the Artists' Department at the Parkside Works of Thomas Nelson, printers. A fine draughtsman and an early photographic enthusiast, he pioneered photolithography at Nelsons and was responsible for the introduction of chromo-lithography there. Died Edinburgh.

Ramsay, Allan 1713–84
Born Edinburgh, the son of Allan Ramsay the poet. Trained at ACADEMY OF ST. LUKE and then under Hysing in London and at Rome and Naples. Worked in London and Edinburgh, maintaining a studio in both cities. Travelled to Rome where he met ROBERT ADAM. The influence of contemporary French portrait painters like Maurice Quentin de la Tour and Nattier became apparent in his best portraits. After 1750 he seems to develop more interest

Allan Ramsay *Lord John Murray of Banner Cross* oil, 1743
Bourne Fine Art

in the landscape settings of his subjects. After 1760 became court painter to King George III and one of the most accomplished portraitists of his day. The Royal portraits were frequently copied by Ramsay's assistants and a lucrative trade developed, which led to Peter Pindar's observation, 'I've heard that when Ramsay died he left nine rooms well stuff'd with Queens and Kings.' After a third visit to Italy in 1775–7, his career as a painter came to an end when he broke his arm.
The later portraits – *Lady Mary Coke* (1762) and *Queen Charlotte and her children* (c.1763–5) – are reminiscent of Van Dyck. In addition to his portraits in oil, Ramsay produced a large number of drawings. His reputation in his day was international and he was admired by Canova and Goethe, amongst others. Died Dover.

Ramsay, Allan fl.1884–1920
Pertheshire based landscape painter in oil. Also painted some portraits.

Ramsay, David 1869–?
Born Ayr, he studied at GSA and became Art Master at Greenock Academy. Painted landscapes in watercolour.

.DR.

Ramsay, David Prophet. 1888–1944
Born Perth and studied at GSA, then in Paris, Italy and Spain on a Haldane Travelling Scholarship (1913). An effective series of oil sketches of Venice were produced at this time. Seriously injured on the Western Front where he produced a series of witty caricatures signed 'Sam Ray'. Lived in Perth from 1920 and exhibited RSA, RA and RGI. Painted portraits, nude figure studies and some landscapes. Died Trochry.

Ranken, William Bruce Ellis 1881–1941
ROI 1910, RI 1915, RP 1916, VPROI 1920
Born Edinburgh, studied at the Slade, lived mostly in England and France. His output of oils and watercolours was large and included portraits, interiors, landscapes and townscapes. At his best, his watercolours are freshly handled and well drawn, such as *View of Hampton Court* (Dundee), but some of his interiors are too large and overworked. His watercolours of gardens in Paris and London can be particularly charming.

Rankin, Alexander Scott 1868–1942
Born Aberfeldy, studied Edinburgh, Joined staff of several magazines including *Today* and *Idler*. Painted landscapes in oil and watercolour in a somewhat 'sweet' but effective style. Also painted animals and genre. Illustrated articles for *Art Journal* including *Aberfeldy and its Neighbourhood* and an article on the Glasgow International Exhibition. Died Pitlochry.

Rankin, Arabella Louise 1871–?
Perthshire oil and watercolour artist who produced a number of coloured woodcuts.

Rattray, Alexander Wellwood 1849–1902
RSW 1885, NEAC 1887, ARSA 1896
Born St. Andrews, educated Glasgow University before turning to art. Painted landscapes in oil and watercolour, almost entirely of Highland and East coast views. Although his watercolour technique is rather heavy, with the paper being well-worked and the colours absorbed into the scrubbed surface, his work can capture the grandeur of the Highlands. Died Glasgow.

Read, Catherine 1723–78
Born in Forfarshire and made her reputation in London as a miniaturist and portrait painter after training in France and Italy. Painted Queen Charlotte with the Prince of Wales (1763), the Gunnings, Lord Cathcart, the Duchess of Hamilton and the Countess of Coventry. Appears to have been influenced by ALLAN RAMSAY and Reynolds. Her work in pastel attracted acclamation. 'Nothing can be so soft, so delicate, so blooming', noted Fanny Burney and in Italy Cardinal Albani recommended her to Lord Bolingbroke. Went to India in 1770 and died at sea off Madras.

Redfearn, W.D. fl. 1860s–70s
Glasgow painter of landscapes and animals, particularly dogs.

Redpath, Anne 1895–1965
ARSA 1947, RSA 1952, RWA 1959, ARA 1960, OBE 1955
Born Galashiels and brought up in Hawick. Studied at ECA under ROBERT BURNS and HENRY LINTOTT. Won a travelling scholarship in 1919 and spent a year in Florence and Siena via Bruges and Paris and then returned to Hawick. In 1920 married the architect JAMES MICHIE. From 1920–1934 they lived in Cap Ferrat where their three sons grew

Anne Redpath *Red Roofs at Calvi* oil ca. 1957, The Portland Gallery

up and Anne painted infrequently. On her return to Hawick in 1934 she started to paint intensively and she remained an extremely hard-working and committed artist until her death thirty years later. Throughout the 1930s and 1940s she painted Border landscapes and studio interiors the latter mainly in oil and showing a debt to Bonnard and Matisse. In 1949 moved to Edinburgh and in 1953 she bought a flat in London Street which became an important meeting place for her artist friends. SIR ROBIN PHILIPSON painted a fascinating record of one of these gatherings (see Philipson entry) which graphically illustrates her central position in artistic life of the day. Her reputation was by now firmly established: she was exhibiting regularly at Aitken Dott in Edinburgh and at Reid and Lefevre in London. In 1952 she became the first woman painter to become a full member of the RSA.
She travelled extensively throughout Europe during the 1950s, painting in Spain, Portugal, Corsica, the South of France, Venice and on Grand Canary. As a result her repertoire of subjects was widened to include hilltop villages and richly ornate altars. These late works are considered amongst her best. Together with GILLIES and MAXWELL, she was a central figure of the Edinburgh School.

Anne Redpath

Reed, William fl. early 19c.
Only one known work by this unrecorded artist: *Leith Races*, a bustling, energetic piece of work in a straightforward descriptive style.

Reeves, Philip b. 1931
ARSA 1971, RSA 1976, RSW 1959, RE 1963 ARCA
Born Cheltenham and studied at Cheltenham School of Art 1947–9 and RCA 1951–4. Appointed to staff of GSA 1954. His landscape work, in a wide variety of media, has become progressively more abstracted but is based upon his experience of the north and north west of Scotland, often seen in angular shape and bulky form. Also an enthusiastic etcher and a founder of the first Printmakers' Workshop in Scotland, in Edinburgh, in 1967.

Regnordson, W. Birch fl. 1880–1900
Painter of the Perthshire Highlands, his watercolours are detailed and accurate without being overworked.

Reiach, Alan b. 1910
RSW 1956
Born London, moved to Edinburgh in 1922 and trained as an architect at ECA. Won two scholarships in 1933 and travelled to Europe, Russia and the United States. Apprenticed in the office of the architect Sir Robert Lorimer, became a career architect but since the early 30s has painted watercolours of architectural subjects and landscapes, as well as drawings. Has exhibited regularly.

Reid, Agnes L. b. 1902
Born Musselburgh, she studied at ECA under DAVID

ALISON, HENRY LINTOTT and D.M. SUTHERLAND. Painter of landscapes, portraits and figure subjects in oil and watercolour.

Reid, Alexander 1747–1823
Painted portraits and miniatures, including a likeness of Robert Burns.

Reid, Archibald David 1844–1908
RSW 1833, ARSA 1892, ROI 1898
Born Aberdeen, the brother of SIR GEORGE REID and SAMUEL REID, studied RSA Schools. Travelled in Europe painting architecture, rivers and pastoral scenes especially in Holland, Northern France, Spain and Venice. Influenced by the Dutch School, his watercolours are well composed and restrained in colour. His figures are often somewhat wooden.

Reid, Flora Macdonald fl.1879–1938
Sister of J.R. REID, studied RSA Schools, and learnt much from her brother. Settled in England, first in Cornwall and later in London. Painted landscapes and market scenes on the continent in oil and watercolour.

Reid, Sir George 1841–1913
ARSA 1870, RSA 1877, PRSA 1891–1902, RSW 1892, HROI 1898, Knighted 1902
Born in Aberdeen he worked as a lithographer before joining the Trustees' Academy in 1862, after Lauder's career as a teacher had ended. In 1866 he was sent by a patron to Holland to study under G.A. Mollinger (1833–67). Reid was impressed by the modern Dutch School which included Bosboom, Roelofs and Weissenbruch, and he became a close friend of Josef Israels, painting his portrait at the Hague. In 1870 Israels visited Reid in Aberdeen. Reid quickly established himself as a portrait painter, and his ability to capture likeness while using a painterly technique ensured a steady flow of commissions. However, rather like John Singer Sargent, he often felt imprisoned by his portraits and turned to landscape as a release. His landscapes, like *Montrose*, were strongly influenced by his Dutch training, using very restrained colours to capture the dull light from an overcast sky

or a winter evening. His snow scenes are particularly effective, and he was also an excellent draughtsman of landscape, using pen-and-ink with monochrome washes. He also painted a number of flower pieces. In 1891 Reid was elected PRSA to succeed SIR WILLIAM FETTES DOUGLAS and despite the official duties, he continued to produce many portraits. As President he took a somewhat reactionary standpoint, disapproving of the innovation of the GLASGOW SCHOOL, but nevertheless under his Presidency several of the Boys including LAVERY, ROCHE, PATERSON, and W.Y. MACGREGOR were elected Associates. He resigned in 1902 to devote himself to portraiture. Died Somerset.

Reid, George Ogilvy 1851–1928
ARSA 1888, RSA 1898
Born Leith, he worked as an engraver before turning to art. He studied at the Trustees Academy, and came to specialize in paintings of social life in the eighteenth century, such as *A Literary Clique*. He also painted scenes from Scottish life in the tradition of FAED and WILKIE, such as *The New Laird*, and scenes from Scottish history life such as *After Killiecrankie*. He was a prolific landscape and seascape painter.

Reid, James B. fl.1850s–60s
Painted genre and animals. Exhibited RSA. His handling was normally vigorous but his colour frequently unadventurous.

Reid, John Robertson 1851–1926
RBA 1880, ROI 1883, RI 1891
Born Edinburgh, he studied at the RSA Schools before moving to Cornwall and later London. He became interested in the Social realist movement, probably influenced by Bastien-Lepage and in 1879 his *Toil and Pleasure* was hung in the Royal Academy and bought by the Chantrey Bequest. In the following year he exhibited *Mary, the Maid of the Inn* at the Academy and it shows his debt to Bastien-Lepage. Reid's neighbour in Hampstead, George Clausen, found Reid's ideas stimulating and his work reflects Reid's influence at this time. Reid's subjects – field workers, humble people – were similar to those of Bastien-Lepage, but his handling of paint was more dynamic reflecting his training at the RSA under CHALMERS and MCTAGGART. He was also a good colourist, and some of his coastal scenes with fishermen and women in the foreground, have rich blues and greens. Reid was also a fine watercolourist in a breezy style, influenced by DAVID COX. Not all Reid's paintings were about hard work and he painted rural people at rest or playing cricket. In the later 1880s Reid's work began to show certain mannerisms – rather coarse handling of paint, a tendency towards forced colours and a repetition of coastal subjects. He was, however, still capable of brilliant work as his later Venetian watercolours show.

Sir George Reid *Montrose* oil, Aberdeen Art Gallery & Museums, Aberdeen City Arts Department

Reid knew the GLASGOW BOYS and probably influenced their early work. He was an important Scottish artist whose work has been neglected. Died London.

J.R.R.

Reid, John T. fl.1860s–80s
Specialised in landscapes and views of Orkney, Shetland and the Western Isles.

Reid, Lizzie fl.1880–1918
The sister of J.R. and FLORA REID, she painted figures.

Reid, Robert Payton 1859–1945
ARSA 1896
Born Edinburgh and studied at the Trustees' Academy and RSA Schools where he received several prizes before travelling to Munich in 1887 to study at the Academy of Fine Arts. Influenced there by Professor Johann Harterick, who painted Dutch subjects, he travelled to Holland in 1889 and painted Dutch landscapes, successfully mastering the soft, grey light in the manner of the Hague School. He travelled on to Venice and the Adriatic in 1890 and come into contact with the work of the Macchiaioli whose style and ideas he now assimilated. There was further study at the Académie Julian in Paris where it is recorded that

Bouguereau bought one of his drawings to hang on the walls of the Academy. Here he came into contact with A E BORTHWICK, who became a firm friend, as did the American artist Richard Levick. After a tour of Italy with Levick, Reid returned to Britain and painted the classical and figure subjects with which he has traditionally been closely identified, for a while in London. He then returned to the family home at North Queensferry to work, was elected an ARSA and was a founder member of the SSA. In the late 1890s he became friendly with ROBERT NOBLE and W M FRAZER and painted a number of oils at EAST LINTON. Married the artist Emily Smith in 1916 and lived in St Ives and near Bognor Regis, returning to Edinburgh in 1933. Apart from painting landscape oils, he also undertook some book illustration.

Reid, Samuel 1854–1919
RSW 1884
Born Aberdeen, younger brother of SIR GEORGE REID, he was a poet and author in addition to being a watercolourist. His watercolours, which depict cathedrals, architecture and landscape, are carefully executed, the medium being treated almost like oil. His works are competent rather than exciting. His collected poems *Pansies and Folly-Bells* were published in 1892.

Reid, Stephen 1873–1948
Born Aberdeen and painted portraits, landscapes and historical subjects. Exhibited RA, RBA and RI.

George Ogilvy Reid *After Killiecrankie* oil, Royal Scottish Academy (Diploma Collection)

J Robertson Reid *The Rookery: Women working in a Field, North Wales* watercolour 1897, Julian Halsby Esq

Reid, William B. fl.1916–38
Edinburgh landscape and figure painter.

Renison, William fl.1893–1938
Born Glasgow. Painter and etcher of architecture and landscape subjects. Exhibited RA, GI and Paris Salon.

Rennie, George Melvin fl.1890s
Painter of landscapes of Argyll, Ayrshire, Arran and the west coast of Scotland. Also painted fishing subjects.

Renton, Joan F (née Biggins) b.1935
RSW
Born Sunderland. Educated at Hawick High School and ECA. Landscapes and coastal scenes in oil and watercolour. Exhibits widely. Works as an art teacher. Lives in Edinburgh.

Ressich, John fl.1920s
Sketched with J.D. FERGUSSON in the Highlands after the 1914–18 war.

Revel, John Daniel 1884–1967
ROI 1923, RP 1924
Born Dundee, he studied at the RCA receiving a diploma for architecture in 1908 and painting in 1911. He was Headmaster of Chelsea Art College 1912–24 and moved to Glasgow where he became Director of the Art School 1925–32. He painted portraits and landscapes.

Revel, Lucy (née McKenzie) 1887–1961
SWA 1922, Lauder Award 1932
Born Elgin, she worked as a flower and portrait painter. She married JOHN D. REVEL, Director of GSA 1925–32. Moved to England in the mid-1930s.

Reville, James b.1904
RSW
Born Sheffield, settled in Dundee. Watercolour and oil painter of flowers and still-life.

Reynolds, Margaret K. fl.1920–50
ASWA 1940
Lecturer at GSA 1929, she won the Lauder Award in 1948.·

Reynolds, Warwick 1880–1926
RSW 1924
Born Islington, the son of a graphic artist, he studied at the Grosvenor Studio, St John's Wood Art School and the Académie Julian, Paris in 1908. He drew the animals in the Regents Park Zoo while in London; later settled in Glasgow where he exhibited at the RSW and Glasgow Institute. Painted strongly composed pictures of animals in which his illustrator's background is visible. Died Glasgow aged 46.

Rhind, Alexander fl.1930s
Lived in Dunfermline and painted Scottish landscape.

Robert Payton Reid *The Cathedral Dordrecht, Holland* oil ca. 1889, private collection

Rhind, Sir Thomas Duncan 1871–1927
Edinburgh architect, he also produced etchings of architectural subjects.

Richardson, Alexander fl.1840s–50s
Edinburgh landscape painter. Exhibited RSA.

Richardson, Andrew fl.1840s–50s
Prolific Edinburgh watercolour painter of landscape, birds and rural scenes.

Richardson, Frances 1892–?
Born Edinburgh, she had no formal art training. Painted oils of France, Spain and Scotland and was involved in the NEW SCOTTISH GROUP in Glasgow in the early 1940s.

Richardson, Joseph Kent 1877–1972
RSW 1917
Art dealer, connoisseur, collector, sportsman and watercolourist. A fine pencil draughtsman much in the style of D.Y. CAMERON, his watercolours of rural scenes and landscapes are relaxed and colourful.

Richmond, Andrew fl.1860s–1900
Glasgow painter of landscapes and seascapes.

Riddell, James 1857–1928
RSW 1905, ARSA 1919
Born Glasgow, studied GSA, and Head of the Art Department, Heriot Watt College, Edinburgh. Painter of landscapes and interiors with figures in oil and watercolour. Worked in Belgium, Holland, Canada and Scotland. His watercolours were often large, using rubbed paper to achieve a broad, somewhat indecisive style. His seascapes and coastal scenes are probably his most effective works. Died Balerno.

Ritchie, Alexander A. fl.1830–45
Topographical, historical and genre painter in oil and watercolour who lived and worked in Edinburgh.

David Roberts *El Deir, Petra, Jordan* lithograph, private collection

Ritchie, Alexander Hay 1822–95
Born Glasgow and trained under WILLIAM ALLAN. Painter of portraits, genre and historical subjects. Emigrated to New York in 1841, where he died.

Ritchie, Charles E. fl.1890s–1918
Lived in Stonehaven and also worked in London. Painted portraits, figures and landscapes.

Ritchie, David n.d.
Nineteenth-century topographical artist, probably from Edinburgh.

Ritchie, John fl.1855–75
Lived in Edinburgh and painted rural genre, humorous scenes and sea views.

Roberts, David 1796–1864
HRSA 1829, ARA 1838, RA 1841

Born Stockbridge, Edinburgh, the son of a shoemaker, he was apprenticed to Gavin Beugo the housepainter. In 1818 he was appointed scenepainter in the Theatre Royal, Glasgow where he saw the work of ALEXANDER NASMYTH. In 1820 he moved to the Theatre Royal in Edinburgh where he met Clarkson Stanfield who was working at the Pantheon Theatre and who became a life-long friend. Stanfield encouraged Roberts to turn to easel painting and in 1822 he exhibited three oils at the Edinburgh Institution. King George IV made his state visit to Edinburgh in the same year, and Roberts' stage scenery was prominently displayed.

Later in 1822 Roberts moved to London with his wife and daughter and was soon successfully designing for Drury Lane and Covent Garden, as well as creating popular dioramas. He also began painting canvases seriously and in 1830 he abandoned the theatre to work exclusively as an artist. Roberts' experience in the theatre influenced his work: he was able to grasp complex perspective and create architectural space effectively.

In 1824 Roberts made his first trip abroad, visiting Dieppe and Rouen with JOHN WILSON, while in 1829 he was in Paris with ALEXANDER FRASER. He

Eleanor Moore Robertson *The Opium Smokers* watercolour ca.1936, private collection

was close to many Scottish artists in London, and WILKIE's visit to Spain in 1828 was the inspiration for his own trip in 1832–3. Roberts sketched in the open around Cordoba and Granada and crossed over to Tangiers to draw Arabs and their costumes for the first time. He failed to meet J.F. Lewis in Spain, but on his return to London his lithographs based on his Spanish drawings, *Roberts' Picturesque Sketches in Spain*, were in competition with Lewis' *Sketches and Drawings of the Alhambra*. In August 1838 Roberts set out for the Middle East, travelling in style with servants in attendance via Egypt, Jerusalem, Baalbeck to Syria, returning to London in June 1839. His oils and watercolours were published as lithographs, *Views in the Holy Land, Syria, Idumea, Arabia, Egypt and Nubia*, between 1842 and 1849. His position as the leading painter of foreign views was firmly established and the market for his prints was strong.

During the 1840s he worked in France, Belgium and Holland and in 1851 he worked in Venice where he met Ruskin who disliked his Venetian work. A mutual antipathy was established and Roberts was reputed to have countered Ruskin's criticism with 'Who are ye to attack me? Ye are just a damned scribbling snob! Ye tried to paint yerself and ye couldna!' Ruskin and several subsequent critics attacked Roberts' work for its lack of chiaroscuro, atmospheric effect and its lack of passion. Roberts' oils and watercolours are unemotional and cool, and appear today surprisingly modern. His work has remained popular since his death, and has never suffered the neglect of many mid-Victorian landscape painters.

Roberts, John fl.1882–1930
Exhibited RSA, GI, RSW. Was a tutor at the CRAIGMILL SCHOOL

Robertson, Alexander 1772–1841
The brother of ARCHIBALD and ANDREW ROBERTSON, he followed Archibald to America in 1792 and painted portraits in watercolour. Died New York.

Robertson, Alexander 1807–1886
Teacher of drawing in Glasgow, painted good views of the city in pencil and watercolour.

Robertson, Andrew 1777–1845
Born Aberdeen, studied under ALEXANDER NASMYTH in Edinburgh, and received advice from RAEBURN. Painted miniature portraits in watercolour on ivory in North east Scotland before moving to London in 1801, where he painted portraits of the Royal Family. He used watercolour in a meticulous but delicate manner. Died London.

Robertson, Archibald c.1765–1835
Elder brother of ANDREW ROBERTSON, born in Aberdeen, he moved to America in 1791 to establish a drawing school. Painted miniatures in watercolour.

Robertson, Archibald 1745–1813
First cousin of ROBERT ADAM, he was a professional soldier who rose to become Lieutenant-General

in the Royal Engineers. Served in America and his *Diaries and Sketches in America 1762–1780* were published in 1930. While involved in the War of Independence, he found time to paint landscapes in watercolour in monochrome with firm drawing and good composition. Much of his work is now in New York, but there are examples in Edinburgh (NGS) and the National Gallery of Wales.

Robertson, A. D. 1807–86
Glasgow painter noted as a teacher of watercolour. His most successful pupil was probably JAMES PATERSON.

Robertson, Charles Kay fl.1880–1931
Edinburgh painter of portraits, landscapes (usually with figures), head studies, figures and flowers, he moved to London after 1900.

Robertson, Eleanor Moore 1885–1955
Born Northern Ireland, studied GSA. Married DR ROBERT CECIL ROBERTSON in 1922 and on his appointment in Public Health with the Shanghai Municipal Council, moved to China in 1925. Painted the people and towns of the Yangtze Delta, some of which were exhibited by Ian McNicol in Kilmarnock in 1934. Evacuated from Shanghai

Eric Robertson *Le Ronde Eternel* oil 1920, EFT Group plc

191

during the Sino-Japanese War in 1937, she returned to Scotland but painted little. Her daughter, Ailsa Tanner, comments that her watercolours 'offer a lively and valuable record of life in the China of fifty years ago seen from a foreigner's eyes, a China that has changed in so many ways since'.

Robertson, Eric Harald Macbeth 1887–1941
Born Dumfries, he studied architecture before turning to art. Trained at ECA, meeting STURROCK and SUTHERLAND. He was described as 'one of the most brilliant art students of his period' at the College. He greatly admired the work of Burne-Jones and Rossetti, and JOHN DUNCAN, some eleven years his senior, whose studio became a meeting point for younger artists. Through Duncan he met CECILE WALTON, the daughter of E.A. WALTON, and much against her parents' wishes they married in 1914. Robertson was a highly talented, but eccentric character whose behaviour was often outrageous. He gained a degree of notoriety with his drawings and paintings of nudes. One critic wrote: 'Half Edinburgh goes to Shandwick Place secretly desiring to be righteously shocked and the other half goes feeling deliciously uncertain it may be disappointed by not finding anything sufficiently shocking.' But Robertson was capable of painting a wide range of subjects including landscapes and portraits; and his range of techniques was equally wide including oil, watercolour, chalk, pastel and pencil.
In 1913 the first EDINBURGH GROUP exhibition took place, followed by a second in 1914. Robertson was one of the leading attractions of the exhibition, but the Group's development was interrupted by the war. Robertson served in France with the Friends' Ambulance Unit, and after the Armistice he helped reform the Edinburgh Group, taking part in the 1919 exhibition with his wife. The marriage was in trouble and in 1923 they separated. The parting proved disastrous for Robertson: his Edinburgh friends ostracized him and he moved to Liverpool where he remarried, but he continued to drink heavily, and was forced to turn to commercial art to try to make ends meet. In Liverpool, he painted decorative panels for the pub *The Grapes* which are still intact.
Robertson's earlier work is Symbolist in spirit and influenced by Burne-Jones, although the imagery and style is updated, as in *The Two Companions*. After the war, he became influenced by the Vorticists and art deco design as can be seen in *Dance Rhythm* (1921) and *Le Rond Eternel* (1920) which incorporates the Dean Village, Edinburgh, the dancer Lucy Smith and Cecile Walton (centre). His work varies in quality but he remains one of the most fascinating figures in early 20th century Scottish art. Died Cheshire.

Robertson, Mrs Henrietta Jane c.1850–1935
Born Glasgow, she studied at GSA c.1880 and was a founder member of the Glasgow Society of Lady Artists. She exhibited regularly at the RSA and Glasgow Institute, marrying in 1871 and living in Glasgow.

Robertson, James D. fl.1880–1900
Landscape painter who produced competent, highly coloured watercolours which he signed with a monogram.

Robertson, James Downie b.1931
RSW 1962, ARSA 1974, RSA 1989
Born in Cowdenbeath, Fife, and studied GSA. Joined staff of GSA 1959 as part-time lecturer. Full-time lecturer in drawing and painting from 1967. Has exhibited widely in the UK and abroad with work in many public collections. Lives in Glasgow.

Robertson, John Ewart 1820–1879
Painter of portraits and genre, he worked in Kelso and Liverpool.

Robertson, Kay fl.1890s
Worked in the Edinburgh area painting portraits. Moved to London c.1895. Married Jane Kay Robertson, a miniaturist, in 1897.

Robertson, McCulloch flc.1900–1920
Landscape watercolourist, probably from Perthshire.

Robertson, Robert Cowan 1863–1910
Born in Glasgow and lived in Edinburgh, he painted seascapes, coastal scenes and landscapes in oil. Died London.

Robertson, Dr R. Cecil fl.1920s–40s
Husband of ELEANOR MOORE ROBERTSON After marriage in 1922 they moved to Shanghai where he worked in Public Health (1925–37). He was also a painter of landscapes and exhibited at the RSA and Glasgow Institute (1932–40).

Robertson, Robert Currie fl.1920–50
Lived in Kilmarnock and Glasgow. Painter and etcher of landscapes and architectural subjects.

Robertson, Struan fl.1903–18
Lived in Glasgow and painted coastal and fishing scenes on the Clyde in oil and watercolour, but best known for pastels.

Robertson, T. d.1866
Painter of genre and figures. Member of the West of Scotland Academy.

Robertson, Thomas fl.1850s–60s
Lived in Glasgow and painted horses.

Robertson, Thomas S. 1850–1923
Glasgow portrait painter, he studied in Paris under Constant.

Robertson, Tom 1850–1947
RBA 1896, ROI 1912 (Hon. Retired 1937)
Born Glasgow, he studied at GSA and in Paris. Painted landscapes, seascapes and coastal scenes often in oil with rich impasto. Interested in atmospheric effects, such as harbours in moonlight, or the effects of strong sunlight and its shadows. He worked extensively on the Continent, including France and Venice, and in North Africa. His oils were influenced by his Paris training, and he also

painted watercolours. He lived in London after c.1899 later moving to Eastbourne.

Robson, William 1868–1952
Born Edinburgh, youngest son of the Earl of Sinclair. Trained at ECA and in Paris at Julian's. Settled in Capri in 1888 and came into contact with an international group of painters, including

Fabbi, Castalanetta, James Charles and Harold Speed. Also lived and painted in Venice and Florence and married an Italian girl. His oils of this period demonstrate the influence of the Macchiaioli. Returned to Edinburgh 1900 and exhibited regularly, becoming President of the SSA. Moved to Kirkcudbright in 1904 where he came to know HORNEL and the other artists working

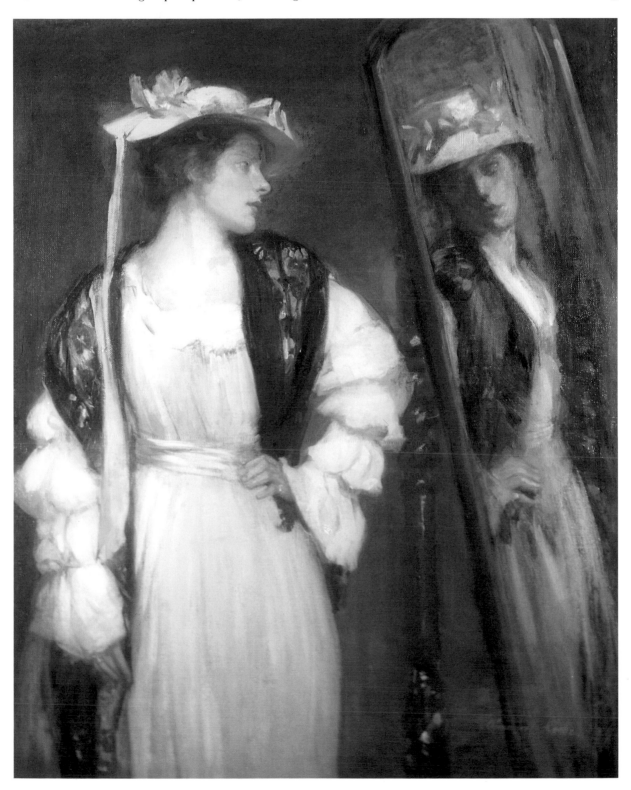

Alexander Roche *The Looking Glass* oil, Whitford and Hughes, London

193

in the area and the style of painting developed in Italy was superseded by a more distinctly Scottish one. His later work is mainly in pastel.

Roche, Alexander Ignatius 1861–1921
ARSA 1893, NEAC 1891, RP 1898, RSA 1900
Born Glasgow, he attended some classes at GSA while working in an architect's office. His real art training came in Paris where he studied under Boulanger, Gerome and Lefebvre. While in Paris he met several other Scottish students including KENNEDY, LAVERY and DOW and together with Lavery they painted at Grez-Sur-Loing. In 1885 Roche returned to Glasgow where he painted a number of rather romantic pictures of girls in gardens, interiors or in landscape such as *The Shepherdess* (RA 1887). He moved to a cottage on the banks of the Luggie in Dumbartonshire and there some of his best landscapes were painted. His most striking work of this period is *Good King Wenceslas* where decorative and naturalistic elements were successfully combined.

He also painted a number of idylls with young girls set in summer landscapes. This direction was reinforced by two trips to Italy in the early 1890s when he painted peasants in the Sabine Hills, but in 1896 Roche moved to Edinburgh and began to paint portraits and figure studies. He was particularly good at portraits of women, and his more informal, uncommissioned examples were best. His sense of colour and confident but always elegant brushwork were well suited to portraiture and in later years this became his main output, visiting the United States to fulfil commissions. He also found time to paint some seascapes and coastal scenes. Roche was considered a member of the GLASGOW SCHOOL, but after the 1880s he was on the fringes of the movement.

Alexander Roche

Röhl, Frieda (Mrs James Pittendrigh Macgillivray) b.ca.1845
Founder member and first Treasurer of the Glasgow Society of Lady Artists, she married the sculptor PITTENDRIGH MACGILLIVRAY in 1886, moving to Edinburgh in 1894. Exhibited at the RSA and Glasgow Institute in the 1880s.

Rollo, J.B. fl.1840s–50s
Painted landscapes and views of Edinburgh. Exhibited RSA.

Ronald, Alan Ian 1900–67
RSW 1935
Studied ECA. Painted on the east coast, and in England and Germany. An official war artist in the Second War. He often painted harbours and quayside views in a powerful and effective style. Died Dunfermline.

Rose, Robert Traill 1863–1942
Born Newcastle, he studied at ECA. He produced illustrations of biblical subjects including the *Book of Job* and *Old Testament Stories* and other books including *Omar Khayyam* and *Children's Dante*. He also produced some exquisite Symbolist watercolours such as *The White Peace* and *The Garden of Memory*. He lived in Edinburgh, later moving to Tweedsmuir, Peeblesshire.

Ross, Alice E. fl.1886–1937
Portrait painter and figure painter in watercolour, she exhibited at the RSA, RSW and Glasgow Institute.

Ross, Christina Paterson 1843–1906
RSW 1880
Daughter of R.T. ROSS and sister of JOSEPH ROSS, she painted figures in interiors, fishing scenes, landscapes and romantic compositions. Her colours are restrained but she used a 'wet' technique, often on quite a large scale.

Ross, Eleanor Madge fl.1880–1925
Society portrait painter working in Scotland. Exhibited London and RSA.

Ross, Jessie S. fl.1860s–96
Painter of flowers.

Ross, Joseph Thorburn 1858–1903
ARSA 1896
Born Berwick-on-Tweed, the son of R.T. ROSS, he worked in business before turning to art. He acquired his father's broad skill as a watercolourist and painted coastal scenes and seascapes, often with figures or birds in the foreground. His watercolours have a spontaneity which was often lost in his larger oils, in particular his large figure subjects. His work was inconsistent in quality, but at its best when most directly expressed.

Ross, Robert Henry Alison fl.1898–1940
Edinburgh painter of landscapes and village scenes.

Ross, Robert Thorburn 1816–1876
ARSA 1852, RSA 1869
Genre painter in the style of NICOL and FAED, he studied under GEORGE SIMSON and SIR WILLIAM ALLAN. His oils were described by Caw as 'merely trivial and commonplace' and certainly do not stand comparison with the Faeds, but his watercolours are fresh and lively, often depicting landscape and landscape details. He also painted portraits. Both his son JOSEPH THORBURN and daughter CHRISTINA were painters.

Ross, Tom 1876–1961
Dundee artist known for his lithographs of Dundee town views. He also worked in oil and watercolour, the latter having strong colours and a 'wet' technique. Following a street accident as a young man he was obliged, for the rest of his life, to paint with his toes, which he achieved with outstanding success.

Ross, William fl.1753

Nothing is known of this artist. One portrait extant, signed and dated 1753, of a member of the Rose family of Kilravock, by Nairn.

Rough, James Johnston fl.1920s–70s

Edinburgh based seascape and landscape painter. Exhibited SSA and RSA. Worked mostly in watercolour, experimenting with sky effects, and also painted architectural subjects.

Rough, William Ednie 1892–1935

Born Kirkcaldy and trained at ECA. Taught art at George Heriot's, Dumfries Academy and Daniel Stewart's. Painted landscapes and exhibited SSA. 'His pictures of lochs and mountains, as well as his Breton street scenes, were proof of his fine draughtsmanship and sense of colour,' an obituary noted.

Rowan, William G. fl.1891–1903

Glasgow architect who painted architectural interiors and exteriors, often of churches and cathedrals, in oil.

Rowat, James n.d.

The brother of Jessie Rowat (MRS FRANCIS NEWBERY), he painted landscapes, interiors and flowers in oil and watercolour.

The Royal Scottish Academy

The Scottish Academy was established May 27 1826. Twelve years later it received the Charter which entitled it to the use of the prefix 'Royal'. The objects of the Academy were:

1 To have an Annual Exhibition open to all artists of merit.
2 As funds increase, to open an Academy where the Fine Arts may be regularly cultivated and students instructed free of expense
3 To open a Library devoted to the Fine Arts.
4 As all artists are not equally successful and as some acquire neither fame nor fortune but, after many years of painful study, at a time of life when it is too late to think of other pursuits, find themselves destitute, to provide charitable funds.
5 And lastly, to add grace to this Society, admit Honorary Members eminent by their talents and attainments.

The standard work on the history of the RSA is *The Royal Scottish Academy of Painting, Sculpture and Architecture 1826–1976* by Esme Gordon (Charles Skilton Ltd., Edinburgh, 1976).

The Royal Scottish Society of Painters in Watercolours (RSW)

In 1878 The Scottish Society of Painters in Watercolours was established in Edinburgh. FRANCIS POWELL was elected the first President with SAM BOUGH as Vice-President and CHARLES BLATHERWICK was Treasurer. In addition there were two Auditors, JOHN SMART and A.K. BROWN, and a Council of five members – JOHN AIKMAN, W.E. LOCKHART, WILLIAM MCTAGGART, J.G. WHYTE and DAVID MURRAY. There were 33 full members in all

and 10 associates, but it was soon decided to abolish the rank of Associate. The Society was granted a Royal Charter in 1888 and Francis Powell was knighted in 1893. It was hoped that subsequent Presidents would be knighted, but despite a discreet request to Buckingham Palace, this did not materialize. Subsequent Presidents were:

E.A. WALTON 1914–1922
JAMES PATERSON 1922–1932
A.E. BORTHWICK 1932–1951
STANLEY CURSITER 1951–1952
JOHN GRAY 1952–1957
ADAM BRUCE THOMSON 1957–1963
SIR WILLIAM GILLIES 1963–1969
JOHN MILLER 1969–1974
WILLIAM BAILLIE 1974–88
IAN MACKENZIE SMITH 1988 onwards

The Society elected some Honorary Members including D.Y. CAMERON (1934), JAMES GUTHRIE (1890) and GEORGE REID (1892) and a number of English artists were elected including George Graham (1927) and Frederic Whiting (1921).

Royds, Mabel (Mrs E.S. Lumsden) 1874-1941

Born Bedfordshire, she studied at the Slade under Henry Tonks and in Paris where she worked with Sickert. After several years in Canada, she moved to Edinburgh, joining the staff of ECA in 1911. Here her colleagues included PEPLOE and FERGUSSON, and in 1913 she married E.S. LUMSDEN the etcher and painter.

During their honeymoon they visited Italy and India, where they returned in 1914, going on a trek through the Himalayas in 1916. India provided a source of inspiration for both their work, after their return to Edinburgh in 1917. Mabel Royds is particularly noted for her colour woodcuts, although she also worked in oil and watercolour and painted the ceiling of the Episcopal Church in Hamilton, Lanarkshire. Her work, after 1918, became increasingly decorative and graphic in style. She also worked on book illustrations and her pictures of children, cats and other animals took on a distinctive illustrative character. Royds used her own highly individual style of woodcut printing, applying the colour with a brush so that each print has its personal variations. While she did not produce limited editions as such, making individual prints on demand, the prints were only ever produced by her own hand. The woodblock was often preceded by collage plans, several of which survive.

Runciman, Alexander 1736-85

Born Edinburgh and apprenticed to the NORIES where he was trained in house painting and decoration, including landscape panels. Left for Italy in 1767 under the patronage of Sir James Clerk upon the understanding that, together with his brother JOHN, they would together decorate Penicuik House upon their return. In Rome he immersed himself in neo-classicism and Italian art of the 16th and 17th century. He was influenced by Henry Fuseli whom he admired and who became a firm friend.

195

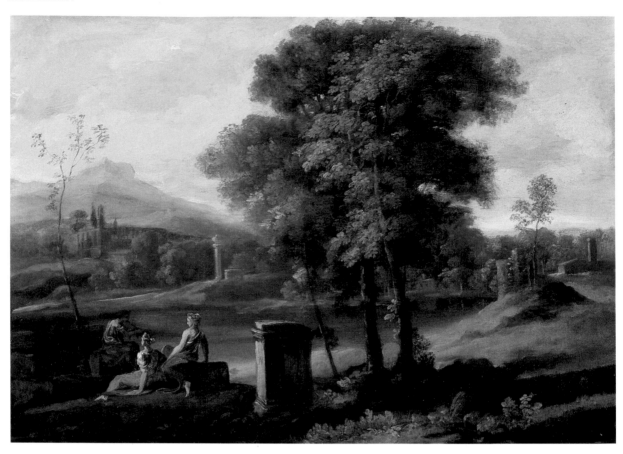

Alexander Runciman *Classical Landscape with Figures* oil ca. 1770, Stephen Somerville Ltd

The years in Italy confirmed his commitment as a history-painter first and foremost (although a small number of oil portraits and watercolour genre sketches are extant).

The painting at Penicuik House (1772) was, alas, destroyed by fire in 1899. This work represented a significant landmark in Scottish painting – the bridge between the mural and sophisticated classically-based landscape painting. This work was followed by murals at the Church of St. Patrick in the Cowgate, Edinburgh (1774).

He also started to paint easel oils around this time, the best of which exhibit a vigorous palette of remarkably fresh colours. Comparatively rare, these oils, typically of Italian scenes in a classical context, were eagerly collected. His history-paintings found a less ready market due to the fashions of the time.

Appointed Master of the Trustees' Academy in 1771, he was a colourful and rumbustious character known in one of his clubs as 'Sir Brimstone.' His work and his energetic social life undermined his health and he died suddenly in an Edinburgh street aged only 49.

Runciman, John 1744–1768
Brother of ALEXANDER RUNCIMAN whom he followed to Italy. Died in Naples aged 24 as a result of either depression or tuberculosis. Very few drawings by him survive, however *Bothwell*

Castle (NGS) shows considerable promise. There are also a number of small oils which evidence great talent in their handling of Old and New Testament themes. He was influenced by German art of the Renaissance, particularly Dürer, Rubens and Holbein.

Russell, Kathleen Barbara b.1940
Born Edinburgh and studied at ECA under GILLIES and PHILIPSON. Moved to London but painted landscapes and seascapes of Scotland.

Rutherford, Archibald 1743–79
Born Jedburgh and worked as a drawing master in Perth. Drawings in the collection of the NGS.

Rutherford, Maggie fl.1900–1914
Glasgow watercolour artist who painted landscapes and flowers.

Rutherford, Mrs Joyce Watson fl.1920–1940
Née Watson, landscape painter in watercolour.

Rutherford, Miss Mary W. fl.1895–1920
Lived in Edinburgh and painted heads and portrait studies. Exhibited SSA.

Ruthven, Lady Mary 1789–1885
Talented amateur watercolourist, married James, Lord Ruthven in 1813. Her watercolours of Greek temples, vases and sculpture are detailed and highly finished.

S

St. Andrews School
The so-called St. Andrews School was a group of artists in the 1940s who revived interest in wood engraving. The leading members were ALISON and WINIFRED MACKENZIE, ANNABEL KIDSTON and JOSEF SEKALSKI.

Salmon, Helen Russell (Mrs Tom Hunt) 1855–1891
Born Glasgow, the daughter of the architect James Salmon, she attended GSA and in 1887 married the artist TOM HUNT. She painted flowers and figures.

Salmon, James Marchbank b.1916
Born Edinburgh and studied at ECA and in Berlin. Principal of Lincoln School of Art 1947–60 and Croydon School of Art 1960–72. Moved to Canada to become Head of the Art College in Calgary. Worked in oil, watercolour and as a lithographer.

Salomon, Robert ca.1775–1840
Marine painter who executed many paintings on the Firth of Clyde in the 1820s. Left for Boston, USA, in 1828 and changed his name to Salmon.

Sandeman, Margot b.1922
Born Glasgow and studied at GSA 1939–43. Won the Guthrie Award 1957 and Anne Redpath Award 1965. Exhibited from 1960 and work in public collections.

Sandeman, Archibald fl.1930s–40s
Lived in Bearsden and painted Scottish landscape, particularly of Arran, in watercolour.

Sanders, George 1774–1846
Born in Fife and trained in Edinburgh alongside WILLIAM ALLAN as a coachpainter. Painted miniatures, marine subjects and landscapes. Went to London in 1805 and concentrated on miniatures. After 1811 devoted himself to painting in oil. Painted watercolours after Dutch and Flemish painters – including Rembrandt – in the collection of the NGS.

Sanders, Gertrude E. fl.1881–1922
Lived in Edinburgh and painted portraits, often in pastel.

Sanderson, Robert fl.1860–1905
Lived in Edinburgh. Oil and watercolour painter of landscape, coastal and fishing scenes.

Sassoon, David 1888–1978
Born Walton on Thames, moved to Kirkcudbright in the early 1920s where he painted landscapes of south west Scotland.

Schetky, John Alexander 1785–1824
Born Edinburgh, the son of a German musician who played the cello in the Edinburgh Musical Society, he joined the army as a surgeon and painted whenever possible, occasionally collaborating with his brother on naval pictures. Died on service on the west coast of Africa, having painted and exhibited a number of landscapes and marine watercolours.

Schetky, John Christian 1778–1874
Born Edinburgh, elder brother of J.A. SCHETKY, studied with ALEXANDER NASMYTH and helped his mother run drawing classes for young ladies in Edinburgh, continuing the classes after his mother's death in 1795. Visited Paris and Rome in 1801, and moved from Edinburgh in 1808 on his appointment as Drawing Master at the Royal Military College, Sandhurst. 1811–1836 Drawing Master at the Royal Naval College, Portsmouth. Largely an oil painter of marine views, but he also executed some watercolours. 1844 Master Painter in Ordinary to Queen Victoria.

Schotz, Benno 1891–1984
RSA 1937
Born in Estonia and left for Glasgow in 1913 where he studied engineering at Glasgow Royal Technical College. Studied sculpture at GSA and held his first one man show at Reid & Lefevre in Glasgow, 1926. Became recognised as the leading portrait sculptor in Scotland, although he also executed figure studies in other media. 'I considered drawing very important – it almost became a passion – first, to conquer its resistance, then as an instantaneous medium of expressing moods and ideas for sculptures' (Benno Schotz: *Bronze in my Blood*, Gordon Wright 1981)

The Scottish National Portrait Gallery
The SNPG first opened in a temporary, single storey building next to its present site in Queen Street in 1885. On July 15 1889 the building designed by Sir Robert Roward Anderson was opened. Its construction was made possible by the generosity of John Ritchie Findlay of the Scotsman, who provided £20,000 towards the cost of the vast Gothic 'palace' redolent of an Italian palazzo.
In 1897 WILLIAM HOLE was commissioned to execute mural decorations in the main entrance

hall and well of the building. There was a processional frieze – a sort of SNPG in miniature featuring eminent Scots down the centuries – together with eight large historical panels. The murals were not completed until 1901 and, in the view of Caw, the Keeper of the Portrait Gallery, 'the effect was of a happy compromise between the rival claims of decoration and representation.'

Scott, Charles Hepburn fl.1902–24
Painter of landscapes often with figures. Worked in a confident and stylish manner.

Scott, David 1806–1849
RSA 1830
The younger brother of WILLIAM BELL SCOTT, David died young before receiving the recognition he deserved. The son of the Edinburgh engraver, Robert Scott (1777–1841) he attended classes at the Trustees' Academy. In 1828 he painted his first important canvas with a prophetic title *The Hopes of Early Genius dispelled by Death*. As a result of his unusual and brooding historical canvases he was elected RSA in 1830.

In 1831 he published *The Monograms of Man*, a series of engravings that trace the life of man in a pessimistic and symbolic way. The influence of Flaxman, Blake and Michelangelo is evident. Scott was interested in the poetry of Coleridge and offered to illustrate the *Ancient Mariner*. These illustrations which were published in 1837 show that Scott was in sympathy with and understood Coleridge's poetry.

In 1832 Scott visited Italy, spending 15 months in Rome; he returned to Edinburgh in 1834 to work in a large studio he built in Easter Dalry. His work was not easily saleable and he withdrew to turn his thoughts inwards. His home life had been gloomy and this coupled with poor health and an unrequited love increased his sense of isolation and depression. Nevertheless, he produced some Romantic images over the following 15 years. He was an inspired colourist, with a flair for vigorous draughtsmanship and a love of rich chiaroscuro. These qualities, combined with a brilliant imagination, produced many memorable works. His subjects ranged over a wide area including Blake, Greek literature and history, biblical subjects and more recent history.

He was interested in the brutal realities of war such as *Russians burying their Dead* (1832) and *Napoleon assailed by the Ghost of his victims in Hades*, in which he makes no attempt to glorify war. He could work in a vast scale, his largest canvas being *The Discoverer of the Passage to India passing the Cape of Good Hope*, which is 18 ft long. This huge canvas was bought by public subscription for Trinity House, Leith, the first painting in Scotland to be so bought.

In addition to his classical and biblical themes he also painted a number of Scottish historical subjects with an interest in Ossian and William Wallace. Probably his most successful historical canvas is *The Traitor's Gate* (1842) in which Thomas, Duke of Gloucester is taken to certain death. Scott creates a brooding atmosphere of evil and apprehension. Scott was interested in the supernatural, mysticism and even mesmerism. He delved into many areas of the imagination and was interested in alchemy as well as astronomy. But despite these wide intellectual interests, his painting never suffers from too literary an approach as does that of SIR NOEL PATON. His public failed to understand the range and scope of his art, and he died, largely ignored, aged 43.

Scott, James fl.1820s
Born Jedburgh and worked in Edinburgh. Portrait painter.

Scott, John Douglas fl.1870–1885
Edinburgh painter of Scottish landscape.

Scott, John Russell fl.1830s–70s
Painted landscapes in Scotland and Ireland; also views of Edinburgh.

Scott, Sylvester fl.1850s
Recorded working as a portrait painter.

Scott, Tom 1854–1927
RSW 1885, ARSA 1888, RSA 1902
Born Selkirk, the son of a tailor, he began painting watercolours as a child and throughout his life he worked almost entirely in watercolour. Entered the RSA Schools in 1877, but was already a proficient watercolourist with a distinctive style. SAM BOUGH was an important influence on his work, as were Cox, Müller, Constable and Fred Walker. Scott was interested in archaeology and made a collection of knives, axes and arrow-heads from Scotland: he also took an interest in the classical past, making studies in Rome and Italy. He was, in addition,

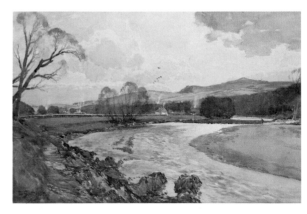

Tom Scott *The Tweed at Philipshaugh* watercolour, private collection

an expert on the history and literature of the Borders.

It was in the Scottish Borders that Scott found his main inspiration, painting the rolling landscape with great depth of colour and a feeling for the changing seasons. He also worked in other areas of Scotland, including Caithness and the Shetlands, and abroad in Italy, North Africa and Holland, but his most memorable watercolours are of the Borders.

Tom Scott

Scott, Walter fl.1899–1938
Edinburgh landscape painter in watercolour and etcher.

W. Scott

Scott, William Bell 1811–1890
HRSA 1887
Born Edinburgh, the brother of DAVID SCOTT, he was trained by his father, who was a well-known engraver. His earliest work is a set of etchings of Loch Katrine and the Trossachs, and his first oils date to around 1830. Scott took some part-time classes under WILLIAM ALLAN at the Trustees' Academy, but his artistic education derived from working with his father.

In 1837 Scott left Edinburgh for London where he worked as an engraver and watercolourist. He came to know artists like Richard Dadd, William Frith and Augustus Egg, but he failed to make his mark in London and in 1844 he moved to Newcastle to become Head of Newcastle School of Art. He retained links with London and became friendly with Rossetti and Holman Hunt. He was sympathetic to the Pre-Raphaelite movement although he was not involved with the foundation of the Brotherhood. In 1853 he met Millais and Ruskin but took a dislike to Ruskin's theories of art education.

In 1854 he was invited to decorate Wallington Hall at Morpeth with a series depicting the history of Northumbria. Scott painted in oil on canvas and the series was exhibited in London in 1861 before being installed. He made many drawings and watercolour studies for the series, and on the whole they are more successful than the finished oils.

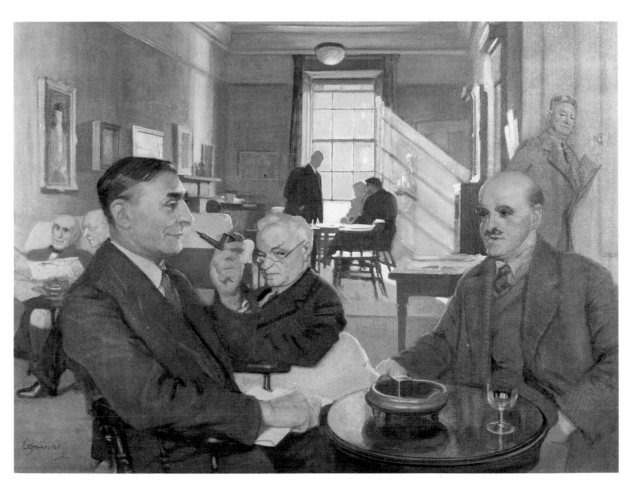

W O Hutchison *At the Scottish Arts Club* oil, The Scottish Arts Club

In 1859 met Alice Boyd of Penkill Castle. Scott's marriage was unsuccessful and he was attracted to Alice Boyd who modelled for *Grace Darling* in the Wallington Hall cycle and for his oil *Una and the Lion*. Boyd invited Scott to paint a cycle at Penkill, and they chose to illustrate a poem by King James I of Scotland *The King's Quair*. Despite Scott's knowledge of wall-painting techniques, this cycle painted in encaustic between 1865 and 1868 has not survived the dampness of the walls. However, preliminary watercolours show that the illustrations were rich in colour and medieval imagery. Scott visited Italy, the Alps and Venice painting watercolours and oils, and he also produced more ambitious Biblical themes in oil and watercolour. He was not, however, a natural draughtsman and his figures can be stiff. Some of his most successful works are the landscapes he painted around Penkill, often at dusk. Scott was known in his time as much for his poetry, art history and art education as for his painting.

The Scottish Arts Club

The Scottish Arts Club was formed at the beginning of 1873 with a distinguished acting committee comprising WILLIAM BRODIE, HUGH CAMERON, JAMES CASSIE, GEORGE PAUL CHALMERS, ROBERT HERDMAN, GEORGE HAY, CLARK STANTON, J. OSWALD STEWART and W.F. VALLANCE.

Thus was established a tradition which has led to most of the leading artists of the day – especially those resident in Edinburgh – taking up membership. The first club rooms were above the premises of fine art dealers Aitken Dott in Castle Street. A complete house at 24 Rutland Square was purchased in 1894 and became a permanent home. At its inception the Club was strictly a painters' club: of 107 members in 1880, all but seven were exhibitors at the RSA. The painting by W.O. HUTCHISON of members at the club in 1945 emphasises the continuing tradition with W.M. FRAZER, A.R. STURROCK and J.G. SPENCE SMITH in evidence.

In the 1990s the net of membership is cast wider but the activities of the painter members of the club still dominate the Rutland Square premises both on and off the walls.

Scougal, David fl.1654–77

Talented portrait painter who emerged in the 1650s. Only one known signed painting, *Lady Jean Campbell* (1654), but many fine portraits were painted by him and can now be satisfactorily attributed on the basis of their style and quality.

Scougal, George fl.from 1715

Following the retirement of his father JOHN SCOUGAL in 1715, George endeavoured to continue his portrait practice. He lacked talent and was not a success.

Scougal, John c.1645–1737

Thought to have been the son or nephew of DAVID SCOUGAL. Married in Aberdeen in 1680. Early portraits of the *4th Earl of Panmure at Glamis* (c.1689) followed by *Sir Francis Grant* and *Lady Grant* (1700). Living in Edinburgh 1690 with a studio and picture gallery. In 1708 painted portraits of King William and Queen Mary for Glasgow Town Council. Retired in 1715.

Seaton, R. n.d.

Early-nineteenth-century Aberdeen artist who painted views in and around Aberdeen in a competent style which owed something to HUGH 'GRECIAN' WILLIAMS. His figures are well drawn. ALEXANDER NASMYTH adapted Seaton's work for his views of Aberdeen.

Sekalski, Joseph 1904–73
ARE 1949, SSA 1950

Born in Poland and studied art at Vilna University. Came to Scotland in 1940 with the Polish Army. Married Roberta Hodges, art mistress at St. Leonard's School, St. Andrews, and lectured in printmaking at Duncan of Jordanstone School of Art. Worked on woodcuts, book illustrations, Christmas cards, bookplates. In 1949 was elected ARE. In addition to prints, he exhibited oil paintings at the RSA.

Sellar, Charles A. 1856–1926
RSW 1893

Perthshire portrait and landscape painter; took a degree in law at Edinburgh University before turning to art. Had a studio in Perth and built up a local reputation painting east coast fishing villages

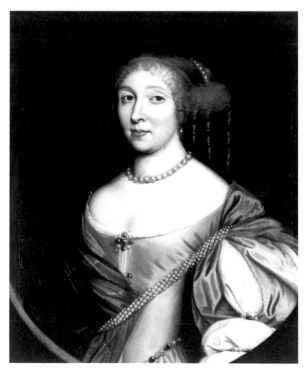

John Scougal *Miss Scott of Harden* oil, private collection

and Perthshire views. His style is rather 'sweet' with good colours and sense of light, although his drawing is imprecise.

Sellars, D. Ramsay 1854–1922
Landscape watercolourist probably from Dundee.

Semple, William fl.1927–38
Glasgow painter of landscapes of Scotland and Spain in watercolour.

Seton, A, of Mounie fl.1820s
Local topographical artist recorded working in Aberdeenshire.

Seton, Isabel Margaret fl.1898–1915
Lived in Edinburgh and painted competent still-life, landscape and copies of historical subjects in watercolour. Exhibited RSA and GI.

Seton, John Thomas c.1735–c.1806
Edinburgh painter of informal portraits and groups in the city 1772–75. In India 1776–85 and returned to Edinburgh 1786 a rich man from his painting.

Seton, Mary E. fl.c.1920–1940
East Lothian landscape watercolourist.

Shanks, Duncan F. b.1937
ARSA 1973, RSW 1987, RSA 1990
Born Airdrie and studied at GSA later becoming a lecturer there. Has exhibited widely including RSA, RGI, in London, Rio de Janeiro and France. Works in many public and private collections.

Shanks, William Somerville 1864–1951
ARSA 1923, RSW 1925, RSA 1934

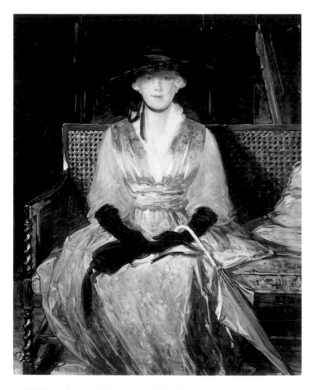

William Somerville Shanks *The Visitor* oil, Royal Scottish Academy (Diploma Collection)

Born Gourock, Renfrewshire, he worked in a curtain manufacturer as a pattern designer, but also attended classes at GSA in the evenings. He turned to art and went to Paris to study under J.P. Laurens and Constant. Later taught painting and drawing at GSA 1910–39. His work is robust, making use of fluent brushwork which was influenced by Manet and the later work of LAVERY. He painted interiors, flowers, still life, figures and portraits, often in oils but he also produced many dashing watercolours in a fluent 'wet' style.

Sharpe, Charles Kirkpatrick 1781–1851
Born Hoddam Castle and studied at Christchurch, Oxford. Amateur artist involved in literature and the theatre, he was a friend of Sir Walter Scott and DAVID SCOTT. He painted drawings in pen and wash, illustrating literary subjects as well as watercolours of theatrical scenes. His caricatures are quite successful being influenced by Rowlandson, but his watercolour portraits are rather weak.

Shearer, James Elliot 1858–1940
Born Stirling, lived Edinburgh. Painted landscapes and, in particular, flowers in watercolour.

Shepherd, Thomas H. fl.1821–35
Born Edinburgh and painted topographical watercolours of the city, often with figures. His drawings were engraved and published under the title *Modern Athens* (1829–30).

Shepherd, Sydney d'Horne b.1909
Born Dundee and studied at GSA 1927–30. Joined staff at GSA and taught painting. Painted portraits and landscapes, as well as working as a lithographer.

Sheriff, John ('Dr Syntax') 1816–1844
ARSA 1839
Edinburgh caricaturist. A large collection of his pen and ink drawings is in Edinburgh City Art Collection. Also painted interiors and historical subjects.

Sherriffs, Robert Stewart 1906–60
Educated Arbroath High School and ECA. Worked for the *Radio Times* from 1927 and also contributed to *Punch* and *The Tatler*. Lived in London and drew many celebrities in stylish pen and ink.

Sheriff, William fl.c.1880–1900
Glasgow painter in oil and watercolour of views in and around the city.

Shield, Jane Hunter fl.1880–1895
RSW 1885 (resigned 1903)
Edinburgh watercolour artist who made a reputation for her flower pieces and studies of birds. Ceased work in 1895.

Shields, D. Gordon 1888–1943
Edinburgh portrait painter.

Shields, Harry Gordon 1859–1935
RBA 1898
Born near Perth, he was Chairman of John Shields and Company, manufacturers of table linen, and

of Shields Motor Company. He painted landscapes and flowers in his spare time.

Shields, Henry fl.1880s–90s
Glasgow landscape and coastal painter.

Shiells, Thornton fl.1898–1938
A close friend of the young RUSSELL FLINT, he encouraged Flint to move to London. Lived in England from 1898, working as an illustrator and watercolourist.

Shiels, William 1785–1857
Painter of domestic genre and animals, he was born in Berwickshire and was a Foundation Member of the Scottish Academy in 1826. Also painted scenes from classical mythology, some portraits, flowers and birds.

Shirreff, Charles ca.1750–ca.1831
Deaf and dumb artist who painted in Edinburgh and, later, London. In Bath, 1794, and visited India 1796–7. Exhibited RA 1770–1831.

Shirreff, William Craig 1786–1805
Born near Haddington and studied at the Trustees' Academy 1802–5. Painted historical and genre scenes.

Shirreffs, John fl.1890–1937
RSW 1895 (written off 1909, although he continued to exhibit into the 1930s)
Aberdeen painter in oil and watercolour, he

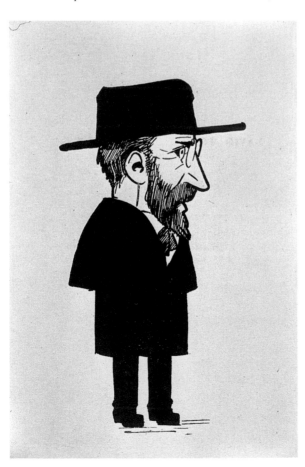

R S Sherriffs *David Foggie RSA* pen & ink, private collection

produced watercolours of interiors of Highland cottages and Highland landscapes with figures. Also painted portraits in oil.

Shillinglaw, T.E. fl.1830s
Artist and drawing master recorded as living in Edinburgh.

Sim, Agnes Mary (Mrs Smythe) 1887–1978
RSW 1927
Montrose watercolour painter of portraits, figures and landscape.

Simpson, Betty 1903–1960
A friend of MARGARET MORRIS and J.D. FERGUSSON, she studied art in relation to dance. She was a founder member of the NEW ART CLUB in Glasgow and later she founded, with ANNE CORNOCK-TAYLOR, the Margaret Morris Movement School.

Simpson, Jackson fl.1930s–40s
Lived in the Aberdeen area where he worked principally as an etcher of coastal, river and fishing subjects.

Simpson, Joseph 1879–1939
RBA 1909
Born Carlisle, he studied at GSA. Worked as a painter, etcher and cartoonist. Book designs for T.N. Foulis, Edinburgh, from 1904. Exhibited in London from 1897, where he had a studio next door to Frank Branywyn, also in Scotland at RSA and RSW.
In 1918 he acted as an official war artist to the RAF in France, and after the war was active as an illustrator of both magazines and books. Also had a studio in Kirkcudbright and came into contact with the COLOURISTS, particularly J.D. FERGUSSON, whose influence is apparent in his later richly coloured work.

Simpson

Simpson, William 'Crimean' 1823–1899
ARI 1874, RI 1879, ROI 1883
Born Glasgow, the son of a marine engineer, he was apprenticed to a firm of lithographers, but when

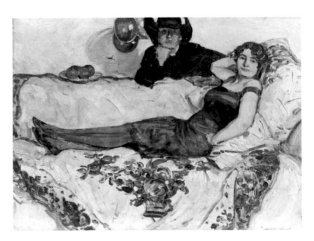

Joseph Simpson *After the Ball* oil, Portland Gallery

he could, he went out sketching into the country-side around Glasgow, often with his friend ROBERT CARRICK. He was one of the first part-time students at Glasgow School of Design when it opened in 1845, but in 1851 he moved to London, where he continued working as a lithographer and where he became a friend of Louis Haghe. In 1854 Simpson was sent by Colnaghi's to cover the Crimean war, thus becoming one of the first war artists. He later published his drawings as 81 lithographs, entitled *The Seat of the War in the East* (1855).

In 1859 he visited India after the Mutiny and remained for three years, covering some 22,500 miles including expeditions into the Himalayas and Kashmir. In 1866 he joined the *Illustrated London News* and travelled extensively, recording important events including the Prince of Wales' Indian Tour 1875–9, the marriage of the future Alexander III to Princess Dagmar in 1866, and his coronation in 1883, the opening of the Suez Canal in 1869 and the Franco-Prussian War with the fall of the Paris Commune in 1871. Caw comments that 'it is the romance of his career, rather than the quality of his art that makes appeal', but Simpson's watercolours are often excellent with firm draughtsmanship and limpid colours. Forced at times to work to a deadline, Simpson inevitably produced some uninspired work, but at his best his work is imaginative, even romantic, reflecting his love of adventure and travel. Later in life he made a series of watercolours entitled *Glasgow in the Forties* based upon earlier sketches depicting the Glasgow of his youth.

Wᵐ Simpson

Simson, David fl.1840s–60s

Born Dundee, brother of WILLIAM and GEORGE SIMSON. Started as a sculptor after moving to Edinburgh. Founded the New Drawing Academy in Edinburgh (1831) with his brother George and took up landscape painting, exhibiting RSA 1850s and '60s.

Simson, George 1791–1862
RSA 1829

Born Dundee, brother of WILLIAM SIMSON. Worked as a printer and turned to art ca.1820. Lived in Edinburgh, painted portraits and exhibited at the RSA and Carlisle Academy. In 1831 he announced the opening of a new drawing academy in Edinburgh, together with his brother, DAVID SIMSON. Died Edinburgh.

Simson, William 1800–47
RSA 1826

Born Dundee, he studied at the Trustees' Academy under ANDREW WILSON. His early work comprised seascapes and landscapes, and in 1827 he visited Holland and Belgium. Around 1830 he began to paint portraits and dogs, and he visited Italy, 1834–5, settling in London in 1838. Here he concentrated on historical works such as *The Murder of the*

Princes in the Tower. He also worked in watercolour and this reveals him as an excellent draughtsman. He often painted WILKIE-like interiors with dramatic chiaroscuro and fluent brushwork, and he also painted landscapes with a loose technique and fresh colours. After his death a series of lithographs based on his studies of Highland peasants and ghillies was published. Died London.

Sinclair, Alexander Garden 1859–1930
ARSA 1918

Primarily an oil painter of landscapes and portraits, a member of the SOCIETY OF EIGHT. He also produced some fine watercolours in a broad, 'wet' style, influenced by the Dutch School. Painted views in Northern France and Scotland, in particular Iona. His large skies and free handling of the medium make his watercolours attractive. He was a contributor to *Evergreen* in his earlier years and, later, a close friend of S. J. PEPLOE.

Sinclair, William b.c.1839

Born Edinburgh and trained at the Trustees' Academy 1853–6. Painted portraits.

Sivell, Robert 1888–1958
ARSA 1936, RSA 1943

Born Paisley, he studied at GSA and in Paris and Florence. He worked for a time as an engineer and served in the Merchant Navy during the First World War. After the First World War he helped to found the Glasgow Society of Painters and Sculptors to rival the Royal Glasgow Institute. Exhibitions took place at the McLellan Galleries, but the first

George Simson *The Girl at the Well* oil, Royal Scottish Academy (Diploma Collection)

exhibition caused a row as many non-members' works were rejected. Sivell was a close friend of MCGLASHAN, COWIE and LAMONT. In 1920 he moved to Kirkcudbright, but in 1942 left to join the staff of Aberdeen College of Art, retiring in 1954 after serving as Head. Died Kirkcudbright. He painted portraits and figures in oil, also large scale murals.

Skene, James of Rubislaw 1775–1864
Born Aberdeen, the younger son of the Laird of Rubislaw, he moved to Edinburgh aged eight. He drew as a child, but entered Edinburgh University to study law. On the death of his elder brother he inherited the estate, while continuing to practise at the Scottish Bar. In 1806 he settled on the estate at Inverbervie, Kincardineshire and began to devote more time to painting, travelling to paint landscapes in Belgium, Germany, France, Switzerland and Italy. In 1824 he embarked upon a project with Walter Scott to produce an illustrated description of Old Edinburgh entitled *Reekieana*. The project was never completed, but Skene painted several hundred watercolours. In 1829 he produced a series of sketches of Scotland illustrating places mentioned in the Waverley Novels, and as a close friend of Walter Scott he organized the National Appeal on Scott's death in 1832. In 1838 he visited Greece for the first time and decided to build a villa near Athens which became his home until 1845. During these years he painted many watercolours of Greece and the Islands. His later years were spent at Frewen Hall, Oxford.

Skinner, William fl.1892–1903
Lived in Edinburgh and painted figures, often illustrating Scottish ballads or nursery rhymes.

Skirving, Archibald 1749–1819
Born in East Lothian. Studied in Italy and returned to Scotland where he executed accomplished portraits in highly worked crayon. One of the few Scottish exponents of what was a fashionable medium in the later part of the 18th century. Subjects included Robert Burns and the Rev. Alexander Carlyle of Inveresk (executed in oil).

Slaney, Noël (Mrs George F. Moules) b.1915
RSW 1946
Born Glasgow, she studied at GSA 1933–7 winning a Haldane Travelling Scholarship in 1939. In 1940 she married GEORGE F. MOULES. She later taught at Hillhead High School. Paints in watercolour.

Slater, Francis fl. 1840s
Glasgow painter of portraits and landscapes. Also worked in Holland. Exhibited WSA.

Sloan, Christine S. 1887–1975
Born in Glasgow she studied at GSA 1907–15 and served as a VAD during the war. She later taught at Laurel Bank School and painted in watercolour.

Sloane, James Fullarton fl.1886–1940
Glasgow painter of landscape, still-life and figures, he also worked as an illustrator and poster artist.

Small, David 1846–1927
Painter of old Glasgow, he produced topographical watercolours for *Bygone Glasgow*, as well as watercolours of Edinburgh, Stirling and Dundee. He also worked as a photographer in Dundee. His style is rather tight, even hesitant, but he had a great sympathy for old buildings and streets.

Small, John W. fl.1880–1900
Stirling architect who painted architectural views of Stirling and other towns in the area.

Small, William, 1843–1929
RI 1870, HRSA 1917
Studied RSA Schools, moved to London 1865. His illustrations appeared in many magazines, and he also painted in oil and watercolour. His watercolours are often romantic and are beautifully executed, being close in style, as Caw points out, to those of Fred Walker and his circle.

W. J. W. SMALL

Smart, John 1838–1899
ARSA 1871, RSA 1877, RSW 1878, RBA 1878
Born Leith, he became a pupil and friend of HORATIO MCCULLOCH, being strongly influenced by his style and subject matter. He was an ardent Scottish nationalist and loved the rugged West Highlands, painting mountains and lochs in the open air. He also worked in Wales. The quality of his work varies; at times he conveys the vivid freshness of the scenery, while in other paintings the colours become too dark and brooding. He was a keen watercolourist and was a founder member of the RSW in 1878. Died Edinburgh.

Smeall, William fl.1830s–60s
Painted landscapes and exhibited RSA. Visited America in the 1830s.

Smellie, John d.1925
Glasgow painter of landscapes often with figures on the beach end promenading on the Ayrshire coast. He worked in both oil and watercolour and his work has the flair associated with the GLASGOW BOYS.

Smibert, John 1688–1751
Born Edinburgh and apprenticed to the housepainter Walter Marshall. Travelled to London 1709 and studied at Kneller's Great Queen Street Academy. Returned Edinburgh 1716–19 where he painted a number of portraits and then travelled to Italy. Went to America 1728. Portrait painter in oil and miniaturist. Died Boston, Massachussetts.

Smieton, James 1869–1935
Art Master, Perth Academy, and painted views of Perth in watercolour in a restricted, almost monochrome, palette.

Smith, Alexander C. 1875–1922
Amateur painter and naturalist, he lived in Perth and painted birds in oil and watercolour.

Smith, Alexander Munro 1860–1933
Born Falkirk, studied GSA, moved to London c.1884, returning to Scotland ca.1915. Illustrator and watercolourist. He was President of the SCOTTISH ARTS CLUB.

Smith, Campbell Lindsay 1879–1915
Born Forfarshire. Painted portraits, animals and birds.

Smith, Charlotte Elizabeth fl.1911–1930
Painter of landscape and flowers in oil and watercolour, she studied at GSA and in Paris. She was art teacher at Peterhead Academy.

Smith, Colvin 1795–1875
RSA 1829
Born Brechin, he studied at the RA Schools in London and visited Italy. He returned to Edinburgh and set up a portrait practice in Raeburn's old studio in 1827. His style was based on that of RAEBURN and WATSON GORDON although he lacked their talent. Died Edinburgh.

Smith, David Murray 1865–1952
RBA 1905, ARWS 1916, RSW 1934 (resigned 1940), RWS 1934
Studied ECA and RSA Schools, moved to London in 1893, remaining in southern England for the rest of his life despite regular trips to Scotland to paint. His landscapes are rather austere with broad skies dominating the landscape, which he rarely populates. Also worked in Italy, in particular Venice, and in Wales. He was successful in his time, but today his work appears somewhat empty.

Smith, Edwin Dalton 1800–?
A contemporary of KENNETH MACLEAY, he painted some fine portraits in watercolour, also flower pictures and miniatures.

Smith, Garden Grant 1860–1913
RSW 1890
Born Aberdeen, his watercolour style was influenced by ARTHUR MELVILLE, and like Melville he was a dedicated traveller, visiting Spain, North Africa and southern France. He liked to paint the bustle of a market or street scene in strong sunlight, and although he lacked the sparkle of Melville he had an eye for colour, detail and a good sense of composition. Worked mostly in watercolour. Smith was also a keen golfer and wrote books on the sport.

Smith, George 1870–1934
ARSA 1908, RSA 1921
Born Mid Calder, and studied at George Watson's College and in Antwerp. Worked in RSA Schools. Painted landscapes, coastal scenes and animals in oil. His work with animals and figures was frequently highly effective as in *Shrimpers, Brittany*. Caw commented: 'It is perhaps in incidents in which man and beast are associated, in shepherding and milking, and reaping or ploughing scenes, that he finds his most congenial motives. Effective in design, good in colour, and very powerfully painted, these pictures and others of a similar character, mostly of considerable size, are able performances and specially notable for fullness of tone and for ensemble – figures, animals, and setting being conceived as a pictorial whole.' Died Edinburgh.

Smith, Ian McKenzie b.1935
ARSA 1973, RSA 1987, PRSW 1988
Born Montrose, he studied at Gray's School of Art 1953–8 and attended courses at Hospitalfield School of Art, Arbroath. His painting was influenced by American colour-field abstraction and more recently by Oriental design and philosophy.

George Smith *Shrimpers, Brittany* oil, The George Street Gallery, Perth

John Smibert *Allan Ramsay* oil ca. 1717, James Holloway Esq

He was appointed Director of Aberdeen Art Gallery in 1968 and President of the RSW in 1988.

Smith, Jane Stewart 1839–1925
Edinburgh topographical artist; wrote and illustrated *The Grange of St Giles* (1898) and *Historic Stones and Stories of Bygone Edinburgh* (1924).

Smith, John Guthrie Spence 1880–1951
ARSA 1930, RSA 1939
Born Perth, he studied at the RSA Schools and ECA under ROBERT BURNS and at the RSA schools. He was deaf and dumb since contracting scarlet fever in infancy and was known to his friends as 'Dummy Smith'. Smith visited France in 1911 and 1912 with his mother, but never again travelled abroad, working instead in Scotland. He was a member of the EDINBURGH GROUP, taking part in the exhibition of 1912 and 1913 and with the reformed group in 1919–21. He worked largely in oil, painting boldly and with great verve: all his paintings have a strong sense of design. Also executed book illustrations. He spent his final years in the house of his friend and fellow member of the Edinburgh Group WILLIAM MERVYN GLASS.

Smith, Joseph Calder 1876–1953
Born Arbroath, worked there and in Dundee painting landscape in oil and watercolour. His watercolours are well drawn.

Smith, Samuel 1888–?
Born Glasgow, he studied at GSA and worked as a painter and etcher.

Smith, Thomas Stuart 1815–69
Born Stirling and studied art in Italy. Gave up life as a gentleman farmer near Stirling to paint in Europe and upon his return bequeathed many of his own works and those of his painter contemporaries, together with a financial endowment, to Stirling. Five years after his death, the Smith Art Gallery and Museum was opened.

J G Spence Smith *Ballachulish Quarries* oil, Robert Fleming Holdings Ltd

Smith, Tom fl.1914–1935
Edinburgh watercolour artist who painted many coastal scenes.

Smith, William Ryle fl.1885–c.1914
Art teacher and watercolourist working at Broughty Ferry; the uncle of SIR WILLIAM GILLIES.

Smith, William d.1941
Born Aberdeen. Painter of landscapes in the Highlands in oil and watercolour.

Smyth, Dorothy Carleton 1880–1933
Born Glasgow, studied GSA. Designed costumes for Quinlan Opera Company, Frank Benson Shakespearean Company and Glasgow Repertory Theatre. Taught GSA 1914–1933 and selected as successor to JOHN REVEL as Director GSA but died before taking up the appointment. Broadcast talks to children on BBC as 'Paint Box Pixie'. Painted in watercolour and pastel, illustrated several books.

Smyth, James fl.1920–35
Edinburgh watercolour and oil painter; on the staff of ECA.

Smyth, Olive Carleton 1882–1949
Sister of DOROTHY SMYTH, born Glasgow, studied GSA. Staff of GSA 1902–1914, becoming Head of Design 1933. Her earlier watercolours were in a visionary style similar to that of NORAH NIELSON GRAY, but her later work was influenced by Chinese brush drawing. Also used a naive, stylized manner.

Society of Eight
Formed in 1912 The Society of Eight was a group of like minded artists, with a fixed limited membership and permanent premises at 'The New Gallery' 12 Shandwick Place, Edinburgh. They were entitled to show about twenty paintings each in the annual exhibitions and the annual subscription was seven pounds five shillings. The original members were CADELL, LAVERY, P. W. ADAM, DAVID ALISON, CADENHEAD, HARRINGTON MANN, JAMES PATERSON and A. G. SINCLAIR. PEPLOE became a member a few years later.

Somerville, Andrew 1808–1834
ARSA 1831, RSA 1832
Lived in Edinburgh and painted portraits, rural scenes, landscapes and legends.

Somerville, Daniel fl.1780–1825
Engraver, etcher and watercolour artist in Edinburgh; painted views of Edinburgh. Teacher of engraving, etching and drawing.

Somerville, Howard 1874–1952
Born Dundee (as H.S. Adamson) he studied in Dundee and painted portraits, figures, interiors and still life. He also worked as an etcher. Died Bristol.

Somerville, John W fl.1902–15
A member of the original EDINBURGH GROUP, he was killed in action in 1916.

J B Souter *Imagery: Self-portrait in Studio* oil, private collection

Soutar-Robertson, Joan fl.1943–61
Painted portraits.

Souter, John Bulloch 1890–1971
Born Aberdeen and trained at Gray's School of Art. A travelling scholarship allowed him to continue his studies in France, Spain, Italy, Germany, Switzerland and Belgium. Initially his work concentrated on portraits and Aberdeen street scenes. Served in the RAMC in the First War and moved to London in 1922. Became a fashionable portrait painter, sitters including Ivor Novello and Gladys Cooper. Exhibited RA from 1914 but his picture *The Breakdown*, showing a naked white girl dancing to a black musician, caused a furore in 1926 and was withdrawn from the show.
Worked in Jersey where he painted landscapes; also etched. Moved back to Aberdeen, 1952.

Spence, Harry 1860–1928
NEAC 1887, RBA 1909
Glasgow artist. Painted landscapes in oil and watercolour, often in Galloway.

Spenlove-Spenlove, Frank 1868–1933
Born Bridge of Allan. Founded Spenlove School of Modern Art in 1896 and lived in London most of his life. Painted landscapes and figure subjects. Exhibited RA.

Spindler, G. James fl.1860s–70s
Lived in Dundee but also worked in Germany and Spain. Painted landscapes in oil and watercolour.

Stanley, Montague 1809–1844
ARSA 1838
Landscape painter. Lived and worked in Edinburgh.

Stanton, George Clark 1832–1894
ARSA 1862, RSA 1885
Born Birmingham, he studied silversmithing at Birmingham School of Art and later worked for Elkington's, who sent him to Florence to study Renaissance sculpture and metalwork. Always a Romantic, he joined Garibaldi and the Red Shirts, and fell in love with the daughter of a well-known Edinburgh family – Clara Gamgee. He followed her back to Edinburgh and, despite parental opposition, they married and settled there. He produced statues and designs for decorative friezes as well as richly coloured watercolours. His subjects were taken from history and literature, especially Shakespeare. He was an excellent anatomical draughtsman, teaching at the RSA Life Schools and illustrating John Gamgee's book on the horse. He was a close friend of SAM BOUGH, but sold little and was always in debt. Died Edinburgh.

Steel, John Sydney 1863–1932
Animal and sporting artist, he was born in Perth and studied at the Slade. Lived in Perth. Died Balquhidder.

Steell, David George 1856–1930
ARSA 1885
The son of GOURLAY STEELL, he was born in Edinburgh and studied at the RSA Schools. Caw comments that his 'work shows an interest in animals for their own sake, but little artistic quality or power'. Died Edinburgh.

Steell, Gourlay 1819–1894
ARSA 1846, RSA 1859, Curator NGS 1882–1894
The son of John Steell, a well-known wood-carver in Edinburgh, he trained at the Trustees' Academy. Became a successful animal painter in oil, but he also painted watercolours of still life, often with dead animals, studies of Scottish characters and animal studies. His drawings of horses, dogs and cattle are good. He was appointed 'Animal-Painter for Scotland' by Queen Victoria on the death of Landseer.

Stein, James fl.1836–64
Watercolour painter of landscapes around the Tweed and the Borders. Lived in Coldstream and later, Haddington. Related to ROBERT STEIN.

Stein, Robert fl.1832–63
Edinburgh landscape painter. Exhibited RSA.

Stenhouse, Charles 1878–?
Born Dundee and studied at GSA. His daughter Kathleen also painted. Lived in Glasgow and painted coastal scenes, harbours and French landscapes.

Stephen, Agnes M. fl.1920–70
Studied at GSA c.1917, she exhibited at the Glasgow Institute. Was Treasurer of Glasgow Lady Artists' Club 1962–70 and Vice President 1964–5.

Sterling, Muriel (Mrs Antony Caton-Woodville) 1898–1940
Studied at GSA 1919–22 and at the Académie de la Grande Chaumière, Paris. Taught at Laurel Bank School and developed as a scene painter working with the Bath Repertory and Birmingham Repertory under Sir Barry Jackson, and later ran his studio in London. She designed for West End plays and the Malvern Festival, but was killed by a bomb in the London Blitz.

Stevens, John (of Ayr) 1793–1868
RSA 1826
Born Ayr, he studied at the RA Schools in London. Returned to Ayr to paint portraits but soon went to Italy where he spent most of his career. He painted scenes from Italian life, dying in Edinburgh following a railway accident in France. He was a Foundation Member of the RSA.

Stevenson, Helen fl.1920–30s
Studied at ECA and produced coloured woodcuts.

Stevenson, James d.1844
RSA 1926
Lived in Edinburgh and painted landscapes in colour. Executed commissions painting country houses. Foundation Member RSA 1826.

Stevenson, Mrs Jeanie fl.1886–1937
Edinburgh painter of landscapes and portraits. Often worked in pastel.

Stevenson, Jean Macaulay
The daughter of R MACAULAY STEVENSON, she went to France with her father and stepmother in 1910. She studied at GSA 1926–31 and won the Lauder Award in 1933. Secretary Glasgow Society of Lady Artists 1955–9.

Stevenson, Robert Alan Mowbray 1847–1900
Born Edinburgh, he painted landscapes and country subjects in Scotland, England and Europe. He was more famous, however, as a critic and art historian. He was Professor of Fine Art at Liverpool University College 1880–1893 and his articles for *Pall Mall Gazette* were amongst the most perceptive of the period.

Stevenson, Robert Macaulay 1854–1952
RSW 1906 (struck off 1913)
Born Glasgow, he studied at GSA. His oils were influenced by Corot and by the Barbizon painters, and he had an ability to capture rivers seen at dusk or in moonlight. He used rich impasto and dense paint to paint landscapes in detail an then he rubbed the surface with a cloth while still wet to give an atmospheric misty effect. He was a fine watercolourist, although he produced comparatively few. They are small in scale and have rich, sonorous washes.
Stevenson became the unofficial spokesman for the GLASGOW BOYS after 1888. He was well connected in the Glasgow world of commerce, and his brother was Sir Daniel Stevenson, the Lord Provost. Stevenson himself was wealthy and was a good propagandist for the Boys. In 1888 the *Scottish Arts Review* was set up with JAMES PATERSON as the motivating force: Stevenson was called in to improve the quality of the third issue.
Stevenson's work is romantic and atmospheric rather than vigorous. Died Milngavie.

Stevenson, Mrs Stanmore Richmond Lesue 1866–1944
Portrait painter. Painted portrait of Neil Munro in SNPG.

Stevenson, William Grant 1849–1919
ARSA 1885, RSA 1896
Born Ratho, he studied at the RSA Schools and became a noted sculptor. He also painted in oil, mostly rural, animal and genre, often with a humorous touch. Died Edinburgh.

Stewart, Allan 1865–1951
Born Edinburgh, he studied at the RSA Schools and in Paris and Spain. Became a specialist in historical and military paintings, but also painted some portraits. He worked for the *Illustrated London News* and accompanied King Edward VII on his Mediterranean cruise.

Stewart, Anthony 1773–1846
Born Crieff, he was apprenticed to ALEXANDER NASMYTH. Painted landscapes in the style of RICHARD WILSON before settling in London where he made his reputation as a portrait painter, primarily of children. He painted a miniature of the Princess Victoria, the future Queen, when she was one year old and again as she grew up. In later years he almost exclusively painted children.

Stewart, Catherine M. fl.1860s
Painted rustic scenes and landscapes.

Stewart, Henry 1897–?
Watercolour painter and etcher from Glasgow.

Stewart, James 1791–1863
RSA 1826
Born Edinburgh, he was apprenticed to ROBERT SCOTT, the engraver, and attended classes at the RSA. He specialized in engraving and engraved many of SIR WILLIAM ALLAN's paintings as well as WILKIE's *The Penny Wedding*. He was a Foundation Member of the RSA in 1826 and moved to London in 1830. In 1833 he emigrated to Cape Colony where he taught and painted portraits and eventually died in South Africa. He exhibited in London between 1825 and 1861 and he also painted some English scenes: it is likely therefore that he returned regularly to London.

Stewart, James b.ca.1828
Born Edinburgh and studied at the Trustees' Academy 1848–9. Ornamental painter.

Stewart, James Hope d.1883
Lived in Edinburgh and painted miniatures, portraits and figures. Exhibited Carlisle Academy and was in Rome in the early 1840s.

Stewart, J.L. fl.1830s–40s
Edinburgh based landscape painter, he worked in Scotland and abroad visiting Italy and Switzerland in the early 1830s.

Stewart, James Malcolm 1829–1916
Lived in Glasgow and painted portraits and genre. Member of the WSA.

Stewart, J. Oswald fl.1870s–80s
Lived in Portsoy and painted marine subjects, fishermen and coastal incidents. Founder member of the Scottish Arts Club.

Stewart, Nellie fl.1900–1935
Watercolour painter of flowers, gardens and landscape.

Stewart, Robert b.1924
Born Glasgow and studied at GSA where he joined the staff, becoming Head of the Printed Textile Department. Designed textiles for Libertys; also posters, mosaics and catalogues. Worked as a printmaker in silk screen and monotype.

Stewart, Robert Wright fl.1905–40
ARE 1911
Studied ECA and worked as a painter and etcher.

Stewart, William fl.1823–1906
Lived in Paisley and painted figures, genre and

interiors in oil and watercolour. Later taught at Paisley School of Design. Painted many Italian subjects.

Stirling, John 1820–71
Lived in Aberdeen and London, visiting Morocco 1868–9. Painted portraits, genre, fairytale and literary subjects.

Stirling, John fl.1830s
Lived in Edinburgh and painted animals, cattle and rural scenes.

Stoddart, Christine fl.1895–1905
Lived and worked in Edinburgh and India. Figure painter.

Stoddart, Miss Frances fl.1830s–50s
Edinburgh landscape painter.

Stoddart, Grace fl.1889–1922
Born Chesterhall, Lanarkshire, she studied with CHRISTINA ROSS in Edinburgh, at Colarossi's in Paris, and at ECA. Painted landscapes and figures in oil.

Stoddart, Mary Tweedie fl.1890s–1910
Lived in Tweedsmuir and exhibited SSA. Painted landscapes, figures and town scenes.

Story, Elma 1886–1941
Born Edinburgh, studied GSA, Edinburgh and Paris. Painted watercolour landscapes, often views of Iona. Memorial exhibition of her work was held at the Glasgow Society of Lady Artists, 1942, along with JANET AITKEN and KATE WYLIE.

Strachan, Andrew d.1673
Armorial painter and portraitist active in Aberdeen during the middle part of the 17th century, he was a friend of GEORGE JAMESONE.

Strachan, Robert Douglas 1875–1950
HRSA 1920
Born Aberdeen, he studied at the RSA Schools for a short period, before working as an illustrator in Manchester. Also trained in France, Spain and Italy, but in 1898 he was commissioned to paint panels for Aberdeen Trades Hall. As a result he gained a commission to decorate Aberdeen Town Hall with frescoes based on the story of Orpheus. He later devoted more time to stained glass window design, being commissioned to make windows for The Palace of Peace at The Hague. Lived at Lasswade, Midlothian.

Strain, Hilary (Mrs Harold Wyllie) 1884–1960
SMA
Born Alloway, Ayrshire she was educated in Germany and at GSA. She painted portraits and marines, and later married the marine artist Harold Wyllie.

Strang, William 1859–1921
RE 1881, RP 1904, ARA 1906, RA 1921
Born Dumbarton, he moved to London in 1875 to study under Legros at the Slade. He produced some 750 etchings, drypoints, mezzotints, engravings,

acquatints and woodcuts of architectural subjects, portraits and some landscapes. He also painted oils, often of figure subjects. He lived in London.

Strange, Sir Robert 1721–92
Born Orkney and apprenticed to RICHARD COOPER, he became a celebrated engraver. His career was set back by the 1745 Rebellion and he was obliged to leave for the Continent where he lived in Italy and France. Returned to London and was knighted by King George III as a result of his fine engraving of West's *Apotheosis of the Children of George III*. Caw opined that 'his plates are remarkable for deliberate clearness and precision.'

Stronach, Ancell 1901–1981
ARSA 1934 (withdrawn 1975)
Born Dundee. Possibly the most eccentric artist ever elected to the RSA, he was trained at GSA becoming Professor of Mural Painting until resigning in 1939. He painted figures, portraits, religious and mythological subjects in oil in a strong and striking manner based upon a combination of Early Renaissance models and stained glass windows. He loved zoos and circuses and in 1939 left academic life to go into show business. He established *Ancell's Painted Pigeons*; highly coloured, trained pigeons which performed aerial acrobatics. He married an acrobatic dancer and they toured together. He disappeared from public view and for many years

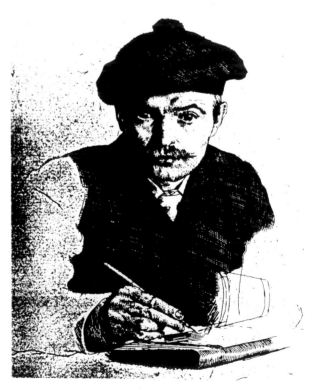

William Strang *Self Portrait* etching 1885, private collection

the RSA attempted in vain to contact him. Died in England having painted in secret for 30 years.

Struthers, M. Fleming fl.1895–1910

Stirling artist involved with the CRAIGMILL SCHOOL, he painted birds and landscapes in watercolour.

Stuart, Sir James 1779–1849

Born Rome, he was an amateur painter and etcher and friend and neighbour of Sir Walter Scott at Melrose. Was 5th Baronet of Allanbank, Berwickshire. Colnaghi published 2 sets of 6 etchings by Stuart illustrating Scott and Byron in 1821. Seven years later a further set of etchings, *Gleanings from the Portfolio of an Amateur*, was published. Stuart was a prolific watercolourist, painting landscapes and battle-scenes in a fluent pen and wash style. Also painted subjects inspired by literature. His best works are probably his landscape sketches of Scotland, especially his fresh views of the Isle of Arran. Died Edinburgh.

Stuart, Robert Easton fl.1890–1940

Lived in Edinburgh and studied at the RSA Schools. Painted landscapes, usually with figures of farm workers, and some still-life.

Stuart, Sheila 1905–49

Studied at ECA and in Paris. Lived in Dalkeith and painted local views.

Sturrock, Alick Riddell 1885–1953

ARSA 1929, RSA 1937, Treasurer of RSA 1938–47

Born Edinburgh, he was apprenticed to a firm of lithographers. Attended classes at ECA where he met ERIC ROBERTSON and D.M. SUTHERLAND, and at the RSA Schools. He won a travelling scholarship and visited Paris, Italy, Munich and Holland.

His paintings deal with the countryside, usually a cultivated man-made landscape with farm buildings, haystacks, ponds and large trees. He worked mostly in oil in a broad style, and many of his pictures are of the Dorset countryside which he visited regularly. He married MARY NEWBERY, daughter of FRA and JESSIE NEWBERY, in 1918. Also painted still-life reminiscent of William Nicholson, and his landscapes are close in feeling to John Nash. Died Edinburgh.

Sturrock, Mary Newbery (née Mary Arbuckle Newbery) 1890–1985

The daughter of FRA and JESSIE NEWBERY, she studied at GSA. She took an interest in a wide range of art including embroidery, her mother's speciality, ceramics and flower painting. Her closest friend was CECILE WALTON, whose parents rented a house in Walberswick, Suffolk near to the house rented by the Newberys. W.O. HUTCHISON and ERIC ROBERTSON would also visit Suffolk and in 1918 Mary Newbery married Robertson's close friend ALICK STURROCK. She painted flowers, her early work influenced by C.R. MACKINTOSH, her later work becoming more naturalistic. She was a close friend of MACKINTOSH and they often painted the same flowers: she would tell him the Latin names so that he could inscribe them correctly.

Surenne, D.F. fl.1830s

Teacher of drawing in Edinburgh. Portrait of Robert Dundas at Arniston House (probably exhibited RSA 1830).

Surenne, James G. b.ca.1835

Born Edinburgh, son of D.F. SURENNE. Trained at the Trustees' Academy 1850–2.

Sutherland, David MacBeth 1883–1973

ARSA 1922, RSA 1937

Born Wick, he embarked on a career in law, but moved to Edinburgh to work as an apprentice in

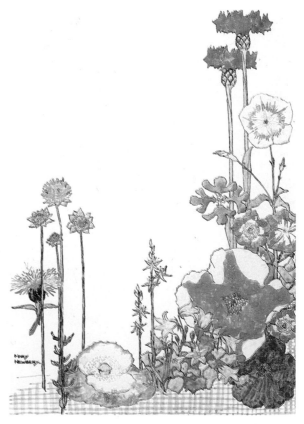

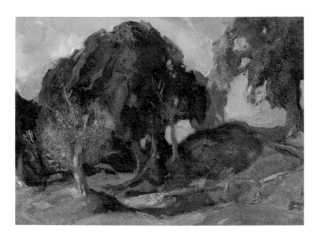

Alick Riddell Sturrock *Anwoth Woods, Galloway* oil, Bourne Fine Art

Mary Newbery Sturrock *Summer Flowers* watercolour, Mr & Mrs John Kemplay

a lithographic firm. He attended classes at the RSA schools, where he was inspired by the teaching of CHARLES MACKIE, and at ECA. He won the Carnegie Travelling Scholarship, which enabled him to visit Spain and Paris in 1911, and in 1913 he went to Holland and Belgium. He served during the war, returning to ECA to teach in 1918. In the following year he helped re-form the EDINBURGH GROUP with the addition of CECILE WALTON, MARY NEWBERY and DOROTHY JOHNSTONE, whom he was to marry in 1924. Sutherland was a successful teacher, respected by his colleagues, who included GILLIES and MACTAGGART. During the late 1920s he began painting in the north east of Scotland often camping with Gillies and MAXWELL, and his landscapes of this period in both oil and watercolour are energetic and reveal some influence from Gillies.

In 1933 Sutherland was appointed Head of Gray's School of Art, Aberdeen and over the next 15 years he built up the reputation of the School. He continued to paint, working on the west coast at Plockton and Gruinard Bay, and on the east coast in Caithness and Cults, Aberdeenshire, where he retired with his wife in 1948.

Sutherland continued painting all his life, but his most powerful, expressive landscapes were done in the 1920s in Concarneau: he also painted some stylish portraits. Died Plockton.

Sutherland, Duncan b.ca.1831
Born Edinburgh and trained at the Trustees' Academy 1852. Executed figure drawings.

Sutherland, John Robert d.1933
Born Lerwick, he trained at ECA. He was a designer and heraldic artist.

Sutherland, Robert Lewis d.1932
Born Glasgow and studied at GSA and in Paris. He painted landscapes, coastal scenes, harbours and the Highlands in a broad and powerful manner.

Swinton, Catherine fl.1830s
Amateur portrait painter working in the Duns area.

Swinton, Miss E.C. fl.1820s
Sister of CATHERINE SWINTON, amateur painter working in the Duns area.

Swinton, James Rannie 1816–68
Born Kimmergehame, near Duns, and trained at the Trustees' Academy in 1838. Painted portraits, mostly of aristocratic and society figures, in oil and also drawings in crayon. Lived in London and Rome. Died London, a wealthy man from the proceeds of his portrait practice.

Syme, John 1795–1861
RSA 1826
The nephew of PATRICK SYME, he was a Foundation Academician in 1826. He was employed by RAEBURN as an assistant and after Raeburn's death was entrusted to complete unfinished canvases in the studio. By 1825 he was established as a portrait painter in his own right in Edinburgh. Died Edinburgh.

Syme, Patrick 1774–1845
RSA 1826
A Foundation Academician, Syme was closely involved with the formation of the Academy and took the chair at the first meeting. He was the leading flower painter of his period and also a noted teacher. In 1810 he published *Practical Direction for Learning Flower Drawing* and he was also an expert on birds, publishing a *Treatise on British Song Birds* in 1823.

A scandal surrounded his marriage to the aristocratic ELIZABETH BOSWELL of Balmuto, who met Syme while attending his classes in Edinburgh. The couple eloped for a secret marriage and her parents never forgave them. Elizabeth Boswell was herself a flower painter of some skill. In later years Syme moved to Dollar where he taught at Dollar Academy.

D M Sutherland *Donkey Rides, Portobello Beach* oil, Robert Fleming Holdings Ltd

Tarbet, J.A. Henderson d.1927
Edinburgh painter of landscapes, mountain, loch and moorland in oil and watercolour. 'In the direct tradition of MacWhirter,' the *Scotsman* obituarist noted. Exhibited RSA, RA and RGI and was an active member of the SCOTTISH ARTS CLUB.

Tarrant, Charles fl.1750s
Landscape painter working in Scotland in the mid-18th century.

Taylor, Arthur John fl.1920–1940
Glasgow painter of fishing and coastal scenes, particularly on the Clyde.

Taylor, Ernest Archibald 1874–1951
A widely talented artist, he worked as an oil painter and watercolourist, etcher, and designer of furniture, interiors and stained glass. His early watercolours are delicate and original in design, but between 1900 and 1910 he produced watercolours in which there is a successful balance between naturalism and stylization. During these years he often painted on Arran and also worked for the Glasgow cabinet makers Wylie and Lochhead. In 1908 he married JESSIE KING and moved to Manchester to manage and design for George Wragge Ltd. and he produced many designs for stained glass. Between 1911 and '14 the Taylors lived in Paris where they established an art school – the Shealing Atelier. The influence of modern French art and the Ballets Russes can be seen on Taylor's art: his style broadened and he made more use of dramatic outlines.
On their return to Scotland on the outbreak of war, they settled in KIRKCUDBRIGHT where S. J. PEPLOE stayed with them many times and they established a summer school at High Corrie on the Isle of Arran. Taylor's work, like that of his wife, became more powerful and dramatic, closer in style to the COLOURISTS. His oils, painted in broad brushstrokes, depict the rugged landscape of the Western Highlands, often with a white croft set against a dark rock face.

Taylor, James Fraser fl.1880–1913
Lived in Edinburgh and painted landscapes and farm scenes, often with figures.

Taylor, John fl.1840s
Kilmarnock based portrait painter. Exhibited WSA.

Taylor, John D. fl.1875–1900
Glasgow oil and watercolour artist who specialized in marine subjects executed in an accurate and detailed manner. His watercolours often have a naive charm. President of the Glasgow Art Club 1884–5.

Taylor, William fl.1860s–70s
Lived at Campsie. Painted views of Loch Ard, Loch Lomond, Ben Venue and the surrounding areas, mostly in watercolour. Also coastal scenes.

Telfer, Henry Monteath fl.1880s
Lived in Edinburgh and painted landscapes, woodland scenes and sunsets.

Telfer, Robert fl.1710–20
Predominantly a decorative painter recorded as working in Edinburgh during the first quarter of the 17th century.

Telfer, William Walker b.1907
Born in Falkirk, he trained as a violinist, but in 1927 attended Falkirk Art School to train under James Davie, father of ALAN DAVIE. He worked in Edinburgh in the early 1930s where he was influenced by Harold Morton, Robbie Robertson and WILLIE WILSON. He was also influenced by the COLOURISTS, visiting the SOCIETY OF EIGHT exhibitions and the PEPLOE memorial Exhibition in 1936. President of Falkirk Art Club 1938–48. He served in the war, and later became chairman of a printing firm. He was an authority on the paintings of JOHN THOMSON OF DUDDINGSTON and formed a large collection of his work. His paintings of still life, flowers and landscape reflect his interest in the Colourists. Also etched and painted portraits.

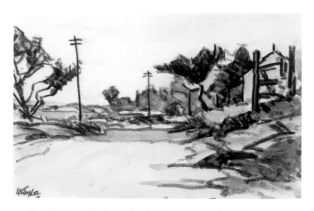

E A Taylor *The Coast Road, Arran* watercolour & crayon, Patrick Bourne Esq

John Terris *The Upper Bow and Lawnmarket, Edinburgh*
watercolour, Paul Roberts Esq

Templeton, Rosa Mary c.1868–1936
Watercolourist born British Guiana, died Helensburgh.

Terris, John 1865–1914
RSW 1891, RI 1913
Born Glasgow, his family moved to Birmingham around 1880 and Terris studied at Birmingham School of Landscape Art. Terris moved back to Scotland ca.1885 and devoted himself to watercolour painting; elected RSW at the age of 26. He adopted a broad 'wet' style with an almost 'square brush' approach. Many of his watercolours are on a large scale, painted with dramatic contrasts. He worked in Scotland, England, France and Holland. His death in Glasgow at the early age of 49 deprived Scottish watercolour painting of a considerable talent.

Terris, Tom fl.1897–1940
Glasgow painter of landscapes in watercolour in similar style to JOHN TERRIS, who was probably his father.

Thomas, Albert Gordon 1893–1970
RSW 1936
Born Glasgow and trained at GSA. He painted watercolours with great panache and style, usually working on the west coast of Scotland with fresh colours and simple but effective composition. He also taught in several institutions in Glasgow.

Thomas, George Grosvenor 1856–1923
RSW 1892 (resigned 1908)
Born Sydney, New South Wales, he was brought to England as a child and educated at Warminster. In art he was essentially self-taught, but he worked as a dealer in Japanese prints and artefacts settling in Glasgow around 1885. His work was influenced by Japanese art and by the Barbizon School. He painted nocturnal, dawn and evening scenes mostly in oil although he did produce some nocturnes in watercolour. His oils are sometimes in a large scale with a brooding sense of melancholy, often with rivers, lakes or estuaries reflecting a weak source of light. He also painted a few flower pieces. His output was small, exhibiting only 9 works at the RSA, 16 at the RSW and 38 at his London dealers, Dowdeswells. He was an avid collector, not only of Japanese works but also stained glass, and he later sold much of his collection to Sir William Burrell.

Thomas, Margaret b.1916
NEAC, RWA
Born London and studied at the Slade and RA Schools. Lives and works in London and Edinburgh.

Thoms, Colin b.1912
Painter of still life and landscape in oil and watercolour. Studied ECA and the Slade. Taught at Gray's School of Art, Aberdeen and paints abstract subjects, usually in oil.

Thomson, Adam Bruce 1885–1976
ARSA 1937, RSA 1946, RSW 1947, PRSW 1956–1963
Born Edinburgh, he studied at ECA and in 1908 he visited Venice with CHARLES MACKIE. He joined the staff of ECA, and colleagues included DONALD MOODIE and D.M. SUTHERLAND. Thomson became friendly with GILLIES, who joined as a student in 1916 and became a colleague on the staff in 1926. Gillies influenced Thomson's style, although the COLOURISTS also attracted him. He worked around Edinburgh, in the Borders and on Iona as well as in the Highlands in oil and watercolour, fluidly handled. He was an influential teacher of etching in Edinburgh in the 1920s.

aBruce Thomson

Thomson, Alexander P. d.1962
RSW 1922
Glasgow watercolourist, painted views of the Highlands in a conservative style, apparently unaffected by 20th-century artistic developments. He used rough paper and a well controlled watercolour technique, often on a large scale, which resulted in satisfying work of a high quality.

Thomson, Isabella Lauder fl.1890s
Lived in Edinburgh and painted landscapes. Exhibited SSA.

Adam Bruce Thomson *Cattle Tweedside, 1975* watercolour,
Jack Firth Esq

Thomson, Horatio fl.1884–1906
Watercolour painter of Glasgow streets and scenes.

Thomson, John of Duddingston 1778–1840
The son of Reverend Thomson of Dailly in Ayrshire,
he studied theology at Glasgow University 1791–2
moving to Edinburgh University in 1793. While
still studying, he received some lessons in art from
ALEXANDER NASMYTH (1798–9). In 1800 he was
ordained and succeeded his father as Minister
of Dailly.
In 1802 he visited the English lakes where he
sketched, later working these up into large water-
colours. His first known oil dates to 1805, and it
reflects the influence of RICHARD WILSON.
In 1805 Thomson moved to the manse at Dud-
dingston, near Duddingston Loch by Arthur's Seat.
This loch became an inspiration to Thomson and he
painted it in differing lights. From 1808 Thomson
exhibited in Edinburgh, taking part in the Institu-
tion's annual shows, and he gained a reputation for
'those terrible seas and skies which only Thomson
can paint.' The freedom of his brushwork and
the direct expression of his reaction to landscape
impressed his contemporaries. It can also be argued
that he was one of the first truly Scottish landscape
artists, for although he was influenced by Claude
Lorrain, via Wilson, and the Dutch, he painted
his own surroundings in a fresh and stylistically
unencumbered manner.
In 1818 Turner and Thomson were commissioned
to produce 11 plates each for Scott's text to *Provincial
Antiquities of Scotland*. Turner stayed with Thomson
in 1822 and went sketching with him and HUGH
'GRECIAN' WILLIAMS. Several writers have seen an
influence of Turner in Thomson's free oil sketches,
but it is difficult to assess the exact extent of Turner's
influence.
Thomson was a Romantic in his approach to paint-
ing, insisting upon 'feeling' and reacting to the forces
of nature. Like many Romantics he related his art to
literature, in particular to Walter Scott, who was a
close friend.

Despite his success, Thomson was in some respects
an amateur, in particular in his lack of technical
knowledge. He used too much bitumen and his
ground was sometimes unstable. As a result many
of his oils have deteriorated. He was, nevertheless, a
major figure in the development of a Scottish school
of art. Died Duddingston.

Thomson, J. Leslie 1851–1929
RBA 1883, NEAC 1887, ROI 1892, ARWS 1910, RWS
1912, HROI 1921
Born Aberdeen, studied Slade and became part
of the English School, returning only rarely to
Scotland. Painted river scenes in oil and water-
colour in England, Brittany and Normandy. His
style, which was influenced by his fellow Scot in
London, DAVID MUIRHEAD, was competent rather
than striking.

Thomson, John Murray 1885–1974
RSW 1917, ARSA 1939, RSA 1957
Born Crieff, he studied at the RSA Schools and in
Paris at the Académie Julian. He specialized in ani-
mal and bird painting, often working in Continental
zoos including Paris, Rotterdam, Amsterdam and
Berlin. He later taught at ECA. With his wife, Ellen
May Frew, he wrote and illustrated *Animals We
Know*. He kept several unusual pets, including a
monkey, a falcon and an owl.

Thomson, Robert Sinclair 1914–1983
ARSA 1952
Born Glasgow, he studied at GSA under HUGH
ADAM CRAWFORD. He became interested in ceram-
ics and in 1950 became a full-time potter. Between
1960 and 1925 he lectured in Drawing and Painting
at GSA. He painted landscapes in oil, pastel and
watercolour and also produced murals.

Thomson, William Hill 1882–?
ARMS 1916, RNS 1923
Edinburgh painter of portraits and miniatures.

Thomson, William John 1771–1845
RSA 1829

John Thomson of Duddingston *Fast Castle* oil, James
Holloway Esq

Edinburgh miniaturist, figure and portrait painter who painted portraits in full colours but, according to Caw, lacked 'the grace which belongs to the more selective and conventional manner of the English Masters'. Exhibited Carlisle Academy 1825–6.

Thorburn, Archibald 1860–1935
Born Edinburgh, the son of a miniaturist who worked for Queen Victoria, he was taught to paint by his father and he first exhibited at the RSA aged 10. During the 1880s he produced a number of illustrations for books including 268 of the 421 plates in Lord Lilford of Northampton's *Coloured Figures of the Birds of the British Islands* (1888). He continued to illustrate books and his *British Birds*, which first appeared in 1915–16, met with huge popularity.
Thorburn settled in London in 1885, moving in 1902 to a country house near Godalming. He returned each year to Scotland to draw, working these drawings up in his studio into full-scale watercolours. He rarely worked in oil, preferring the delicacy of watercolour, but he made extensive use of Chinese white and they often have the appearance of oils. Thorburn was good at composing animal and bird pictures, and his background landscapes were accurately and freely drawn. He often sketched in the Forest of Gaick in Inverness-shire and was able to capture the different seasons. Some of his watercolours of ptarmigan in winter plumage seen against a snow landscape are masterpieces of tonal painting. Although he was best known for his birds, he also painted deer and other Highland animals.

Thorburn's art is different in approach and aim from that of CRAWHALL and EDWIN ALEXANDER, but he was certainly the finest painter of his genre.

A.T. Archibald Thorburn

Thorburn, Robert 1818–85
ARA 1848, HRSA 1857
Born Dumfries. Miniaturist who specialized in portraits of aristocracy and worked for Queen Victoria. Caw notes that, 'His colour was fresh, his compositions agreeable, his handling delicate and very detailed.' On the introduction of photography he was forced to turn to portraits in oil, but was less successful at this. He was the father of ARCHIBALD THORBURN. Died Tonbridge.

R.T.

Thornton, George B. fl. 1880s
Edinburgh painter of landscapes and seascapes.

Thwaites, Frances 1908–87
Lived in India until the age of 12. Moved to Scotland and has worked in Paris and London. Studied stained glass at ECA and won travelling scholarships. Studied sculpture 1946–48, then turned to landscape painting. Exhibited from 1950.

Archibald Thorburn *Cock Pheasant* watercolour, Malcolm Innes Gallery

Tod, Murray Macpherson 1909–1974
ARE 1947, RE 1953, RSW 1953
Tod trained at GSA 1927–31 where he was a contemporary of IAN FLEMING. He moved to the RCA receiving his diploma in 1935 and won a scholarship to the British School in Rome 1935–7. Married the artist MARJORIE LUCAS in 1938 and they lived and worked in Edinburgh. Tod painted and etched landscapes and townscapes in Scotland, Italy and Spain. He worked in oil and watercolour, but from the late 1940s suffered from muscular dystrophy. Later lived in Dalbeattie and drew whimsical places, not unlike Heath Robinson.

Todd, James Henry fl.1898–1913
Lived in Glasgow and painted flower pieces, seascapes, coastal scenes and landscapes. Exhibited SSA.

Toland, Peter fl.1860s–70s
Glasgow landscape painter. Exhibited Glasgow Institute.

Torrance, James A.S. 1859–1916
Born Glasgow, he worked for many years in London as an illustrator and portrait painter. His work includes illustrations for *Scottish Fairy and Folk Tales* edited by Sir George Douglas (1893). He was a sophisticated black-and-white illustrator. Married the flower painter LOUISE PERMAN in 1911 and they lived in Helensburgh. Died Helensburgh.

Townsend, W.H. d.1848/9
Edinburgh landscape painter in watercolour and oil.

Train, Thomas 1890–?
Aberdeen artist, born in Carluke, he studied at GSA.

Traquair, Phoebe Anna 1852–1936
HRSA 1920
Born Dublin and trained Dublin School of Art. Settled in Edinburgh. Religious paintings, embroidery and enamelling. Also undertook murals, including decoration of the Catholic Apostolic Church at the corner of London Street, Edinburgh. Died Edinburgh.

Traquair, Ramsay
The son of PHOEBE TRAQUAIR, he exhibited in Edinburgh 1908–12.

Trotter, Alexander Mason 1891–1946
ARSA 1942, RSW 1930
Trained at ECA, he worked for a period as a commercial illustrator for publishers. Later turned full-time to art, often painting commonplace objects such as bicycles, kitchen utensils, views of kitchen tables and chairs. He also painted mural decorations and his humorous mural of the Naval Canteen at Rosyth was well received.

The Trustees' Academy
In 1760 the Board of Trustees for the Encouragement of Manufacturers in Scotland opened an Academy in Edinburgh to provide instruction for pupils who were either already in a trade or interested to follow a trade such as carving, gilding, housepainting, cabinet making, engraving or calico printing. The Master was always a fine artist, the first being the French painter WILLIAM DELACOUR, but the intention of the Trustees was to establish an industrial training school, not an academy for fine artists. The third master, ALEXANDER RUNCIMAN, appears to have challenged the Trustees' emphasis upon industrial design, which in effect meant drawing ornaments and decorative patterns, but Runciman's successor DAVID ALLAN established a balance between the two approaches.

Students were taught to draw from casts of classical sculpture as well as from natural objects such as fruit or flowers which played a part in calico and damask design. Although there is no evidence, one can assume that an enlightened master like David Allan also introduced his students to Italian painting via prints or his own drawings. Thus despite the Trustees' policy, many successful painters were trained at the Academy, including JOHN BROWN, ALEXANDER NASMYTH and ANDREW WILSON. A large number of engravers were also trained.

In 1798 a separate Drawing Academy for fine artists was established and JOHN GRAHAM was invited to run it. On the dismissal of John Wood in 1800 Graham became Master. He persuaded the Trustees to spend £50 on casts from the Antique and he placed the emphasis of his teaching on history painting. Oil painting was introduced to the curriculum and during Graham's Mastership,

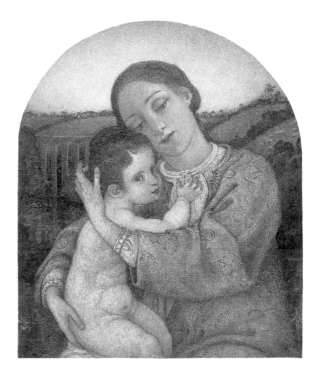

Phoebe Traquair *Triptych* Scottish National Portrait Gallery

which lasted until 1817, many future artists were trained.

ANDREW WILSON was appointed Master in 1818 and, although not an outstanding teacher, his knowledge of Italian art widened the outlook of his students. He was followed by WILLIAM ALLAN and in 1826 the Academy was moved into the Royal Institution Building (now the RSA) on the Mound. In 1851 a row between the RSA and Trustees' Academy came into the open. The RSA had long intended to establish its own School specifically for fine artists, but as long as the Academy had good rooms, casts and a collection of pictures the RSA, which had none of these, could not rival it. However, by 1851 the Academy's standards had fallen badly under the direction of ALEXANDER CHRISTIE. The President of the RSA, WATSON GORDON, persuaded the Trustees to appoint ROBERT SCOTT LAUDER as Director of the Antique, while Christie was effectively downgraded as Director of Design classes. Under Lauder the Academy flourished. He was a strict disciplinarian, but his enthusiasm was infectious. While encouraging drawing from casts and clothed models, he also urged students to paint, and his own predilection for the rich colours of the Venetian School informed many of his pupils, who included MCTAGGART, MACWHIRTER, PETTIE, HERDMAN, PETER GRAHAM, THOMAS GRAHAM, ORCHARDSON and the BURRS.

In 1858 the RSA finally won its long standing conflict with the Trustees' Academy and was allowed to take over the Life School, leaving the Academy to teach only the Antique. In effect it meant that Lauder was responsible for the elementary instruction, the better students moving on to the RSA Life Classes. Moreover, the Academy came under the Department of Science and Arts. In 1860 Christie died and after 1861 Lauder ceased to teach. Their places were taken by Mr Hodder, about whom little is known, and SUSAN ASHWORTH, a minor flower painter, and the Trustees' Academy slowly withered into insignificance.

Turnbull, William b.1922
Born Dundee and worked as an illustrator with Thomson-Leng, Dundee. Studied at the Slade 1946–8, lived in Paris 1948–50 and in London with travels to USA, Japan and the Far East. Influenced by American painting and particularly by Rothko and Still and moved towards minimalism. Also developed as a sculptor dividing his energies between sculpture and painting. Exhibited internationally from 1950 with work in public and private collections in Britain, Europe and USA.

Tweedie, William Menzies 1828–78
Born Glasgow and studied at Edinburgh Academy, RA Schools and in Paris under Couture. Settled in London in 1859 and exhibited portraits and religious subjects at the RA and WSA.

Tyre, John fl.1850s–60s
Glasgow painter of rural genre and flowers.

U

Urie, Daniel fl.1850s–60s
Taught at Greenock School of Art and painted landscapes. Exhibited RSA.

Urquhart, Annie Mackenzie 1879–?
Studied at GSA 1897–1904 under FRA NEWBERY and Delville, also in Paris. Produced illustrations of children and young girls in landscape settings, using ink outlines and colour stippled in with dry brushes. Often painted on parchment.

Urquhart, Edith Mary fl.1910–50
Born Edinburgh and trained at Heathley's and Newlyn. Painted landscapes, portraits and figure subjects. Exhibited RSA, RP, SSA, SWA.

Urquhart, Gregor fl.1830s–60s
Lived in Edinburgh and painted historical subjects. Exhibited RSA.

Urquhart, Grigor b.1799
Born Inverness and trained in Rome 1818–25. Was befriended by SIR DAVID WILKIE. Worked as a portraitist and copyist. Was in London in 1830s and returned to Inverness in 1844 where he established a studio. Died Inverness.

Urquhart, Murray McNeel Caird 1880–?
RBA 1914
Born Kirkcudbright, he studied at ECA, the Slade, Westminster and in Paris. Settled in the South of England and painted atmospheric oils and watercolours. He used a pointilliste method similar to that of Eliot Seabrooke.

Murray Urquhart *Sunlit Street* oil, Mr & Mrs D Young

Vallance, William Fleming 1827–1904
ARSA 1875, RSW 1878, RSA 1881

Born Paisley, he was apprenticed to Aitken and Dott in Edinburgh as a carver and gilder, his family having moved to Leith. As an apprentice he painted portraits and genre, and later attended classes at the Trustees' Academy where, from 1855, he was taught by R.S. LAUDER. Although he first exhibited at the RSA in 1849, he did not take up art as a profession until 1857. During the 1860s he painted marine views with shipping, but after 1870 he painted a series of pictures of Irish life and humour, working in Wicklow, Connemara and Galway.

Vallance was a friend of MCTAGGART and during the later 1860s they worked together in Cadzow Forest, but Vallance never achieved the freedom of colour and technique of his friend. Vallance's watercolours can be effective, often depicting coastal views in a restricted range of colours.

His most famous painting is *Reading the War News* (1871), but his freer seascapes are probably more interesting than his larger, more formal works. Founder member of the SCOTTISH ARTS CLUB.

Vanson, Adrian fl.1580–1601
This Netherlandish portrait painter found favour at the Scottish court in the late 16th century and was appointed official painter in 1584 after ARNOLD BRONCKHORST moved to London.

Visitella, Isaac fl.1649–57
Lived in the Canongate, Edinburgh and painted portraits. Sitters included the Earl of Caithness, the Earl of Winton and the Lord of Mey. Died 1657.

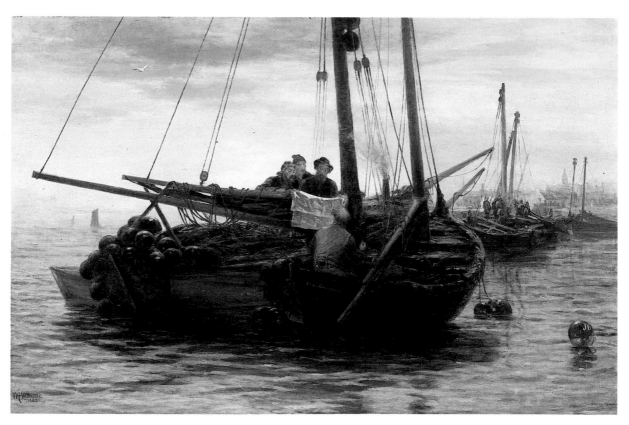

W F Vallance *Reading the War News* oil 1882, Royal Scottish Academy (Diploma Collection)

Waitt, Richard fl.1708–30
Married in Edinburgh 1707. Probably a heraldic painter by training, becoming a self-taught portraitist. Earliest known portrait is *Mrs Boswell* (1709). Came under the patronage of the Clan Grant and painted the Laird, his family and members of their Highland Court, including their pipers and champions. Thus a unique and fascinating record was established. In the 1720s he is known to have painted at least one remarkably competent still-life and in 1728 he produced his own extraordinary satirical self-portrait, possibly based on GEORGE JAMESONE's of 100 years previously. Died 1732.

Wales, James 1747–95
Born Peterhead. Portrait painter who worked in Aberdeen and London before settling in India (1791) where he painted native princes and local dignitaries.

Walker, Ada Hill d.1956
St Andrews artist, studied London and GSA, returned to St Andrews where she painted the Fife coast in a dashing watercolour style. Her stylish figure studies are typical of their period.

Walker, Alexander fl.1894–1933
Watercolour painter and etcher, he lived in Glasgow moving to England ca.1916.

Richard Waitt *Self portrait* oil, Scottish National Portrait Gallery

Walker, Alison G. 1893–1981
Painter and designer in stained glass, she studied at GSA 1912–13 and 1919–23.

Walker, Dame Ethel 1867–1951
RBA 1932
Born Edinburgh and trained at Westminster and the Slade. Lived in London and Robin Hood's Bay most of her life. Painted landscapes, seascapes, flower pieces and portraits. Died London.

Walker, Frances b.1930
ARSA 1970
Born Kirkcaldy. Studied at ECA and won Carnegie Travelling Scholarship. Joined staff at Gray's School of Art, Aberdeen. Landscapes and coastal scenes in a variety of media.

Walker, Robert J. fl.1890s–1938
Glasgow painter of landscape, architectural subjects and flowers.

Walker, Robert McAllister 1875–?
Born Fleetwood, he painted landscapes working in oil and watercolour and worked as an etcher. He lived in Bothwell, Lanarkshire.

Walker, William 1878–1961
ARE 1914
Born Glasgow, he studied in Glasgow, London and Paris. He was lecturer in History of Art at Chelsea Polytechnic 1919–21 but returned to Scotland where he lived in Callander and later Edinburgh. He painted mainly architectural subjects often working abroad in Holland, France and Spain. Also produced many etchings.

Wall, Cynthia (Mrs William Birnie) b.ca.1927
RSW 1971
Glasgow painter and teacher, she paints landscapes and flower pieces. In recent years she and her husband have painted during the summers in France and their colours have brightened.

Wallace, Anne Paterson b.1923
Born Montrose, grand-daughter of JAMES PATERSON. After demobilisation from WRNS trained at Chelsea School of Art 1947-50. Married 1951 and moved to Suffolk. Mainly paints landscapes in watercolour.

Wallace, Harold Frank 1881–1962
Lived at Corriemony, Inverness-shire, and painted natural history subjects, particularly red deer of which he made a life-long study. Wrote and illustrated books on stalking and game and, together with Lionel Edwards, was responsible for the classic *Hunting and Stalking the Deer*.

Wallace, William 1801–66
Born Falkirk and lived in Edinburgh until 1833, when he moved to Glasgow. Painted portraits, genre and figures. Member WSA.

Walls, William 1860–1942
ARSA 1901, RSW 1906, RSA 1914
Born Dunfermline and studied at the RSA Schools and later at Antwerp Academy. In Antwerp he drew the animals at the zoo, concentrating on the wild animals like lions, jaguars and panthers which could not be studied in Scotland.
On his return to Scotland, Walls established a reputation as an animal painter in both oil and watercolour. He was influenced by the work of JOSEPH CRAWHALL and EDWIN ALEXANDER, who became his brother-in-law. His watercolours have the same simplicity and concise draughtsmanship as Crawhall and he also used tinted paper with bodycolour. His oils are more worked and finished.
Walls visited Hamburg and London zoos and was one of the founders of Edinburgh Zoo near his home in Corstorphine. Also painted landscapes, sometimes small sketches done from the train while travelling, at other times larger, more complete works painted on holiday in Perthshire or Dornoch. Was related by marriage to CHARLES MACKIE. Died Edinburgh.

Walton, Cecile 1891–1956
Born Glasgow, the daughter of E.A. WALTON, she lived in Chelsea in the 1890s before moving to Edinburgh with her parents. Was introduced to the work of the Symbolist painters by JOHN DUNCAN, and they had a greater influence on her style than the Glasgow School, of which her father was a leading member. She trained in Edinburgh, Florence and Paris (1908–9) and in 1911 her illustrations for Hans Christian Andersen were published by T.C. and E.C. Jack. They show a strong influence of JESSIE KING and her Glasgow associates. The Waltons were friends of FRA and JESSIE NEWBERY and Cecile was close to their daughter MARY. It was at their summer cottage in Walberswick that Cecile met ERIC ROBERTSON and in 1914, against her parents' wishes, they were married.
In 1917, when Eric Robertson was in France with the Friends' Ambulance Unit, Cecile Walton began work on illustrations to *Polish Fairy Tales*; these were

William Walls *In the Park* oil, private collection

published in 1920 and reflect her visit to Florence in 1914 (sent by her parents in an attempt to prevent the marriage). Her figures were now influenced by the Italian Renaissance in addition to Burne-Jones, Rossetti and John Duncan. In 1919 she exhibited with the re-formed EDINBURGH GROUP and showed 21 watercolours illustrating *Polish Fairy Tales* at the 1921 Edinburgh Group exhibition. In 1923 her stormy marriage finally broke up and she visited Vienna with DOROTHY JOHNSTONE, returning to settle in Cambridge where she worked on theatre designs for Tyrone Guthrie. She returned to Edinburgh before the War to work on children's radio and during the late 1940s took up painting again, working on illustrations, murals and designs. Her most interesting work, however, had been done between 1909 and 1923. Died Edinburgh.

Walton, Constance (Mrs W.H. Ellis) 1865–1960
RSW 1887
Born in Glasgow, the sister of E.A. WALTON and George Walton, the designer, she studied in Paris. Painted flowers in watercolour using a formal composition. Married in 1897.

Walton, Edward Arthur 1860–1922
RSW 1885, NEAC 1887, ARSA 1889, RP 1897, RSA 1905, PRSW 1914–1922
Born at Glanderston House, Renfrewshire into an exceptionally talented family, he spent two winters studying art in Dusseldorf and then attended classes at GSA where he met GUTHRIE. In the summer of 1879 Walton, Guthrie and CRAWHALL worked together at Rosneath on the Clyde. Walton's brother had married Judith Crawhall in 1878 and a nucleus of the GLASGOW SCHOOL came together in 1879. In the following year Walton painted in Surrey while in 1881 he joined Guthrie, Crawhall and HENRY at Brig o'Turk in the Trossachs where they painted village life, rather than the spectacular landscape. 1882 saw Walton in Lincolnshire at Crowland painting the picturesque village in the flat countryside and its people. In the following year, Walton joined Guthrie who had taken a house in the Berwickshire village of COCKBURNSPATH. Walton made great progress at Cockburnspath, painting in the open air in both oil and watercolour. He also made a remarkable series of watercolours in Helensburgh in 1883 depicting the prosperous suburb and its well-dressed people. These watercolours are amongst the finest of the Glasgow School with their clarity of image and colour and strong decorative sense.

In 1885 Walton began work on *A Daydream* in the open air at Cockburnspath. This is Walton's last large Realist picture, for he was turning towards Whistler's more subjective approach. In 1889 he received official recognition, being elected ARSA and from 1894 to 1904 he lived in Chelsea, a neighbour of Whistler and LAVERY, living at 73 Cheyne Walk in a house designed by Ashbee.

During his period in London, Walton often painted

Cecile Walton *Mother and Child* watercolour,
Mr & Mrs John Kemplay

E A Walton *The Briony Wreath* watercolour, private collection

223

in Suffolk where he spent many summers at the Old Vicarage, Wenhaston. FRA NEWBERY and his family also spent summers in Suffolk, and it was here, some years later, that CECILE WALTON met ERIC ROBERTSON. The Suffolk landscape was important to Walton and he painted pastoral scenes in both oil and watercolour, the latter often on buff paper with marvellously inventive use of bodycolour and watercolour. Walton was also a master of oil technique, using extensive underpainting to create subtle effects. In 1904 the Waltons returned to Scotland settling in Edinburgh and in 1905 he was elected RSA. He continued to travel painting regularly in Suffolk and abroad. In 1907 he visited Algiers and Spain with Guthrie and in 1913 worked in Belgium. During the war he discovered the Galloway landscape. In 1914 he was elected President of the RSW. Died Edinburgh.

Walton, Hannah 1863–1940
Born and died Glasgow, sister of E.A. WALTON. Miniature painter and painter on glass and china.

Walton, Helen 1850–1921
Born Cardross, the sister of HANNAH, CONSTANCE and E.A. WALTON, she studied at GSA, joining the

staff in 1894–1902. Designed and decorated ceramics and painted on glass.

Warrender, Thomas fl.1673–1713
Born Haddington and apprenticed to John Tait of Edinburgh in 1673. Worked in the 1690s at Hamilton Palace, Cramond Kirk and Craigie Hall on decorative work. Later recorded executing landscapes on panels at Hopetoun House, as well as marbling, gilding and varnishing. Only one easel painting by him – a politically motivated still-life – is known to exist, although it is difficult to believe that a picture of such stunning quality was unique in his *oeuvre*.

Waterson, David 1870–1954
ARE 1901, RE 1910
Etcher and engraver of landscapes, he also worked in oil, watercolour and pastel and painted some portraits. He lived in Brechin.

Waterstone, John fl.1840s–60s
Edinburgh landscape painter. Exhibited RSA.

Watkins, Dudley Dexter 1907–69
Born Nottingham and trained at Nottingham

Thomas Warrender *Still life* oil, National Gallery of Scotland

Art School. Moved to Dundee 1925 to work for Thomson-Leng Publications where his long career was spent drawing cartoon characters. He was the creator of such legendary figures as Desperate Dan, Oor Wullie and the Broons. Also painted landscapes and buildings in oil and watercolour, but these efforts were not of the same inspired quality as his cartoons. Lived and died in Broughty Ferry.

Watson, Emma 1842–?
Born Greenock and studied at GSA 1880–1889. Painted landscapes, often with figures, garden scenes and figures.

Watson, George Cuthbert. d.1965
RSW
Taught art at Dunfermline High School and Trinity Academy, Edinburgh, where he was Head of Department. Painted landscape and still-life in watercolour and gouache.

Watson, George 1767–1837
RSA 1826, PRSA 1826–1837
Born Berwickshire, he attended classes at the Nasmyth School, before moving to London aged 18 to work in Joshua Reynolds' Studio. Returned after two years and settled in Edinburgh where he established a successful practice. His portraiture was, in Caw's words, 'workmanlike and worthy of respect' but it lacked flair. Watson was involved with the formation of the Scottish Academy in 1826 and was elected its first President. Died Edinburgh.

Watson, George Cuthbert fl.1920s–40s
Lived in Edinburgh and moved to Dunfermline ca. 1932. Paints landscapes and harbours of England and the Highlands in watercolour. Was part of the group around GILLIES and MACTAGGART in the 1920s. Art master at Dunfermline High School and Trinity Academy, Edinburgh.

Watson, George Patrick Houston 1887–1960
RSW 1938
Architect and watercolour painter, studied ECA. His watercolours are sensitive, using pencil outlines and light colours; usually painted landscapes. He was married to the potter and painter ELIZABETH ISOBEL AMOUR.

Watson, James n.d.
Twentieth-century artist, art master at Morgan Academy, Dundee. Painted landscape, sometimes with figures, in France, Spain and Scotland, using a dynamic watercolour style influenced by MELVILLE.

Watson, John fl.1888–1901
Lived in Kilmarnock and painted flower pieces.

Watson, Robert fl.1890s
Glasgow painter of Highland sheep and cattle.

Watson, T.R. Hall fl.1890–1914
Glasgow watercolour and oil painter of Scottish landscapes.

Watson, William Smellie 1769–1874
RSA 1826
The son of GEORGE WATSON, the first President of the RSA 1826–37, he was himself a Foundation Member of the Academy. Studied at the RA Schools and painted mostly portraits, with some landscapes.

Watson, William Stewart 1800–70
Edinburgh artist who painted portraits and genre and historical subjects. Exhibited Carlisle Academy (1830) and at the RSA 1850s–60s.

Watt, Elizabeth Mary 1886–1954
Born Dundee, she studied at GSA 1906–1917. Painted portraits, especially of children, flowers and also landscape. Her favourite subject was the white sands on Iona but she regarded herself principally as a potter. Also decorated china.

Watt, Albert George Fiddes 1901–86
Son of GEORGE FIDDES WATT, trained at Goldsmith School of Art. Painted portraits and landscapes, especially of the area around Aberdeen.

Watt, George Fiddes 1873–1960
ARSA 1910, RSA 1924, RP 1926
Born Aberdeen, he attended Gray's School of Art and the RSA Schools. Painted mostly portraits working in Edinburgh and London. Died Aberdeen.

Watt, James George fl.1883–6
Aberdeen painter of landscapes and portraits.

Watt, T. Archie Sutter b.ca.1920
RSW 1966
Born Edinburgh and studied before the War at GSA 1939 and ECA 1946–49, under MAXWELL, GILLIES and MACTAGGART. Initially painted watercolours very much in the tradition of Gillies, but in recent years has developed his own distinctive style, painting flower pieces and landscapes – especially of the Galloway area in which he lives – which are often large and abstracted. Paints in both oil and watercolour and produces blockprints. Exhibits widely including SSA. Runs summer schools at Kirkgunzeon and Kirkcudbright and is a founder member of Dumfries and Galloway Arts Festival.

Watt, Thomas fl.1840s
Glasgow painter of landscapes. Exhibited WSA.

Watts, D. fl.1918–1938
Landscape watercolour artist who painted views of the east coast in a 'wet' watercolour style.

Webb, Thomas fl.1820–1860
Topographical watercolour artist who worked in Edinburgh.

Webster, Alfred George fl.1876–1907
Edinburgh based painter of landscapes and seascapes.

Webster, Robert Bruce fl.1930s–40s
Edinburgh painter of landscape who often worked on coastal scenes in Fife.

Weir, Walter d.1816
Edinburgh genre painter, studied in Italy and worked in a style influenced by DAVID ALLAN. His faces are more of caricatures than are Allan's, suggesting that he had seen the work of GEIKIE. Associated with RAEBURN in the early 1780s in life drawing classes.

Weir, Wilma Law fl.1912–1940
Born Glasgow, studied ECA. Painted landscapes in oils and watercolour.

Welch, John fl.1830s
Edinburgh painter of miniatures.

Wellington, Hubert 1879–1967
Born Gloucester and brought up in the Cotswolds. Studied at Gloucester School of Art, Birmingham and the Slade. Exhibited NEAC 1916 and with the London Group. Principal, ECA 1932–42 and returned to London thereafter. Died Henley on Thames.

Wells, William Page Atkinson 1872–1923
RBA 1906
Born Glasgow and studied at the Slade before moving to Sydney, Australia where he lived and worked for five years. Returned to Europe, working for a time in Paris and rural France where he acquired an admiration for the Barbizon School with its rich tones and glowing colours. After a short stay in Glasgow he settled in Preston, Lancashire, for seven years as a scene painter. He finally settled in Appledore, Devon where he died aged 51. Wells painted rural scenes, often farm girls feeding chickens or working in the fields. What is unusual about his work is his extraordinary technique both in oil and watercolour. His oil paint is applied thickly in small brushstrokes, building up a rich impasto which enhances the tones and gives a physical presence to each picture. His watercolours are painted on rough paper, often over a framework of charcoal and pastel, again creating rich tones and depth of colour.

West, David 1868–1936
RSW 1908, VPRSW
Born Lossiemouth, the son of a ship's captain, he went to sea as a youth and took part in the Klondyke Gold Rush in Alaska in 1898. Returned to Lossiemouth where he worked as a watercolourist for the rest of his life, interrupted only by a short visit to South America in the mid-1920s. West painted the landscape and coastal scenery of the north east in a 'wet', fluent style using subtle shades of blue and greys and achieving great sense of light.

Westwater, Robert Heriot 1905–62
ARSA 1948, RP
Born in Fife, the son of a schoolmaster, he studied at ECA and on the continent. Taught in London for three years and returned to ECA where he joined the staff for ten years. Also taught at Fettes College. Became a most successful portrait painter, his sitters including Lord Boothby, Sir Compton Mackenzie and Hugh MacDiarmid. Was art critic of the *Scotsman*. Moved to London and died Southfleet, Kent.

De Wet, Jacob 1640–97
Born Haarlem, son of a painter, and travelled to Scotland ca. 1673 at the request of Sir William Bruce to work on the Palace of Holyrood House. Returned to the continent 1677–84 but then reappears in Scotland as 'His Majesties picture drawer in Scotland.' Also painted for the Duke of Hamilton (1685) and the Earl of Strathmore at Glamis (1688). Returned to Haarlem in 1691. Died Amsterdam.

White, Charles fl.1688–1720
Lived in Aberdeen. Heraldic painter and copyist. Paid £10 for a copy of GEORGE JAMESONE's portrait of Robert Gordon of Straloch (1701).

White, John 1851–1933
RBA 1880, RI 1882, ROI 1886
Born Edinburgh, moved to Australia as a child, returned to study at RSA Schools. Moved to

William Wells *Feeding the Hens* oil, Robert Fleming Holdings Ltd

David West *The Skerries, Lossiemouth* watercolour, private collection

England c.1880 and painted delicate oils and watercolours of the English countryside in a pretty style. Later lived in Devon.

Whyte, Duncan Macgregor 1866–1953
Born Oban and studied at GSA, Paris and Antwerp. Painted portraits and landscapes, coastal scenes and marine views around Oban where he lived for many years. He worked mostly in oil. Also worked in Australia and on Tiree.

Whyte, Mrs D MacGregor (née Barnard) d.1946
Married to DUNCAN MACGREGOR WHYTE. Studied in Paris and painted landscapes and seascapes in pastel and watercolour.

Whyte, John G. c.1836–1888
RSW 1878
Amateur Glasgow artist, dentist by profession. Founder Member of the RSW. He was a keen collector of paintings by the GLASGOW BOYS, and painted in watercolour himself. His subjects were usually flowers in natural settings such as woods or meadows, and trees. Also painted some still-life.

Wighton, William fl.1850s–70s
Glasgow portrait painter. Member of the West of Scotland Academy.

Wilkie, Sir David 1785–1841
ARA 1809, RA 1811
Born near Pitlessie, Fife, the son of a minister, Wilkie began to draw as a child, making sketches of local characters. Entered the Trustees' Academy in 1799. As a student he was noted for his ability to draw characters and he was impressed by DAVID ALLAN's watercolours.
In 1804 he returned to Fife and began work on a view of Pitlessie Fair, which he sold for £25 in 1805, enabling him to move to London and enrol at the RA Schools.
In London Wilkie was impressed by the work of the Dutch and Flemish Schools in particular Teniers. In 1806 he exhibited *Village Politicians* at the RA: it was an instant success earning Wilkie the title the 'The Scottish Teniers'. A series of pictures over the following years cemented Wilkie's success – *The Blind Fiddler*, *The Jew's Harp*, *The Cut Finger* and *Rent Day* being the most notable – and in 1809 he was elected ARA, becoming a full Academician two years

Robert Heriot Westwater *Sir Compton Mackenzie* oil, National Gallery of Scotland

Sir David Wilkie *Domestic Life* oil, The Robertson Collection, Orkney

later. In London Wilkie met many leading artists, including Flaxman, Fuseli, Nollekens and West as well as his compatriots ANDREW WILSON and JOHN BURNET, who engraved many of Wilkie's pictures. The success of his earlier genre paintings lies in his ability to capture ordinary human situations with humour and sympathy. Technically, although his work was detailed, Wilkie achieved a richness of colour and confidence of handling which prevents his pictures being overworked.

Wilkie was one of the first great popular artists, his pictures being reproduced and circulated so that they were known by huge numbers of people. Paintings such as *Blind-Man's-Buff*, *The Letter of Introduction*, *The Penny Wedding* and *The Reading of the Will* were widely acclaimed through prints and in 1822 a crush barrier had to be erected at the RA in front of *The Chelsea Pensioners*.

In 1814 Wilkie visited France with Benjamin Robert Haydon and saw the Dutch painters in the Louvre. He returned to Europe in 1816 visiting Holland and Belgium, and in 1822 he started work on a large oil commemorating the visit of George IV to Edinburgh. Wilkie wanted to break away from his role as the Scottish Teniers, but this first attempt at history painting posed many problems. As a result Wilkie's health suffered and in 1824 he left for a recuperative trip abroad.

Wilkie's stay in Italy in 1825 opened his eyes to the colours of the south and he was fascinated by the clarity of fresco painting. In 1827 he reached Spain where he was impressed by the technical brilliance of Velasquez.

Wilkie returned to London in July 1828 and exhibited three Spanish canvases at the RA in 1829. The critics and the public lamented Wilkie's change of style and subject, although George IV admired and purchased his new work. During the 1830s Wilkie executed many official portraits in his freer, more fluent style. He also painted many exquisite watercolours and sepia drawings, revealing his mastery of draughtsmanship. Wilkie did not abandon genre, working in Ireland in 1835, but they lack the sincerity of his earlier genre. Between 1834 and 1838 Wilkie worked on *Sir David Baird discovering the body of Tippoo Sahib*; this Indian subject aroused his interest in the East, and in 1840 he set off for Turkey and the Holy Land. During his four months in Constantinople, Wilkie produced over 60 sketches, some later engraved as *Oriental Sketches*. These fluent watercolours are extraordinary for their quality and for Wilkie's ability to capture the characteristics of a Negro, Egyptian, Persian, Jewish or Turkish face. Wilkie stayed in Jerusalem before returning via Alexandria, but on June 1, 1841 he died at sea on his way to Malta. His burial at sea was recorded by Turner. Wilkie's influence upon Scottish art was enormous. He spawned a century of genre painters who, for better or worse, reworked his unique mixture of observation, sympathy and humour: and his Spanish oils and watercolours were to influence artists like JOHN PHILIP and W.E. LOCKHART.

Wilkie, John D. fl.1850s–60s
Lived in Edinburgh and painted west coast landscapes and rural scenes.

Wilkie, Robert 1888–?
Born Sinclairtown, Kirkcaldy, he studied at ECA. Painted Scottish Highland scenes often with streams, for which he is best known, and also interiors. He produced some lithographs. His wife was the painter Mary Ballantine and they lived in Glasgow.

Williams, C *see* **Glass, John Hamilton**

Williams, Hugh 'Grecian' 1773–1829
Williams was born at sea, his father a Welsh sea captain, his mother the daughter of the Deputy Governor of Gibraltar. He lost both his parents when young and was brought up by his grandmother in Edinburgh. Attended DAVID ALLAN'S classes in Dickson Close and those of ALEXANDER NASMYTH in York Place, but it was the elegant penwork and roccoco colours of David Allan that had the greatest influence on Williams.

During the 20 years before he went to Greece in 1816, Williams painted many watercolours of Scotland, working around Edinburgh and Glasgow, on Lochs Lomond and Ard, on the Isle of Arran, in Argyllshire and on the East coast around Angus. From around 1810 Williams' style began to broaden, possibly as a result of taking up oil painting. He painted on the spot for smaller watercolours, although his larger, more finished works would have been painted in the studio. Williams' colours often have a roccoco charm and he makes use of light browns, pinks and powder-blues. In many works, he replaces the rugged Scottish landscape with a vision of pastoral tranquillity and pastoral elegance.

In 1816 Williams set off on a Grand Tour through Italy to Greece, returning to Scotland in 1818. A successful exhibition of his Greek watercolours was held in Edinburgh in 1822 and he published an illustrated account of his journey *Travels in Italy, Greece and the Ionian Islands* (1820), as well as a series of engravings from his watercolours *Select Views in Greece*.

Some of his Greek watercolours are painted on a large scale. He found that good effects could be created 'by painting first with opaque watercolours and afterwards varnishing and finishing with oil colours'. These large works have a grandeur and power lacking in his earlier watercolours, and his earlier rococo elegance has given way to an almost Romantic sensibility. Other watercolours relating to the Greek trip are more informal and show a great sensitivity towards the light and colours of Greece.

During his last ten years, he painted almost entirely Italian and Greek views. He had married into money, and moved amongst the best society in Edinburgh where he was a popular figure. Died Edinburgh.

Williams, James Francis 1785–1846
RSA 1826
Born Perthshire, worked in London as a scene painter, returned to work in the theatre in Edinburgh in 1810. Elected Foundation Member RSA in 1826 and devoted himself entirely to landscape. His watercolours and oils are restrained, his colours influenced by the earlier topographical artists, and his work is somewhat lacking in sparkle.

Williams, John fl.1860s–70s
Lived in Campsie and painted landscapes.

Williams, Morris Meredith 1881–?
Born Cowbridge, Glamorgan, and studied at the Slade, in Paris and in Italy. Painter, illustrator and stained glass worker who was an art teacher in Edinburgh for a while ca. 1905. Exhibited widely 1905–37.

Williams, Thomas d.ca.1885
Glasgow artist, painted views of the Clyde and the landscape surrounding Glasgow in oil and watercolour.

Williamson, David fl.1860s–90s
Lived in Hamilton and painted landscapes.

Williamson, John fl. 1880
Edinburgh portrait and figure painter.

Willison, George 1741–97
Born in Scotland, trained in Italy, lived in London and went to India in 1777. Returned to Edinburgh a rich man and continued his portrait practice.

Wilson, Alexander 1819–1890
Landscape painter who worked in Ayrshire and Renfrewshire. He also designed textiles.

Wilson, Alexander fl.1808–13
A Scot who emigrated to America and illustrated his important book *American Ornithology*, published in 7 volumes between 1808 and 1813.

Wilson, Alice 1876–1974
Brought up in Dalmuir, Dunbartonshire, and studied at the Slade. Painted portraits and landscapes in watercolour, oil and pastel. Moved in later life to London.

Wilson, Andrew 1780–1840
Born Edinburgh, he trained for a short period with ALEXANDER NASMYTH before moving to London aged 17. Studied at the RA Schools and then went on to Italy which he reached before 1800. This

Hugh 'Grecian' Williams *Kenmore, Perthshire* watercolour, Lady Evelyn Brander

first visit lasted three years and he spent most of the time in Rome and Naples studying Italian art and sketching in the countryside. He was back in London in 1803, but returned to Italy in the same year to purchase Old Master paintings. The renewal of the war posed serious problems and for two years he lived in Genoa posing as an American citizen. He returned to London in 1805, laden with some 50 canvases which included Rubens' *Brazen Serpent* and Bassano's *Adoration of the Magi*. Between 1805 and 1818 Wilson worked in London, painting mostly watercolours based on his Italian sketches. During this period he met DAVID WILKIE and the two became close friends.

In 1818 Wilson returned to Edinburgh to become Master of the Trustees' Academy. He was not an outstanding teacher but his knowledge of Italian art widened the outlook of many of his students. In Edinburgh, Wilson continued to work in both oil and watercolour, painting both Italian and local views.

In 1826 he resigned his post at the Trustees' Academy and returned to Italy, living in Rome, Florence and Genoa for the next 20 years. He continued to act as an art dealer buying Italian works for Lord Hopetoun, Lord Pembroke, Sir Robert Peel and other collectors. He was a popular figure amongst the British community in Rome and, along with the Duke of Hamilton, presided over a public dinner in honour of David Wilkie in 1826. He left Italy in 1847 for a short visit to Scotland but died in Edinburgh in November 1848.

Wilson's long periods abroad have contributed to his comparative obscurity as a painter, but he was a fine watercolourist with a cool, draughtsman's approach, using crisp outlines and areas of transparent washes. He was equally talented as an oil painter, Claude Lorrain being his main influence here.

Wilson, Charles Heath 1809–1882
ARSA 1835

The eldest son of ANDREW WILSON, he was born in London and studied under his father, accompanying him to Italy in 1826. He stayed there until 1833 when he returned to Edinburgh to practise as an architect and to teach. He held a number of administrative posts including Director of Somerset House School of Art (on the resignation of WILLIAM DYCE in 1843) and Headmaster of the new Glasgow School of Design in 1849. Wilson had cooperated with Dyce on the 1838 report on art schools abroad and much of his career was spent implementing the recommendations made in that report. He was also, like Dyce, an expert on fresco painting, and in addition took an interest in stained glass. Despite his official duties, he found time to paint, especially after his retirement in 1869 when he moved with his family to Florence. In Italy he painted in watercolour, working in Florence, Rome and Venice and he wrote about Italian art, publishing a life of Michelangelo. He was a good draughtsman and his watercolours have that combination of firm draughtsmanship and transparent washes which distinguish the early Victorian period.

Wilson, David Forrester 1873–1950
ARSA 1930 RSA 1933

Born Glasgow, the son of John Wilson, a lithographer, he trained at GSA and later joined the staff. He specialized in portraits and large decorative panels and was commissioned to paint one of the panels in the Banqueting Hall, part of Glasgow's Municipal Buildings. Also painted landscapes with figures.

Wilson, Francis 1876–1957

Born Glasgow, he studied at GSA, Paris and Italy. Painted landscapes and portraits in a broad and powerful style.

Wilson, George 1848–1890

Born near Cullen in Banffshire, he was educated at Edinburgh University before turning to painting which he studied in London at Heatherley's. After a period at the RA Schools he left to study at the Slade. He established a reputation in London as a follower of the Pre-Raphaelites in both figure and landscape painting, but his shy, retiring nature denied him greater recognition. His figure paintings are often melancholic and romantic, although his oil technique was frequently rather overworked and uninspired.

Wilson painted landscape, often in watercolour, capturing the intricacies of woodlands and thick undergrowth and flowers. He visited Italy where he painted landscapes and studied the Italian Renaissance, but most of his landscapes were painted in north east Scotland where he returned regularly.

Wilson's work is rare: he had eager collectors of his paintings, including Halsey Ricardo, but he exhibited rarely and died young of cancer.

Wilson, George Washington 1823–93

Born Waulkmill of Carnoustie, Banffshire. Executed a limited body of work in watercolour and pencil, but best known as a pioneer photographer.

Wilson, Hugh Cameron 1885–?

Born Glasgow, he studied at GSA. Lived in Glasgow and exhibited landscapes, portraits and figure paintings at the Glasgow Institute. He painted broadly handled landscapes, often of Oronsay.

Wilson, James 1795–1856
HRSA 1827

Zoologist and painter of portraits, figures and bird studies.

Wilson, James fl. 1860s–81

Born Falkirk. Trained Trustees' Academy, 1855. Glasgow painter of portraits and figures.

Wilson, James C.L. fl. 1885–1911

Glasgow watercolour landscape artist.

Wilson, John ('Old Jock') 1774–1855

Born Ayr, he was apprenticed to the NORIES in Edinburgh and he also attended classes at the NASMYTH School in York Place. After two years in Montrose, where he taught and painted, he moved to London in 1798 working first as a scene painter, but later specializing in marine painting in oil and watercolour. He visited Holland in 1816 and in 1824 accompanied his friend DAVID ROBERTS to Dieppe, Le Havre and Rouen. In addition to his Continental coastal scenes, he painted views in Scotland. Wilson's oil style was strongly influenced by the Dutch School, in particular Cuyp.

Wilson, Margaret Thomson (Mrs James Hamilton Mackenzie) 1864–1912

Born Cambuslang, studied GSA. Painted in Holland and later, after her marriage to J. HAMILTON MACKENZIE, in Italy.

Wilson, Mary Georgina Wade 1856–1939

Born Falkirk, studied Edinburgh and Paris. Watercolourist and pastelier, she illustrated books on gardens and exhibited her paintings of gardens with considerable success.

Wilson, Peter Macgregor d.1928

RSW 1885 (resigned 1926)

Studied GSA and London and Antwerp. Travelled widely, working in America, India, Persia, Russia and Europe. His watercolours are always competent with firm composition and solid colours, but at times his drawing is weak. Painted landscapes and river scenes on the west coast.

Wilson, Scottie 1889–1972

ARSA 1939, RSW 1946, RSA 1949

Born Glasgow and in 1906 enlisted in the army, serving in India, South Africa and France. Around 1930–1 he went to Canada and opened a junk shop. He collected old fountain pens to salvage the gold nibs and it was with these that he began drawing, creating patterns in tightly hatched ink lines. He drew an imaginative world filled with decorative birds, fish, flowers, trees and buildings. He returned to London in 1945 and his work was soon recognised by the Surrealists. In 1952 he went to Paris, meeting Dubuffet who admired his work and had included it in his *Art Brut* exhibition of 1949. Picasso also admired his work. Scottie Wilson also decorated plates, designed tapestries for Aubusson and the Edinburgh Tapestry Company and painted a mural in Zürich.

Wilson, Thomas fl.1870–1914

Edinburgh coastal and landscape painter in oil and watercolour. His landscapes often have figures.

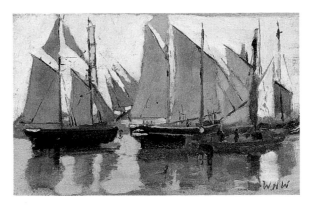

William Heath Wilson *Venice* watercolour ca. 1885, Bourne Fine Art

Wilson, William 1905–1972

ARSA 1939 RSW 1946 RSA 1949

Born in Edinburgh, he served an apprenticeship with James Ballantine, the Edinburgh stained-glass maker. He studied at ECA and his engravings and etchings won him a Travelling Scholarship to France, Germany, Spain and Italy in 1932. In 1934 he studied engraving and stained-glass in Germany, and in 1937 opened his own stained-glass studio in Edinburgh. By the late 1930s Wilson's style both in glass and watercolour had moved towards a free Expressionist manner, influenced both by his knowledge of German Art and by the work of GILLIES and other staff at ECA. He painted dramatic watercolours depicting the Scottish landscape, hill villages in Provence and Italy, the Dolomites, Venice and Normandy and Brittany. His watercolours are based on a pen-and-ink construction and often include architectural features, such as churches or old buildings.

Wilson was one of the leading Scottish print-makers of his period, but in 1961, in his mid-fifties, he lost his sight as a result of his diabetes.

Wilson, William Heath 1849–1927

The son and pupil of CHARLES HEATH WILSON, and

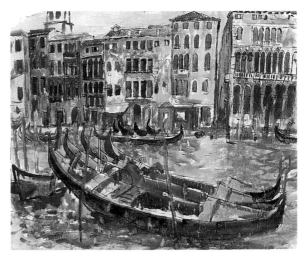

William Wilson *Venice* watercolour, The Scottish Arts Club

grandson of ANDREW WILSON, he was born in Glasgow and later became Headmaster of GSA. He painted genre and landscape, often of Italy where he lived in the 1870s and 1880s. Worked primarily in oil and most effectively on a small scale.

Wingate, Helen (Mrs Thornton) fc.1911–38
Daughter of SIR JAMES L. WINGATE, painted landscapes in oil and watercolour.

Wingate, Sir James Lawton 1846–1924
ARSA 1879, RSA 1889, PRSA 1919–1924
Born at Kelvinhaugh near Glasgow, he attended some part-time classes under ROBERT GREENLEES at GSA. He began exhibiting in 1864 and two years later he left his job to devote himself to painting.
In 1867 Wingate visited Italy, painting on-the-spot and producing some 150 watercolours during the six month trip which took him to Rome, Florence and Venice. On his return he settled in Hamilton from where he could easily reach Cadzow Forest. He met the artist W.D. MCKAY, who encouraged him to attend the RSA life class where he was influenced by MCTAGGART and CHALMERS.
During the 1870s Wingate's style became freer and less academic. He began to paint rural life, often working in the Perthshire village of Muthill, where he settled in 1881. He attempted to record all the aspects of rural life, in a similar manner to McKay, ROBERT MCGREGOR and JOHN R. REID.
In 1887 he moved to Colinton, then a village on the outskirts of Edinburgh, and while figures still feature in his work, the main emphasis is upon atmospheric effects and light. His later work, painted after 1910, is even less concerned with the details of landscape, concentrating entirely upon the effects of sunsets, storms and summer skies. He found the sunsets on Arran particularly beautiful and some of his most evocative works were painted on that island. He was elected President of the RSA in 1919 at a time when he was considered Scotland's leading landscape painter.

Wintour, John Crawford 1825–1882
ARSA 1859
Born Edinburgh, he studied at the Trustees' Academy under SIR WILLIAM ALLAN and his early work consists of portraits and genre. Around 1850 he turned to landscape, being influenced by Constable, but his later work was more subjective and even romantic, influenced by French painters like Corot. He was particularly good at evening scenes or misty

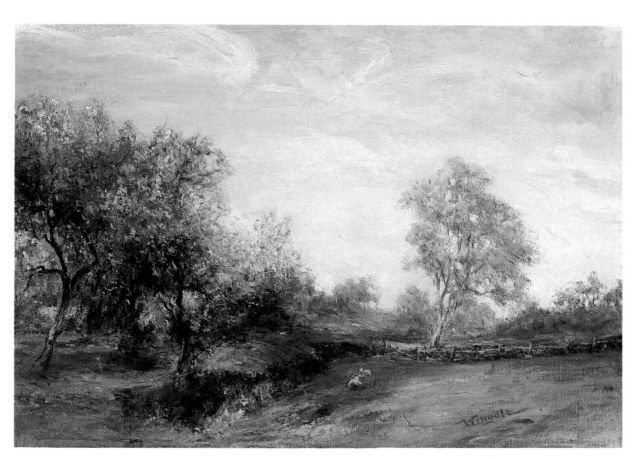

J Lawton Wingate *Springtime* oil, private collection

landscapes where forms were not too clearly defined and where he could create atmospheric effects. His watercolours with their broad brushwork and mellow colours looked forward to the Glasgow School, who admired his work. He was elected ARSA in 1859 but his behaviour, as unconventional as his art, precluded his election as Academician.

Wishart, Peter 1852–1932
ARSA 1925
An interesting and forward-looking artist, Wishart lived and worked in Edinburgh painting landscapes and seascapes in oil and watercolour in a broad style which was influenced by the later work of MCTAGGART. He captured the effect of a windy day on the coast or a storm in the mountains, using rich colours and broad brushstrokes which have Expressionist tendencies.

Wood, Frank Watson 1862–1953
Born Berwick-on-Tweed, studied South Kensington and Paris. Second Master at Newcastle School of Art 1883–9 and Headmaster of Hawick School of Art 1889–99. Exhibited regularly in Edinburgh; he was known for his watercolours of sailing ships and various battleships, and he also painted effective, 'wet' watercolours of the Highlands and Borders.

Wood, Wendy 1893–1981
Talented and prolific amateur painter who employed a wide variety of media ranging from pencil and watercolour to linocuts, scraperboard and oil. Illustrated many of her own books and drew inspiration for some of her work from Celtic legend and mythology. Best known as the founder and moving force behind the Scottish Patriots. Her earlier work is more consistent and committed in artistic terms.

Woolard, William fl.1883–1908
Edinburgh painter of landscapes and seascapes.

Woolford, Charles Halkerston. 1864–1934
Born and lived Edinburgh. Painter of landscapes and townscapes.

Woolford, Harry Halkerston Russell b.1905
Born Edinburgh, he studied at RSA Schools and in France and Italy. He worked as a picture restorer and painter.

Woolford, John Elliott fl.1800–20
Painted landscapes in the classical style of the 18th century. Moved to North America where most of his work is now to be found.

Woolnoth, Alfred fl.1867–96
Painted landscape and still life. Moved to England in the 1890s.

Woolnoth, Charles Nicholls 1815–1906
RSW 1878
Born London, he trained at the RSA Schools but moved to Scotland where he remained until his death in Glasgow. A founder member of the RSW he painted intricately detailed landscapes in watercolour using the medium like oil. He painted the Highlands and the west coast and some of his large highly finished works have undeniable grandeur.

Woon, Miss Annie K. fl.1880–1907
Edinburgh sculptor and etcher, she also taught art.

Woon, Rosa E. fl.1881–1914
Lived in Edinburgh, moving to London ca.1904. Painted landscapes and exhibited SSA.

Workman, James fl.1570–1600
A decorative armorial painter who worked at the

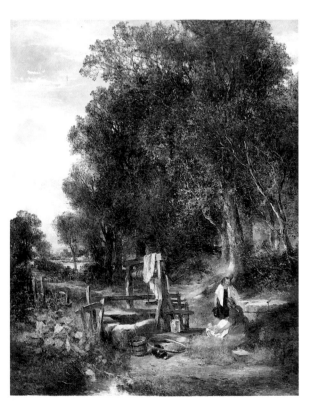

John Crawford Wintour *The Old Draw Well near Golspie* watercolour, Dundee Art Galleries & Museums

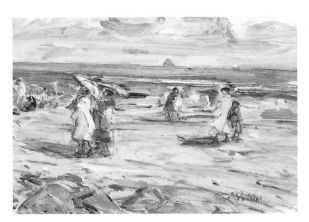

Peter Wishart *Figures by the Sea* oil, The Scottish Arts Club

233

John Michael Wright *Lord Mungo Murray* oil, Scottish
National Portrait Gallery

Scottish court together with his brother JOHN
WORKMAN.

Workman, John fl.1570–1603
A decorative and armorial painter who worked at
the Scottish court together with his brother, JAMES
WORKMAN. He painted banners and arms for the
nobility. In May 1603 he painted the coach in which
Anne of Denmark left for England.

Wright, Isabel (Mrs Thomas Calder) 1880–1958
Glasgow painter, she was born in Renfrew and
studied at GSA 1901–4.

Wright, James d.1947
RSW 1920, VPRSW
Born Ayr. Trained GSA, painted breezy views of the
west coast in bright, vibrant colours with exuberant
brushwork. Also worked in France.

Wright, Margaret Isobel 1884–1957
Born in Ayr the sister of JAMES WRIGHT she studied
at GSA c.1902–8 and possibly in Paris. In 1921 she
married Dugald Campbell, later Chief Steward of
the PS *Caledonia*, and lived in Gourock. They also
took a summer house on Holy Loch. She painted
landscapes on the Firth of Clyde and Loch Tay
executed in strong colour and bold brushwork. Also
painted children and during the war produced at

least one important work after the Greenock Blitz
of 1941.

Wright, Meg 1868–1932
Painter of landscape and figures who worked in oil
and watercolour. 'Handled watercolour in a finely
suggestive if somewhat loose way', the *Scotsman* obi-
tuary noted. Lived in Edinburgh and in Glasgow
and after the turn of the century worked on the
fringes of the Glasgow School.

Wright, John Michael 1617–94
Born London. Travelled to Scotland in 1636 to be
apprenticed to GEORGE JAMESONE until 1641. In
1648 became a member of the Academy of St.
Luke in Rome. Upon return to London around
1658 was a sought after portrait painter, winning
Royal patronage after the Restoration in 1660.

Wylie, Kate 1877–1941
Born Skelmorlie, studied GSA, painted portraits,
flowers and landscapes in oils and watercolour.
Her watercolour style is similar to that of EMILY
PATERSON, while her flower pieces are similar, if a
little freer, to those of CONSTANCE WALTON. She often
painted on Arran where she stayed in a cottage on
Blackwater Foot. In 1942 a Memorial Exhibition
of her work and that of JANET AITKEN and ELMA
STORY was held at the GLASGOW SOCIETY OF LADY
ARTISTS.

Wyllie, William fl.1920s–30s
Lived in Paisley and painted landscapes and Con-
tinental scenes in oil and watercolour.

Wyse, Henry Taylor 1870–1951
Born Glasgow, he studied at Dundee School of
Art, GSA and in Paris. He became art master
at Arbroath High School and a close friend of
JAMES WATTERSTON HERALD, but he later moved
to Edinburgh. He painted in watercolours and
pastels, decorated pottery and wrote a number of
books on painting, including *Modern Methods of Art
Instruction* and *Memory and Imaginative Drawing*.

Wyper, Jane Cowan 1866–1898
RSW 1896
Born Glasgow. Marine and coastal painter, killed
by falling over a cliff on Sark.

Yellowlees, William 1796–1855
Portrait painter, he was a pupil of WILLIAM SHIELS in Edinburgh. Moved to London ca.1829 and painted for Prince Albert. Yellowlees painted on a small scale, often little larger than miniatures, but he painted with a fluent technique and full impasto, earning him the title 'The Little Raeburn.'

Young, Alexander 1865–1923
Born Edinburgh, he painted landscapes and coastal scenes. Lived in Edinburgh and later Fife, but spent some years in Surrey.

Young, Bessie Innes 1855–1936
Born Glasgow, she studied at GSA and in Paris. She shared a studio in Glasgow with ANNIE FRENCH and JANE YOUNGER between 1906–1922. Painted landscapes in oil and some genre and still life.

Young, Edward Drummond 1876–1946
Born Edinburgh. Amateur painter who worked professionally in the city as a photographer. Author of the *The Art of the Photograph* (1931). Painted accomplished still-life.

Young, Robert Clouston 1860–1929
RSW 1901
A Glasgow watercolourist who painted coastal scenes and views of the Clyde with shipping. He used a 'wet' technique which well captures the spirit of his subject. He also painted children shrimping or fishing by the sea or by country streams. He later lived in Ardrossan.

Young, William 1845–1916
RSW 1880
Glasgow artist who, along with WILLIAM DENNISTOUN and COWANS, established the GLASGOW ART CLUB. An amateur artist for many years, he turned professional in 1878. Painted oils and watercolours of the west coast and Arran in a detailed and well worked style. In addition to painting, Young was known as a local historian and expert on early art and archaeology.

Young, William Drummond 1855–1924
Born Glasgow. Moved to Edinburgh where he became established as a portrait painter. A founder of the Pen and Pencil Club, Rustic Arts Club and The Trotters. Father of EDWARD DRUMMOND YOUNG.

Younger, Jane 1863–1955
Born Glasgow, she studied at GSA 1890–1900 and also in Paris, probably during the 1890s in the studio of Courtois and possibly at the Beaux Arts. Her sister Anna married Walter Blackie the publisher, who commissioned Hill House, Helensburgh, from C.R. MACKINTOSH. From 1906 to 1922 she shared a studio at 227 West George Street Glasgow with BESSIE YOUNG and ANNIE FRENCH, being known as 'Faith'. Annie French was known as 'Hope', but Bessie Young remained 'B.I.'. She painted mostly in watercolour and developed a bold, colourful almost pointilliste style for her landscapes. She painted in Scotland, often on Arran and in the Lanarkshire hills, and in France.

Yule, William James 1867–1900
Born Dundee and studied at Royal Institution in Edinburgh. Became a close friend of DAVID MUIRHEAD and moved to London with him in 1889. Continued training at Westminster under Fred Brown and in Paris where he developed his skills as a portraitist. Laurens opined, 'He paints like a cello.' Returned to Britain in 1893 and shared a studio in Edinburgh with A E BORTHWICK, from which he sketched and painted the city. Visited Spain 1894–5 and returned to live in London. The style of his later works have led to him being termed 'the Scottish impressionist' and he successfully captured life in town and country in a series of atmospheric oils. A promising career was cut short prematurely when he died at Nordrach-on-Mendip. Caw wrote enthusiastically of his work.

W J Yule *The Girl in Crimson* oil, private collection

Aleksander Zyw *The RSA and National Gallery from the Mound* pen & ink illustration for *Edinburgh as the Artist Sees It* (1945)

Zyw, Aleksander b.1905
Born Lida, Poland, and studied at Warsaw Academy of Fine Arts 1926–32; also in Athens, Rome and Paris. Came to Scotland in 1940 with the Polish Army and was appointed official war artist to the Polish Forces. First one man show in 1945 at the Scottish Gallery. Draws and paints landscapes, townscapes and figure subjects and, latterly, abstracts. Lives in Edinburgh and Italy.

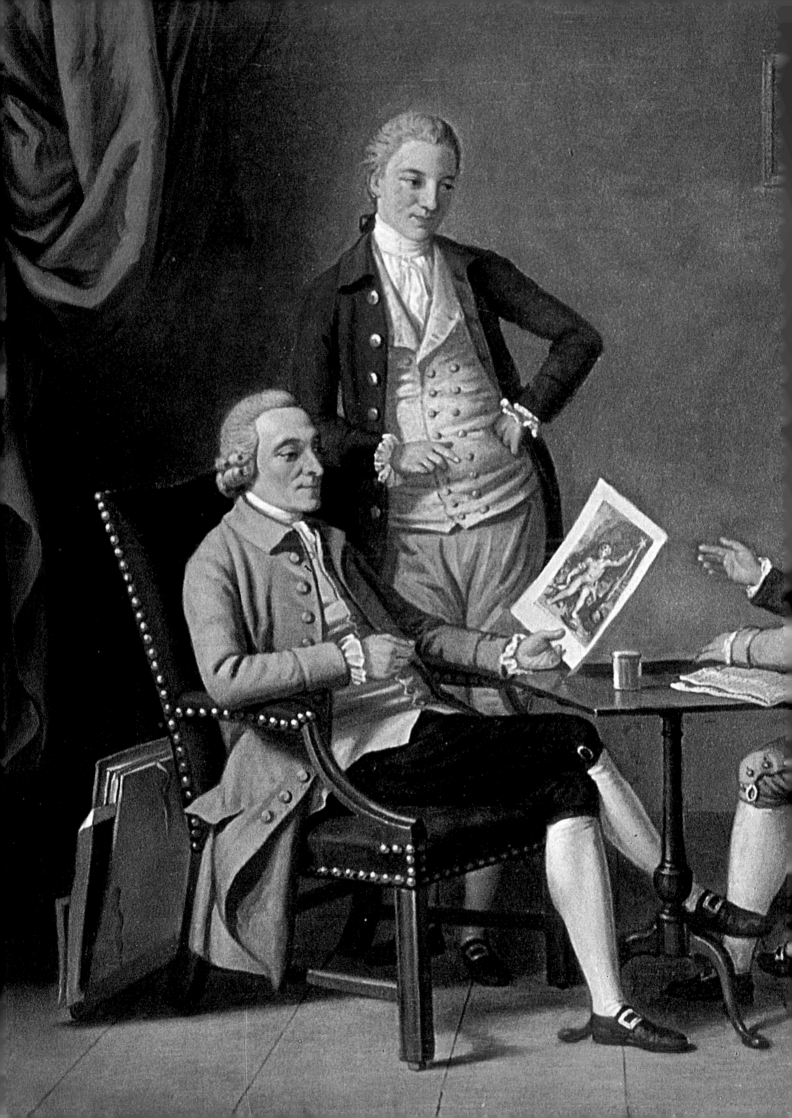